This book is to be returned on or before
the last date stamped below

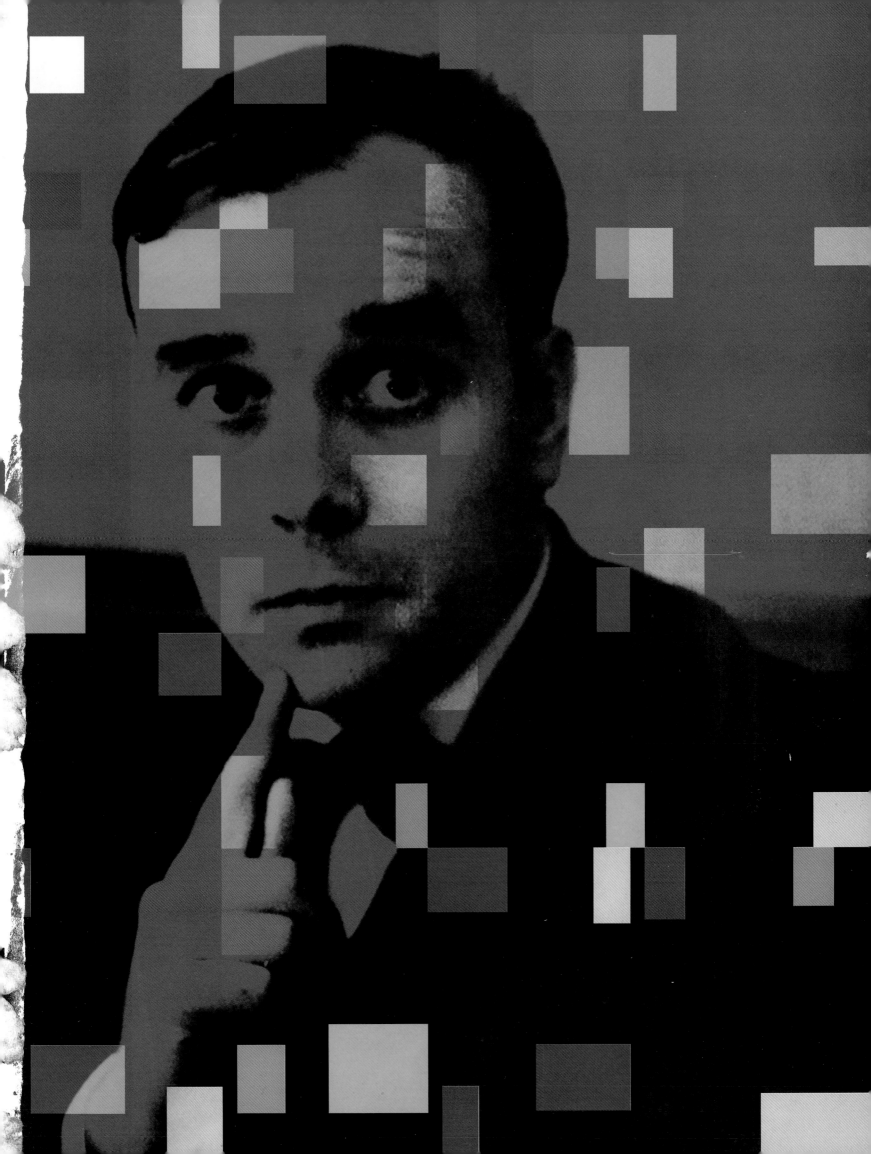

Yves Klein

Nicolas Charlet

Preface by
Pierre Restany

VILO
■
ADAM
BIRO

To my father

Acknowledgements

My warmest gratitude to Rotraut Klein-Moquay and Daniel Moquay
for having granted me permission exceptionally to consult
the Yves Klein Archives.
I am especially grateful to Pierre Restany, whose encouragement
and support prompted me to undertake my own work on Yves Klein.
I am indebted to Philippe Valode and Adam Biro, as well
as to Marlyne Kherlakian who accompanied this book from
its inception to its final draft.
I also wish to thank Françoise Levaillant of the Centre national
de la recherche scientifique (CNRS), who agreed to direct my doctoral
thesis on Yves Klein's writings at the University of Paris-I. I am also
grateful to Professors François Fossier, Dario Gamboni and Denys Riout.
To Philippe Siauve of the Yves Klein Archives, my gratitude
for his assistance.
My thanks, finally, to Béatrice and Antoine, Alain and Marie-Hélène
Charlet, Marie-Colombe Valode, Simone Cruset, José Bulnes
and Antoine Robaglia, Mathilde Rivalin and Annie Boulat.

The Yves Klein Archives, the author and the publisher are grateful
to the following persons: Mrs Aischman, Mr David Bordes,
Sister Superior Andrina Donato, Mr and Mrs Durand-Ruel,
Mr Pierre Gasperini, Mrs Krystyna Gmurzynska,
Miss Emmanuelle Gueneau, Mr Julian Heynen, Mrs Hannelore Kersting,
Mr Chrysanthi Kotrouzinis, Mrs Maria Eugenia Le Noci,
Mr Michel Motron, Mr Claude Parent, Mr Claude Pascal,
Mrs and Mr Irmgard and Robert Rademacher, Mr Mathias Rastorfer,
Mr Marc Sheps.

Note

We have endeavoured to reproduce all citations from
Yves Klein's writings as faithfully as possible.
Many of the artist's manuscripts are rough drafts – Klein took notes
constantly. His idiosyncratic punctuation, repetitions, occasional slips
and awkwardness have been retained for accuracy's sake
in the translation as well as in the original French. When set off
by quotation marks, all the superscriptions that illustrate this monograph
are drawn from Klein's writings, unless otherwise indicated. When not
given between quotation marks, they are taken from the author's text.

Translation by Michael Taylor

© 2000, Société nouvelle Adam Biro
28, rue de Sévigné
75004 Paris
Authorised English-language edition © 2000, Vilo International
30, rue de Charonne, 75011 Paris

© Yves Klein, Adagp, Paris, 2000,
for all the reproductions of works, documents
and texts by Yves Klein

© Adagp, Paris, 2000, for the reproductions of works
by Fred Klein and Marie Raymond

ISBN: 2-84576-017-5
Printed and bound in Italy

Contents

Introduction

'I am the painter of space. I am not an abstract painter, but on the contrary a representational one, a Realist.'[1] The author of this peremptory and enigmatic statement was a meteor in the sky of modern art. Yves Klein blazed across the firmament of art history like a shooting star. He burnt himself out in the two-fold incandescence of his dazzling career and visionary intuitions.

His life was a whirlwind. He was born in Nice in 1928 and died in Paris in 1962. The 'painter of space' passed away at the age of thirty-four, leaving behind a flamboyant œuvre. An authentic realist, he had garnered some fifteen hundred 'traces of life' in the shape of monochromes and body, fire, water and air prints. Space was his studio, the sky his source of inspiration, life his principal preoccupation. A larger-than-life figure, a gentleman burglar of the pictorial sensibility present in space, a woman's body or a bough, Yves Klein was – though his materialist exegetes would disagree – a 'megalomaniac'[2] and a myth.

Was he an artist? A poet? A painter or an alchemist? He wanted to 'become a kind of nuclear reactor, a sort of generator giving off a constant radiation saturating the atmosphere with its entire pictorial presence trapped in space after its passage'.[3] And of course he did leave durable traces of his passage through life.

He started out as a judo champion, then became a painter, a complete artist who expressed his vision using a wide range of media including pure colour, architecture, sculpture, literature and music. He was one of the leading pioneers of Performance Art and installations, as well as a forerunner of Body Art, Land Art and Conceptual Art. In eight years lived at a breakneck pace, he left an enduring imprint on art history and, above all, on an entire generation of artists. As the tutelary genius of Nouveau Réalisme[4] and the Zero group,[5] he carved out a permanent place for himself in the art of the second half of the twentieth century.

He was also an endearing presence in post-Second World War Montparnasse. A regular patron of La Coupole, he gleaned ideas there in endless conversations at all hours of the day and night. The 'waking dreamer' that he was imagined a joyous world from which gravity and time were banished. The eternal present would become viable, he liked to think, deep in space, in the incandescent heart of the void. An inexhaustible flame burned in Klein. His drive and imagination, his combination of dreaminess and realism, made him an exceptional individual. His œuvre appears silhouetted against the light in a space midway between plenitude and emptiness, presence and absence, modernity and post-modernity, transcendence and nihilism, earth and sky, present and future, painting and writing.

Often misunderstood, a man anxious to convey a message, Klein left behind a substantial, as yet mostly unpublished, body of writings. In the light of these manuscripts and a treasure trove of other documents, it is now possible to re-examine his life and work. Such a re-evaluation can yield valuable results. Contemporary art clearly demonstrates the importance of Klein in the history of twentieth-century art. Pierre Restany has done pioneering work on just this topic, but a great deal remains to be done.

Klein's quest was that of an explorer entirely committed to his undertaking. He was the first to throw himself unreservedly into monochromy. 'I know personally that I didn't hesitate, I gave up everything for it, judo and all the rest . . . Without compromise . . . May the painters I've named and others as well paint truly and genuinely in monochrome and not only this but let them experience to the full that pure, absolute, total colour, and not just with a painting here, a painting there, touching a little of everything without touching a thing.'[6] Klein's total engagement and his deliberate confusion between his life and work are the keys to the apparent vacuousness of his monochrome paintings. For the void is plenitude in Klein's art; absence is an impalpable presence; being inhabits nothingness.

Klein has been criticised, among other things, for his faith, his religious syncretism, his Rosicrucian affinities, his childish penchant for dressing up, his panache and dandified manners, his fondness for Tintin comic strips. Neither Marxist or abstract artist, atheist or formalist, he succeeded in antagonising a fair portion of the politically correct intelligentsia in France. He was rumoured to possess a fortune – which was far from being true – and to harbour dubious political ideas when in fact he was unashamedly indifferent to all ideologies. The simple truth is that Klein desperately wanted to be a part of the world: he was no angel, no demon either, but simply a man brimming with creativity; a lover of colour; an immensely intelligent artist gifted with intuitions like bolts of lightning.

Yves Klein at the inauguration of the 'Monochrome und Feuer' exhibition, Museum Haus Lange, Krefeld. 14 January 1961.

Overleaf: **Yves Klein** at Nice. c. 1947.

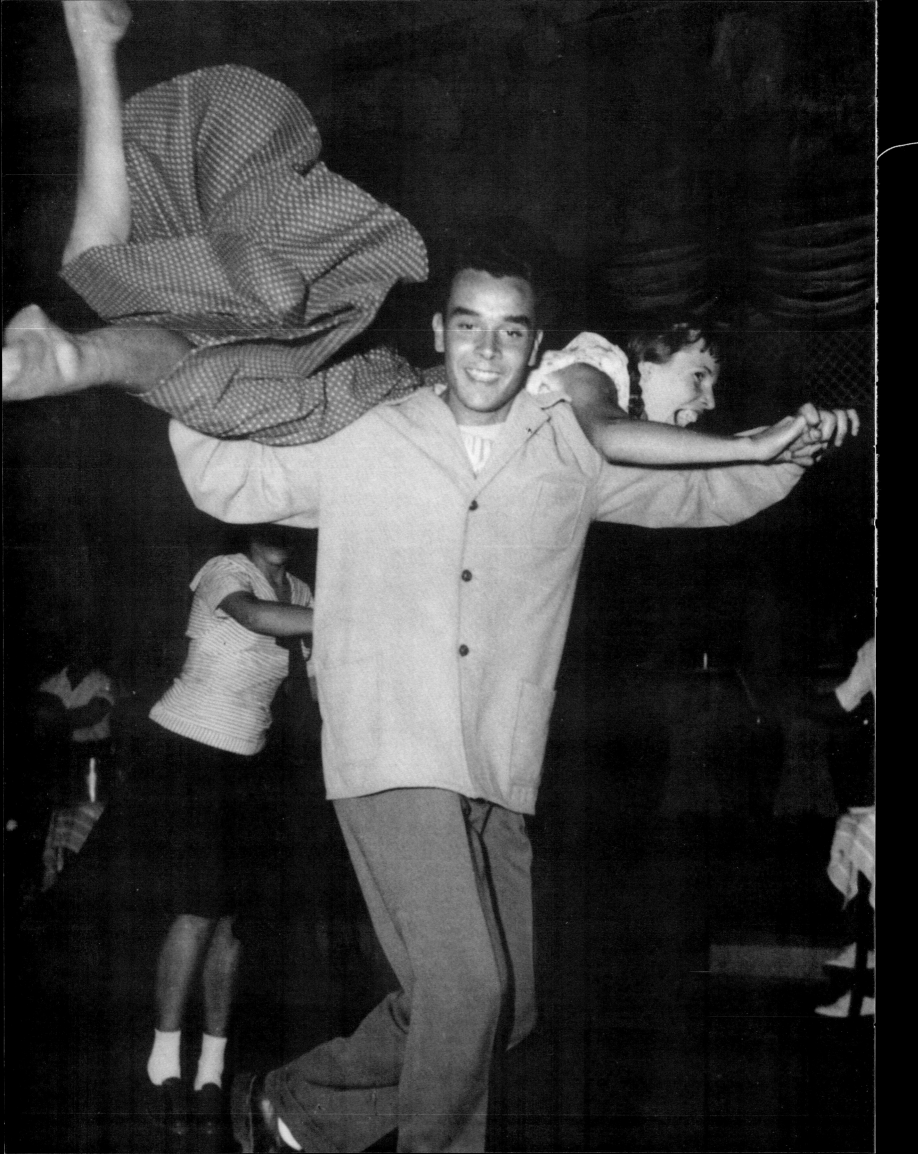

The fire in the heart of the void never burns out

On his death on 6 June 1962, Yves Klein immediately left the realm of controversy and entered legend. As with all figures who have spectacular careers in history, he did so on two levels: first on the trivial plane of existential anecdotes, and then increasingly on the most comprehensive level, that of referential myth. The monochrome painter has now become the poet of the void and master of the immaterial in art; the proprietor of the sublimating solution to the Suprematist impasse; the absolute precursor of Conceptual Art, Body Art and the relational aesthetic; and, above all else, the twentieth century's visionary alchemist, the conceptualist of the last *apocatastasis* of our modern time: the return to a state of nature and levitation in a technical Eden, the grand utopia of air architecture and the combined use of water and fire.

Nicolas Charlet faced a considerable challenge. He had to wrest Yves Klein, within the space of a single book, from the metaphoric time of the artist's legend and reinstate him in the ordinary time of his personal history – in short to rescue the man from the myth. The young author sought to accomplish this delicate undertaking with all the modest scrupulousness that such a task requires, and with all the affectionate admiration he feels towards the subject. He has found the right tone and appropriate analytic level; and, reading the pages that follow, I recognise the lucid enthusiasm with which Charlet, a student from Lyon, approached me not so very many years ago and endeavoured to explain the goal and motivations of his academic dissertation on Yves Klein. Deeply impressed by our conversation, I directed him to Daniel Moquay, who heads the Yves Klein Archives in Paris and who eventually asked the young man to inventory and put into order the monochrome painter's writings.

Thus Nicolas Charlet knows what he is talking about and what needs to be talked about. In the first and, in my opinion, most successful part of this book, 'The Atomic Gestation of a Painter', he succeeds in extracting the salient traits of an exceptional individual from the ore of his family environment, the formative events of his adolescence and judo experiences. In passing, he stresses the fundamental – and founding – significance of Klein's metaphor of appropriating the Nice sky and he gives a fair assessment of the very relative Rosicrucian contribution to crystallising the sublimating energy that characterised Klein the man. More importantly still, Charlet from the very first distinguishes the consistency of the existential drive towards transcendence that links the man indissolubly with his work in a perpetual striving to overcome limits. Having laid the foundations of his undertaking, Charlet is able to graft his biography of Klein onto the artist's *œuvre*; thus fleshing out the human trace of the latter's irresistible, sublimating, lightning passage through life. In their sequence, the chapters of this book reflect that irreducible continuity: 'The Life of Pure Colour', 'Igniting Sensibility', 'Traces of Life' . . . The current flows from monochromy to the void and on towards the fiery path of alchemy. The expression 'the fire in the heart of the void' is drawn from the title of a book of mine published in 1990, and I am pleased to note that Nicolas Charlet has understood

its point perfectly. Fire's twin violence – its burning and brightness, catharsis and sublimation – such is without the slightest doubt the deepest lesson from that extraordinary vitalist phenomenon: Yves Klein, his work and life. The end of Charlet's book is a bit elliptical, very much of course in the image of Yves's premature death. The coda on the artist's votive offering at Cascia, and his appeal to Saint Rita to intercede with God to 'make beautiful everything that comes from me', independently of the mark of his desire for the absolute, may well disconcert the reader with its Christ-like innocence.

Like all alchemist-mystics, Yves Klein was at times appalled by the vertiginous prospects that the cosmic scope of his thought opened up before him. What he experienced then was the 'fear of God', whose material punishment took the form of scandal, mockery or the public's lack of understanding. Conscious that he possessed a truth that revealed itself by increments, Yves wanted the tenor of his message to be universally legible. During his lifetime, each of his shows presented a new step forward in his progression towards the absolute truth. The public response to his work was far from what he hoped it would be. He suffered a great deal from this, but, in spite of everything, clung unwaveringly to his belief that he would ultimately prevail. This is where Saint Rita came in, the patron saint of desperate causes, the symbol of Klein's hope and pertinacity.

This proselytising side of Klein's character, which Charlet (who perhaps deemed mistakenly that it was obvious) does not stress sufficiently, emerges in all the painter's correspondence and writings. His habit of repeating metaphors and statements he thought would persuade the reader is highly significant. It was his view that if people didn't understand him, they had to be educated. His project for a school of sensibility was quite consistent with this strategy of spreading the word, and so was his active participation in the founding of the Nouveaux Réalistes. It was no accident that the group's inaugural meeting was held, on 27 October 1960, at Klein's apartment on rue Campagne-Première in Paris and that he tried to organise a collective anthropometry of its members. In his mind, the Nouveaux Réalistes were to be the bold knights of the Blue Revolution. Having said this, in my capacity as a front-rank witness of that exceptional adventure, I gladly acknowledge the immense pleasure I got from recognising in the pages of this book the profile of the man whose visionary destiny I was privileged to share. Our meeting and collaboration in actively conceptualising ideas that welled up from the fountainhead of a transcendental instinct changed my life. Restany would not have become Restany without Yves Klein. Klein taught me to look a little further, to feel a bit more deeply, beyond the two-way mirror of appearances. He helped me to understand that dreams are the most beautiful reality when they bear a powerful utopian project, one capable of acting on the sensible nature of human beings, of altering their approach to the world, of spiritually elevating the quality of their lives. My debt towards him is great: the feeling of genuine fervour conveyed by Nicolas Charlet's book prompts me to acknowledge it publicly. Charlet has my gratitude.

Pierre Restany

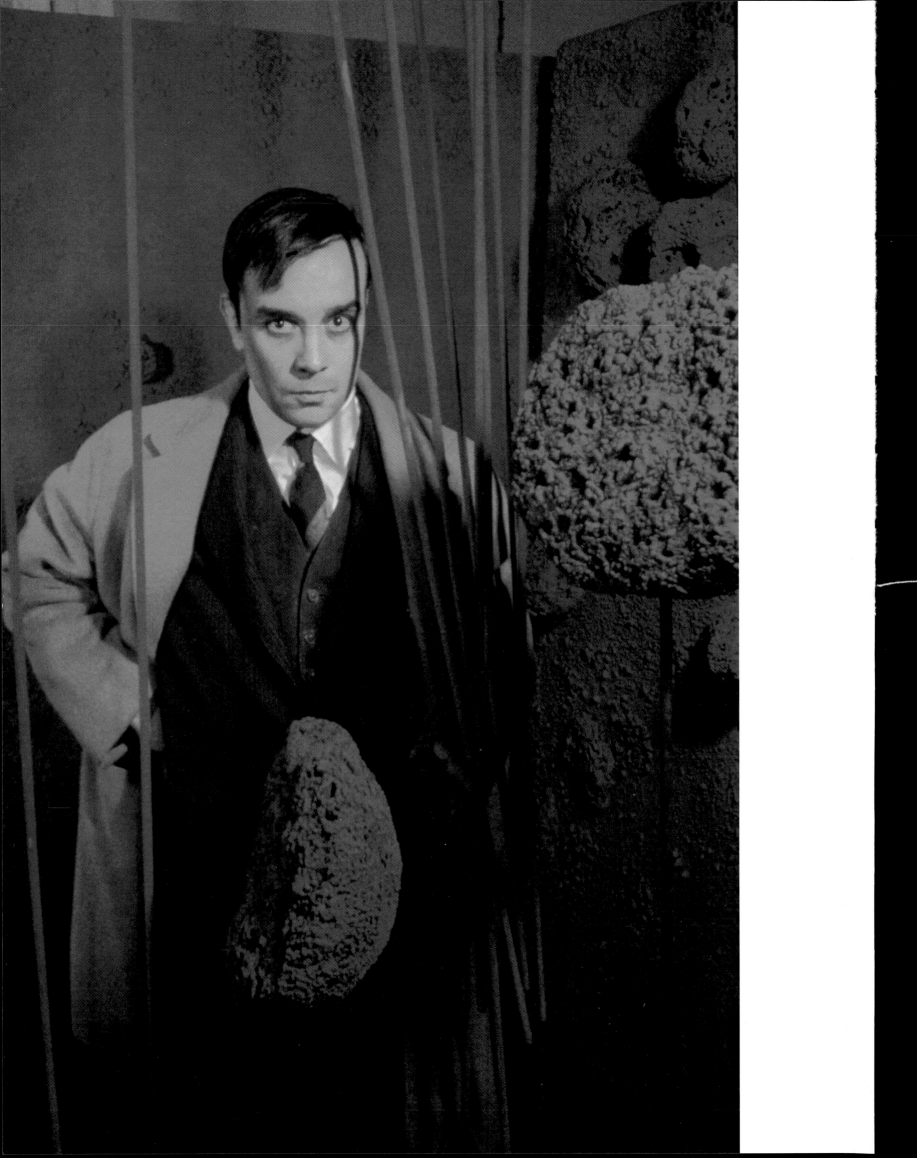

The atomic gestation of a painter

Born to a family of painters

From his birth on 28 April 1928, Yves Klein was immersed in the art world. He first 'drank painting from a baby's bottle',[1] and this manifestly helped his outstanding artistic gifts to blossom. Klein very early developed that sensitivity and mental structure that were to make him a major twentieth-century artist.

Born to a couple of painters who lived in an old studio-house at Cagnes-sur-Mer, Klein grew up in the sunshine of France's Côte d'Azur, surrounded by jars of raw pigment, easels, canvas stretchers, fresh paint, blue sky and the blue sea. His parents were influential figures in the constellation of international artists who resided, for various lengths of time, in and around Cagnes. These were ideal conditions for awakening a child's creativity. Full of life, enthusiastic, joyful, his eyes sparkling at every detail in the surrounding landscape, Yves first awakened to the beauty of nature on family outings along the coast or in the parched hills of the hinterland. Freedom and sensitivity characterised his childhood.

One of Yves Klein's earliest friends, Michel Gaudet, recalls the impetuous, dreamy, sensitive 'little captain' whose games he shared: 'Children of peasants, artists' children, we had the same vigour, the same thirst for the life of the streets and alleys of the old town. Endlessly racing and pursuing each other, their hearts pounding with imaginary fears – that is what the kids of Old Cagnes were like, and still are. But Yves was something else: ideas, drama, the intoxication of inventing everything, puppet theatres,

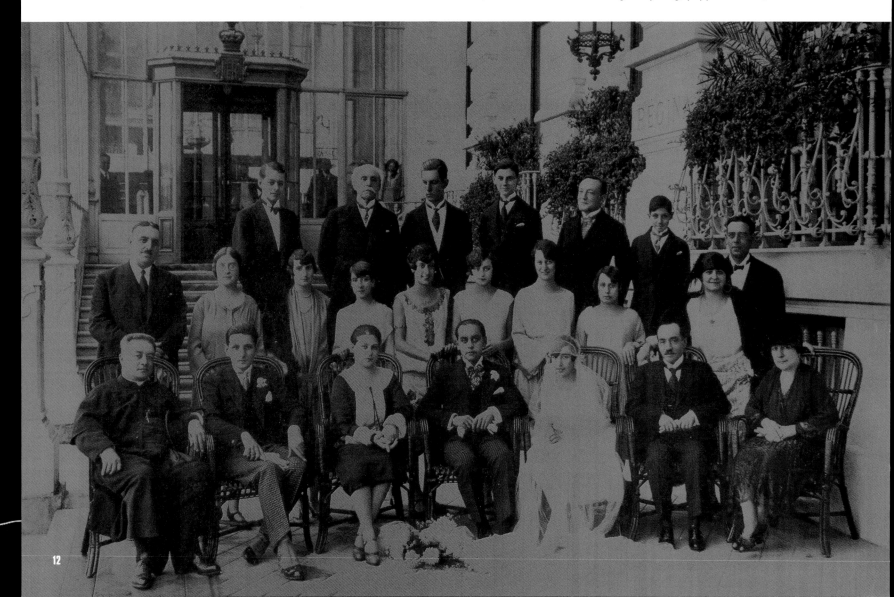

crusades . . . How splendid our armour was in the sunlight!'[2] Armour and shields that Yves fashioned from the canvases of Nicolas de Staël, a family friend, who had abandoned them after their thick impasto had hardened to a crust. In de Staël's studio, Yves would play at knights with Anteck, the son of the painter and Jeannine Guillou, and their combats would have the smell and flavour of paint and turpentine.

During the war, Yves Klein's parents carried on in spite of their poverty, painting on doors, bed sheets and whatever came to hand. They were in touch with the 'Grasse circle' around Susi and Alberto Magnelli, Sophie Taeuber-Arp and Jean Arp and, later, Sonia Delaunay. It was through the Kleins that Nicolas de Staël met Magnelli. Like de Staël, Yves's mother, Marie Raymond, was strongly influenced by the abstract masters who had settled in Grasse to wait out the war.

Yves was a cosseted only child. Under the watchful eye of his parents and his mother's sister, Rose, he lacked neither love nor attention. His health, education, intellectual growth, and later his professional success, were major preoccupations for his family. His Aunt Rose – who fondly called him 'Raton' ('young rat', an equivalent of 'my pet') – was especially close to him and remained supportive and unstintingly generous towards him throughout his life. Klein's parents, Fred and Marie, attached little importance to his marks at school, but taught him to use his eyes, rely on his feelings and get the most out of life. Under their influence, Yves's sensitivity opened up to an exceptional degree. With the passing years he gradually absorbed the artistic atmosphere at home. He became an artist the way a tree grows – in the rich loam of time.

Yves Klein's father, Fred, represented the great tradition of the School of Paris. Of Dutch nationality, born in Bandung, Indonesia, in 1898, Fred had settled in what was then the world's capital of the arts in 1920. A shy, modest representational painter neglected today, he traversed the twentieth century, an isolated figure in the shadow of modernism. He was on the edge of the Bohemian world of Montmartre and Montparnasse. Mondrian, Van Dongen and Jean Pougny were among his friends. There is no question that his son Yves was influenced by his father's unflagging efforts to depict joy, celebrate the eternal light of an enchanted world and immortalise 'the flame of poetry' illuminating the present. Like Odilon Redon and Monet towards the end of his life, Fred Klein was a poet of colour. As Raymond Cogniat aptly put it, '[Fred] Klein has a penchant for sumptuous illuminations, human figures and animals dazzling with light and gold'.[3] 'Whatever he paints,' wrote another critic, 'colour is the thing that matters; it is colour that drives our painter.'[4]

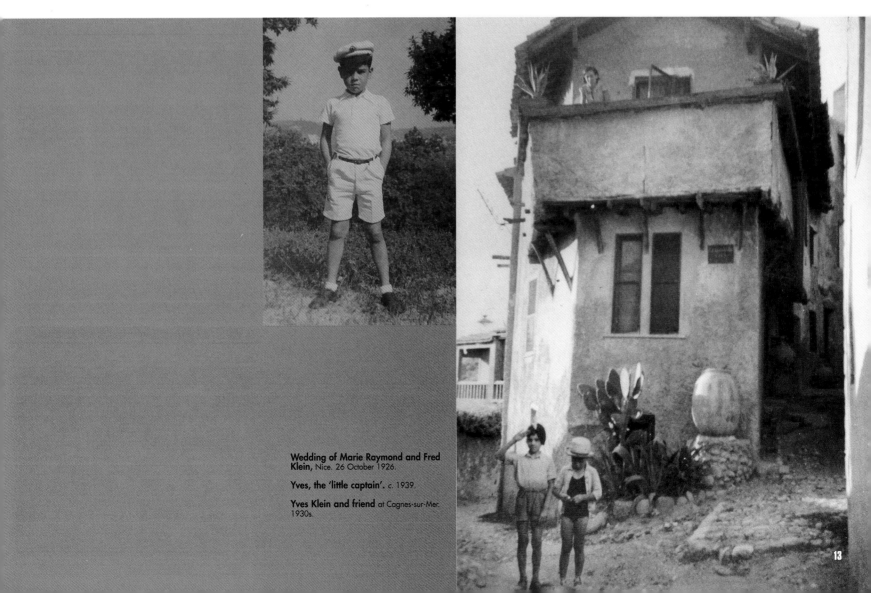

Wedding of Marie Raymond and Fred Klein, Nice. 26 October 1926.

Yves, the 'little captain'. c. 1939.

Yves Klein and friend at Cagnes-sur-Mer. 1930s.

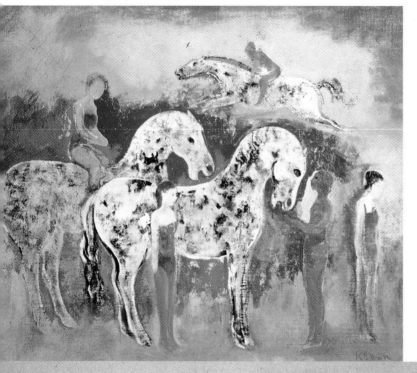

Marie Raymond, on the other hand, belonged to the generation that came after the School of Paris. Born to a bourgeois family from Nice, she had a very successful career as an abstract painter in the 1950s. She was one of the core members of the Galerie Denise René's stable of artists. Her style was close to that of Jean Bazaine, Maurice Estève, Alfred Manessier and Charles Lapicque. Like them, she combined Cubist structures with Fauvist colours, abstraction with a residual figuration. As early as 1946, she exhibited regularly at the Denise René[5] and Colette Allendy[6] galleries, as well as at the Galerie de Beaune[7] with the time's leading exponents of modernity (Jean-Michel Atlan, Jean Dewasne, Deyrolle, Hans Hartung, Alberto Magnelli, Richard Mortensen, Pierre Soulages, Gérard Schneider, Serge Poliakoff, Victor Vasarely). In 1949, Marie Raymond and Chapoval were awarded the prestigious Kandinsky Prize (previously awarded to Dewasne and Deyrolle in 1946, Poliakoff in 1947, Max Bill in 1948, and given to Mortensen the following year). Marie Raymond exhibited frequently in group shows of the 'Painters of the School of Paris.' She shared with her husband an unconditional love for colour and, like him, was determined to 'make the invisible visible,' as Paul Klee expressed it. The Kleins were lyric painters and assigned to art the power of revelation.

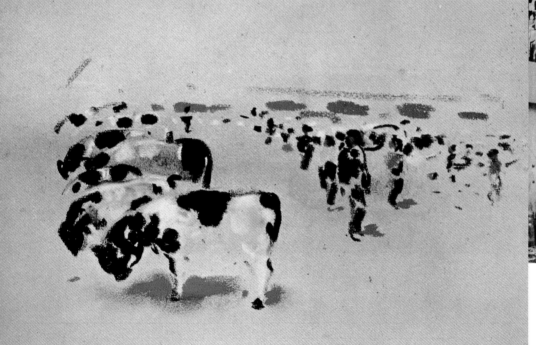

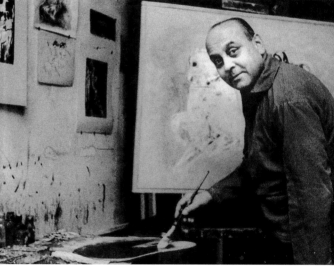

Fred Klein, **Circus Horses.** Undated. Oil on canvas, 61 x 50 cm. Gemeentelijk Collection, Centraal Museum, Utrecht.

Fred Klein, **Cattle Market.** Undated. Pastel, 33 x 24 cm. Private collection.

Fred Klein in his studio.

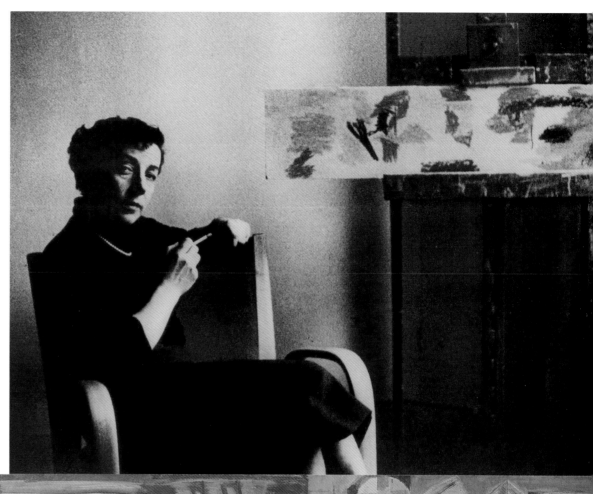

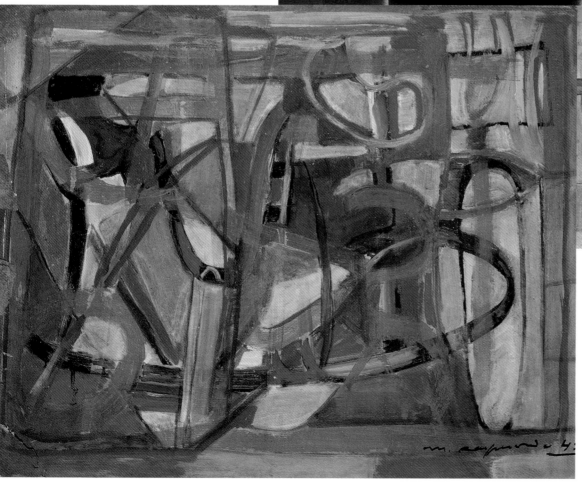

Marie Raymond in her studio.

Marie Raymond, *Untitled.* 1946.
Oil on canvas, 73 x 92 cm.
Rotraut and Daniel Moquay Collection.

Left: Marie Raymond, *Angles and Curves.*
1945. Oil on canvas, 72.5 x 93.5 cm.
Rotraut and Daniel Moquay Collection.

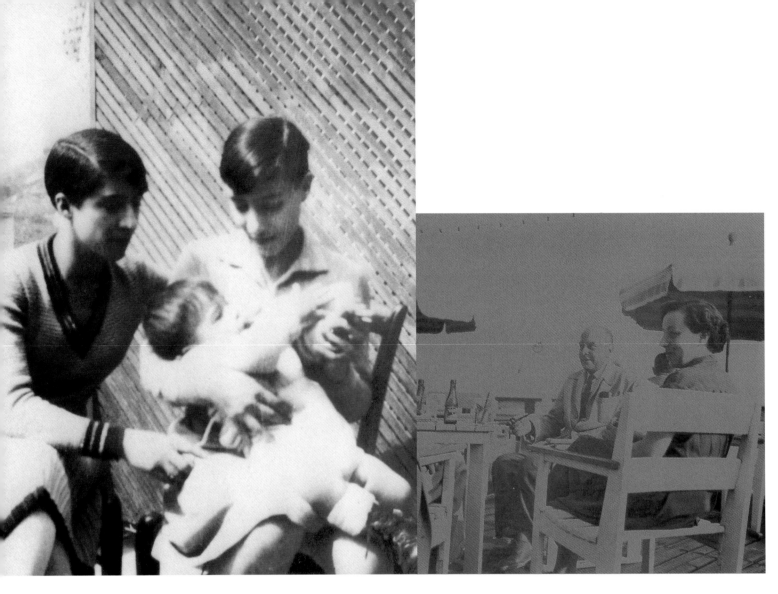

Marie Raymond's writings are oddly like those of her son, who might easily have signed his name to the following statements by his mother: 'The art of painting is the contemplation and celebration of life itself';[8] 'Art is the link that makes life richer and attaches one to it';[9] 'Colour, a symbol of "life", must attain its maximum expression and through its harmonies must somehow constitute the image of a whole to which thought clings';[10] 'From the deepest recesses of space to our own deepest recesses infinities are constantly being measured. The aim of painting as an art is to express this intangible, fleeting yet real action of life which is always different, always new and is eternal in its own right . . . I feel I am being led forward by a seemingly ambitious, perhaps inhuman dream';[11] 'Shadow and light, so close and yet so distant from each other, are a problem that has to be eternally solved and readapted; everywhere we seek to push back the shadow, the figure of nothingness, and to play with light, to exalt vitality';[12] 'Abstract art doubtless belongs to the domain of the invisible that each of us endeavours to concretise and give a living, tangible, plastic expiation to.'[13]

Marie Raymond was a figure of some importance on the relatively small art scene of the 1950s. It was through her that Yves Klein became acquainted with the more adventurous advocates of contemporary art. From 1946 to 1954, between trips, the young Klein would attend Marie Raymond's 'Lundis' ('Mondays'), weekly gatherings of painters and critics at his parents' home at 116, rue d'Assas in Paris. In the tradition of France's literary salons, these reunions gave avant-garde artists an opportunity to comment on current cultural events and to present innovative research to a select and receptive audience. Marie Raymond's set included a large number of artists, collectors, critics and gallery owners, and Yves Klein got to know them all. Hans Hartung, Jacques Villon, Frantisek Kupka, Serge Poliakoff, Serge Doméla, Louguet, Deyrolle, Nina Kandinsky, the writer Eugène Ionesco, the photographer Maywald, the future Nouveaux Réalistes – César, Jean Tinguely, Jacques Dufrêne, Raymond Hains and Jacques de La Villeglé – all came to these soirées from time to time, as did various provincial and foreign artists visiting Paris. The Dutch and Flemish community was well represented – clearly Fred Klein's influence. The art critic Charles Estienne was also an habitué at the Klein's home, as were Georges Boudaille, Claude Rivière and later (thanks to Yves) Pierre Restany. Yves Klein's discoverers, the art dealers Iris Clert and Colette Allendy, were also occasionally present at Marie Raymond's 'Mondays'.

Rose and Marie Raymond with Yves.
c. 1929.

Fred Klein and Marie Raymond.

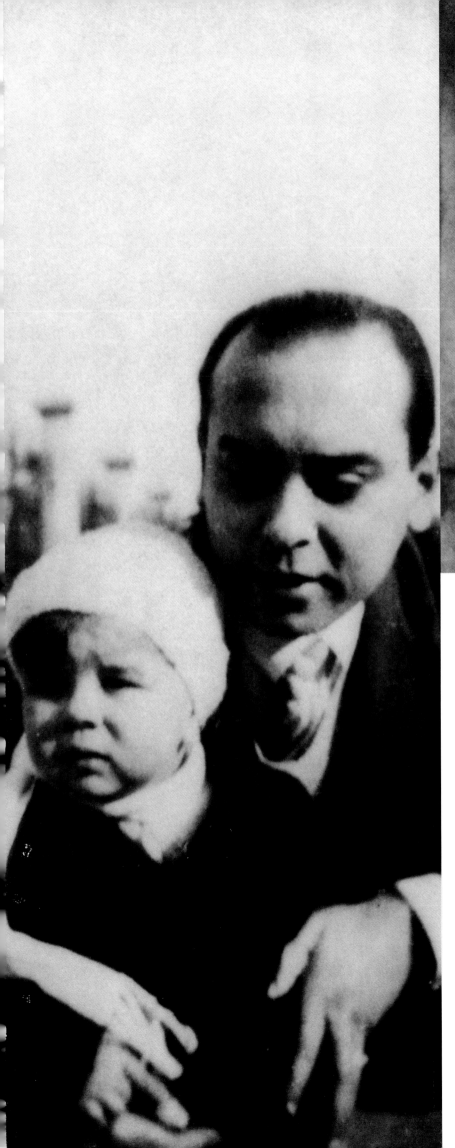

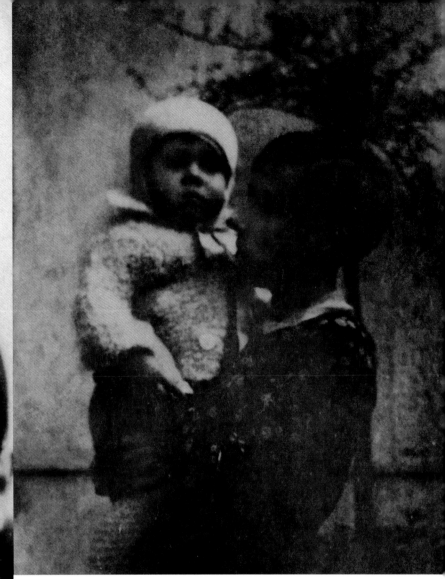

Yves in the arms of his father,
Fred Klein. c. 1929–1930.

Yves in the arms of his mother,
Marie Raymond. c. 1929–1930.

The artistic climate of the 1950s

On the eve of his arrival on the Paris art scene, Yves Klein was well versed in the main artistic trends of the day. In the years following the Second World War, abstract art rapidly become a dominant trend in France's cultural landscape. Initially grouped under the banner of the Abstraction-Création association, the abstract movement fragmented after the war. The conflicting theoretical claims of painters and critics variously committed to abstraction produced increasing dissension within the ranks of the movement. It was in this context that, in the decade between 1945 and 1955, Yves Klein made the acquaintance of leading painters and critics belonging to rival schools. His parents' home, an ideal forum for discussions of personalities and theories, provided him with the opportunity to come to his own conclusions.

Geometric abstraction had its special platform, the Salon des réalités nouvelles, which had been set up in 1946 on the ruins of Abstraction-Création (itself founded in 1931 after the collapse of the Cercle et Carré group). Dewasne, Deyrolle, Magnelli,

of physical gestures, as opposed to a painting of the intellect. Their activity helped to foster the birth of a new type of Expressionism in France. Its forerunners were Hans Hartung and Wols. Jean Fautrier, Jean-Michel Atlan, Pierre Soulages, Gérard Schneider, Camille Bryen, Georges Mathieu and Jean-Paul Riopelle were its leading representatives.

Some artists of the 1950s considered speed of execution as a guarantee of an authentically 'inner' pictorial discourse welling up straight from the unconscious. Georges Mathieu, in his book *Au-delà du tachisme* (Beyond Tachisme), published in 1963, elaborated a true aesthetic of speed. 'Today I wonder over the reasons that led to my being given the rather futile sobriquet of "the world's fastest painter",' he wrote with aplomb. 'The only reason I can see is, as I said, an inevitability that was, and still is, inherent in the intrinsic laws of pictorial evolution.'[15]

The more tormented Expressionist trend had its own theorist, Michel Tapié. With Wols, Fautrier and Henri Michaux, painting broke loose from its iconic base to refer exclusively to itself or the artist's subjectivity. Not immediate expression, but raw matter was its battle cry. In 1952, Tapié published a book whose title, often truncated by critics, is a manifesto in itself, *Un art autre, où il s'agit de nouveaux dévidages du réel* (An Art that is Different, Concerning New Unwindings of Reality). The intense physical involvement with matter led to Informal Art. Wols and Fautrier

GEOMETRIC ABSTRACTION
Lyrical Abstraction
New unwindings of reality
ART BRUT

Mortensen, Vasarely and Auguste Herbin were the prime exponents of 'cool' abstraction in the post-war years. Under their leadership, geometric abstraction made a comeback. Though Herbin was perceived as the movement's founding figure, Magnelli soon came to be viewed as its leader. Championed by the critics Léon Degand and Michel Seuphor, geometric abstraction gained a firm toehold in the market, through the René Drouin and Denise René galleries, and expounded its theoretical position in the review *Art d'aujourd'hui*. Such was its vogue that in 1950 Charles Estienne felt moved to attack it in a pamphlet entitled *L'art abstrait est-il un académisme?* (Is Abstract Art Academic?).[14]

Charles Estienne, for his part, championed the 'hot' lyrical school of abstraction. He and Michel Ragon advocated a painting

flattened painting, made it spurt or explode under their fingers and at times even slashed it with a palette knife or brush handle. Their painting was like lava; it had no connections with the references of Western artistic culture. Discourse yielded to shouts. Form was dissolved in a formless mass and signs were buried under sheer substance.[16]

The boundaries within the galaxy of Parisian Abstract Expressionism were never hard and fast, but a fundamental division opened up between artists (like Hartung, Soulages and Mathieu) who were committed to a painting of illegible signs and the partisans (Wols, Fautrier and Dubuffet) of a painting of an ineffable primal matter which, in the words of Camille Bryen 'doesn't think, speak or say anything'.[17] Likewise, pure pigment, the monochrome panel,

'sensitivity on the level of sheer matter', were seen as wordless, silent, yet deeply expressive. Above and beyond the splintering of the abstract movement, an entire generation of post-war painters strove to explode language. For the void created by destroying words was not regarded as being devoid of meaning. Expressionism – formless, Tachiste, gestural art – assigned to painting the task of saturating expression to the point of bursting it into smithereens. This meant sacrificing the legibility of form. A painting of calligraphic signs flung on paper or formless matter beyond the range of words, it associated the lightning-bolt speed of signs with the immediacy of forms wrenched from crude matter.

In the forefront of the literary avant-garde of the 1950s, the Lettriste group[19] cultivated its own approach to deconstructing language. Through François Dufrêne, whom he met in 1952 at one of his mother's Monday gatherings, Klein became friendly with the Lettristes, who were attempting, under Isidore Isou's authoritarian leadership, to create a universal language stripped of conventional meanings. This 'hypergraphic metalanguage' came in a variety of forms (phonetic, visual, musical and so forth). Dufrêne, for instance, gave recitals of sound poetry, or glossolalia, midway between shouting and chanting after the manner of Antonin Artaud – a pre-verbal musical poetry or, as Didier Semin defined it, an attempt to 'hark back to the cruelty of sound prior to articulated language'. Dufrêne called his invention the 'Ultralettrist Cryrhythm'. He and the other Lettristes sought

In 1952, Dufrêne went even further and created invisible movies by shooting them without film, thus treating nothingness as a subject.

Around the same time, Raymond Hains, whom Yves Klein had been acquainted with since 1950, and Jacques de La Villeglé began developing their own technique for fracturing language. Using panes of wavy glass, these two former students of the École des Beaux-Arts in Rennes distorted words to produce 'ultraletters', as they called them: letters teased to a level of paroxystic energy. Photographed through the wavy glass, the ultraletters seemed to float in space. Their wave-like shapes had the quality of reflections on the surface of a rippling pool. Using this process made it possible to divest words of their consistency and dissolve legibility into a flow of constantly evolving shapes. Was this an illegible language or an expression of the ineffable? Camille Bryen's sound-poem *Hépérile*, transformed by the distorting effect of wavy glass into *Hépérile éclaté* (Burst Hépérile),[20] has the uncanny expressive force of an apparition.

These experiments made a durable impact on Yves Klein. 'At this time too (1946–1947),' he wrote, 'I was painting and drawing but not much. The fact that my mother and father were painters annoyed me and put me off from painting. But because of that, I kept abreast of the most extreme ideas of avant-garde painting thanks to them. And therefore I was always striving unconsciously to go a little further.'[21]

HYPERGRAPHIC METALANGAGE
Ultralettrist cryrhythms
Scratch films
Ultraletters

to undermine the foundations of language by focusing on meaningless letters of the alphabet. They turned the elementary letter into both the object and subject of writing, much as Klein was to transform elementary colour into the object and subject of painting.

As early as March 1952, Klein began viewing Lettriste films, including Isidore Isou's famous 175-minute *Traité de bave et d'éternité* (*Venom and Eternity*), the film that had founded *cinéma ciselant* (scratch films) and won a prize at the Cannes Film Festival in 1951. Each expressive element in this film (image, sound and text) was treated independently. The sound and image tracks were not synchronised and the film itself was scratched. Like the illegible Lettriste poems, *Traité de bave* was indecipherable.

On the one hand, the influence of the Klein family environment was overwhelming, and, on the other, Yves was beginning to take an interest in things apparently far removed from art. There is no doubt that the young man needed to get away from his parents and his Aunt Rose and immerse himself in a different atmosphere. At any rate, during those post-war years, Yves broke away from that circle of rather angst-ridden painters and began to explore what were to him new physical, intellectual and spiritual activities. Later he was to claim that he was a self-taught artist, which is true in a way, for Klein never attended a fine arts academy or decorative arts school, nor did he enrol in a university. This was not particularly unusual for the times. What was unusual was Klein's determination to get to the top in every field he became interested in.

The 'triangle'

It all began with a group of friends coming together: '1947: three young men in a triangle binding their preoccupations and experiments together: Yves, Claude and [Arman].'[22] Yves Klein, Claude Pascal and Armand Fernandez (later to become famous under the pseudonym Arman) met at the judo club of the Nice Préfecture de Police, where each had signed up separately for lessons. They soon became inseparable, a trio of young men determined to take life by storm.

Claude Pascal was twenty-one, two years older than Yves and Armand. He wrote poetry in a style inspired by Jacques Prévert and pushed Yves to work on his gifts as a philosopher and poet. Under his influence, Klein in 1952 composed a body of texts, which he hoped to publish as a book. Though this project fell by the wayside, Yves never stopped writing from that time on. Armand, who was studying at the Ecole Nationale des Arts Décoratifs in Nice, already had one foot in the art world and firmly intended to become a painter. Yves, his closest friend, shared Armand's artistic sensitivity but was less clear about what he wanted to do later in life. Between one chum who was a painter and the other who was a poet, he was searching for a third road.

Under Yves's growing influence, the trio became increasingly interested in the occult sciences. They often got together on the roof of the Fernandez' home and meditated lengthily in the lotus position. They made a makeshift temple out of the Fernandez' cellar. Yves is said to have painted one wall blue and to have suggested that the three of them leave their handprints on it to seal their friendship. Clearly, as early as 1947, young Klein was already interested in the concept of imprints, for a photograph taken that year shows him in Claude's company proudly sporting a shirt decorated with the trio's handprints. Arman recalls that in their discussions about judo, that same year, Yves declared he 'wanted to daub blue paint on *judokas* so as to obtain clear, violent prints'.[23] In short, Klein was already pondering the basic concepts of his aesthetic: space, colour, 'impregnation', ritual and myth.

Klein's first mythic gesture was to sign the Nice sky, his 'biggest and most beautiful work'. Naturally, the only trace of this extravagant performance is a written document: 'In my teens, one

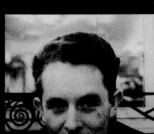

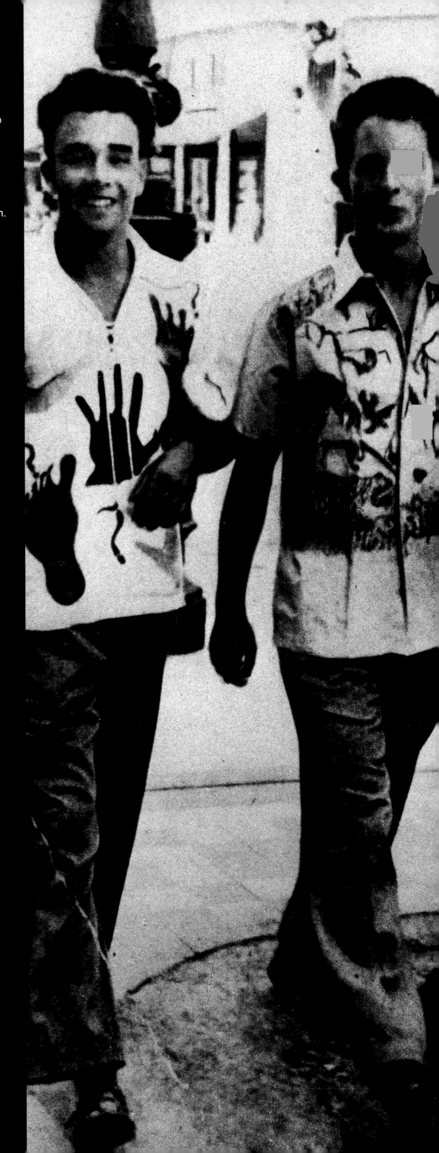

day as I was lying on the beach in Nice I went on a fantastic realistic-imaginary journey to sign my name on the back of the sky . . . Ever since that time, I've always hated birds, for they keep trying to make holes in my biggest and most beautiful work! Birds must go!'[24]

Signing the sky was truly to embark on a 'realistic-imaginary journey'. Klein's first work has the ambivalence of a waking dream. As a realist act, it is the gesture of a demiurge. In a splendid gesture, the future artist autographs, affixes his signature, to a universal object, thereby claiming it for his own. Who would challenge this?

Yet, inasmuch as it is imaginary, the signature only exists through words. The sky belongs to everyone. As a space indispensable to life and a symbol of the vital spirit, the sky is a constant source of fascination. By laying claim to it, Klein was affirming his right to universality, his penchant for lofty daydreams, his poet's consciousness. The sky is no ordinary readymade. In contrast to Marcel Duchamp, who took possession of the most banal manufactured objects (a bicycle wheel, a urinal, a bottle rack), Klein was appropriating a most extraordinary object. His readymade is not just a chunk of rough reality; it is the reality of a dream experienced daily, the reality of a poetry of blue depths.

Yves and his two friends wanted to push back the limits of their lives — the physical (they became vegetarians, fasted and learned judo), psychological (they changed names, observed sexual abstinence and prolonged introspection) and cultural boundaries (they questioned the bases of society and Christian dogma). The Three Musketeers were turning into a trio of mystics. Raised in the Christian tradition, they were all three receptive to esoteric alternatives, to the alchemical tradition, to oriental philosophies and religions. Their 'readjusted' spirituality foreshadowed the Far Eastern vogue of the 1960s and 1970s, as well as today's New Age esotericism. Yves plundered his parents' shelves for books on the occult sciences, Buddhism and Zen. India, China and Japan were often the goals of his spiritual forays. But his principal discovery at this time was an occult work of the late nineteenth century, Max Heindel's *Cosmogonie des Rose-Croix*.[25]

The 'triangle': Yves Klein, Arman (left) and Claude Pascal.

Yves Klein and Claude Pascal in the street in Nice. 1948.

'In my teens, one day as I was lying on the beach in Nice I went on a fantastic realistic-imaginary journey to sign my name on the back of the sky . . .'

Vitalism and idealism

Rosicrucianism, a secret society that was an esoteric offshoot of Christianity, was much in vogue in nineteenth-century intellectual and artistic circles. Heindel's opus was a bible for adepts seeking initiation. In a jargon that must have been incomprehensible to neophytes, Heidel's obscure system of thought required constancy and an unquestioning immersion in its complexities. Reading the *Cosmogonie* was an initiatory trial in the pure tradition of alchemical literature. In a word, like Hains' and Villeglé's 'ultraletters', Dufrêne's 'cryrhythms', the 'hypergraphics' of the Lettristes – and monochrome painting a few years later – it was illegible.

From his reading of Max Heindel, Klein gleaned the concept of vitalism. Heindel proclaimed that life is present throughout the universe and that the mineral, vegetable, animal and human realms are interconnected in a great chain of permanently evolving life. A mineral is an embryonic form of life destined to evolve into a plant, thence into an animal, a human and eventually a spiritual form. Heindel was a firm believer in an ascending evolution of all creation, including seemingly inert matter. Like Darwin, he viewed history as a gradual process whereby increasingly fit species evolve, and he predicted that humanity would eventually undergo a radical transformation. In the course of successive reincarnations, man would little by little shed his body; humans possessed a physical envelope because they were imperfect, but a day would come when they would be changed into purely spiritual superhumans, for history is moving towards an increasing immaterialisation of life. At the ultimate stage of evolution, Heindel prophesied, 'ideas and thoughts would be alive',[26] and human beings would instantly perceive the object of their thoughts. It would be enough to think 'blue' to actually see – and communicate – the colour blue. Endowed with an objective and creative consciousness, humans would be able to engender life mentally. Art would be omnipresent and stripped of its materiality.

Klein read Heindel until 1953, culling the best of his prose – the concepts derived from Darwin, Hegel and, above all, the alchemists – and retaining the idea that matter must be transmuted into pure energy. Neither idealist nor anti-materialist, Heindel's philosophy was a kind of mystical materialism based on the sublimation of matter in its immanence. If nothing else, the *Cosmogonie* taught Klein to organise his thought into a system. Yves took correspondence courses with the Rosicrucian Order, though he never became a full-fledged member. The idea that he was initiated into the Order is mistaken. True, Klein was keenly interested in Heindel's book, but he was neither fanatical nor sectarian, and his reading was by no means limited to a single book. His personal library, his works and particularly his writings bear witness to a considerable cultural breadth and contradict Thomas McEvilley's peremptory statement that Heindel totally dominated Klein's thought.[27]

The globetrotter

The decade between 1945 and 1955 was a time of travel for Klein – a period of drifting that was also a period of discovery. During military service in Germany in 1949, he experienced idleness and loneliness. Used to being pampered by his family, he found himself isolated, without books, without friends. Yet he quickly developed a taste for travel. In late 1949, after his sojourn in Germany, he visited England with his friend Claude Pascal. He got a job with a London framer named Savage, where he learned to handle gold leaf and executed decorations with pure pigments. He later wrote that it was 'during this year at "SAVAGE'S" that I received the illumination of matter in its profound physical nature'. The delicate art of applying and polishing gold leaf ('What a material!' he exclaimed) fascinated the future artist, who experimented with these and other techniques in his spare time: 'In my digs, when I got home in the evening, I made gouache monochromes on pieces of white cardboard and I also began to use pastels a great deal.'[28]

On 4 April 1950, Klein and Claude Pascal left London for Ireland, where they hoped to take lessons in horse-riding – for they dreamt of travelling to Japan on horseback. They got a job on a farm, but were disappointed to find that their work left them little time for riding. Klein was soon forced to admit that riding was a demanding sport, one that required arduous training. Though he gave up the notion of becoming an expert horseman, he resolved to become fluent in the language of the country. It was his principle – one might almost say, his traveller's aesthetic – to steep himself in the local culture wherever he happened to be, which meant learning the language of the inhabitants. When in English-speaking countries, Klein made a point of writing his journal in English; in Spain he wrote in Spanish; and before leaving for Japan he took Japanese lessons at the École des langues orientales in Paris.[29] Thus, on the threshold of his career as an artist, he was fluent in English and Spanish and possessed rudiments of German and Japanese.

No sooner had he returned to France from Ireland than Klein left for Madrid (on 4 February 1951), where he continued his practice of intensive cultural immersion. He drew up lists of Spanish vocabulary and applied himself to learning new words every day. Proscribing all contacts with fellow Frenchmen, he chose his friends exclusively among native Spanish speakers. In April, after vainly seeking work in Madrid, he offered his services as an expert *judoka* to the two main judo clubs of the Spanish capital. Being a twenty-two-year-old judo teacher gave him a social position, a trade. Pleased with this successful beginning, he returned to Nice and then Paris in the summer of 1951 with the intention of going to Japan to study judo at Tokyo's prestigious Kodokan Institute. He spent the following winter in administrative formalities and waiting for a visa. It was only on 22 August 1952 that he embarked on the steamer *La Marseillaise* bound for Japan. The four-week crossing was an adventure in itself: Klein travelled

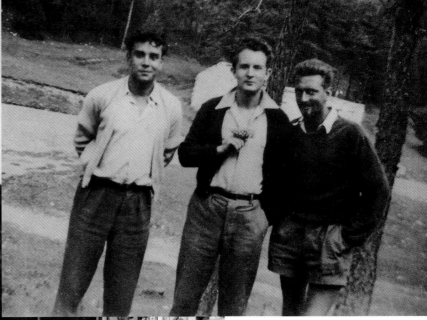

Yves Klein on a beach. c. 1951.

A page from Yves Klein's notebook. 1951.

Yves Klein riding a horse. Ireland, 1950.

Yves Klein, Claude Pascal
and an unidentified friend. 1950.

Yves Klein in Madrid. 1951.

in steerage and suffered from a badly infected foot. On his arrival in Tokyo, a family friend, the art critic Takachiyo Uemura, met him. He immediately threw himself into judo training with such determination that his instructors became worried about his state of health. For the first time in his life, Yves demonstrated an impressive capacity for work, an inflexible drive to succeed and a remarkable ability to handle contradictions and unforeseen situations. He showed that he had what it takes to succeed: an unusual degree of physical stamina combined with self-assurance and an unerring sense of human relations. After struggling for a year and a half against the limits of his body under the supervision of some of Japan's supreme judo masters, disciples of the sport's founder, Risei Kano, Klein was granted by the founder's son, Jigoro Kano, the title of fourth dan. This made him, upon his return to France in February 1954, one of the highest-ranking *judokas* in his own country. The French Federation of Judo, however, declined to ratify his Japanese title on the grounds that its ruling committee did not recognise titles awarded by foreign federations. This was a severe blow to Klein, for it barred him from entering European judo championships and from pursuing a career as a judo teacher in France.

Deeply disappointed, Klein returned to Madrid in May 1954 and found employment there as a technical director for the Spanish Judo Federation. It was a well-paid position and, through his participation in numerous judo demonstrations, Yves began to make a name for himself in Spain. But a clash with Fabian del Valle, the president of the Spanish federation, forced Klein to resign and, in December 1954, he returned to Paris, where he was to live for the rest of his life. He published two books that winter: a judo manual and a booklet presenting his monochrome painting. And, in January 1955, he decided to make a career of painting.

Yves Klein in Singapore.
September 1952.

Yves Klein and his judo instructor,
Master Oda (ninth dan), one of Japan's
leading *judokas*. 1952–1953.

Yves Klein, ***Christ Bearing the Cross.***
1952. Watercolour, 33 x 25.4 cm.
Menil Collection, Houston, Texas.

Yves Klein in Japan. 1952–1953.

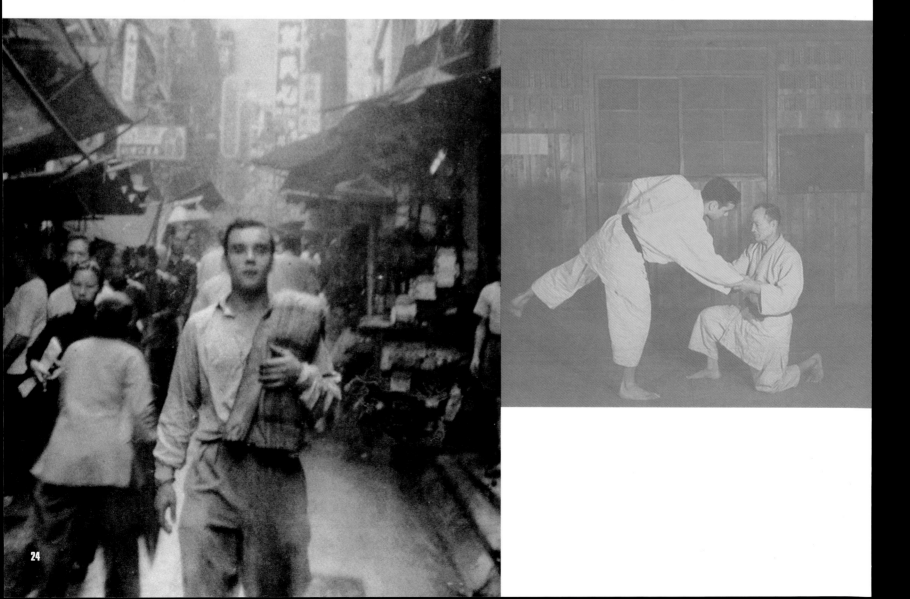

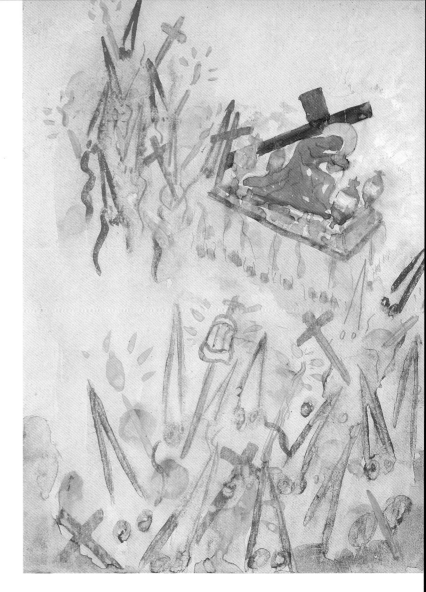

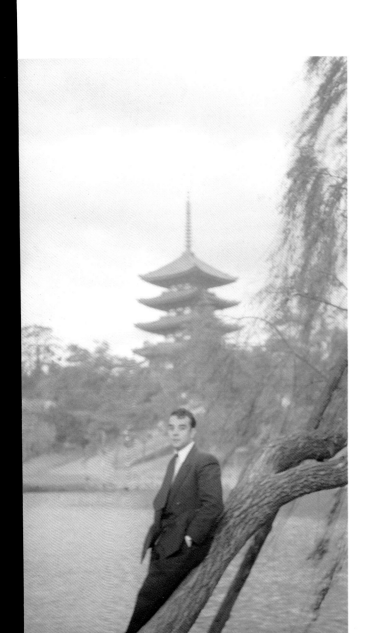

This was not as abrupt a switch as might be imagined. Throughout his years of travelling, Klein had kept in touch with the art world and had carried on experimenting with monochrome painting. He had shown his first monochromes in London in 1950, had hoped to do so in Madrid the following year and had shown several more in Tokyo in 1953 in the presence of an art critic. These small private showings, whose existence has often been questioned (for they were too informal to leave any documentary traces), are perfectly plausible and have been confirmed by several witnesses. In addition to these admittedly marginal artistic activities, Klein seems to have acted as an agent or dealer on a number of occasions. Seeking to promote his parents' work, he contacted galleries in London, tried to arrange for a show of Fred Klein's work in Madrid and organised a joint Fred Klein-Marie Raymond exhibition in a major Tokyo gallery.[30] He had a gift for negotiating and promoting cultural projects; despite his youth, he was a persuasive agent and displayed a flair for public relations.

'To acquire the spirit of Victory'

Les Fondements du judo

Klein badly wanted to make a name for himself in the world of judo. Despite the French federation's refusal to admit him to the closed circle of Europe's leading *judokas,* nothing prevented him from pursuing a pedagogical project he had conceived in Japan, where he had compiled a vast photographic archive devoted to judo. He had come back to Europe with hundreds of photographs and, even better, dozens of film reels. With the help of one of the eight foreign students at the Kodokan Institute, the American judo enthusiast Harold Sharp who had a movie camera, a powerful car and connections among Tokyo's wealthiest citizens, Klein had filmed international judo champions like Osawa ('the star of the Kodokan'), Mifune (tenth dan, 'general of the red belt judo pantheon'), Ishikawa (eighth dan, director of Tokyo's police headquarter's judo school), as well Master Kotani, Yoshimatsu (the Japanese champion in 1953), Daïgo (the 1954 champion), and the seventh dans Matsumoto and Ito (one of the finalists of the 1953 Japanese championships).[31] On returning to Paris, Klein had immediately had these films copied and had begun selling them, mainly with the intention of boosting his reputation in judo circles. No mean self-advertiser, he was well aware of the value of associating his name with the sport's leading champions. Klein's desire to become a legendary figure never flagged; on the contrary, it was soon to become the driving force of his luminous trajectory through the firmament of art history.

In the spring of 1953, Klein had negotiated a contract with the publisher Bernard Grasset for a book on judo. *Les Fondements du judo* (*The Foundations of Judo*)[32] went on sale shortly before Christmas 1954. Klein promoted the book with a television appearance, a series of demonstration matches and book signatures, and by donating copies to French judo clubs. Getting published by the prestigious literary publisher Grasset – hardly a firm one would associate with a judo manual – was a brilliant coup for a twenty-six-year-old recently back from the Far East and totally unknown in France. Unlike the French Federation of Judo, Grasset offered Klein a chance to make a name for himself. In his preface to the manual, the Kodokan's official representative in France, Ichiro Abé, paid tribute to the author by underlining that 'the weak point of European judo is generally the *katas* or fundamentals. Their spirit and execution are poorly understood and have been distorted. This book fills a great gap in European judo literature: it explains the *katas.*'[33]

Klein's book is in effect a grammar of judo. A true manual, it is organised into a series of 'instructions'. Each hold is broken down into the movements that compose it, and explained visually with the help of photographs – there are 375 in all – taken from the film reels Klein had brought back from Tokyo. The backgrounds in the pictures were brushed out to give prominence to the movements of the judo wrestlers.

A few words of technical explanation in the margin completed this essentially visual discourse. Aside from the preface, a brief introduction and a preliminary note of instruction, the book contained virtually no text.

Thus Klein's first book is to all appearances a strictly formal work. Nevertheless, in keeping with judo's founding philosophy, which the author upholds in the introduction, the 'romanticism of movement' is contrasted with an absolute mastery of gesture viewed not as something artificial but as a precondition for self-mastery. The implication is that becoming proficient in a sport's 'grammar', much as one learns a language, is the surest way to master it. In the same way that an inspired calligrapher is able to form letters in a single movement, the expert *judoka* executes the *katas* with dexterity and an automaton-like precision in order to attain vacuity. Body and mind become one; emptiness becomes plenitude. Mastering the *katas* guarantees an inner equilibrium and harmony with the world in the spirit of Zen. This is what the author of the preface to the *Fondements du judo* calls 'mutual prosperity'. At this juncture, Klein can be seen as a brilliant technician on the verge of becoming an initiate in the true sense. Choosing sensibly to remain a fourth dan, he does not cross over this threshold to another territory – a realm requiring a total mental and physical commitment.[34]

As Klein expresses it, judo teaches the adept to acquire 'the spirit of Victory'.[35] It would be a mistake to view this as an aggressive statement. For Klein, victory is necessarily shared. To have 'the spirit of Victory', one cannot content oneself merely with a formal triumph. Victory means life, and life is sensibility uniting the body, the heart and mind. Sensibility is the thread running through all of Klein's judo activities. 'The true *judoka* practices in [a state of] pure spirit and sensibility'.[36] And the painter? The apparent differences between the two fields of painting and judo fade away beneath an inspiration common to both.

Cover of Yves Klein's book
Les Fondements du judo,
Éditions Grasset. 1954.

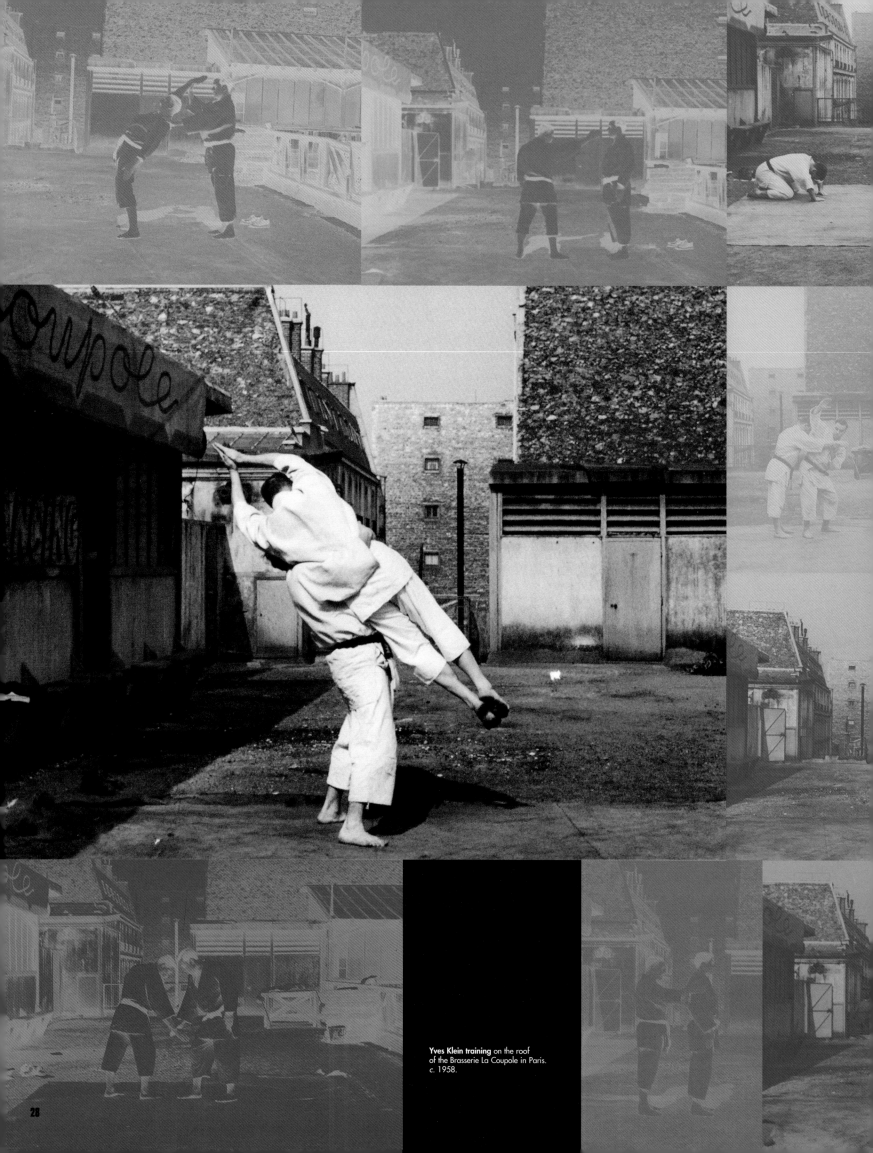

Yves Klein training on the roof
of the Brasserie La Coupole in Paris.
c. 1958.

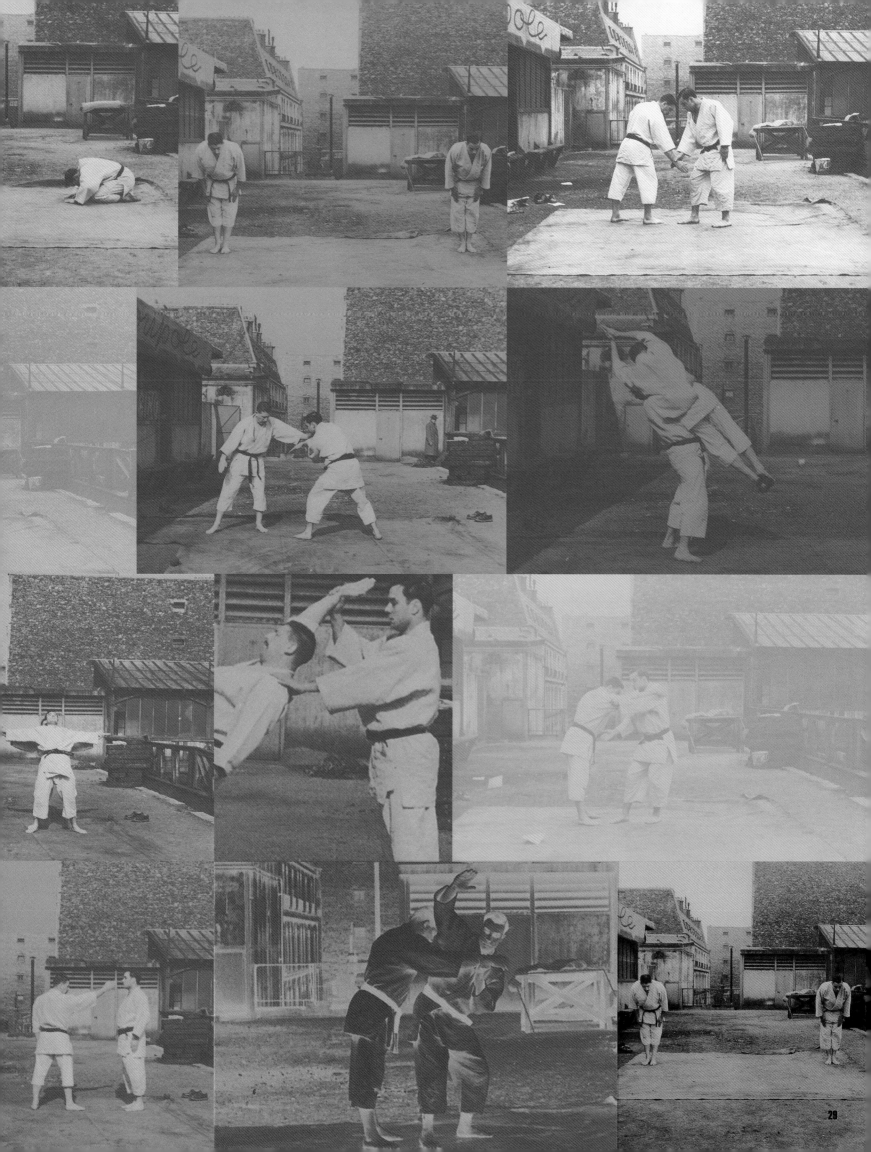

Yves, peintures and Haguenault, peintures

In November 1954, almost at the same time as his book on judo was published, Klein, with the help of his friend Fernando Franco de Sarabia, who owned a judo club in Madrid, issued a set of twin 'pseudo catalogues' illustrated with monochromes he had executed during his travels since 1950. *Yves, peintures* and *Haguenault, peintures* have the appearance of small, very costly art catalogues.[37] They are printed on superior paper almost as rigid as cardboard, and the colour illustrations are printed on a professional press. Prefaced by 'Pascal Claude', the two booklets suggest that Yves and Haguenault are twin artists of sufficient stature to merit a luxurious publication.

They appear to be strictly identical. They both have the same disconcerting foreword consisting of three pages of thick horizontal black lines grouped in paragraphs under the heading 'Preface' and followed by the name 'Pascal Claude', an inversion of Claude Pascal (Klein's friend and travel companion). This is followed by ten loose, unpaginated sheets of pasteboard-like paper slipped between the cover of each booklet. On each page an illustration is pasted – a paper rectangle of a uniform bright hue and tone. Some of these monochromes are signed 'Yves' in the lower right corner and below each one of them is a printed caption.

Yves, peintures (Yves, Paintings). 1954. Cover, preface signed by 'Pascal Claude' and colophon. Sheets of printed paper and *papiers collés*. 24.5 x 19.5 cm. Private collection.

YVES

PEINTURES

10 PLANCHES
EN COULEURS

PREFACE DE
PASCAL CLAUDE

PREFACE

Yves, peintures and *Haguenault, peintures*
contain the seeds of Klein's future work, which is
characterised by a language of disjunction and deflection;
by humour and irony; by form reduced to a minimum
and colour rendered immaterial.

PASCAL CLAUDE

Cette édition illustrée de
10 planches en couleurs
a été achevée d'imprimer
sur les presses du maître
imprimeur Fernando
Franco de Sarabia á Ma-
drid, Jaen, 1, le 18 novem-
bre 1954.

———

Il a été tiré cent cinquante
exemplaires numérotés
de 1 à 150.

———

EXEMPLAIRE N.°

———

YVES A PARIS, 1954 (195×97)

At first glance, all of the copies of this twin set are identical, yet
on closer examination one observes a multitude of differences
between them. The seeming uniformity of this twofold publication
is in fact fraught with diversity. The order of the images varies from
copy to copy and the captions turn out to be random: there
is no typographical coherence to unify them, the information they
give is inconsistent and their relationship to the images is strictly
haphazard. Nor is there any logic to the way the pseudo-
illustrations in diverse colours and sizes are combined with the
printed captions. The orange paper signed 'Yves' (12 x 19.3 cm.)
appears above two different captions: 'Yves, À Paris, 1954
(195 x 97)' and 'Yves, À Madrid, 1954 (146 x 89)'; elsewhere
it is designated 'Yves, Tokyo, 1952' and 'Yves, À Nice, 1951
(195 x 97)'. Captions normally serve to describe and are
subordinated to the images they accompany, but Klein's captions
are strictly autonomous. Thus each booklet, and indeed each copy
of each booklet, is a unique object. What is more, the illustrations
are not mechanical reproductions but simple rectangles of coloured
paper. They are neither photographs, nor engravings nor
lithographs; each one is a unique handmade exemplar.
Yves, peintures and its clone *Haguenault, peintures* are true
livre d'artiste(s). Their meaning masquerades behind an apparent
meaninglessness. As polysemic objects open to several levels
of reading, they require concentration on the part of the viewer.

With the wordless lines of their preface to a series of images
devoid of lines, they are first perceived as a provocation.
The author has banned all verbal and pictorial representations
and reduced art and literature to silence – a silence overshadowed
by absurdity. The twin 'catalogues' constitute an object that prompts
amusement, if not mockery. Klein takes an iconoclastic stance
in favour of *nothing* while suggesting an array of signifiers proper
to the monochrome aesthetic.

One could say that Klein was publishing the first instalment
of a work in progress. As an artist, he had so far produced almost
nothing. In a reversal echoing the inversion of the prefacer's name
and patronymic, 'reproductions' of his work seem to precede actual
productions. What is the meaning of this paradox? The rectangles
of coloured paper do not in fact reproduce any original works;
they illustrate and date an original concept: monochrome painting,
invented around 1950. In other words, each one is an authentic
artwork and the 'catalogues' can thus be regarded as a twin salvo
aimed at the representational tradition. To mime reality
is to sanction appearances. The representational and the mimetic
are artifices, hence flawed. Klein does not wish to create in reality's
image but to present reality directly. A catalogue is conventionally
an ensemble of successive representations of an intangible reality.
The painter's representations are relayed by the representations
of the photographer or engraver, which are relayed in turn
by the printer's representations.

YVES A MADRID, 1954 (146×89)

The orange paper signed 'Yves' (12 x 19.3 cm.)

appears above two different captions:

'Yves, À Paris, 1954 (195 x 97)'

and 'Yves, À Madrid, 1954 (146 x 89)'.

Yves, peintures: **orange-coloured paper**, 12 x 19.3 cm. The caption reads, 'Yves, À Paris, 1954 (195 x 97)'.
Private collection.

Yves, peintures: **orange-coloured paper**, 12 x 19.3 cm. The caption reads, 'Yves, À Madrid, 1954 (146 x 89)'.
Private collection.

Thus veil upon veil upon veil is thrown over the original matrix. Does anything of its original reality come through? What Klein is doing is resurrecting originality in identical representations. Providing the viewer is receptive to infinitely small differences, he transforms the multiple into the unique. Everything depends on the way the work is viewed. The reader is invited to ask himself or herself whether all forms of matter – even those most like each other – are not fundamentally unique. Authenticity is not measured in terms of appearance. The authentic being is immaterial, invisible – and thoroughly impersonal and elusive. The author calls himself indifferently 'Yves' or 'Haguenault' (a brand of gingerbread), Claude Pascal or Pascal Claude. His name isn't important. The work exists independently of its creator; like him, its inventor, it simply participates in life – life that is greater than any one individual. The personal vanishes behind the universal. Matter is freed from the weight of the object and becomes a subject, a scrap of life. All of this can be read between the lines of Klein's twin *livre d'artiste(s)*.

With these two ambiguous objects to his credit, Klein had gained a toehold in the art world. Had he not, after all, demonstrated that he was, as the pseudo-catalogues are designed to suggest, a genuine artist? With tremendous wit, in a style that owes its panache to the tradition of dandyism, Klein had cocked a snook at Lyrical Abstraction. A few rectangles of unicoloured paper were enough to launch a career!

Why bother with canvas, why fling paint around and wield a paintbrush like a sabre? 'With the very first pages the eyes of the Abstract [painters] changed. Their eyes lit up and deep within them appeared pure, beautiful uniform colours.'[38] *Yves, peintures* and its twin volume have one foot in myth and the other in aesthetics. They oscillate between artistic hoax and ontology, irony and harmony, silence and signifier. In that pendulum swing between two extremes you have the essence of Klein's approach to art.

Klein had thus condensed in an illegible and almost invisible form his reflections on paintings since 1947. The intellectual strides he had accomplished, within mere months of his first show, are awesome. *Yves, peintures* and *Haguenault, peintures* contain the seeds of his future work, which is characterised by a language of disjunction and deflection; by humour and irony; by minimalist form and colour rendered immaterial; by polysemy and hermetic signifiers; by an absolute rejection of the mimetic function of the artwork; by the creator distancing himself from the work; by the pure presence of 'living' colour; by an acceptance of randomness; and, lastly, by a strategy of inscribing the work in history, magnified to the level of myth.

Yves, peintures: **green-coloured paper.**
The caption reads, 'Yves, A Nice, 1951 (195 x 97)'. Private collection.

Yves, peintures: **pink-coloured paper.**
The caption reads, 'Yves, À Madrid, 1954 (146 x 89)'. Private collection.

Yves, peintures: **blue-coloured paper.**
The caption reads, 'Yves, À Paris, 1954 (195 x 97)'. Private collection.

Page 36: **Yves Klein, the** *judoka,* Paris. 1956.

YVES A MADRID, 1954 (146×89)

YVES A PARIS, 1954 (195×97)

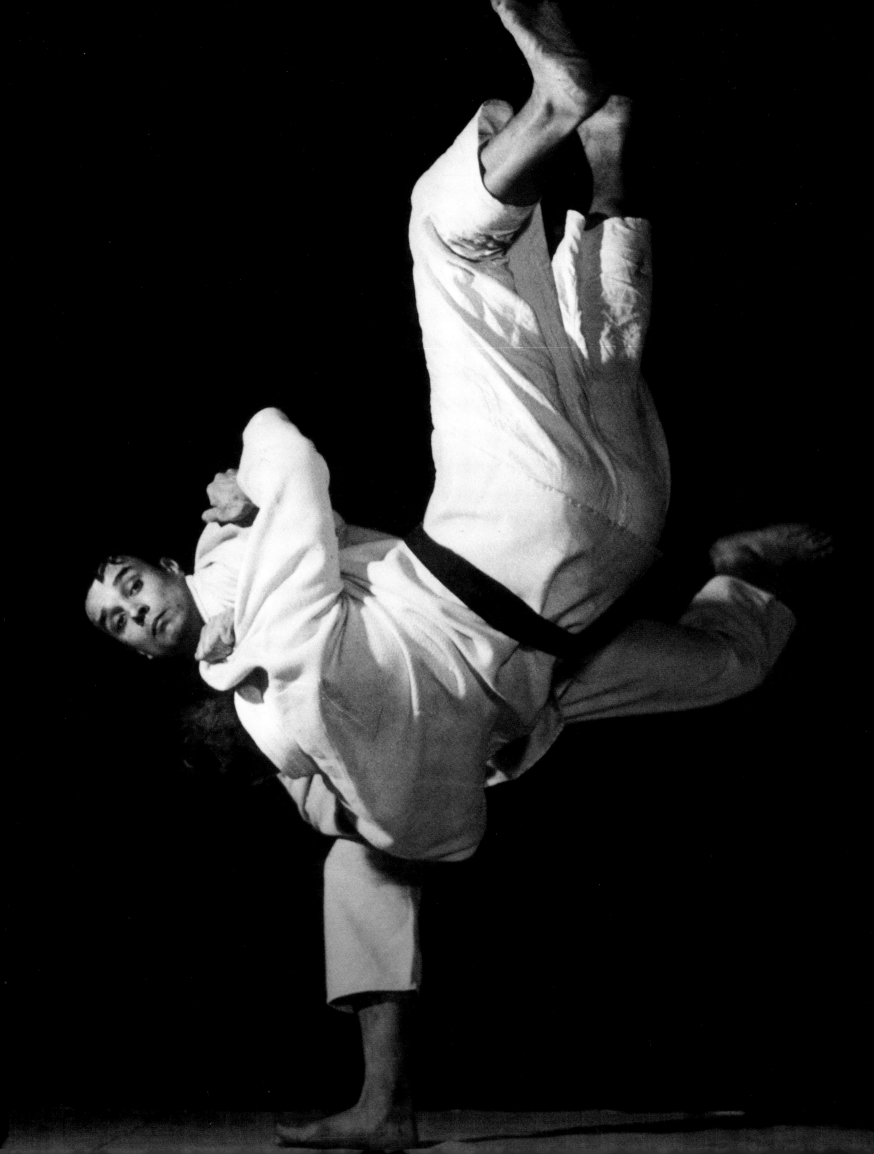

The life
of pure colour

Symphonie monoton-silence

'Fundamentally, the true painter of the future
will be a wordless poet who won't write anything
but, without articulating, in silence,
will recount an immense and boundless painting.'

Score of the *Symphonie
monoton-silence*
(Monotone-Silence Symphony),
arrangement by Pierre Henry. 1960.

The theory of monochrome painting is stated implicitly
in *Yves, peintures*. The same aesthetic appears in a musical guise
in a composition conceived in 1949 and completed in 1960.
Klein imagined a 'monotone-silence' symphony consisting of
'a single musical mass infusing in space . . . a single, sustained,
uniquely same note from beginning to end'[1]; a single chord
followed by a silence of equal duration. In the composer's words,
'It was an audible silence-presence!'[2]

Klein's chord in A major took the form of a vibration 'deprived
of its attack and its end'.[3] A deep, low-pitched sound that seemed
to emerge from the bowels of the earth, it dissolved in silence like
the sun slipping below the horizon in the evening. The *Symphonie
monoton-silence* (*Monotone-Silence Symphony*) is a solar music.
Its presence has intense vibrational accents which create a 'feeling
of vertigo'.[4] It first overwhelms the listener with its magnificence,
then it vanishes into the twilight. Yet, though the luminous vitality
of the sustained sound seems to go to sleep, it does not die –
it continues to resonate in the mind. It is a presence initially
requiring neither movement nor diversity; it simply is. No gesturing
disturbs its inner potency. Taut as a guitar string, it draws its first
breath of air and vibrates; the vibration becomes muted, inaudible,
imperceptible, yet in spite of everything it persists. The sun does
not perish at night; it is simply veiled. The artist's task is to unveil
the world's reality. Klein presents us with life's fundamental
continuity, its appearance and disappearance within
the permanence of being.

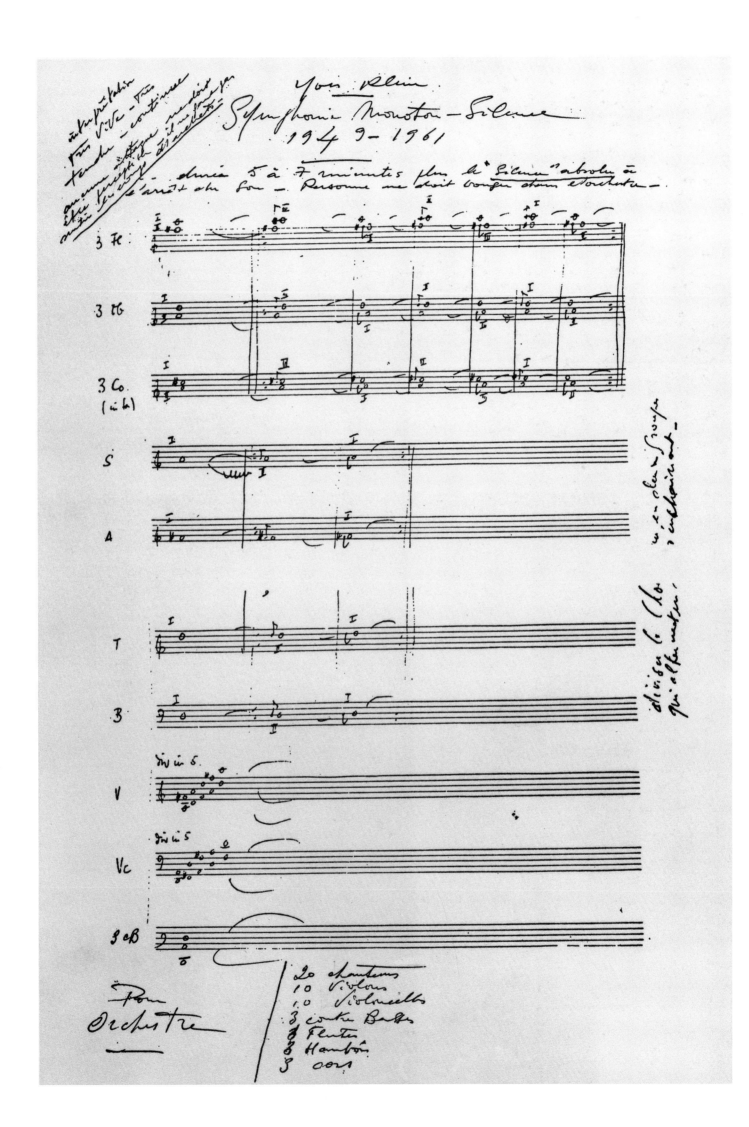

The symphony may thus be an allegory of eternal life. After death, a person's unique, absolute presence in the world lingers on in absence. The resonance of every individual's personal history takes the form of memory or, for Christians, a true presence in resurrection. Klein believed in resurrection after death, in life after life. The silence of the hereafter transcends the physical presence of the music's beginning. 'Silence generating everything within each of us'[5] is an essential revelation of immaterial presence. Like Jesus resurrected who ascends to Heaven and scatters his spirit over the earth, the musical sound vanishes but leaves an indelible trace – if only within the audience's memory. The *Symphonie monoton-silence* made a strong impression on everyone who heard it. Silence had seldom been so compelling. 'Silence . . . That is where my symphony lies, not in the sound before and during the performance. It's this very wonderful silence that gives us the "chance" and sometimes even the means to be truly happy, if only for a single instant, an instant the duration of which is incommensurable. Vanquishing silence, dismembering it, removing its skin and clothing oneself in it so as never again to be spiritually cold. Face to face with universal space I feel like a vampire!'[6]

Klein longing to absorb silence! Considering his life cut short at its prime, the artist's obsession with presence-within-absence takes on an existential character. The vampire of silence, of emptiness and absence has indeed vanished. Hannah Weitemeier writes insightfully that 'by analogy with his symphony his work came into being like a dancing star born from a creative chaos, a star which appeared like a breath of air, manifested itself in his creative life and vanished again like the silence that followed it.'[7] Gifted with what appears to be an uncanny foresight, Klein gave his life the shape of his monotone-silence composition: 'My life must be like my 1949 symphony, a sustained sound with no attack and no end, at once limited and eternal because it has no beginning and no finish. A duration suddenly appearing and, for a time, living eternally in the senses, in the physical forever challenging the psychological. I want it said of me: he existed, therefore he exists!'[8]

Yves Klein 'conducting' the
Symphonie monoton-silence
in the empty Gelsenkirchen Musiktheater.
1959.

Yves Klein. 1962.

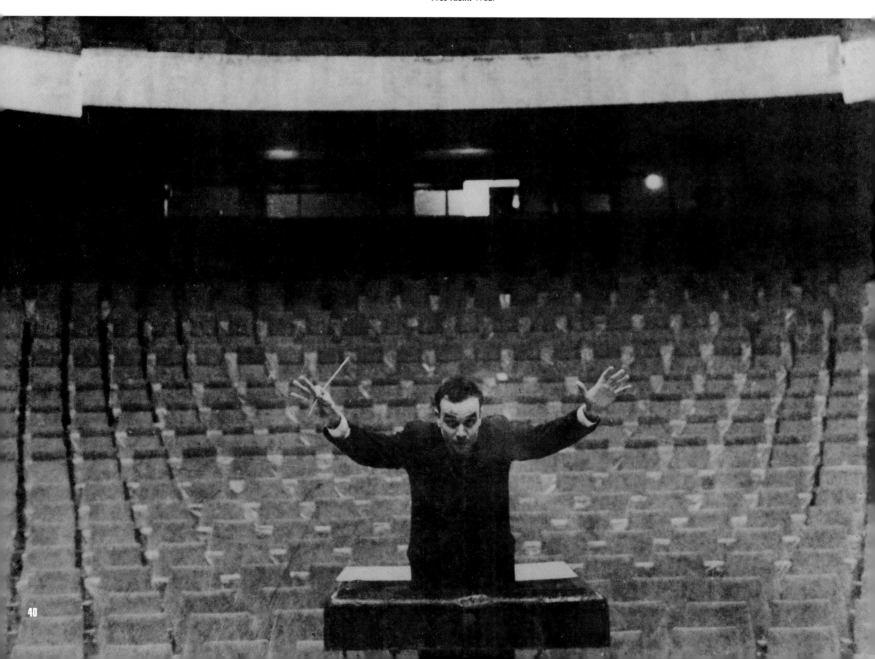

Plural monochromy

The painter at his home
at 14, rue Campagne-Première, Paris.

Letter from Yves Klein to the
Administrative Committee of the Salon
des réalités nouvelles, which had refused to
exhibit his monochrome *Expression du monde
de la couleur mine orange*. 8 July 1955.

The mythical genesis of an invention

The *Symphonie monoton-silence* was, in the words of the painter,
an attempt to reach beyond the phenomenology of time. It had
no beginning and no end, extended beyond the limits of the sense
perceptions – can silence be heard? – and was therefore timeless.
Klein nevertheless took the trouble to date his composition:
'1947–1961'. Though transcended by its subject, the musical
object was inscribed in history. The same paradox characterised
the first public appearances of the artist's monochromes.[9]

Klein had for several years been hanging his unicolour paintings
on the walls of judo centres where he taught, and few people outside
French judo circles knew of their existence. In June 1955, he submitted
one of his monochrome canvases to the Salon des réalités nouvelles,
which was devoted exclusively to abstract art. Viewing it as a hoax, the
members of the jury refused categorically to exhibit this compositionless
work. Though they themselves were all abstract painters, they did not
consider that colour by itself deserved being labelled a work of art.
An art creation, even when reduced to formlessness, scribbling or raw
materials, still required, they felt, the artist's physical gesture, the practice
born from his skill. Marie Raymond was a regular participant of the
Salon and one of the jurors phoned her to say that if her son would
at least add a dot or a line to his painting they would exhibit it.
Klein refused. The lack of comprehension was mutual and total.
Ironically, the Salon's refusal to show Klein's painting would eventually
be perceived as a milestone in art history.

The rejected painting bore an eloquent title and suited the work
perfectly: *Expression du monde de la couleur mine orange*
(*Expression of the World of the Lead-Orange Colour*).[10] The canvas
was uniformly coated with orange pigment and had no other
subject than the colour orange. Klein had written
(on 27 December 1954): 'I believe that in the future painters will
end up painting only pictures consisting of a single colour at a time
and nothing but colour. I mean there'll be no more drawing
no more lines no more forms. Nothing but uniform colour spread
very regularly on the canvas. What people will look for then will
be the purity of the colour represented, the tone.'[11] *Expression
du monde de la couleur mine orange* is just that: a celebration
of the purity of colour, without resorting to form. At first glance,
a feeling that the spectator is being connected with the world
suggests that the painting belongs to the lyric tradition in art.
Far from being an abstraction, it is perceived as a presence.
The pure orange paint shimmers on the canvas as if it were stirring
with an inner life. The luminosity of each grain of pigment renders
the life of the material tangible. The picture has a warm and lusty
vibrancy, an atmosphere of voluptuous pleasure. The frost
of abstraction is thawing in the sunlight of pure pigment.
This is a painting of empathy.

Yves KLEIN
116, rue d'Assas
Paris - VIme

Paris, le 8 Juillet 1955
9 h.30

Comité du Salon des
REALITES NOUVELLES
Musée des Beaux-Arts
de la Ville de Paris
Avenue du Président Wilson
P a r i s

Messieurs,

Votre lettre du 5, reçue effectivement le 7, j'ai décidé de maintenir ma position. A savoir: être accroché dans votre Xme Salon, - cela après avoir lu votre lettre, très attentivement.

Mon tableau représente une idée d'unité absolue dans une parfaite sérénité: idée abstraite représentée de façon abstraite, parfaitement en accord avec vos Statuts.

Dans l'attente du vernissage, veuillez agréer, Messieurs, mes salutations distinguées.

Yves Klein

'I believe that in the future painters will end up painting
only pictures consisting of a single colour at a time
and nothing but colour.'

K. mai. 55.

Using writing to inscribe this work in history, Klein composed an epic account of this first rejection in his career. 'In short,' he concluded caustically, 'complete dictatorship in a salon that prided itself in being wide open to all of the most advanced experiments, ideas and research.'[12] Which meant that the so-called leaders of avant-garde art were blinkered by the traditional supremacy of drawing. They were trapped within their fashionable abstract painters' certitudes while monochrome painting was making a clean sweep of all the artistic traditions bequeathed by the Renaissance. Unicolour painting, which is neither abstract, nor mimetic nor optical, was laying the foundations of a new vision, which was interior rather than formal.

The *judoka* turned artist was certainly not lacking in self-assurance. The leading exponents of French painting had rejected his painting as not worthy of being publicly exhibited, and Klein was proclaiming that he, on the other hand, had revealed it through the splendour of its absence. For one could say that *Expression du monde de la couleur mine orange* was immaterially present at the exhibition, thanks partly to the fact that there were no limits to the artist's determination and partly (in what was either a brilliant stroke of self-advertising or an inspired flight of poetry) to the artist arranging for some fifty friends of his to visit the Salon and inquire where the Klein was hanging.[13]

Expression du monde de la couleur mine orange (Expression of the World of the Lead-Orange Colour) **(M 60).** Orange monochrome. 1955. Dry pigment and synthetic resin on board, 95 x 226 cm. Private collection.

Public debut of the monochromes

On New Year's Day 1955, Klein took a long hard look at himself and concluded that there was not much in his life thus far to boast about. He was an expert at judo but had not achieved the fame he had hoped for within the small world of European judo. However, he was certain he was a genius. 'Today 1955,' he wrote, 'here I am at the Select in Paris, searching for something big. I've discovered that pleasure can be found in pride as well. I think I'm a genius and yet I'm producing nothing sensational.'[14] His public career was about to take off. His insights were exceptionally acute, his views on art had matured and his concept of the monochrome panel had now evolved far beyond its initial stammering: potentially, it was already a full-fledged achievement. Years of intuitive work were about to pay off and things would now suddenly begin to move fast. Indeed, the remainder of the painter's life reminds one of a marathon race.

The initial public showing of Klein's monochromes took place under the aegis of the Club des solitaires in a reception room at the Éditions Lacoste publishing house in Paris. The artist gave himself a dandy's demeanour, as he was to do throughout his career – elegant, provocative, brilliant, insolent, iconoclastic yet classical, the look of an aristocrat on a big gambling spree. In the wake of such figures as Alfred de Musset, Théophile Gautier, Baudelaire and, later, Edouard Degas, Toulouse-Lautrec and Oscar Wilde, dandyism had been fashionable in artistic and literary circles of the late nineteenth and early twentieth centuries.[15] After the First World War, Francis Picabia and Salvador Dalí had carried on the tradition. In the 1950s, Yves Klein and Georges Mathieu were the leading dandies on the Paris art scene, the first with greater finesse, the second with more panache, but the two artists never had much understanding for each other. Klein once remarked that Mathieu had no stomach for 'the terrible Void of pictorial space. He clings and desperately hangs on to signs and then tries to regain composure and get his breath back and pass for a dandy. He isn't a dandy in fact, he plays the part of one.'[16]

The twenty-seven-year-old Klein summoned his friends and acquaintances to view his monochromes at the Club des solitaires. Each picture was painted a uniform colour. Not a single line disturbed the serene expression of the pigment. 'There was no drawing, no variation of tone, only very uniform COLOUR. In a sense, the dominant [colour] invaded the entire painting,' the artist later explained.[17] Nothing distinguished the paintings from each other except the dimensions of the canvas and the colour of the paint. Some were framed with simple flat mouldings; others had no frame at all. The hanging was rudimentary.

Éditions Lacoste.

CLUB DES SOLITAIRES — 121, AVENUE DE VILLIERS

GAL. 24-80

YVES
PEINTURES

Le Samedi 15 Octobre à 17 heures

Métro : Place Péreire - Porte Champerret **INVITATION**

Yves Klein. 1955.

Invitation card to the 'Yves, peintures'
show at the Club des solitaires, Paris.
October 1955.

**Opening night of the 'Yves, peintures'
show,** Club des solitaires, Paris.
October 1955.

Yves Klein painting with a roller. 1955.

In fact the show looked somewhat amateurish. The painter's
sincerity was open to question. Klein presented himself as an artist,
but his works seemed to have more in common with house painting
than with art. Modern art before 1955 had not witnessed such
a provocation since Dadaism. Marcel Duchamp had titled
a reproduction of the *Mona Lisa*, *L.H.O.O.Q* (pronounced
Elle a chaud au cul, meaning 'she's got a hot arse') and had
signed a urinal and called it *Fountain*. Klein's coloured rectangles
carried the same ironic charge: the artist's traditional brush had
been replaced by a commercial house-painter's roller; inspired
brushwork had yielded to a purely mechanical gesture; figurative
expression had given way to pure pigment. There seemed
to be no skill whatsoever in their execution and what evidence
of pictorial discourse they had, if any, was indiscernible.

Was anything left of art in the traditional sense of the word?
Well aware of the controversial nature of his work, Klein provided
the visitors to the show with a short text in which he outlined
his intentions for the first time: 'I endeavour to individualise colour
in this way, for I have come to believe that there is a living world
for each colour and I [want to] express these worlds. My paintings
also depict a concept of absolute unity in perfect serenity . . .
For me, every shade of a colour is an individual so to speak . . .
There are shades that are soft, nasty, violent, majestic, vulgar,
calm, etc. . . In short, every shade of every colour is a true
"presence", a living being, an active force that is born and that
dies after having lived a kind of drama in the life of colours.'[18]
From the outset, then, Klein associated colours with life – 'life itself,
which is the absolute art.'[19]

'For me, every shade
of a colour is
an individual so to speak.'

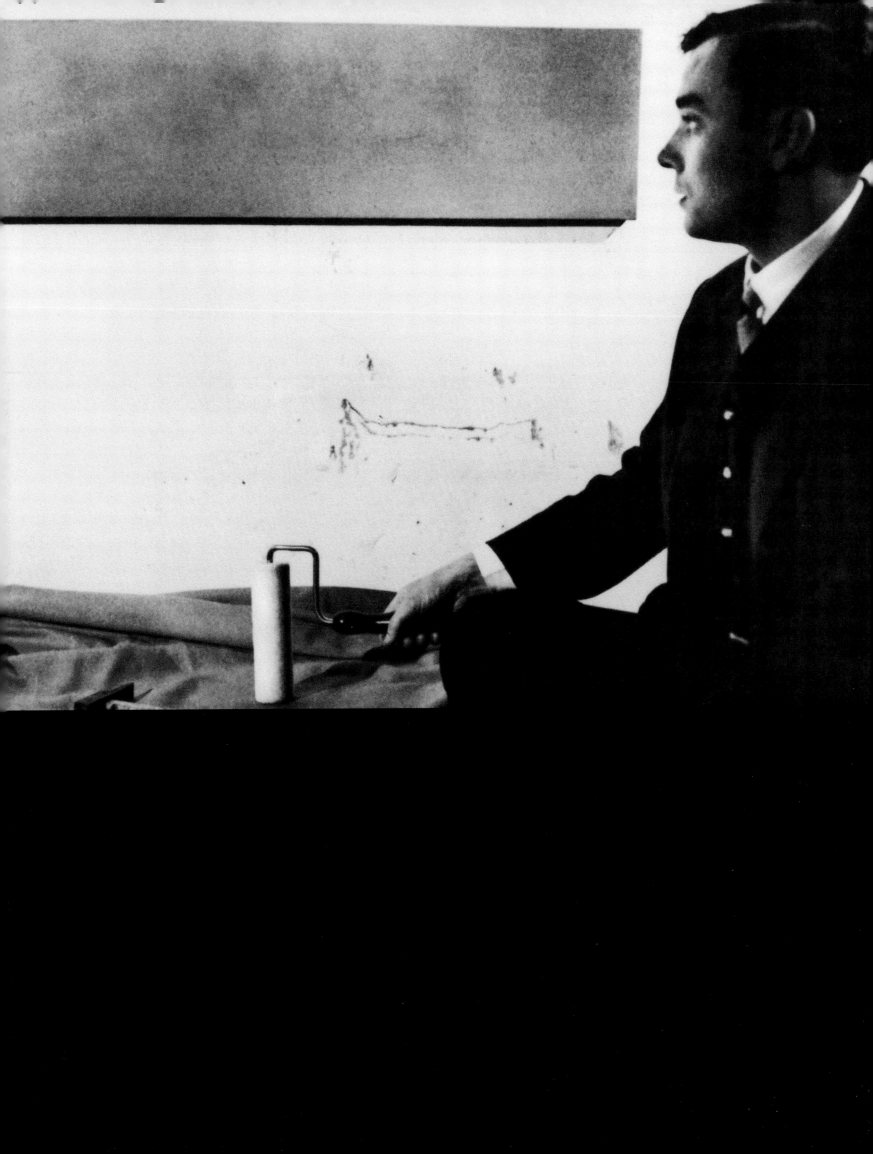

Klein thus summons the viewer to a journey below the surface,

where microscopic matter is manifestly alive.

Having its own individuality, character and soul, each colour is 'a living being'. Klein's aesthetic rests entirely on this premise. Life is the elementary principle of the artist's *Einfühlung*.

This vitalism is not obvious, however. To many of us, Klein's unicolour paintings are merely 'areas of a blank wall.'[20] Conscious of this problem, the artist justified his undertaking by declaring, 'I'm not interested in any sign that helps me to orient myself when I'm navigating on the sea of sensibility.'[21] Klein thus summons

the viewer to a journey below the surface, where microscopic matter is manifestly alive. Do not the laws of physics contradict the flatness of the pictorial surface from which all perspectival illusion has been removed? Viewed through a microscope, inert matter is always alive with inner movement. The surface alone does not suffice to account for reality. Does this not point to the existence of another reality, one that is visible neither to the naked eye nor under the lens of a microscope? Depth eludes the physicist's grasp. Klein leaves the visible unresolved in order to question the invisible.

Yves Klein and Pierre Restany: an exceptional duo

Klein's monochromes went almost unnoticed at the Club
des solitaires. Few visitors came to the show and those that did
were either perplexed or inclined to dismiss it as a hoax.
No art critic bothered to review it. An exhibition of paintings
by Marie Raymond's son was obviously not considered
an important event at the time. Yet the show brought about
one encounter, and this was enough to change the artist's life.
Urged by his bodyguard, Klein's old friend Armand Fernandez,
to take a look at the bizarre show, Pierre Restany, then a junior
official at the Ministère des Travaux publics, could hardly believe
his eyes: the monochromes released an indefinable poetic
atmosphere. But even more than the paintings, it was the artist
himself who fascinated Restany. Klein was the same age
as Restany; he brimmed with life, talked with fiery enthusiasm;
his face shone and his eyes sparkled. Stimulated by the presence
of someone who was receptive to his ideas, Klein talked a great
deal. He was intuitively aware of the depth of his approach.
He knew that his paintings possessed a tremendous expressive
potency. Yet, though he could argue forcefully in favour of his art,
his thoughts were still unclear. All that he needed to fully articulate
his aesthetic was an appropriate grammar and vocabulary.
The spirit was there: with Restany's help, he would transform
its vital energy into a conflagration.[22]

From the very first the two men instinctively understood each other.
Klein 'immediately established the direct, spontaneous contact that
was to become the golden rule of our friendship: a two-voiced
transmission of thought,' Restany later wrote.[23] And indeed the pair
had a great deal in common. Both were intuitive, intelligent,
sincere and unusually sensitive. Their careers seem to have been
predestined to intertwine. They formed a team of two that
is unique in art history. Restany observed that his friend
'had the faith of great visionaries, and their charisma',[24] and Klein
declared that Restany was 'the most important critic of our
generation'.[25] Artist and critic shared the same lifestyle and, above
all, had the same sensitivity towards authentic creativity. Klein,
perpetually in pursuit of the ideas that were freely circulating
at the time, could call on Restany at all hours of the day and night.
Together they broke down the barrier between criticism and
creation. The painter's inspired inventiveness captivated the critic.
The brilliant, passionate critic put his intelligence at the service
of his eye. And what an eye! Restany had streaked into art
criticism in the same way that Klein had burst into painting – like
a meteor. Both newcomers to the art world, they made their debut
together. In truth, Restany belonged to the lineage of creators.
It is impossible to grasp the nature of his relationship with Klein
if one does not understand this. From 1955 to 1962, the two men
constantly shared their thoughts. Restany, who had contacts all over
Europe, organised exhibitions and participated in public
discussions, was present at Klein's side at every stage of what
he was to call the 'monochrome adventure'.

***Untitled* (M 45).** White monochrome.
1957. Dry pigment and synthetic resin
on canvas on wood, 50 x 50 x 5.5 cm.
Private collection.

Pierre Restany and Yves Klein
at the 'Yves Klein le Monochrome' show at
Galleria Apollinaire, Milan.
20 November 1961.

La Minute de vérité

Impressed by the young critic's intellectual sanction of his friend's
art, Colette Allendy, who was one of Marie Raymond's dealers,
decided to give Klein a chance. Presenting an array of his
'monochrome propositions',[26] her one-man show of Yves's work
opened on 21 February 1956. As with the earlier show
at the Club des solitaires, the paintings came in a variety of colours
and sizes. Each monochrome invited the viewer to journey deep
into the world of a single colour. Pierre Restany wrote a text
for the occasion, a gem of intelligence and insolence – the first
of many he was to devote to Yves Klein. In keeping with
a complementary approach that was to be characteristic
of Klein's method, *La Minute de vérité* (*The Minute of Truth*),
as it was called, supplied the discursive element that was lacking
in the artist's paintings.

On the printed invitation to the show, the critic explained that
the spectator was being summoned to 'a cure of silence' which
would have no written trace and would be far removed from
any gesturing, including informal gesturing. A 'pure contemplation'
of the artist's 'monochrome propositions' would not yield forms
(colour rectangles akin to the work of Kasimir Malevich), but merely
a spiritual content (a timeless, silent yet perceptible 'coloured
space'). Thus Klein's 'propositions' were in fact less provocative
than would seem at first glance. Their baffling simplicity
was not intended as an attempt to go one better than the modernist
discourse on pure forms. On the contrary, in Klein's paintings
an aesthetic of sensibility superseded the aesthetic of form.

The artist, for his part, clearly approved of Restany's anti-formalist
thesis and, referring to this historic show, explained that
'what I wanted from the public was that "minute of truth"
which Pierre RESTANY spoke of in his preface to my exhibition,
making it possible to clear the slate of all outside contamination
and to reach a level of contemplation where colour becomes
a pure, full sensibility.'[27] Klein wanted the monochrome
to be considered a living epidermis, a presence, an anti-form
steeped in sensibility. 'Colour,' he writes further, 'is sensibility
transformed into matter, matter in its primal state.'[28]
As an incarnation of a sensible phenomenon, colour is a body
filled with life. Thus the aesthetic experience takes place on the level
of an encounter between a colour and a spectator.
But how are we to attain this level of perception? Klein's universe
is a relatively hermetic one. Hypersensitive individuals
can penetrate 'the heart of the void' without too much difficulty;
the others struggle to understand. Let us try and understand
what brought the artist to paint with a single colour
and what exactly his intention was.

LA MINUTE DE VÉRITÉ O A tous les intoxiqués de la machine et de la grande ville, les frénétiques du rythme et les masturbés du réel, YVES propose une très enrichissante cure de silence asthénique O Bien au-delà des dévidages de mondes autres, déjà si peu perceptibles à notre sens commun du raisonnable, à côté sans doute de ce qu'il est convenu d'appeler ''l'art de peindre '' au niveau en tous cas des plus pures et plus essentielles résonances affectives, se situent ces propositions rigoureusement monochromes : chacune d'entre elles délimite un champ visuel, un espace coloré, débarrassé de toute transcription graphique et échappant ainsi à la durée, vouée à l'expression uniforme d'une certaine tonalité O Par dessus le public-public, si commode miroir aux alouettes, les vieux habitués de l'informel se mettront d'accord sur la définition d'un ''rien'', tentative insensée de vouloir élever à la puissance + ∞ la dramatique (et désormais classique) aventure du carré de Malévitch O Mais il n'y a précisément là ni carré noir ni fond blanc, et nous sommes au cœur du problème. L'agressivité de ces diverses propositions de couleur projetées hors des cimaises n'est qu'apparente O L'auteur requiert ici du spectateur cette intense et fondamentale minute de vérité, sans quoi toute poésia serait incommunicable ; ses présentations sont strictement objectives. Il a fui jusqu'au moindre prétexte d'intégration architecturale des espaces colorés. On ne peut le suspecter d'aucune tentative de décoration murale O L'œil du lecteur, si terriblement contaminé par l'objet extérieur, échappant depuis peu à la tyrannie de la représentation, recherchera en vain l'instable et élémentaire vibration, signe auquel il s'est habitué à reconnaître la vie, essence et fin de toute création... comme si la vie n'était que mouvement. On l'oblige enfin à saisir l'universel sans le secours du geste ou de sa trace écrite, et je pose alors cette question : où, à quel degré d'évidence sensible, se situe donc le spirituel dans l'art ? O L'omnisciente dialectique a-t-elle fait de nous des mécanismes de pensée, incapables de totale accomodation sincère ? En présence de ces phénomènes de pure contemplation, la réponse vous sera donnée par les quelques hommes de bonne volonté encore survivants. O **PIERRE RESTANY**

COULEURS

DÉCEMBRE 1956 Nº 18

LA MINUTE DE VÉRITÉ

A tous les intoxiqués de la machine et de la grande ville, les frénétiques du rythme et les masturbés du réel, YVES propose une très enrichissante cure de silence asthénique. Bien au delà des dévidages de mondes autres, déjà si peu perceptibles à notre sens commun du raisonnable, à côté sans doute de ce qu'il est convenu d'appeler "l'art de peindre", au niveau en tous cas des plus pures et plus essentielles résonances affectives, se situent ces propositions rigoureusement monochromes : chacune d'entre elles délimite un champ visuel, un espace coloré, débarrassé de toute transcription graphique et échappant ainsi à la durée, vouée à l'expression uniforme d'une certaine tonalité. Par-dessus le public-public, si commode miroir aux alouettes, les vieux habitués de l'informel se mettront d'accord sur la définition d'un "rien", tentative insensée de vouloir élever à la puissance + ∞ la dramatique (et désormais classique) aventure du carré de Malévitch. Mais il n'y a précisément là ni carré noir ni fond blanc, et nous sommes au cœur du problème. L'agressivité de ces diverses propositions de couleur projetées hors des cimaises n'est qu'apparente. L'auteur requiert ici du spectateur cette intense et fondamentale minute de vérité, sans quoi toute poésie serait incommunicable ; ses présentations sont strictement objectives. Il a fui jusqu'au moindre prétexte d'intégration architecturale des espaces colorés. On ne peut le suspecter d'aucune tentative de décoration murale. L'œil du lecteur, si terriblement contaminé par l'objet extérieur, échappant depuis peu à la tyrannie de la représentation, recherchera en vain l'instable et élémentaire vibration, signe auquel il s'est habitué à reconnaître la vie, essence et fin de toute création... comme si la vie n'était que mouvement. On l'oblige enfin à saisir l'universel sans le secours du geste ou de sa trace écrite, et je pose alors cette question : où, à quel degré d'évidence sensible, se situe donc le spirituel dans l'art ? L'omnisciente dialectique a-t-elle fait de nous des mécanismes de pensée, incapables de totale accommodation sincère ? En présence de ces phénomènes de pure contemplation, la réponse vous sera donnée par les quelques hommes de bonne volonté encore survivants.

PIERRE RESTANY.

Tout en reconnaissant le mérite des monochromies présentées par YVES, et qui constituent un retour à Dada et à Monsieur de la Palice, on ne peut s'empêcher de demander à M. Pierre RESTANY, son laudateur :
« QU'EST-CE QU'UNE VERITE QUI NE DURE QU'UNE MINUTE ? »

En peinture, c'est précisément une couleur qui no trouve pas une autre avec qui s'accorder, car les bons peintres sont rares, qui réussissent des harmonies savoureuses, inédites, sensationnelles. Mais dans le cas actuel, la Couleur majuscule qui nous est offerte, ne peut pas trouver d'harmonie colorée puisqu'elle est théoriquement, et de fait, UNE COULEUR SOLITAIRE. Notre distingué critique a donc tort de parler des... mœurs solitaires de tous les autres peintres, ceux de la polychromie.

Un peintre n'est pas obligé de réfléchir, surtout s'il a du génie. Un critique, si.

P.G.

10

Invitation card to the 'Yves, propositions monochromes' show at the Galerie Colette Allendy, Paris, with Pierre Restany's text, *La Minute de vérité*. February 1956.

Yves Klein's scrapbook with Restany's *La Minute de vérité*, published in *Couleurs*. December 1956.

Untitled (M 27). Red monochrome. 1956.
Dry pigment and undetermined binder
on canvas on wood, 18 x 12 cm.
Private collection.

Untitled (M 28). Turquoise monochrome.
1950. Pastel on paper mounted on wood,
23 x 12.5 cm. Private collection.

Ontogenesis of the monochrome

First came an experience of wonder, an ecstatic vision of pure pigments. Whoever has had this experience knows the luminous intensity of pictorial matter. Klein, no stranger to this common perception, compared the beauty of powdered pigment to that of gold leaf and gemstones. 'What clarity and lustre! What infinite brilliance! That is what I want to capture in my colour matter: a vital particular water at once full of lust and serenity.'[29] The son of artists, raised in a world of painting, Klein viewed powdered pigment in its perfection as a light-object. His wonder gradually developed into a spiritual contemplation. That he was never able to recapture the incandescence of natural pigments on canvas perplexed him: 'The affective magic of colour had vanished. / Each grain of powder seemed to have been extinguished individually by the glue or whatever material was supposed to fix it to the other grains as well as to the support.'[30] The media the artist used as fixatives invariably attenuated the powder's 'lustiness': its gossamer, velvety matte texture that evoked the richness of an inner life, the depth of blueness and the vitality of fire. When mixed with a fixative, the pigment lost some of its brightness and appeared lifeless. How could pigment be made fast to the support without its beauty being diminished? How was one to accomplish the leap from contemplation to imagination?

Clearly, the binding agent had to be proscribed – or changed. With the help of a friend, the architect Bernadette Allain, and Édouard Adam, a retailer of paint supplies, Klein developed a medium that did not obscure the incandescence of powdered pigments. Not only did it not 'kill' colours, but it also allowed 'total freedom to the specks of pigment, such as they are found in powder form, perhaps combined with each other but nevertheless autonomous.'[31] Using a binder of ethyl alcohol, ethyl acetate and Rhodopas (a resin manufactured and distributed by the Rhône-Poulenc chemical firm), Klein was able to preserve the sparkle of raw pigment in the pure state.

This impression of purity linked as closely as possible with matter brings the object to life. The sacred gives a sheen to the surface of colour-light. Surely radiant powder deserves a singular gaze? Its immanent presence challenges banality and ordinariness: irreplaceable, unique and timeless, it is rooted in the world. The instant in which an encounter takes place lasts forever. The beauty of a colour is experienced as something matchless. Being naturally suffers no comparison. Klein made this his credo: 'I refuse to create a spectacle in my painting. I refuse to compare and confront in order to bring to the fore this or that stronger element in relation to others that are weaker.'

'Par la couleur . . .' (Through colour . . .).
From the **manuscript of Mon Livre,**
Yves Klein Archives.

'C'est avec la monochromie que je me grise le plus . . .' ('It's with monochromy that I get drunkest . . .'), **manuscript,**
Yves Klein Archives.

Claude Rivière X - 1957

C'est avec la monochromie que j'ai conquis la pur...

Je ne sais pas, mais j'ai déjà beaucoup essayé et j'ai été peintre comme il est admis...

et être peintre, j'ai été plus avant et avant-garde même, toutes les périodes je les ai passées, j'étais insatiable, et puis les plaisirs et les consolations — j'en suis déjà blasé — Je crois en tout...

...ce n'est qu'avec la monochromie que je vis vraiment la vie picturale, la vie de peintre dont je rêvais, c'était bien exactement ce que j'espérais de la peinture où j'y suis, et dans cette matière spéciale la matière picturale...

c'est vrai je suis pour la première fois pleinement satisfait pleinement en peignant (monochrome).

La vie de la couleur ! et puis ça me rappelle à Colombo les marchands de pierres précieuses...

Cette petite histoire m'est venue a propos de : Pourquoi pas deux couleurs à la fois ?

Eh bien parce que je refuse de donner un spectacle. Je refuse de comparer et de ~~disposer par~~ mettre en présence pour faire ressortir tel ou tel élément plus fort par rapport à d'autres plus faibles.

La représentation ~~même~~ la plus civilisée est basée sur une idée de combat entre différentes forces et le lecteur assiste dans un tableau à une mise à mort à un drame, morbide par définition qu'il s'agisse d'amour ~~ou~~ de haine ~~et que je~~ Le tableau pour moi est comme un individu — je désire le considérer ~~comme~~ tel qu'il est et ne pas le juger — surtout ne pas juger —

Dès qu'il y a deux couleurs dans un tableau, ~~les deux~~ un combat et ~~rapport~~ deux ~~combat~~ spectacle je me

Love brooks no comparisons. Once the visual field is broken up an authentic encounter becomes impossible. For formal tensions engender spectacles. They oblige us to discriminate, to chose and order. 'The minute you have two colours in a painting, a struggle ensues,' the painter deplores, adding, 'I absolutely do no want to choose which of two persons is the better.' Each individual life is a sacred history.

A unique being is an imprint of a universal principle. Again, Klein associates colour with life: 'Paintings are living, autonomous presences.'[32] Thus the substitution of monochromy for polychromy assumes an ontological dimension, for the pictorial being is at once unique and universal. The shift from aesthetics to ethics is a corollary of the transition from surface to body. Irreducible life energy is deposited within the pictorial body. Colour is an element of the mystery of living beings.

Lines, on the other hand, symbolise death. They sunder and fragment. Lines are the 'chains' that bind us, our 'prison bars'. Whether written or drawn, they restrict the pure expression of life. 'The line pierces space, it is always in transit, it inscribes itself; it is a tourist. Colour finds itself permeated with space, it dwells in it.'[33]

To dwell in space the way a human being inhabits his or her body, to exist in harmony with the world – this is monochromy's ambitious programme. For 'lines may be infinite, like the spiritual realm, but they aren't able to fill the incommensurable whole; they don't have

that faculty for permeation which colours have.' Klein uses the metaphor of bathing to signify this ontological capacity for saturation: 'Colours bathe in the whole like anything that partakes of an indefinable, formless and boundless sensibility.' But in what way does a colour 'bathe in the whole'? Klein regards colour as a two-fold thing: as both material and immaterial. Colour's formal beauty is a reflection of its inner beauty. Colour is sensibility – and 'sensibility has no hidden recesses, it's like moisture in the air'.[34]

Colour's relation to life is established on the level of sensibility. For Klein, 'sensibility is the currency of the universe, of space, of greater nature, which allows us to purchase LIFE in its raw-material state!'[35] Colour is 'the medium best suited to receiving the impressions of events'[36] like negative film in photography. Life ('a flame of poetry')[37] is deposited and steeped in pure colours thanks to its capacity for absorption of sensibility. The monochrome is an imprint of life.

'Pourquoi pas deux couleurs à la fois . . .' ('Why not two colours simultaneously . . . '). From the **manuscript of Mon Livre,** Yves Klein Archives.

Untitled (M 3). Undated red monochrome. Paper on canvas and stretcher, 8.7 x 18.2 cm. Private collection.

This obviates any strictly formal approach to the monochrome. 'Painting is not colour, lines, forms, isolated colours with or without lines or forms inscribed in them. Painting is a painted surface that becomes a living epidermis as the painter paints and as a result becomes a presence, but not an animal or vegetable presence or a simple being; there is the marvellous mystery. A miracle, it is sensible matter consisting of scraps of sensibility torn from space by the painter each time he ventures into it as well as scraps of his own sensibility, which he adds in order to blend all the components together and get them to live tangibly in the midst of Humans.'[38] The pictorial presence cannot be reduced to any single form; it is a trace of perceptual energy in matter. Receiving this impression, matter (rendered perceptible) becomes a 'living epidermis'.

Naturally, the first monochrome experiments that Klein exhibited at Colette Allendy's gallery in 1956 could not possibly fulfil such a vast programme. Klein wanted the viewers of his paintings to experience a meditative 'moment of truth', but was forced to admit that, instead of concentrating successively on each individual canvas, their attention was divided between all the pictures in the show. In effect, they were merely re-creating the elements of a 'decorative polychromy'; they were comparing colours and allowing themselves to be distracted by the variety of the hues displayed. The artist's method clearly had its limits. Klein saw that he would have to bring greater clarity to his discourse and radicalise his approach. His obsession with the singular and universal rendered polychromy and the game of discriminations irrelevant.

Pure monochromy: the Blue Period

Untitled (IKB 18). Blue monochrome.
1959. Cartoline, 21.5 x 18 cm.
Private collection.

Untitled (IKB 68). Blue monochrome
(detail). 1961. Dry pigment and synthetic
resin on gauze on wood, 199 x 153 cm.
Private collection.

Blue depths

Pierre Restany helped to organise a new show of Klein's
monochromes at Guido Le Noci's Galleria Apollinaire in Milan,
and thus, in the first days of 1957, the painter's exploration of the
immaterial made further public progress. On 2 January, the artist
inaugurated eleven seemingly identical monochrome panels.
The principle of unity prevailed throughout: unity of setting, format,
colour and brushwork. Thus far, a certain diversity had
characterised Klein's monochromes, but now apparently nothing
distinguished one panel from another.

Klein's universe was now solidly blue. Its blueness took one's breath
away and overwhelmed the eye. The painter's monochrome panels
were hung to make them look like they were suspended in thin air
and their blue coloration acquired an uncanny depth,
the fathomlessness of a black hole. Their texture, opaque and matte
as velvet, seemed to absorb light. There were no reflections
to trouble their powdery blue surface, which seemed to lie loosely
on the panels. Klein had devoted himself during the preceding year
to 'experimenting with the most perfect expression of blue'.[39]
The colour of the majestic cloak of the Virgin, the Queen
of Heaven, blue is associated symbolically with eternity.
In the words of one dictionary of symbols, 'blue is the deepest
of colours: one's gaze sinks into it without encountering
any obstacle and loses itself in infinity, as if drawn by a perpetual
elusiveness in the hue. Blue is the most immaterial of colours: when
it occurs in nature it generally consists of transparency, that
is to say of accumulations of emptiness, the void of air, water,
crystals and diamonds. A precise void, pure and cold.
Blue is the coldest of colours and, in the absolute, the purest, aside
from the total void of neutral white. Its fundamental properties
determine the range of its symbolic uses.'[40] Klein could thus
proclaim that, by using blue, 'the "grand COLOUR",
I am increasingly able to approach the "indefinable"
which DELACROIX speaks of in his Journal as a painting's only true
"WORTH".'[41] Klein considered himself a disciple of Delacroix,
who had stated that the 'indefinable' is 'what the soul adds
to colours and lines in order to reach out to the soul'.[42]
Blue renders visible, palpable, almost odorous, the indefinable
sensibility present in everything.

Klein Blue – IKB, International Klein Blue – had the power,
its inventor believed, to reveal the indefinable.[43] A draught of this
magic potion, Klein assures us, enables the artist to give visibility
to the energy of sensibility flowing in the veins of matter.
Awash in a great blue pool, matter is thoroughly penetrated
and saturated with sensibility – ubiquitous and all-powerful
sensibility. Under the chemical action of a revealing solution,
the section of blank wall becomes an apparition (a formless trace).
The monochrome is like a rectangle of exposed paper soaking
in a blue wash.

This blue unquestionably belongs to the domain of poetry. Klein is like a comic strip hero undertaking to conquer the moon. First he appropriates the sky above Nice by signing his 'first and biggest monochrome'.[44] Now he totally immerses himself in a 'blue painted blue'. For the child of the Côte d'Azur that he was, blue was almost a natural environment. He was endlessly fascinated by the colour. In itself, this was nothing unusual: blue expressions are the leitmotif of Romantic poetry. Klein knew this well and liked to quote from poets who celebrate the colour blue: Shelley who says that 'blue is the blood of sensibility', the Comtesse de Noailles who speaks of a 'searing blue', Mallarmé who suffered from 'the irony of the azure sky', and above all Gaston Bachelard who observes, 'First there is nothing, then there is a deep nothingness and then there is a blue depth.'[45]

1

L'international Klein Blue
a été mis au point par
Yves Klein le Monochrome
dans le courant des
années 1954 - 55 - 56 - 57
58... La Formule chimique
actuelle en est exacte.

MEDIUM FixatiF
de L'I.K.B
1 Kilo, 200 RHODOPAS
 (produit facteur)
 MA (RHône Poulenc)
 (Chlorure de Vinyl)
2 Kilo, 200 Alcool Ethylique
 95% industriel
 Dénaturé
0 Kilo 600 acétate
 d'Ethyle.

un tout 4 Kilo, 00.
Mélange à Froid — en agitant
et ne Jamais chauffer a Nu !

The 'monochrome epic'

After Milan, Klein's monochrome panels were shown, in that same year of 1957, in Paris, Düsseldorf and London. Not only were they uniformly blue; they were also all the same size: 78 x 56 cm., a traditional easel-painting format. They could not be mistaken for strictly decorative items: they were true works of art.

These panels were unusually thick and had rounded corners, for the principle of monochromy excluded any abrupt discontinuities. Dissolving disjunctive edges and intrusively sharp corners, Klein's monochromes melted into space. Canvas was wrapped around each panel, extending even to its back, and in its expanded thickness colour unfolded more deeply, as though to emphasise its limitless capacity to absorb. The pigment lay on the canvas, in the rounded corners, on the sides, devouring space. Standing in front of the panel, the spectator physically plunged his gaze into the blue mass. The panel's three-dimensionality produced a feeling of ambivalence: was it a painting, was it a sculpture? Years before Donald Judd and Frank Stella, Klein's monochrome 'propositions' played felicitously with this generic ambiguity. In the case of Klein's works, material depth was of course subordinated to true depth. With their pigment-saturated thickness, the monochromes established their objective presence through a contradictory motion of immaterial dilation.

The fact that the panels were unframed enhanced this expansion of the 'colour' field beyond their physical limits. They had no gilded edges; there was no plain wooden moulding to offset them. The canvas on a stretcher was, so to speak, unclothed: nothing set it artificially apart. The blue colour was free to expand in every direction. It radiated, soaked into the surrounding space, beyond the canvas's physical boundaries. The monochromes could be viewed from the physical standpoint of their visible manifestation as well as from the non-physical perspective of their invisible, yet perceptible penetration of space. 'In short, the physical painting owes its right to life solely to the fact that while people believe only in visible things, they feel obscurely the essential presence of something else, something far more important,' wrote the painter.[46] The expansion of blue beyond the edges of the painting was the artwork's invisible aspect, analogous to the silence in the *Symphonie monoton-silence*.

To create an impression of suspension and dilation in space, the panels were hung approximately 20 cm. off the wall. Each panel presented itself as an unattached, independent unit and appeared to float weightlessly in the gallery space. Its colour dissolved freely. Disconnected from the wall's physical presence, which by definition encloses, protects and excludes, the colour mounted on the panel was free. The concept of space replaced the concept of the gallery wall.

With pictorial areas the same size as traditional paintings, hanging away from the wall, without a frame, without a title, without any caption or information, the panels appeared to vibrate

in an atmosphere of ineffable quiescence and repleteness. On the one hand, each panel was celebrated as a unique item, isolated from its context like a sculpture or 'specific object' on a base. It was electrically visible. Its texture drew the eye. On the other hand, it was an object that melted into space. It was non-formal. It expanded and filled the empty gallery. Its capacity to dissolve before the viewer's gaze contradicted its nature as a specific object. As its blue dissolved into space, subject consumed object and depth swallowed blue.

In the preface he wrote for the catalogue of Klein's Milan show, Pierre Restany cited Giotto's blues and spoke of the symbolic significance of blue. He warned against identifying the monochromes with the work of the Russian formalist, Kasimir Malevich. The Klein controversy was launched. The Italian press accused the painter of being an impostor. Visitors flocked to the gallery and a number of them were very favourably impressed. Declaring that the show was a revelation to him, Piero Manzoni visited the show daily. The Italian painter's work, as yet in gestation, especially his *Achromes* (white monochromes), would be a response to Klein's. Lucio Fontana, well established on the Italian contemporary art scene, purchased one of the French painter's monochromes and subsequently moved towards a unicolour painting of his own. His famous lacerated canvases echo the monochrome/void polarity in Klein's work. Other Italian artists noticed Klein as well. Enrico Baj and Sergio de Dangelo invited Restany and Klein to sign the Arte Nucleare manifesto against style. The Milan show was unquestionably Klein's first major success. Count Panza di Biumo, soon to become a leading art collector, purchased a red monochrome in the gallery's storeroom (though he returned it to the gallery a week later). Other monochromes were acquired for the collections of Italo Magliano and the industrialist Peppino Palazzoli. A favourable article by the renowned Italian writer Dino Buzzati, in the daily *Corriere della sera* of 9–10 January 1957, may have had something to do with this success. At any event, Klein's sojourn in Italy had a durable impact there. After his departure, Palazzoli opened his Galleria Blu in Milan and had an ultramarine blue logo designed for it, and the now famous song *Nel blu dipinto di blu* (*In the Blue Painted Blue*) was broadcast from every Italian radio station.

The painter's archives contain a short text on the Milan show. In a single paragraph, Klein considers the public reception of the exhibition and, with hindsight, establishes the meaning of his approach. 'The rather heated controversy the event stirred has demonstrated to me the value of the phenomenon,' he writes. 'The public recognised that each of those seemingly identical blue propositions was very different from the others.' Not surprisingly, 'the prices were of course very different', for 'the pictorial quality of each painting was discernible by means of something besides its physical appearance'.[47] In other words, the objects may have been identical, but the subjects were unique. The monochromes were like identical twins: they looked alike but each had its own identity.

Untitled (IKB 191). Blue monochrome. 1962. Dry pigment and synthetic resin on gauze on board, 65 x 50 x 2.8 cm. Private collection.

They had the same genetic make-up, were born from the same egg, so to speak, but each was unique. Their individual identity was in contrast to their collective sameness; their respective difference sprang from their very resemblance to each another. In short, their identity could not be reduced to their appearance. The different prices asked for panels having the same size and colour emphasised the basic singularity of each painting. Naturally the prices were different: no two monochromes were alike.

After Milan, as we shall see, Klein exhibited his blue 'monochrome propositions' in a double show in Paris, before exporting them to Germany and England.

At the suggestion of the sculptor Norbert Kricke, Alfred Schmela invited Klein to exhibit his work in Düsseldorf. On 31 May 1957, the man who would become one of Germany's leading art dealers inaugurated his gallery with the colour blue. Pierre Restany once again contributed his *Minute de vérité* in French. The critic also took part in a debate on the evening of the show's opening. The discussion went on at length. Klein disturbed people and was forever provoking controversy. But he gained followers in Germany, as he had earlier in Italy. Like Piero Manzoni and Lucio Fontana, a number of German avant-garde artists came under the influence of the young painter from Nice. Norbert Kricke invited Klein to join an international team of artists competing for a commission to decorate the Gelsenkirchen opera and concert hall. Klein also impressed the artists of the Zero group, Heinz Mack, Otto Piene, and Klein's future brother-in-law Günther Uecker, all of whom were later to have successful careers. Klein was to participate in group shows with them on several occasions and would have a decisive influence on their artistic development in the late 1950s and 1960s. The painters Peter Brüning and Konrad Klapheck sympathised with his views as well. In short, a whole generation of young German painters was drawn to the works of Klein's Blue Period with a fervour that no one would have predicted. Klein was fast becoming a phenomenon.

The trend grew that spring. Klein was having one show after another: Milan in January, Paris in May and Düsseldorf in June. Then, in late June, an exhibition of his work opened in London at Gallery One and caused something of a furore. The show included not only six blue monochrome panels identical in size, but also a large blue sponge on a base and, in a side room of the gallery, an array of monochromes in red, white, black, yellow, green and pink. The public reacted with laughter. A debate was organised at the Institute of Contemporary Art, on 26 June, in the presence of Yves Klein and Pierre Restany. The atmosphere was heated. During the discussion, one member of the audience jumped up and shouted angrily, 'This whole thing is just a huge joke!' Klein typically answered with a quip, preferring to raise a burst of laughter than to engage in a serious discussion.

His charisma and high spirits made him a likable figure, an artist unlike any other, and his youthful charm and dandyish appearance amused British public opinion. Klein played up to the press (which Victor Musgrave, the gallery's director, had invited to the opening) with self-assurance and a certain very British humour. By the beginning of July, Klein's monochromes had become news. British reviewers wavered between scepticism and curiosity, irony and sarcasm. The writer for *Architects Journal* found the exhibition hilarious. *The Observer* applauded the painter's wit. One reader wrote a letter to *Art News and Review* to protest against the periodical's caustic dismissal of the show, and suggested that Klein's aesthetic could be defined as a tension between rationalism and metaphysics.

Victor Musgrave replied to Bernard Levin of *The Spectator,* who had described IKB as cheap industrial paint and had identified Pierre Restany as a staff writer of an unknown review called *Prismes*. All the critics acknowledged the amplitude of the controversy surrounding the monochromes. *The Sun* headlined its review, 'Blue and Blank Pictures – Frenchman Causes Art Furore in London' and the reviewer went on to wonder if the show wasn't a turning point in modern art or simply one of the century's great hoaxes.[48]

'Yves Klein, Proposte monocrome, epoca blu', Galleria Apollinaire, Milan. January 1957. From left to right: Yves Klein, Adriano Parisot, Pierre Restany, Ada Parisot, Lutka Pink, Bellegarde.

Untitled (IKB Godet). Blue monochrome. 1958. Dry pigment and synthetic resin on paper on canvas, 198 x 150 cm. Private collection.

The climax of the Blue Period: a double hit in Paris

Between Milan and Düsseldorf, Klein returned to Paris to put together a double show at the Iris Clert and Colette Allendy galleries in May 1957. This twin event was the climax of pure monochromy (as distinct from plural monochromy), shortly to be succeeded by Klein's Blue Period. No sooner had he given monochromy a formal expression than Klein felt the need to push it to its conclusions. Realising that the shift from matter to IKB generated sensibility, the artist now wanted to extend his vision to a broad range of objects. Paintings would no longer be the only support for artistic expression. Blue could make any object light up: any item bathed in IKB could generate 'pictorial sensitivity'. If the colour-sensitised object appealed to the viewer's eye and heart, the artist's gamble would pay off: he would succeed in creating an encounter.

The two Paris shows were literally twinned. Klein designed a single invitation to both events. In the form of a postcard, it also served as an 'explanation' of the double event. Pierre Restany gave his endorsement in a short text in which he outlined the 'great history of the Blue Period'. It was handwritten and reproduced in facsimile. The address was handwritten in blue ink. The stamp was a small pasted paper the size of an ordinary postage stamp and coated with Klein blue. It was thus a genuine miniature monochrome, its proportions similar to those of the panels displayed at the Galerie Iris Clert. 'Klein', observes Nan Rosenthal, 'was suggesting the possibility that the size [of his works] could be reduced to nothing, but also expanded to infinity.'[49] The quality of a monochrome does not depend on its size for, as Klein writes, echoing Gaston Bachelard, 'blue has no size, it is beyond dimensions'.[50] Georges Mathieu could inflate his pictures to gigantic proportions, but really there was no need: a postage stamp was big enough. Whether it was small, large, thick or thin was beside the point. Had not Delacroix stated that a painting's worth lies in the 'indefinable, which is precisely that which eludes precision'?[51] Whether it occurred on a postage stamp or a panel, IKB made the indefinable absolute a tangible thing.

To those who might still have harboured doubts about his monochromes, Klein showed that his genius had been officially validated: the postal authorities, in other words the state, had franked his monochrome stamps. Great painters are sometimes depicted on postage stamps (or banknotes); Klein, breaking into the exclusive circle of immortal artists, was indulging in the luxury of a monochrome self-portrait. Each time the post office franked one of his stamps, the state was validating a 'monochrome proposition'. While the artist was not being knowingly endorsed by the state, he was nevertheless projecting an avant-garde artistic expression into the public arena. Up until now, his shows had been limited to a few connoisseurs and curious onlookers – never more than a few hundred persons. But the twin Paris exhibition was a public event. Indeed, Klein narrowly missed getting into trouble with the public authorities.

Untitled (IKB 220). Undated blue
monochrome. Dry pigment and synthetic resin
on gauze on cardboard, 40 x 35.3 cm.
Private collection.

Above: ***Untitled*** (IKB 241).
Blue monochrome. 1960. Dry pigment and
synthetic resin on gauze on board,
60.5 x 49 cm. Private collection.

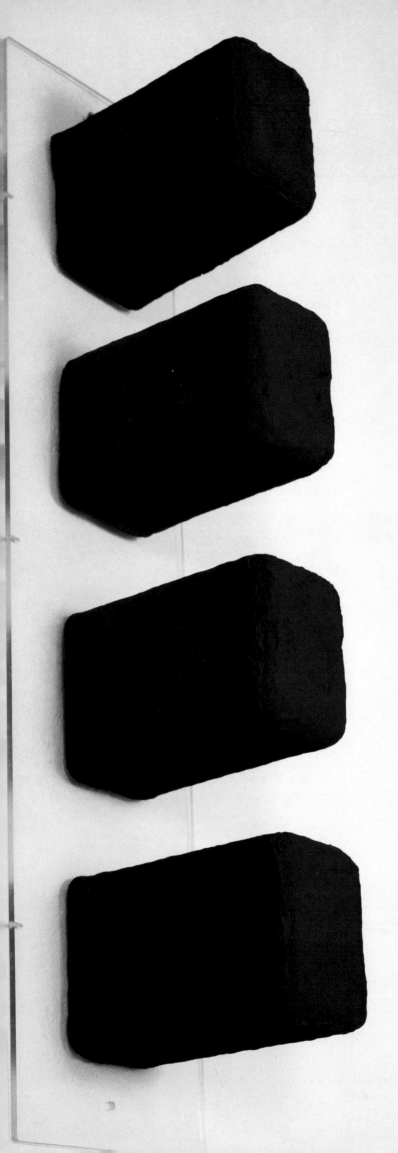

The postal employees who took part in the illegal scheme were less fortunate. To underline the public dimension of his work, Klein extended his activities beyond Iris Clert's gallery and invaded the street. To mark the opening of the show, he organised a spectacular launching of IKB balloons in front of the church of Saint-Germain-des-Prés. The blue balloons drifted up into the blue sky, involving everyone present in a display of sculpture being released from the laws of gravity. But the event had a further purpose. Klein had no intention of seeming more modern than the moderns. His 'airborne aerostatic sculpture consisting of 1001 blue balloons' heralded a new era. In the future, humans would be 'capable of levitating with a total physical and spiritual freedom'.[52]

The organisation of the show was relatively complex. IKB panels characteristic of the Blue Period were shown at the Galerie Iris Clert. One very large monochrome was added to the standard-sized panels and a great deal of variety was brought to the way the paintings were hung on the walls of the small gallery. A strange sculpture completed this ensemble: a gigantic sponge gorged with blue paint, rising above a rough stone base at the end of a slender, slightly bent metal rod. The thoroughly imbibed sponge appeared to float in thin air. At once ghostly and weirdly present, it was a tangible expression of the phenomenon of saturation. This first experiment was to give rise, some two years later, to a veritable forest of sponges.

The demonstration of IKB's power to infuse space continued at Colette Allendy's. The monochromes displayed at the Galerie Iris Clert were merely examples, but Klein conceived his show at Colette Allendy's as a didactic presentation of the monochrome undertaking. Naturally, each object on display was coated with blue paint and was designed to cast light on one or more aspects of monochromy.

A tray of pure IKB pigment placed on the floor became, in the words of the artist, 'a floor painting, not a painting to be hung on a wall'.[53] Since each speck of powdered pigment possessed its own unique value, there was surely no reason to add even the minimal quantity of fixative used on the monochrome panels. 'The fixative solution was as immaterial as possible; it was no more than the force of attraction itself and it did not affect the grains of pigment individually,' noted the painter in his accompanying 'Remarks concerning several works exhibited at Colette Allendy's'. The tray of pigment was, in short, a purified version of the monochrome panels. Dissociated from both fixative and walls, the pigment attained its full radiance. Discarding the picture was the first step in the process of immaterialising creation.

Klein also exhibited two screens consisting respectively of four and five panels painted blue. These modular monochromes were literal expressions of the painter's desire to create a 'radiant pictorial atmosphere',[54] for colour, he explained, is 'an authentic denizen of space'.[55]

The screens gave the spectator an opportunity to 'wrap himself in Blue'. However, this did not compensate for the semi-circular screen's lack of depth: the surface of the individual panels did not generate much of a feeling of depth.

Another work, *Reliefs bleus* (*Blue Reliefs*), consisted of eight rectangular volumes fastened endwise to a wall one above the other in a physical translation of the monochromes' inwardness. Depth was their main dimension. Though this sculpture could have passed for one of Donald Judd's 'specific objects', its shapes were distinctly more sensual. Soaked in blue paint that washed over their slightly rounded corners, Klein's reliefs seemed to absorb the viewer's gaze.

Similarly, *Disque bleu* (*Blue Disc*), measuring approximately 24 cm. across, beckoned the spectator into a spiralling vortex. Hung in the centre of one of the gallery's walls, it recalled a black hole suspended in space. Viewed from afar it appeared to be spiralling inwards, but when examined from up close its circular motion appeared to be expanding.

In yet another piece, entitled *Tapisserie bleue* (*Blue Tapestry*), Klein brought further perceptual phenomena into play: 'Everything depends on the distance from the eye to the surface displayed,' he commented. 'At one metre from this roughly 2 x 1.4 metre tapestry, it's a piece of cloth. At 3 metres it's a tapestry and at 8 metres it's a painting. In the true pictorial sense.'

Reliefs bleus (*Blue Reliefs*) (**S 1, 3, 4, 5**). Sculptures. 1957. Dry pigment and synthetic resin on four cubes fastened to clear plastic, 19.5 x 12 x 9.5 cm. each. Private collection.

Untitled (**IKB 54**). Blue plate. 1954. Dry pigment and synthetic resin on porcelain, 24 cm. diameter. Private collection.

Following pages:
Yves Klein in 1957, looking through the 'perforated monochrome' executed in 1955.

Tableau de feu bleu d'une minute (*One Minute Blue Fire Painting*) (**M 41**). 1957. Dry pigment and synthetic resin on board, with burn marks from Bengal lights, 110 x 74.8 x 2.1 cm. Menil Collection, Houston, Texas.

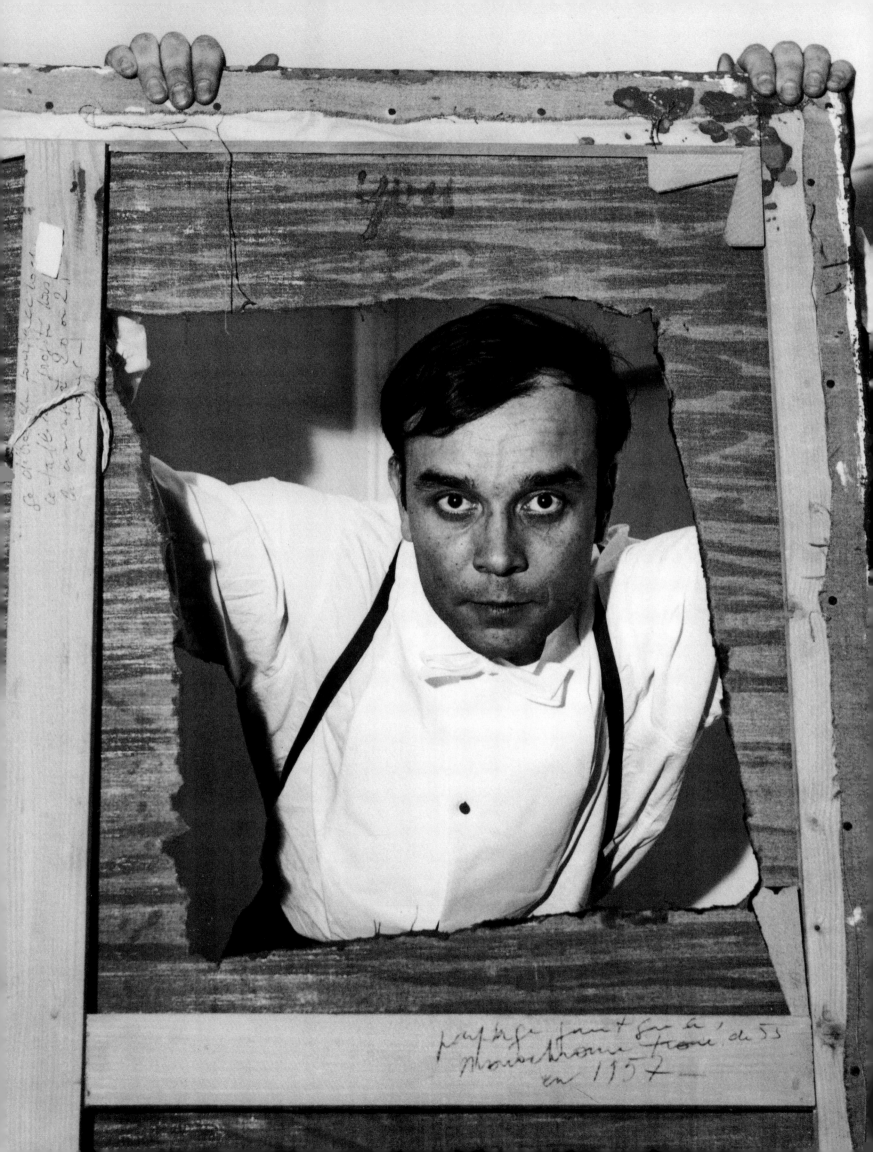

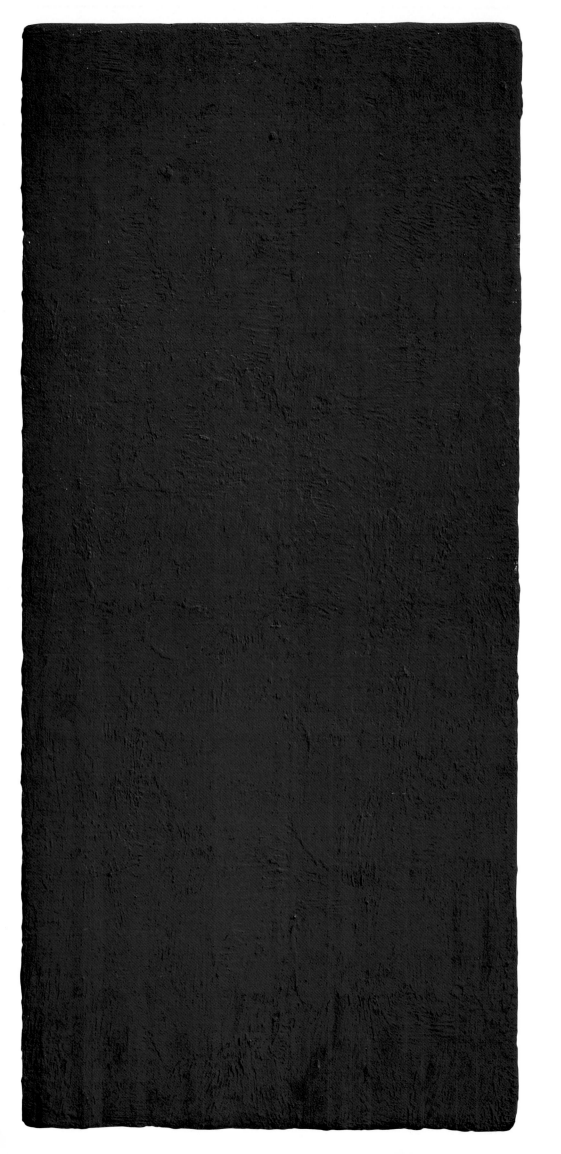

'Painting is a coloured surface which becomes a living epidermis.'

The problem for Klein was how to bring the spectator to recognise the infusion of sensibility in space as something like an ambient moisture. The tray of pure pigment radiated colour; the blue screens enveloped the viewer; the blue reliefs absorbed the eye – but this was not enough. And so Klein imagined yet another work. Called *Pluie bleue* (*Blue Rain*), it consisted of a dozen wooden rods 2 m. high painted blue and hung at different heights above the tray of pigment: a blue rain washing through space. Visitors to the gallery could walk through this work, which was thus a pioneering example of 'penetrable' sculpture (later to become the favourite concept of Jesus Rafael Soto). One more expression of Klein's obsession with weightlessness, this hovering sculpture was, like Calder's mobiles, a truly poetic invention, yet it wasn't a very effective translation of the notion that pure colour has the special power to infuse. The lines figuring rain could easily be mistaken for the bars of a prison cell. Thus Klein was led to design a further piece: *Piège bleu pour lignes* (*Blue Trap for Lines*), a rectangular monochrome object surrounded by lines. At its centre, colour seemed to suck in, crush and swallow lines.

These blue pieces invaded the ground floor of the Allendys' town house, thoroughly transforming the atmosphere of its rooms. Klein's show was no ordinary exhibition; it was an installation inasmuch as the setting and overall organisation were more important than the individual artworks. What is more, it suggested a total atmosphere, an inhabited space. Klein had by now ceased to think of his work in terms of surface: his creations were henceforth spatial. On the one hand, his painting had the objective character of three-dimensional sculpture – they were *pieces* – and, on the other hand, it manifested a depth indiscernible to the eye. Transcending the three-dimensionality of the visually apparent world was the heart of the monochrome proposition. The artist's period of physical expression (plural and pure monochromy) rested on a contradiction between object and subject. Hence the subject – an impression of feeling – signals the advent of the immaterial in the artwork.

Klein made the transition towards an art of the void with two installations, both of them fundamental to his future development. The first one was without question the highlight of the show's inaugural soirée. A *Tableau de feu bleu d'une minute* (*One Minute Blue Fire Painting*) was ignited in Colette Allendy's garden. Blue Bengal lights fastened to an IKB monochrome standing on an easel burned simultaneously for a maximum of sixty seconds – long enough to make a powerful, lasting impression on the audience. The 'blue-coloured Bengal flares gave one the feeling after they had burned out that the Fire painting was swelling, retrospectively expanding in one's Visual memory'.[56] Thus the spectators' memory of the fleeting experience of seeing the piece burning paled in relation to their actual after-impression of the event. The work lived on and kept expanding through its absence.

Nicolas de Staël had had an intimation of the fiery nature of blue. Like him, Yves Klein 'burned his retina on raw blue'.[57] No other colour exalts the withdrawal of the visible as powerfully as blue. Plunged in the acid bath of blue, matter loses its consistency, dissolves into ashes or smoke. Klein described his paintings on a number of occasions as the ashes of his art. His monochrome panels could be regarded as visible, residual expressions of a primordial invisible state. Blue's bite becomes a burn. It transforms the radiating presence into something ineffable, intangible, unearthly. Touched by the everlasting flame of essential things, colour and matter smoulder until they are entirely consumed. Klein's monochromes are like little heaps of ashes in the hearth of pure colour. Colour's flames lick matter into disappearance. IKB, that solar colour, that trace of energy, has the fulgent brevity of a skyrocket or shooting star. It is a presence on the point of vanishing.

Untitled (IKB 52). Blue monochrome. 1958. Dry pigment and synthetic resin on gauze on board, 74.5 x 34.5 cm. Private collection.

Paravent à cinq panneaux (*Large Folding Screen*) **(IKB 62)** on display at the Galerie Colette Allendy. May 1957.

Yves Klein seated on a radiator in the Galerie Colette Allendy. May 1957.

Invitation card to the twin 'Yves Klein, propositions monochromes' shows at the Iris Clert and Colette Allendy galleries, with Klein's blue postage stamp. May 1957.

Self-addressed envelope by Yves Klein, with blue stamp. 22 April 1958.

Klein's second installation received less notice, though it was equally, if not more, significant. On the first floor of the town house belonging to Colette Allendy and her recently deceased husband, the psychiatrist René Allendy, in the very office where Antonin Artaud had confided his distress to the latter, Klein invited visitors to experience his first space of immaterial sensibility. In the gallery on the ground floor, the public contemplated the artist's numerous blue pieces. Outside, in the garden, Klein had set fire to the colour blue. But what he displayed upstairs was something else – a void. Here he appropriated a space that had not been designed for showing art, though a signboard downstairs clearly designated it as a continuation of the show. Until recently occupied by its owner, the room still felt inhabited. It was filled with traces of Doctor Allendy's presence. Those who entered it could not help being reminded of the well-known psychiatrist, along with Artaud and all the other patients who had reclined on his couch. Who were they? What dramas had they experienced? What fantasies or libidinal impulses had they confessed to? The doctor's office still seemed to echo with their words. This intense atmosphere of absent presences was both disquieting and singularly alive. Who has not experienced a similar feeling after the death of a family member or close friend? The deceased is still there, but his or her presence is impalpable. The connection between a void and a tangible plenitude could not have been plainer.

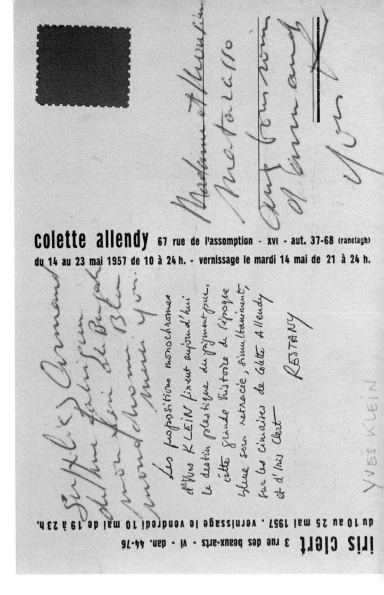

Klein was now able to stabilise feeling diffusing freely through space without having to resort to visual aids. 'For me,' he marvelled in 1958, 'colours and the blue period that came afterwards were the acme of freedom in the art of painting and now I realise that this freedom was merely an interval, a boundary. I'm now entering another country, another kingdom, one completely unknown to me though it clearly exists.'[58] Klein was by then acutely conscious of the experimental work he had accomplished thus far. He knew that void and vacuity are two different things; that the void was the vital principle par excellence: it was energy.

'And so,' he wrote, 'I thought that the next step after the blue period would be to present to the public that pictorial sensibility, that "poetic energy" of the intangible material of freedom in its non-contracted, non-concentrated state . . . In my pursuit of the non-physical blue, I had ardently and impatiently launched myself towards an invisible reality, towards the non-visual in my painting, towards a total pictorial reality.'[59]

Piège bleu pour lignes (*Blue Trap for Lines*) **(S 14).** 1957. Dry pigment and synthetic resin on wood, ht.: 14 cm. Private collection.

Untitled (IKB 269). Blue monochrome. 1959. Dry pigment and synthetic resin on cartoline, 22 x 18 cm.

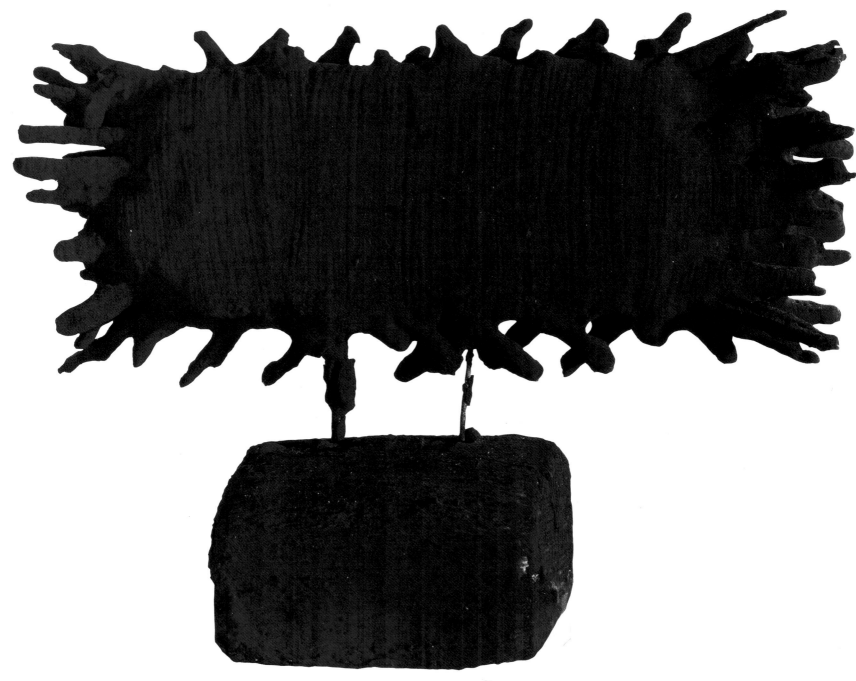

'The deeper the blue the more powerfully it draws man towards infinity

and awakens in him the nostalgia for Purity and for the ultimate suprasensible [realm].'

(Wassily Kandinsky)

The life force of the void

Being in twenty square metres of emptiness

On 28 April 1958, Klein celebrated his thirtieth birthday with his usual panache. Iris Clert turned her gallery over to him and he stripped it bare, painted it white and invited thousands of people to come and view its empty interior. This now famous show was perfectly consistent with the general tenor of the monochrome adventure. Klein's work unfolded in a natural continuity punctuated by his shows. Each new show signalled a new stage in the artist's development. Klein's constantly evolving thought was never strictly grounded in theory; it came to life in artistic forms; it offered itself to the eye, gave itself to the world – in a word, it displayed itself. In Klein's work, experience always followed close on the heels of ideas. The bones of his *œuvre*, its organising principle, was anything but capricious. It had the coherence of a system, so rigorously articulated was it. The principle of its growth, which Pierre Restany awakened and brought to the fore, was progressive. The artist's early plural monochromy was succeeded by his Blue Period, which was followed in turn by his Pneumatic Period. Isolated colours, the colour blue and the void characterised, respectively, the first three stages of his career. They correspond to three successive experiences: the revelation of pure colour, the revelation of blueness and the revelation of blue's immaterial essence. Sensibility was the system's backbone. The evolution of Klein's work was continuous, seamless, step-by-step. The 'void' works do not contradict the monochromes; on the contrary, they bring out their meaning.

Le Vide (*The Void*). Interior of the Galerie Iris Clert. April-May 1958.

'Le Vide' made a considerable impact as a show. Its venue –
an art gallery – seemed ill suited to the artist's gesture. Had Klein
contented himself with showing a few friends his own living room
emptied of its furniture, there would have been no fuss. But
a gallery is designed for hanging pictures or displaying sculptures.
A gallery is a convention. Like museums, art galleries are designed
to contain artworks. People go to them expressly to *see* art.
The art experience is a visual experience. Remove the art object,
banish anything tangible from that vessel, *and blue is all there
is to be seen.*

When the show opened on 28 April 1958, the scene had been
carefully prepared. Every detail of the relatively complex setting
had been worked out. There was nothing inside the gallery –
not a single object or item of furniture, and seemingly not a single
presence. A small showcase set in one of the walls of the tiny
gallery (its floor measured no more than 20 sq. m.) was empty.
A single neon tube on the ceiling lighted the room. Klein had shut
himself up in the gallery for forty-eight hours to paint it white.
Using his by-now customary technique, he employed 'pure
lithopone white ground in a special alcohol, acetone and vinyl
resin varnish (which doesn't kill the dry pigment when binding
it to the support), spread with a glossy industrial paint roller.'[60]
The gallery was immaculately white.

Outside, 'it was impossible to see anything other than Blue'.[61]
The main entrance to the building, which admitted visitors to the
show, had a monumental ultramarine blue canopy and the door
of the gallery was concealed behind a blue drape. The gallery's
windows were painted over in ultramarine. In the hall leading to
the exhibition, guests were served blue cocktails. The original plan
had called for the obelisk of the Place de la Concorde, in the heart
of Paris; to be lit up with blue light, with its base left in darkness.
Like a blue sculpture floating in space, it would have appeared
'changeless and static in space, within a monumental motion
of affective imagination, above the entire Place de la Concorde,
above the prehistoric gas lamps, in the night, like the huge vertical
stroke of an unpunctuated exclamation!'[62] The trials had been
'grandiose', but at the last minute the Préfecture de Police had
rescinded its decision to authorise the illumination of the famous
monument. A scattering of complaints had been enough to make
the public authorities back down, and so the obelisk remained
in darkness. Twenty-five years later, in 1983, on the occasion
of the Yves Klein retrospective at the Centre Georges-Pompidou,
it would be illuminated as the artist had instructed.

Thus the show's perimeter was blue and its centre was empty.
'We turn clay to make a vessel,' says Lao Tzu, 'but it is on the
space where there is nothing that the usefulness of the vessel
depends.'[63] The inner void is the equivalent of 'depth'
in Bachelard's statement, 'First there is nothing, then there is a deep
nothingness and then there is a blue depth.'

Obélisque illuminé en bleu (*Blue-lit Obelisk*). 1958. Drawing by Yves Klein. Biro on paper, 27 x 21 cm. Private collection.

The obelisk of the Place de la Concorde in Paris illuminated with blue light in 1983, following Yves Klein's 1958 sketch.

Though 'that particular perspective can't be seen with the naked eye',[64] it is nevertheless the origin of all forms and phenomena. Thus Klein did not do away with surface (blue was present everywhere outside the gallery); he revealed its underlying significance.

Surfaces are the visible rind of an essential depth that is not visible. From Chinese philosophy Klein borrowed the concept of the void, as something 'eminently dynamic and active. Connected with the idea of vital breath and the principle of alternating Yin and Yang, it is the locus par excellence where transformations occur, where fullness is supposed to achieve true plenitude.'[65] The opposite of a 'no man's land', the void is the primordial source of energy ('In the beginning there is Nothing'[66]; 'The Void gave birth to the Cosmos whence issues the vital Spirit'[67]); it is also a phenomenal substance active in the physical world. Life and matter appear out of the void's plenitude. The void makes the vital spirit circulate. This spirit is fire.

'9.30 p.m. The place is packed, the corridor is full, the gallery too,

outside, the gathering crowd has difficulty getting in.

9.45 p.m. It's crazy. The crowd is packed so tight that it's impossible

to move anywhere. I station myself inside the gallery.

10.0 p.m. The Police arrive in force (three vans full) from the rue de Seine;

firemen in force too . . .

10.10 p.m. 2,500 to 3,000 people are in the street, the police

from the rue de Seine, the firemen from the rue Bonaparte try to push

the crowd towards the banks of the Seine . . .

10.20 p.m. A representative of the Order of Saint Sebastian arrives

in full regalia (cocked hat and cape with red Maltese cross) . . .

10.30 p.m. The Gardes Républicains leave in disgust;

for the last hour students from the Beaux-Arts

have been tapping them on the shoulder in a familiar way,

asking them where they have rented their costumes or if they're movie extras.

11.0 p.m. The crowd outside after being broken up by the police

and firemen returns in small exasperated groups . . .

12.30 a.m. We close and head for the Coupole . . .

1.0 a.m. Trembling with fatigue I deliver my revolutionary speech.

1.15 a.m. Iris faints.

Next morning. Iris immediately summoned to the Gardes Républicains.

She is interrogated for two hours and charged with having

committed an offence against the dignity of the Republic.'

Klein could thus write, 'Tangible, visible Blue will be outside, on the exterior, in the street, and inside there will be the immaterialisation of Blue. A colour space that can't be seen, but which one soaks up.'[68] For blue is everywhere: visible outside, invisible inside, 'a formless presence possessing an infallible inner structure'.[69] Our perception of it depends on our sensibility. Klein was in fact exhibiting a gigantic monochrome. Its surface unfolded in the public arena and its heart beat within the four walls of a tiny art gallery. Provided the eye could see with the heart and mind, the empty space became a filled space: 'This pictorial state invisible in the gallery space must be present and endowed with a life of its own to the point that it literally becomes a "radiance", which is the best definition of painting that anyone has yet given.'[70]

The inaugural soirée of 'Le Vide' cannot be dissociated from Klein's own detailed account of what happened that evening.[71] It is written in the present tense, in a style at once precise and filled with enthusiasm. The artist dwells at great length on the show's complex organisation. A minute-by-minute account, it creates a powerful impression of urgency. The events of the magical evening of 28 April 1958 unfold at a breathtaking pace. Klein's words transform the show into a performance. The reader is swept along as the text substitutes for the experience.

This text is probably one of the best examples of the way Klein's work includes the written word. The history of 'Le Vide' and its quasi-mythical telling form an integral part of the event itself. Without the text, the show would have been amputated, deprived of a perhaps fictitious but nevertheless delightful dimension. The text documents the event, indicates how it is to be interpreted and completes the artist's creative act.

There is, of course, a comical side to the whole affair. The text's tone is solemn and the disparity between the ceremoniousness of the description and the disconcerting emptiness of the gallery space is rich with humour. The way Klein set the stage is worthy of Don Quixote. How would anyone miss the drollery of 20 sq. m. of empty space surrounded by three thousand guests, two police vans and a fire engine ('with a big ladder even!')? Klein wanted the visitors to soak in blue and, thanks to the cocktail, many of them were later surprised to find that they were in fact physically imbibed with that colour. 'They'll be pissing blue tomorrow,' wrote Jean Tinguely to Pontus Hulten. Often underestimated, humorousness and its correlative, laughter, have a legitimate place in Klein's work. Laughter is after all a sign of sensibility and health.

Moreover, if one considers the climate of the Paris art scene in the late 1950s, Klein's wit was tinted with irony. Tachisme, Abstract Expressionism and Informal Art were the trends of the day. Georges Mathieu was giving public performances of his 'gestural' painting on huge canvases. His inflamed imagination required the stimulus of speed. Garbed in theatrical costumes, he gestured wildly and 'ejaculated'[72] his ego with frantic brushstrokes, to the stupefaction of audiences around the world. Given this context, Klein's 'emptiness' show was a kind of caustic parody. In lieu of a twelve-metre painting, the performance produced an empty space on which three thousand people converged – as if to show that emptiness could be fuller than a gigantic painting.[73]

'**Préparation et présentation de l'exposition du 28 avril 1958**' ('Preparation and presentation of the exhibition of 28 April 1958'). From the manuscript published in *Le Dépassement de la problématique de l'art.*

Le Vide (*The Void*). Interior of the Galerie Iris Clert. April-May 1958.

Immaterial transfers: gold ingots for blue blood

In June 1959, Klein again displayed his 'immaterial' blue. Asked to participate in a group exhibition at the Hessenhuis in Antwerp, the painter declined to show any of his monochromes. Instead, positioning himself in the portion of the hall reserved for his works, he stood facing the public, declaiming Bachelard's statement, 'First there's nothing, then there's a deep nothing and then there's a blue depth.' In other words, the artist himself stood in for his blue. The event was in a sense a repeat of 'Le Vide', with the addition of a few spoken words. But this wasn't all. Using a by now tried and tested method, Klein retrospectively associated a written declaration with his performance: 'My intention was precisely to reduce my pictorial action for this show to its furthest limits; I might have mimed symbolic gestures like sweeping the area of the hall that had been reserved for me, I might even have painted the walls with a dry brush, without pigment. No! The few words that I uttered were already too much. I shouldn't have come at all and my name shouldn't even have been listed in the catalogue.'[74]

Klein is obviously referring to the absolutely impersonal quality of his action. As an artist, he was withdrawing. His physical presence in the exhibition room in lieu of his artworks could not be equated with a living sculpture or the presence of a genius called Yves Klein. The painter was there purely in his capacity as a 'nuclear reactor of sensibility' – a nameless man filling the gallery space with his natural charm.

This was followed by a statement concerning the terms under which the 'immaterial' could be purchased. Here Klein was simultaneously innovating and renewing the meaning of his spaces filled with 'immaterial' blue. To the show's curator, who had asked him the price of one of his invisible pieces, Klein is said to have replied laconically, 'A kilo of gold, a one-kilo ingot of pure gold will do.'
'Why such extravagant terms,' the curator wondered, 'when you could simply have set a normal price in cash?'
'Because you can't set a cash price on raw pictorial sensibility in the space I've specifically created and stabilised by uttering those few words which, on my arrival, spilled the blood of that spatial feeling,' declared the artist. 'Shelley said that "the blood of sensibility is blue", and that's exactly what I think. The price of blue blood can never be cash, it has to be gold.'[75]

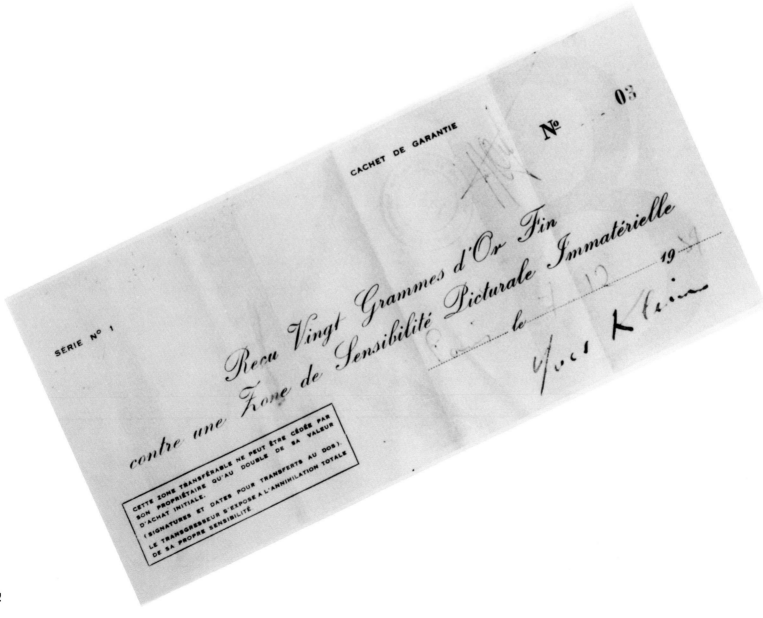

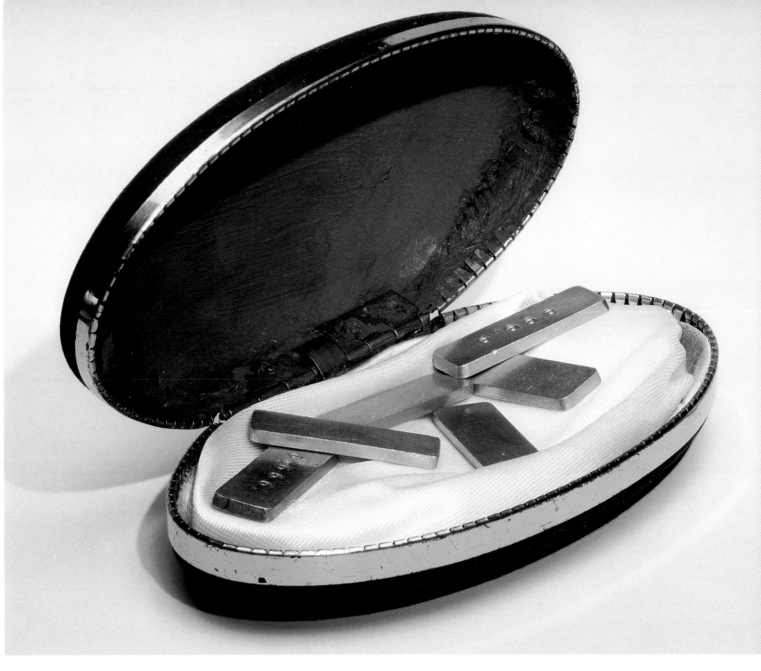

Receipt for the sale of a zone of immaterial pictorial sensibility
(series 1, zone 03) for 20 grams of fine gold.

Box containing small gold bars.
c. 1959. 11 x 5.5 x 3.5 cm.
Private collection.

In other words, sensibility has no price. It cannot be bought or sold, but can possibly be bartered for something of equivalent value. Cash has no place in the sphere of sensibility. Sensibility, a noble material *par excellence,* is worth gold. Its fluid, its lifeblood, is the colour blue. Gold ingots for blue blood, a refulgence for an exhalation of beauty: obviously, this was a poetic, not a strictly mercantile trade-off.[76]

A short time after the Antwerp experiment, Klein formally defined the terms of this exchange. In December 1959, he drew up a list of 'Ritual rules for the transfer of areas of immaterial pictorial sensibility'.[77] Sensitive spaces saturated with invisible blue were offered for a certain weight of pure gold. The transaction was recorded on a receipt made out to the purchaser. But 'in order for the basic immaterial value of the area to belong to him [the buyer] permanently and to become part of him, he had to solemnly burn his receipt'.[78] The destruction by fire of the receipt guaranteed the purity of the act. The acquisition became a permeation. The object became immaterial. The possession of the immaterial sensibility was subordinated to the gratuity of the act.

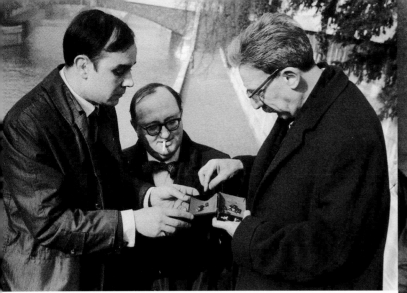

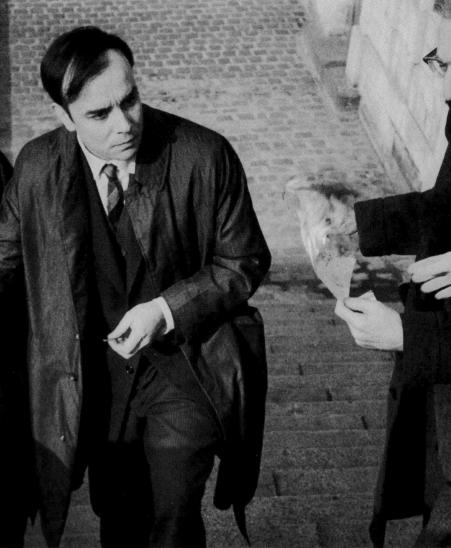

Transfer of a zone of immaterial pictorial sensibility on the banks of the River Seine in Paris. Klein exchanging a zone of sensibility for several gold ingots with the writer Michael Blankfort. 10 February 1962.

The purchaser burning his receipt.

The painter throwing gold ingots into the river.

Sale of a zone of immaterial pictorial sensibility to the Italian writer Dino Buzzati. 26 January 1962.

If, however, the owner of a zone of sensibility 'did not wish to appropriate it in an absolute, intrinsic manner', he could resell it for double its value.[79] This did not in any way alter the ritual of material dispossession, which applied to the new transaction: the gold had to be returned to its original owner and a new receipt burned. Thus it was impossible to make money with the voucher, unlike the Teeth's Loan & Trust Company cheques with which Marcel Duchamp paid his dentist's bills. The laws of the market were one thing, the zones of sensibility another.

Klein pushed this logic to an extreme. Like the buyer, who gave up any physical claim to the area of sensibility he purchased, the painter relinquished his part of the deal as well, by returning the gold to nature. 'Yves Klein the Monochrome must (in the presence of irrefutable witnesses) throw half the weight of gold into the sea, a river or any other ordinary location

'The price of blue blood can never

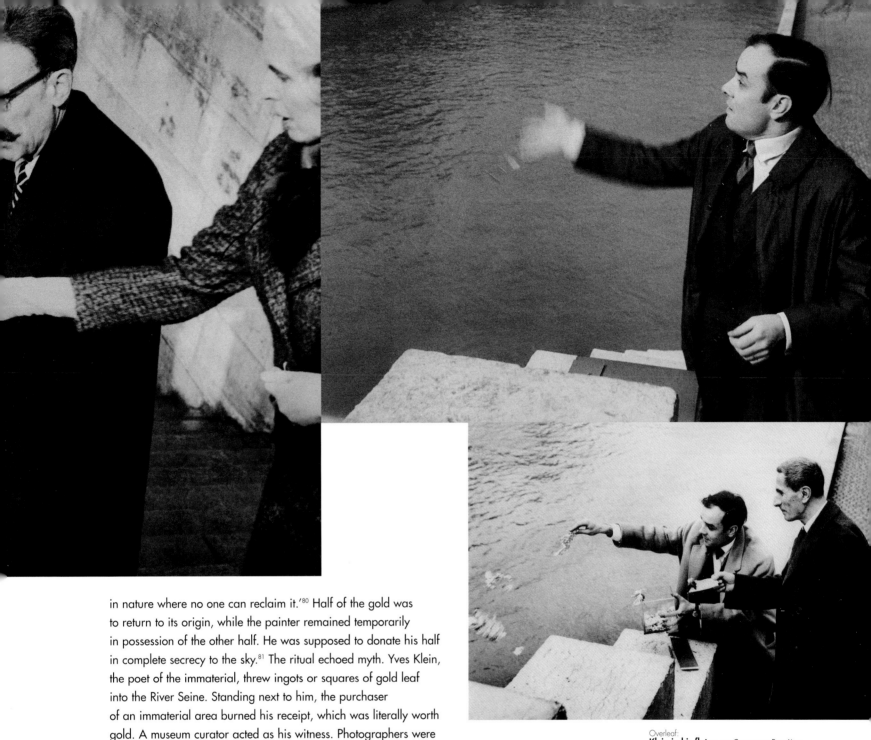

in nature where no one can reclaim it.'[80] Half of the gold was
to return to its origin, while the painter remained temporarily
in possession of the other half. He was supposed to donate his half
in complete secrecy to the sky.[81] The ritual echoed myth. Yves Klein,
the poet of the immaterial, threw ingots or squares of gold leaf
into the River Seine. Standing next to him, the purchaser
of an immaterial area burned his receipt, which was literally worth
gold. A museum curator acted as his witness. Photographers were
present to record the event in history. Klein took the whole thing
very seriously. Only a poet can invent a scheme like this. Between
poetry and provocation, dream and reality, the painter became
the magician of a strange ritual with initiatory overtones.
While money went up in flames and the glimmer of gold sank
beneath the waves, sensibility quivered.

Overleaf:
Klein in his flat on rue Campagne-Première
in Paris, 1960.

be cash, it has to be gold.'

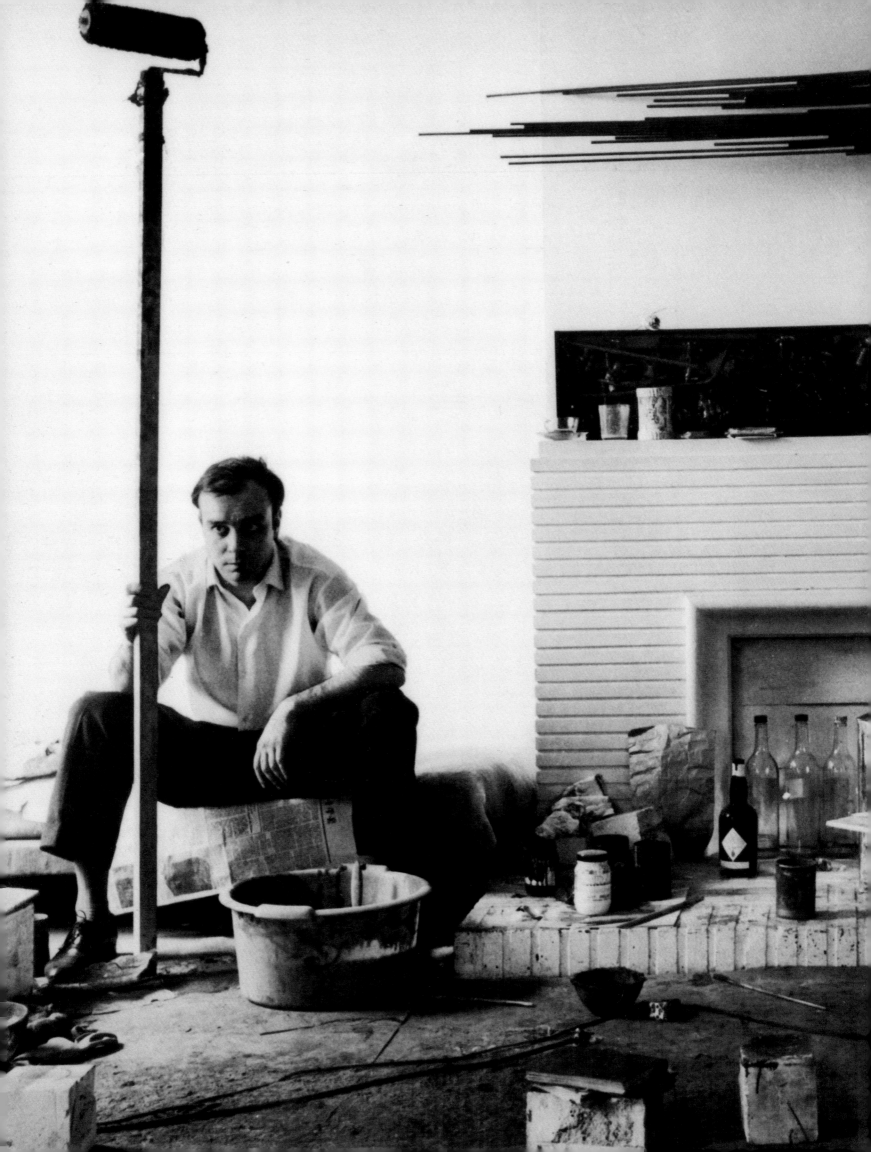

Igniting sensibility: the Blue Revolution

The Gelsenkirchen Musiktheater

Gelsenkirchen Musiktheater. Perspective
drawing of the lobby by Werner Ruhnau.
Coloured by Yves Klein. 1958.

Between June 1957 and December 1959 – roughly one-third
of his brief artistic career – Yves Klein conceived and created
six immense monochrome IKB reliefs for the main lobby
and cloakrooms of the Gelsenkirchen Musiktheater (music centre)
in Germany. As a member of an international team of artists
working under the supervision of the German architect
Werner Ruhnau, Klein lived a unique experience in his recently
begun yet already well-advanced artistic career.

Indeed the Gelsenkirchen experience marked a new stage
in the artist's monochrome researches. Following a contemplative
exploration of the different realms of colour, Klein had gone
on to use blue to sensitise space and, through experimenting
with the concept of the void, to discover the energetic basis
of sensibility. Initially embracing colour in general, his artistic
development had focused on blue in particular and then
on the void. Klein had thus gradually turned inwards towards
the essence of things, while the impetus of his work, in contrast,
had been increasingly outwards through the artwork's irradiation
of space. The equilibrium between these two opposite tendencies
attained its full measure and expression at Gelsenkirchen,
and the monochrome adventure took on monumental amplitude
scaled to the artist's ambitions. The Musiktheater project was both
interdisciplinary and international in nature: it brought together
artists from different countries; it abolished the boundaries between
architecture, painting and sculpture; and the modernist ideology
of its glass-based construction was certainly transnational.
In physical terms, the vast size of the panels required certain
formal adjustments and considerable technical experimentation.
Financially and in terms of publicity value, it catapulted Klein
to a new level of recognition. For the first time in his life, the artist
was given an opportunity to address a large audience. He was
able to move on from a problematic of the object to a problematic
of space – from gallery art to public art.

Klein's principal contribution to the Gelsenkirchen Musiktheater
is articulated on the walls of the spacious grand lobby which
centres around a staircase built inside a glass cylinder.
Four ultramarine blue panels surround this volume, which
is the core of the building. The grand lobby thus resembles
'Le Vide' of the Galerie Iris Clert. Blue on the surface and a void
within. And fire in the heart of the void.

The rectangular lobby houses two enormous monochrome reliefs,
likewise rectangular, which face each other on its two longest walls.
Some 20 m. in length and 7 m. high, these twin IKB reliefs present
themselves to the eye in all their splendour. Avoiding the monotony
of very large flat surfaces, Klein created ridges, pits and bumps
on the surface of both panels. Light and shadows play over
this rough husk, accentuating the perfectly matte pigment
that coats them. The paintings' deep, ardent blue gives them
an aura of mystery.

*'An ineffable peace ceaselessly rises and falls
From the deep blue of the soul to the deep blue of the sea.'
(Victor Hugo)*

They remind one of the earth's crust or the cratered surface of the moon; they seem to be animated by seismic movements – or perhaps deep-sea stirrings. They intrigue and fascinate. The presence of naturalist references in the painter's vocabulary brings out the fundamental link between life and monochromy.

On the smaller back walls, two sponge reliefs frame a glassed-in stairway. They too are sizable (10 x 5 m.). They required a special treatment to prevent their surface from looking flat and shiny, as they are exposed to direct light. Klein's solution was to accentuate their surface relief by gluing natural sponges to it and coating both them and the base with a sustained ultramarine. Of different shapes and sizes, the sponges cover most of the surface. Saturated in blue, the panels give one the impression of being immersed deep down in the ocean, or else that one is gazing up at a constellation of stars in an electric blue sky. The panels' rectangular shape appears at either end to be sucked into the void. A few isolated sponges spill over into this void like meteorites raining down from outer space. They are a formidable technical achievement, these two sponge-reliefs, these new versions of Klein's pantheon of 'blue painted blue'. For on the advice of engineering consultants specialising in raw materials, the artist completely transformed his technique. The fact that the panels had to be maintained and preserved as artworks meant soaking hundreds of natural sponges in a solution of polyester resin, then immediately squeezing them dry and leaving them to harden for ten minutes before they were sprayed with IKB paint.

Yves Klein working on a sponge relief
in the lobby of the Gelsenkirchen
Musiktheater. 1958–1959.

La Vague (*The Wave*) **(IKB 160 c).**
Model for the walls of the Gelsenkirchen
Musiktheater. 1957. Dry pigment and
synthetic resin on plaster, 78 x 56 x 17 cm.
Private collection.

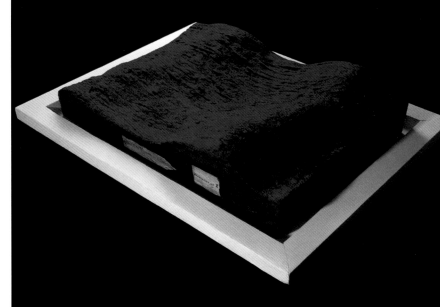

'I believe that one can speak here of an alchemy of painting, born from the tension between each passing instant and the material (the pictorial material). The suggestion of a bath in a space vaster than infinity. The blue is the invisible made visible.'

Yves Klein and Rotraut Uecker
at La Coupole in Paris.

Yves Klein with his mother (right) and aunt, Marie and Rose Raymond, at the inauguration of the Gelsenkirchen Musiktheater. 15 December 1959.

Yves Klein working on a relief for the Gelsenkirchen Musiktheater lobby. 1958–1959.

The lobby's ambience was thus thoroughly permeated with blue. As Klein explained to the commission overseeing the project, his aim was to create an 'alchemy of painting, born from the tension between each passing instant and the material (the pictorial material). The suggestion of a bath in a space vaster than infinity.' And he added, 'The blue is the invisible made visible.'[1] Through the monumental scale of his creation and its formal and technical innovations, Klein was able to animate a space.

Actually, Klein was commissioned to decorate two very different spaces in the theatre: the grand lobby, an eminently public space, and the more intimate space of the cloakrooms. Oddly enough, the artist made no distinction between the two volumes, transforming them both into zones of intense sensibility using the same chromatic saturation. He executed two monochrome IKB relief panels for the cloakrooms, their shape similar to the panels in the main lobby, but their size proportionate to the smaller volume of the cloakroom lobby.

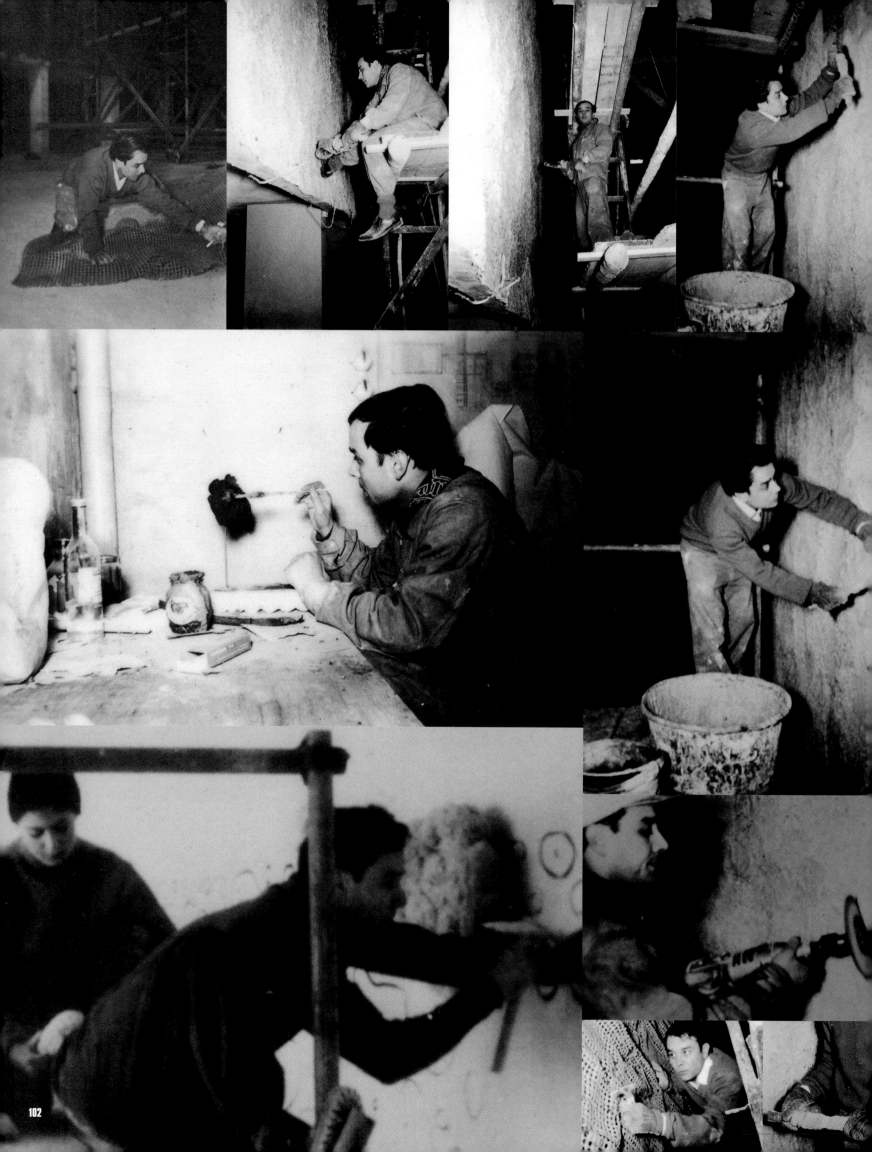

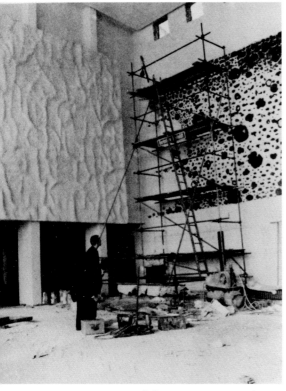

Sponge reliefs in the Gelsenkirchen Musiktheater lobby (detail).

Relief in the theatre lobby (detail).

Scaffolding in front of a sponge relief.

Previous pages: **Yves Klein working** on his reliefs and sponge reliefs at Gelsenkirchen. 1958–1959.

Relief in the theatre lobby (detail).

Manifestly, Klein was able to adapt his work to the physical setting. Without abandoning his style, ideas and originality, he thoroughly understood the requirements of architectural integration and public appropriation inherent in a programme of this nature. The panels harmonised with the transparent, immaterial glass construction. Like glass, Klein's blue creates a feeling of immateriality. The French artist collaborated well with the team of international creators working at Gelsenkirchen. He was forceful yet tactful and won his colleagues over with his charisma and cheerfulness. That he spoke little German was no problem: he simply engaged the services of an interpreter and wrote his letters in English. Nor was the fact that he lived hundreds of miles away from the theatre site an obstacle: he shuttled back and forth between Paris and Gelsenkirchen, worked unstintingly on the project and showed that he was willing to move mountains in order to accomplish his goal. When the members of the study commission decided they wanted white panels, he listened respectfully to their reasons, then defended his concept of blue permeation with steady determination.

He began by convincing Ruhnau and his fellow artists, then persuaded the mayor of Gelsenkirchen and finally won over the members of the commission. His work at Gelsenkirchen was a one-man crusade. He displayed all the determination of a *judoka* concentrating on performing *katas*.

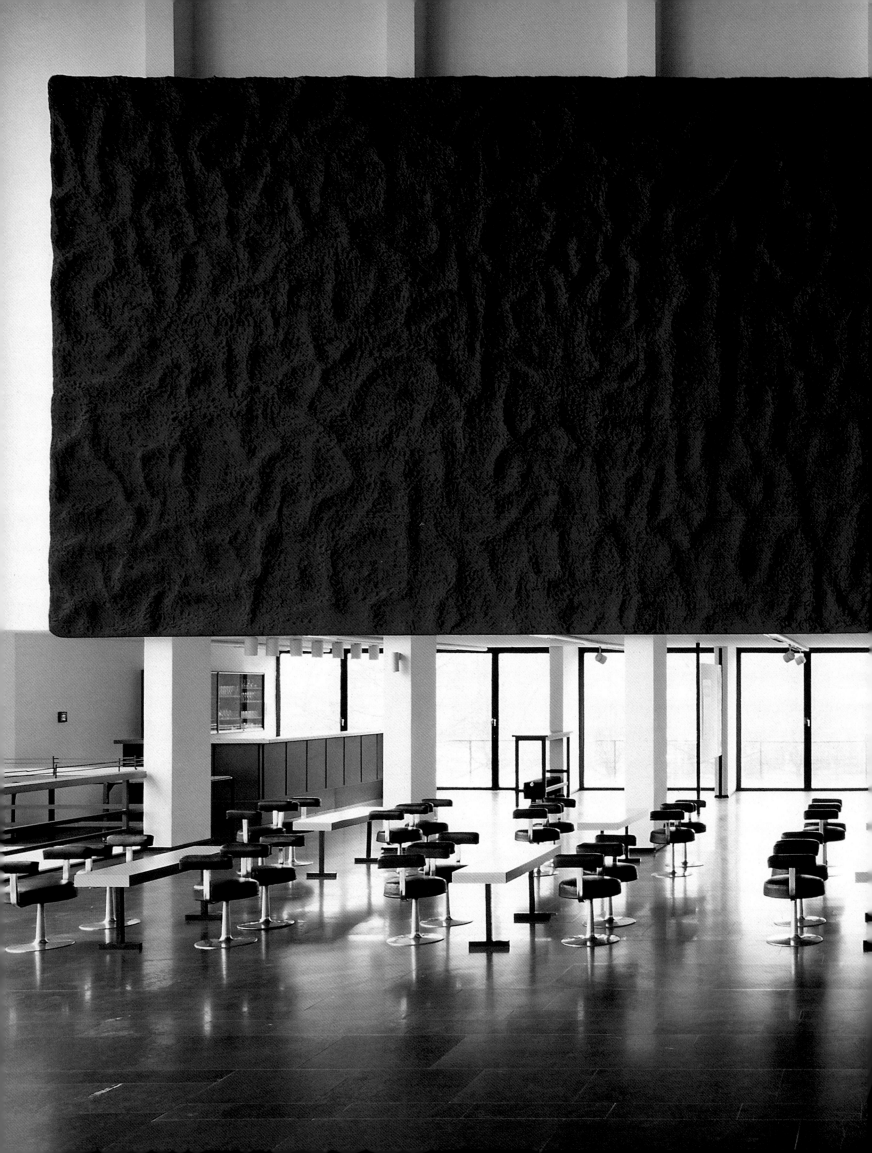

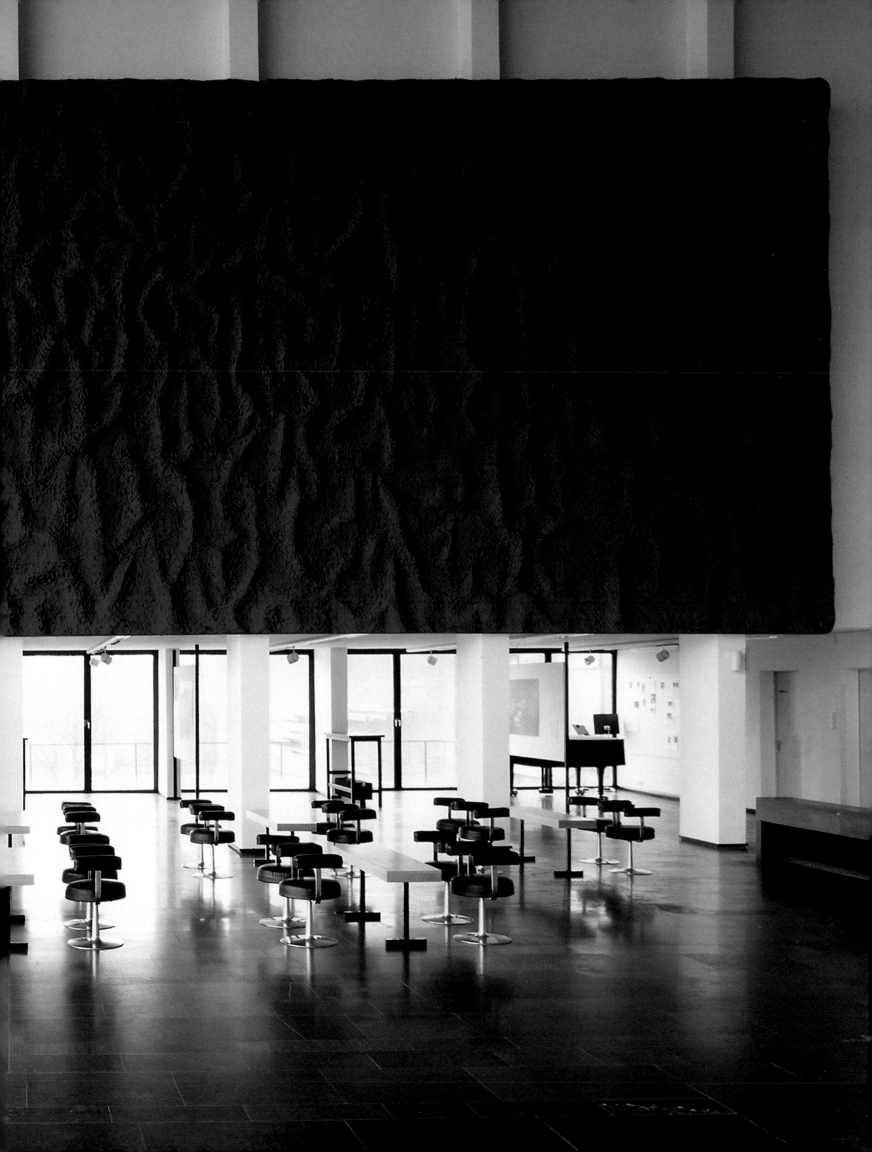

He built model after model, defended his concept in private talks, impassioned presentations and numerous letters and, in November 1958, finally got his way. The reliefs would all be painted blue instead of white as had been decided initially. Gelsenkirchen was both a test of the artist's creativity and his determination. It was unquestionably a broadening experience: it released Klein's energies, shattered the limits of easel painting and expanded his expressive means. Thanks to his flair for handling human relations, he was able to get his ideas accepted, assume the leadership of the team of artists, and earn the trust of Werner Ruhnau. But what Klein revealed chiefly at Gelsenkirchen was his personal magnetism. Günther Uecker's sister, Rotraut, came under its spell and, soon after meeting Klein, became his constant companion, first as his assistant and translator, and eventually as his wife and mother of his child.

The success of the Gelsenkirchen project owed much to the intelligent teamwork of those who worked on it. On the one hand, Werner Ruhnau saw to it that the relations between the city and the building commission remained smooth and, on the other, there was a perfect coherence between the architectural programme and the choice of the artistic projects, which were perfectly in keeping with the leading trends in modern art and architecture. The horizontality, transparency and large volumes of the building echoed the aesthetic of monochrome painting (Klein), Kinetic Art (Tinguely), water, Plexiglas and iron sculpture (Kricke), plastic reliefs (Dierkes) and geometric compositions (Adams).

In May 1959, Iris Clert, enthusiastic as ever and still under the charm of 'her Yves', undertook to exhibit all of the models and sketches produced by the 'international collaboration of artists and architects in creating the new opera at Gelsenkirchen'. Klein, the instigator of the show, seems to have been fascinated by the notion of concentrating multiple energies on a single project. The spirit of cooperation between artists appealed to him so much that he would make it a thematic – and indeed an ethics – of creation. On the heels of the Gelsenkirchen project, he would throw himself into other collaborative undertakings with Jean Tinguely and, eventually, Norbert Kricke and Werner Ruhnau, all members of the Gelsenkirchen 'team'. These collaborations went beyond their joint work on the theatre. More sporadically, Klein worked with the architect Claude Parent, the electro-acoustic composer Pierre Henry, the critic Pierre Restany, the sculptor Arman, the poet Claude Pascal, the theatre director Jacques Poliéri, and the poet and painter André Verdet, among others.

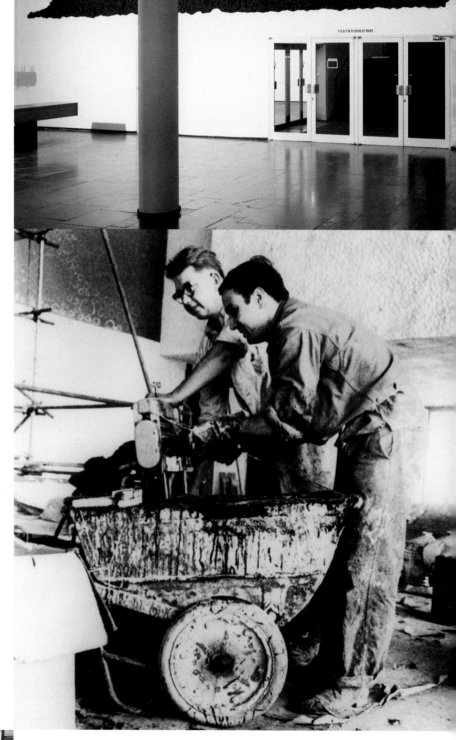

Previous pages: **Relief** in the lobby of the Gelsenkirchen Musiktheater, 7 x 20 m. Gelsenkirchen Musiktheater Collection, Germany.

Sponge relief at the Gelsenkirchen Musiktheater, 3 x 10 m. Gelsenkirchen Musiktheater Collection, Germany.

Yves Klein and an assistant saturating sponges with blue paint.

Blue sponges drying.

Sponge relief at the Gelsenkirchen Musiktheater (detail).

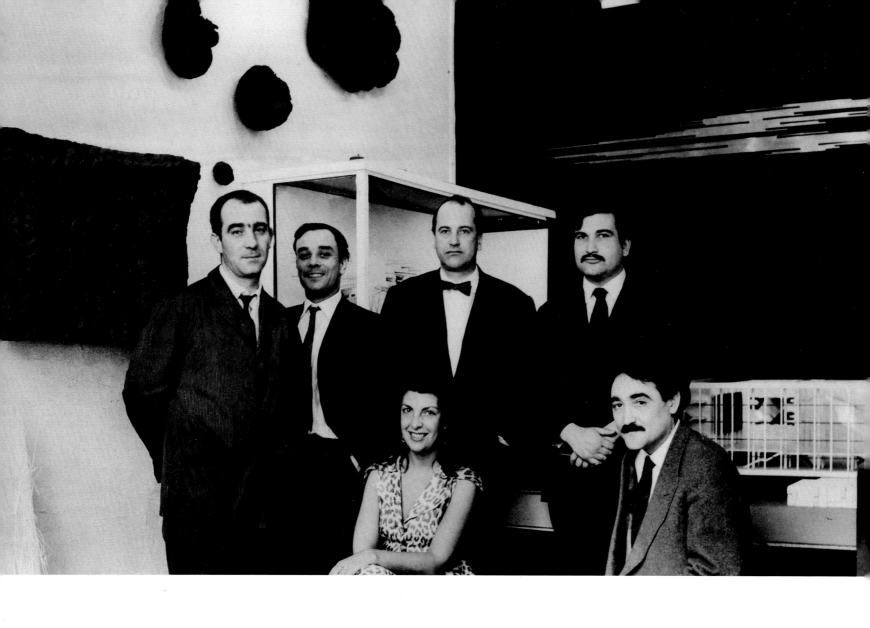

In May 1959, Iris Clert, enthusiastic as ever and still under the charm of 'her Yves', undertook to exhibit all of the models and sketches produced by the 'international collaboration of artists and architects in creating the new opera at Gelsenkirchen'.

Opening night of the 'International Collaboration between Artists and Architects' show at the Galerie Iris Clert in Paris. 29 May 1959. From left to right: Jean Tinguely, Yves Klein, Iris Clert, Werner Ruhnau, Bro and Jesus Rafael Soto.

Yves Klein and Jean Tinguely at Tinguely's studio on impasse Ronsin in Paris, preparing their joint show, 'Vitesse pure et stabilité monochrome' ('Pure Speed and Monochrome Stability'). 1958.

Invitation card to the 'Vitesse pure et stabilité monochrome' show, Galerie Iris Clert. 17 November 1958.

Previous pages: **Yves Klein** posing in front of one of the Gelsenkirchen Musiktheater sponge reliefs. 1958–1959.

Sponge relief at the Gelsenkirchen Musiktheater (detail).

Klein and Tinguely: static speed

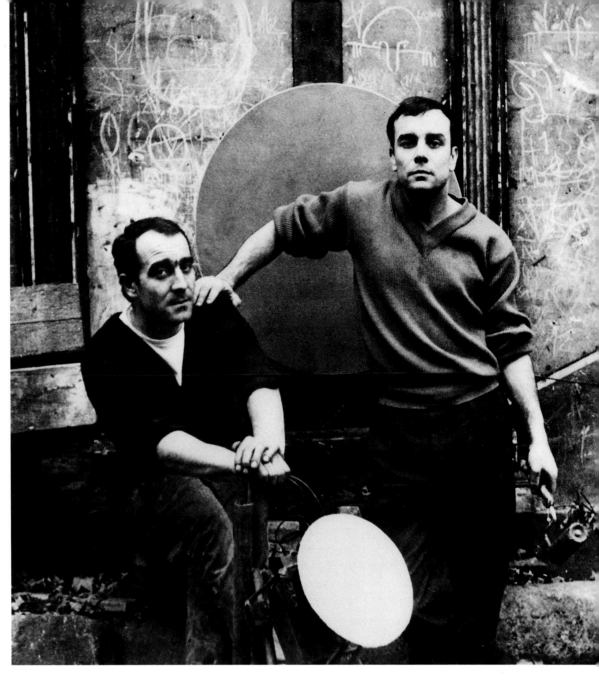

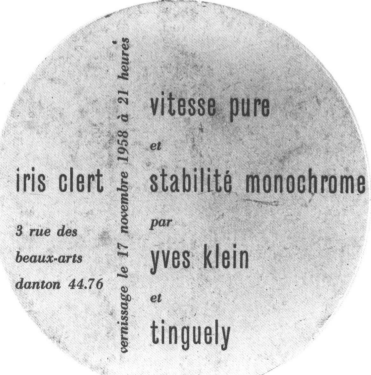

vitesse pure

et

stabilité monochrome

par

yves klein

et

tinguely

iris clert

3 rue des
beaux-arts
danton 44.76

vernissage le 17 novembre 1958 à 21 heures

With his friend Jean Tinguely, as yet to be discovered
as an inventor of genius, Klein wanted to 'jointly create a large
monochrome painting on which [Tinguely] would animate elements
having the same colour' as the ground.[2] The project was hardly
formulated than it was rejected by the Salon des réalités nouvelles.
The two artists promptly envisaged 'organising an event to protest
against the Salon'. They literally planned to 'colonise all
of the paintings and works on exhibit' at the show's inauguration
by projecting beams of blue light onto them. Three years earlier
Klein had transformed his rejected orange monochrome into
an immaterial presence. Now he wanted to turn his kinetic painting
into an immaterial appropriation of the entire Salon. The void
was clearly expanding its territory.

Nothing actually came of this plan of action, for Klein, with work
to complete at Gelsenkirchen, was unable to attend the Salon's
opening night. But a few months later, in the autumn of 1958,
he and Tinguely began jointly exploring the artistic possibilities
of speed at the limit of perception.

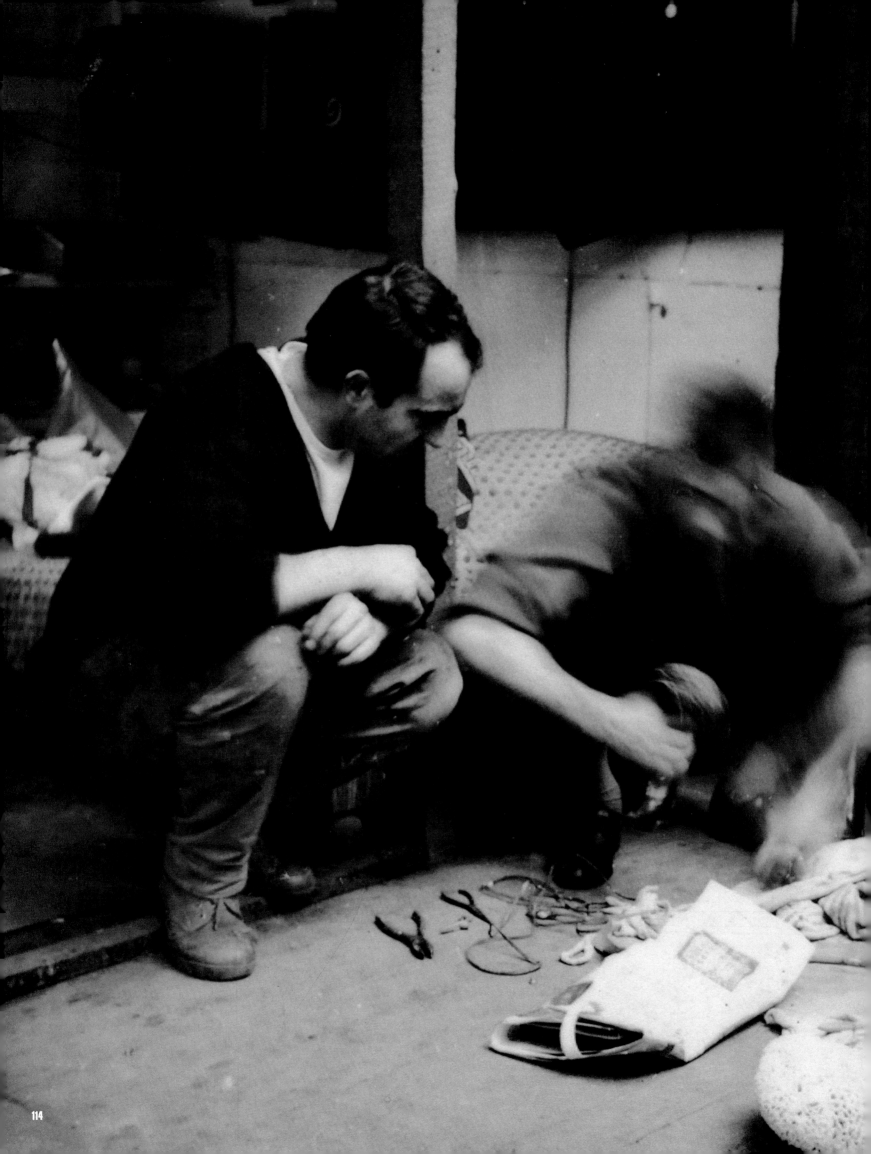

On 17 November 1958, Iris Clert presented their collaborative research under the heading 'Vitesse pure et stabilité monochrome' ('Pure Speed and Monochrome Stability'). The invitation, printed on a blue disc, was an augury of the objects on display. Klein had executed eight blue discs for the show and Tinguely had devised mechanisms to set them in motion.

Hung a few centimetres off the gallery walls, the discs appeared to float in thin air. Two disc sculptures mounted on ramshackle wooden and scrap iron legs, *Perforateur monochrome* (*Monochrome Perforator*) and *Excavatrice de l'espace* (*Space Excavator*), were connected to a second-hand electric motor. The salvaged materials and the rickety assemblage gave a foretaste of Tinguely's work in the years to come. The structures – machinery, crossbars and pulleys – were totally visible and the motors droned loudly, overheated and gave the impression that they were about to explode. Klein, who was fundamentally interested in the essence of movement, had given Tinguely an opportunity to formalise his machine-inspired vocabulary. The Swiss sculptor would from now on create machines with salvaged materials as he found them and would no longer endeavour to conceal the bare bones of his pieces. In short, the problematic of the works that the two artists showed at Iris Clert's gallery was of a philosophical nature: does motion have meaning? In what form does motion become a signifier? What exactly is motion's connection to monochrome painting and the void?

To the first question – does motion have a meaning? – Klein replied that 'speeding doesn't mean going fast' and that 'pure speed is a vertiginous static speed'.[3] In other words, 'today motion no longer in any way signifies "life" to someone who is "aware", but "death", while the truly contemporary manifestation, the authentic efficiency beyond picturesque agitation is "stasis".'[4]

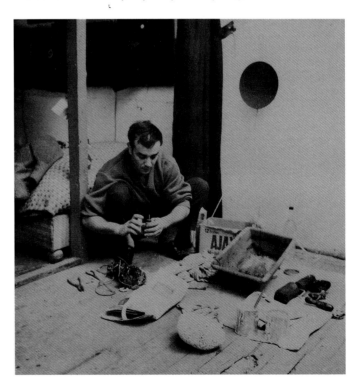

Jean Tinguely and Yves Klein
at Tinguely's studio in Paris, preparing the 'Vitesse pure et stabilité monochrome' show. 1958.

At the other end of the spectrum, Georges Mathieu would soon postulate 'a saturation of psychic energies up to the orgasm of the uncontrolled explosion'.[5]

Klein and Tinguely's presentation of static motion was based on these ideas and on the fact that at high speed, motion seems to come to a standstill and forms become stabilised. Nothing except a vibration and a few sparks reveals the driving energy. The flat shape of the blue disc and the void that surrounds it become one, wedded into a thick shape that is visually recomposed through an optical impression. The void becomes entangled in the core of the object.

Klein had imagined a similar optical phenomenon a few years earlier. He had put forward the implausible thesis that the earth is actually 'flat and square'.[6] Far from being a solid ball, he saw it as a coin. It was only because of the speed with which it spins, he held, that we perceive it as a globe. Like the blue discs, 'the flat Earth revolving on its axis at a tremendous speed . . . creates a void within its rotation'.[7]

Once again, the subject of the artwork was the void. Klein went beyond the optical phenomenon to give it meaning. He subordinated the visual experience to his aesthetic. In his blue universe, he equated speed with lines – with prison bars and death. Static motion, on the other hand, was a manifestation of life to him. If gesticulating was a loss of energy, static motion was a breath of life. Pure colour and the void had the power to free man from the 'torments that torture him in the hell of composition and the speed of lines and forms'.[8] In short, pure colour and its essence, the void, have the same nature as static motion. Monochromy and static movement are forms of the void. The artistic collaboration between Klein and Tinguely was remarkably successful. Philosophically, it owed much to Klein, but the two artists' joint objects belong entirely to Tinguely's world, which is characterised by 'the energetics of insolence', as Conil Lacoste puts it.[9]

Their mechanical devices, pseudo-modernist objects charged with dreams of spatial conquest and technological power, are *also* assemblages of odds and ends. They are rich with intimations of the poetry of crazy machines that Tinguely was to create a few years later. Klein, in his account of the exhibition, observed jubilantly, '"Pure Speed and Monochrome Stability" was a triumph of total in-depth collaboration.'[10]

Buoyed by the success of this venture, the two artists were soon envisaging other collaborative works. In March 1959, they conceived 'a machine to execute monochromes'. Speed, they decided, would be Tinguely's domain and the immaterial would be Klein's: 'Tinguely the owner of speed enters my territory and launches air . . . makes it circulate [and finally] in the wake of this circulation Blue once again reappears visually.'[11] The transformation of circulating air into blue would occur in a tube heated at one end. Klein visited Hamburg to consult with 'engineers in a large factory for making turbines for air-conditioning systems', but lacked the time to carry out this project.[12] On 14 April 1959, he nevertheless patented his invention of a 'levitating tube' derived from the concept of a 'machine for executing monochromes'.

It was at the inauguration of an exhibition of Tinguely's works in January 1959 in Düsseldorf that Klein chose to publicise his theory of artistic collaboration. 'Immortality is conquered jointly, it is one of the laws of nature for man in relation to the universe!' he expounded. 'Artists who are unable to collaborate work with their stomach, their plexus, their gut! Artists who collaborate work with their heart and head! / These artists know what it means to be a MAN RESPONSIBLE towards the UNIVERSE! . . . To these artists willing to collaborate with each other, to IMAGINE is to absent oneself, to throw oneself into a new life . . . I would therefore find it perfectly natural and normal to learn one day that somewhere in the world one of the members of this famous pact [between artists] had suddenly, spontaneously, signed one of my paintings without even mentioning me or the COLLABORATION.'[13]

'Pure speed is a vertiginous static speed.'

Excavatrice de l'espace
(*Space Excavator*) **(S 19).** 1958.
Dry pigment and synthetic resin on a metal
disk driven by an electric motor; metal legs.
35.5 x 20 cm. Private collection.

Fountains of water and fire

Water-and-fire fountains and walls.
Design by Yves Klein and Werner Ruhnau for
the Gelsenkirchen Musiktheater esplanade.
Drawing by Werner Ruhnau. 1958–1959.
Private collection.

Water-and-fire fountain for a public
square. Drawing by Yves Klein. Oil pastel
on paper. 1959. Private collection.

Around the same time – late 1958 – Klein began to work with Norbert Kricke, a sculptor on the Gelsenkirchen team, making sketches of a series of projects they would undertake in common. The two artists explained the nature of their collaboration in a manifesto entitled *L'Eau et le Feu* (*Water and Fire*). In the same spirit as Klein and Tinguely's apportioning of respective territories (speed and air), the French painter and the German sculptor shared the natural elements: 'We have divided between us the domains and kingdoms of the elements at our creators' convenience in the following manner: / KRICKE = <u>water</u> and <u>light</u> / YVES = <u>air</u> (plus <u>wind</u>: the anger of sensibility) and <u>fire</u>.'[14]

The two artists intended to begin with a fusion of elements: 'We have decided to create in collaboration and as a first stage, fountains of water and fire.'[15] A large number of sketches bear witness to their joint work and give one a fair idea of what they hoped would be the outcome of their combined researches. Huge jets of fire arranged diagonally were to intersect jets of water. The clash of naturally incompatible elements – fire and water – would produce clouds of vapour. Up to a certain point, one can visualise these clouds of vapour as an equivalent of the monochrome painter's 'ashes'. Ashes and vapour are engendered by fire – fire that Klein associated with expansive creativity. The objects generated by art (flamboyance) are but the ashes and vapour of creativity.

> '*Colour is a vital necessity.*
> *It is an indispensable raw material for life,*
> *like water and fire.*'
> (*Fernand Léger*)

With the fountains of water and fire, Klein engaged directly in an aesthetic of the elements. A fervent reader of Gaston Bachelard, he pondered the phenomenology of water and fire as he had earlier mused over the phenomenologies of colour and the void. Feeling that he was a virtual proprietor of air associated, doubtless through breath, with fire, he claimed to have 'gone beyond the problematic of art'. His aesthetic was at the centre of life. Water feeds the earth, and fire – whether solar or spiritual – quickens life. Water is the purifying element, the 'essential female element which we need to establish an equilibrium between justice and violence'.[16] And fire regenerates. Klein was perfectly familiar with the alchemical tradition of combining water and fire. As testified by many engravings in books of occult knowledge, humans have always been fascinated by the 'unnatural' conjunction of these two elements. And naturally Klein was captivated by the aura of secrecy surrounding the experiments of the alchemists. He, too, was perpetuating the alchemical tradition by handling natural

forces and transmogrifying matter into immaterial art. In April 1959, Klein sought to patent an invention he described as 'Jets of combined water and fire on a basin. Decorative purpose.'[17] The alchemist was protecting his invention and preferred to conceal its meaning beneath the label of a banal decorative function. Who would have suspected him of acting on natural forces?[18]

Judging from the volume of documents concerning fountains of water and fire, Klein must have been especially fond of this invention very much in the spirit of his monochrome experiments. It manifestly meant a great deal less to Norbert Kricke, who soon bowed out of the project. Klein, for his part, never gave up his 'waking dream' of bringing water and fire together. In 1961, he was still proposing to install fountains of conflicting jets of water and fire on the promenade in front of the Gelsenkirchen Musiktheater, as well as at the Palais de Chaillot in Paris and in the Tivoli Gardens in Italy. His efforts came to nothing.

Water-and-fire fountain for a public square. Undated drawing by Yves Klein. Oil pastel on paper. Private collection.

Water-and-fire fountain for a public square. Drawing by Yves Klein. c. 1959. Oil pastel on paper in a spiral sketchpad. Private collection.

Top right: **Water-and-fire fountain** for a public square. Undated drawing by Claude Parent. Private collection.

The mayor of Gelsenkirchen was initially receptive to his idea but did nothing about it, and the mayor of Tivoli did not even bother to answer the letters of the artist and his dealer in Paris, Jean Larcade.

Towards the end of 1958, Klein and Kricke also began thinking of creating fountains of fire and light as well as fountains of air and water, at the meeting point between aesthetics and the technology of air conditioning.[19] This was to be the second stage of their work together. But Kricke withdrew from their collaboration a few months later and, in mid-June 1959, Klein associated himself with the French architect Claude Parent to carry on with the project. Between that date and 1961, Parent translated his friend's ideas into drawings – no easy task, for it often meant reading Klein's thoughts. Claude Parent's drawings, sweeping perspectival views, are expressive and not merely technical. Executed with lead pencils or pen and ink on tracing paper,

cardboard or ordinary paper, they are among the best examples of Klein's collaborative work. Parent's touch is light but full of expression. The result is a series of exceptionally beautiful designs. It is regrettable that the public authorities remained unconvinced by the two artists' display of inventiveness. Klein and Parent imagined a broad array of effects produced by combining water and fire. Parent's pen gave life to a stunning variety of solutions: waterfalls crowned with horizontal jets of fire to suggest fountains gushing from flames; walls of fire rising above pools of water; a geyser of fire in the centre of a basin; flames playing on the surface of water; spectacular clashes between the two elements, and so forth.

Architecture of air

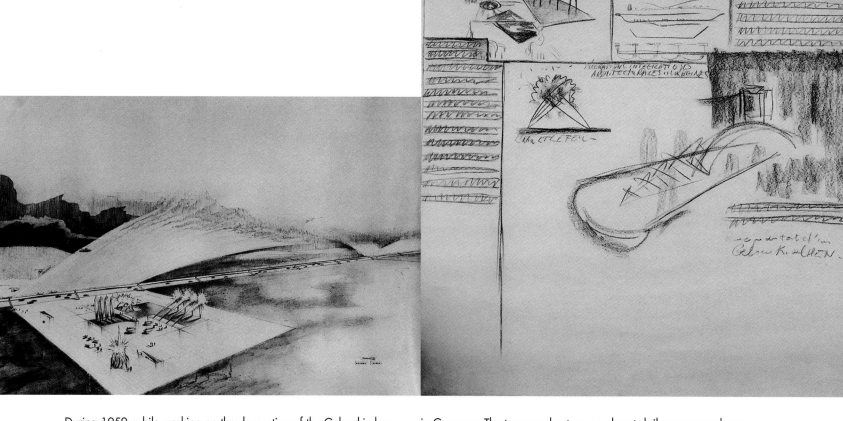

During 1959, while working on the decoration of the Gelsenkirchen Musiktheater and conceiving various urban projects centring on fountains of water and fire, Klein was seriously reflecting on architecture, town planning and social organisation. The fountains were only one element in a system he called 'Architecture of air', which the artist subsumed under his 'Blue Revolution' social project. Werner Ruhnau and Claude Parent gave a technical and formal expression to the monochrome painter's ideas.

Should we be surprised at this leap from painting to architecture? As we have seen earlier, Klein's researches were always driven by an urge to go further and to jump barriers. Ever since 1954, the artist had constantly been expanding his field of vision and action. From meditations about surface he had gradually moved on to consider the problematic of space; the perception of his creations by the viewer; the articulation of the private space in public space; object yielding to subject. Finally, the traditional cleavages between different fields of thought and creation had begun to look meaningless to him. No wonder, then, that he was tempted to shift from painting to architecture and even politics. Colour had its own vital energy, and the artist's field of action encompassed far more than easel painting.

Initially, architecture of air was the result of a cooperation between Klein and Werner Ruhnau. The architect of the Gelsenkirchen Musiktheater was the person with whom Klein had the most contact in Germany. The two men kept up an almost daily correspondence. Ruhnau was fascinated by the young painter's monochromes and Klein was impressed with the older man's skill and professionalism. By himself, the artist was unable to give a concrete expression to the extravagant ideas teeming in his mind; he needed the architect to give them reality. The Klein-Ruhnau collaboration rested on the complementary characters of the two men – one of them a dreamer, the other a builder. For Klein, the two activities were indissociable.[20]

Initially, each of them felt hampered by the limits of their artistic field: 'He, ill at ease, hindered by the last obstacle that Mies van der Rohe hasn't yet overcome, the roof, the screen that separates us from the sky, from the blue of the sky. And me, impeded by the screen consisting of the tangible blue on the canvas and which prevents man from constantly being able to see the horizon.'[21] Klein viewed architecture of air as a logical step in the development of his *œuvre* for, he said, 'colour sensibility, which is still very material, must be reduced to a more pneumatic immaterial sensibility'.[22] Ruhnau, for his part, 'is certain that today's architecture is headed for the immaterialisation of tomorrow's cities'.[23]

Water-and-fire fountain for a public square. Undated drawing by Yves Klein. Charcoal on paper. Private collection.

Urbanisme de l'air, architecture de l'air . . . (*Town Planning of Air, Architecture of Air . . .*). Drawing by Yves Klein. c. 1959. Charcoal on paper on canvas. Private collection.

Cité climatisée, accès à l'Éden technique (*Air-conditioned City, Access to the Technical Eden*). Drawing by Yves Klein in collaboration with Claude Parent and Sargologo. 1961. Pencil and biro on paper. Private collection.

This ideology, like the solutions the two men invented, was in fact wholly consistent with Klein's vision. The immaterial at the centre of his monochromes was simply being projected onto the city: 'With the air roofs, the walls of fire by Yves KLEIN, the walls of water, the materials for building a new architecture. / The classic city of tomorrow will be built with the three classic elements, fire, air and water, and at last it will be flexible, spiritual and immaterial.'[24]

Klein and Ruhnau made a principle of the flexibility and openness to the exterior that are characteristic of modernism. The glass and steel building devoid of load-bearing walls was a step in the direction of immaterial architecture. And yet modern construction materials – glass, steel and concrete – were already things of the past. Building with the painter's favourite elementary materials, on the other hand, opened fascinating perspectives. In the future, architecture would use light, 'air, gases, fire, water, sound, smells, magnetic forces, electricity, electronics, etc.'[25] Of course such an architecture would have to be functional and its materials would have to provide a protection against wind and rain, sun and cold.

Concretely, the immaterial habitation would be completely transparent. There would be no walls, no roof. Instead, a stream of air would keep out the rain and the wind. Coloured vapours added to this air roof would screen out solar radiation.

Sheets of fire and water would function as walls, serving both atmospheric and aesthetic ends. Klein and Ruhnau even envisaged 'radiant heat or ground heating'[26] and 'air beds' designed to allow one to sleep suspended in thin air. In this open architecture, 'it will not be necessary to supply locks, for there will be nothing tangible inside to steal or remove'.[27] In contrast, the technical and utilitarian facilities (toilets, kitchen, storage space, machine rooms, etc.) would be built underground with solid materials such as mortar, concrete, stone, clay and iron, and it would be possible to lock them. Tomorrow's dwelling would thus be devoid of anything material and its invisible, soundproof basement would be exclusively utilitarian. As for the planning of public spaces, Klein envisaged a grandiose setting with water and fire fountains, coloured smoke screens and vapour clouds. His city would be enclosed under a monumental air roof. In the future, humans would live in a permanent state of levitation between earth and sky.

The 'Blue Revolution',
a blueprint for a political philosophy

Letter from Yves Klein to the 'Secretary General of the International Geophysical Army [?]'. May 1958.

Architecture de l'air (Architecture of Air) **(ANT 102).** 1961. Dry pigment and synthetic resin on paper on canvas. Tokyo Metropolitan Museum Collection.

"L'acclimatisation de l'atmosphère à la surface de notre globe"
... la conclusion technique et scientifique de notre civilisation
est enfouie dans les
entrailles de la terre et assure
le confort par le contrôle absolu du
Climat à la surface de tous
les continents, devenus vastes
Salles de séjour communes.

.....C'est une sorte de retour à l'eden
de la légende. (1951)
.. Avènement d'une société nouvelle, destinée à
subir des métamorphoses profondes dans sa
Condition même. Disparition de l'intimité
personnelle et familiale. Développement
d'une ontologie impersonnelle.
 La volonté de l'Homme peut enfin
régler la vie au niveau d'un
 "merveilleux" constant.

L'Homme libre,
 l'est à tel point, qu'il
 peut même léviter !
Occupation : Les loisirs.
. Les obstacles autrefois subis dans
l'architecture traditionnelle sont
éliminés.

Soins du corps par des méthodes
nouvelles, telles le lit d'air

Klein did not hesitate to conceptualise a social organisation in harmony with his architectural utopia. Since the instruments for total climatic control were buried 'in the entrails of the earth', human beings could enjoy the space between earth and sky as a 'vast shared living room'. 'The free individual is so free that he can even levitate! His occupation: leisure activities.' In short, 'The advent of a new society destined to experience profound metamorphoses in its very condition. The disappearance of personal and family intimacy. The development of an impersonal ontology. Human volition can at last regulate life to a constant "marvellous" level.' Total freedom would manifest itself as levitation, nudity and the primacy of leisure activities. This idyllic life would mean giving up intimacy and all forms of personality. Liberated from his or her psyche, the individual would become a nuclear reactor of sensibility living in an eternal present. Klein dubbed his social project 'the Blue Revolution'. It was a utopian political philosophy and, as with all such ideal schemes, it involved a radical rethinking and transformation of social organisation. The new structure was dissociated from the contingencies of actual reality.[28]

Space was the central principle of this utopia. Klein noted in the margin of his manifesto,[29] 'I'm speaking personally of absolute space in the dimension where one finds nothing material, physical etc.'[30] In the artist's blue universe, space is boundless, immaterial and saturated with sensibility.

With his views on dismantling the contemporary social and economic system, Klein was rebelling against 'the traditional concept of force and power based on accumulating capital'. He felt that owning material things was pitifully limited. Ultimately, the owner of the whole Earth would not be owning much in cosmic terms. Furthermore, Klein observed bitterly, our sensorial perceptions are 'very limited'. Sensibility, on the other hand, 'can be expanded infinitely'. Therefore, he wondered, 'Why should I now limit myself to painting even immaterial paintings proportionate to my 5 senses?' And he added: 'I want to take the whole of France as the support for my next painting. This painting will be called the Blue Revolution!'

In a bold comparison between individuals and grains of pigment, Klein associated this aspect of his political philosophy with his monochrome experiments. 'In my system, I will consider each individual while realising my painting, "La France", as a grain of pigment which, in total freedom when the pigment is a powder and not fixed, has an extraordinary sheen and radiance and which, once it is fixed to the base with a fixative medium that does not alter it, loses nothing of its tone.'[31] Like the speck of pigment which is able to retain its dazzling natural beauty when bound to the monochrome canvas (thanks to the invention of a fixative medium that respects the speck's individuality), the men and women 'fixed' in Klein's utopia would retain their natural aura as individuals. It would be impossible for him or her to merge into the multitude. This meant that the preservation and celebration of the individual's (the grain of pigment's) total freedom would be subordinated to the choice of a cohesive agent other than money. Klein proposed using 'quality' as a social binder. United in a quest for excellence rather than quantity, individuals in society would not lose an iota of their natural aura.

Quality and creativity are so closely intertwined in Klein's system that the painter declared, 'To fix independent individualities into a great dynamic multitude on the surface of FRANCE, I want to make them discover that they are artists / everyone is an artist and creator.' Here was the crux of the matter: everyone is an artist! The role of the monochrome painter — that initiator of spatial depth — is to reveal. If each individual human becomes aware of his or her talents in terms of sensibility, the social group as a whole will achieve excellence and will share absolute happiness. Klein's project was predicated on the good will of all French citizens: 'We must stop drinking ordinary wine in FRANCE but only the best vintages'; 'We must no longer have merely economical and utilitarian cars, but the most beautiful cars in the world.'

To complete his blueprint for a political philosophy, Klein composed a *Manifeste technique de la révolution bleue* (*Technical Manifesto of the Blue Revolution*) and an *Esquisse et grandes lignes du système économique de la révolution bleue* (*Sketch and Rough Outline of the Blue Revolution's Economic System*). Everything pertaining to Klein's ideology is generally universalist: each country, starting with France, is 'subordinated to the moral and political control of an international chamber . . . modelled on the UN.'[32] To make himself perfectly clear, Klein noted in the margin of his document, 'Our patriotism must of course become the world's patriotism. As the patriotism of art already is in France.'[33] Though universal and pacifist, the Blue Revolution would be born in France before spreading to the rest of the globe: 'France has been radiating over the entire world for centuries . . . Today the disappointed world is waiting for France to set an example of the spiritual Quality of the French Revolution of 1789 . . . and once again fascism will be stopped.'[34]

Feeling himself entrusted with a solemn mission, the painter took the trouble of informing the presidents of the United States and the Soviet Union of his ideas in a letter dated 20 May 1958 and headed 'THE BLUE REVOLUTION' and classified – by Klein himself – 'Strictly confidential/Ultra Secret'.[35] The artist also sent off a witty missive to an international organisation to suggest that one of the world's seas be coloured blue and renamed the Blue Sea, 'in consideration for a fee to be agreed upon (but which will of course defray the costs of planktonic IKB – in my opinion the best colouring agent for this task – as well as my artistic contribution) . . . PS: no risk for goldfish.'[36]

In addition to colouring a sea blue, Klein also wanted to colour nuclear bombs blue, 'so that their eventual explosions can be observed . . . by all those who have the highest interest in being the first to be informed . . . I mean the entire body of my contemporaries.' And the painter added playfully, 'It is quite evident that we exclude cobalt blue as ignominiously radioactive and that we will use exclusively <u>Klein</u> blue which earned me the renown that you know of.'[37]

A harmless megalomaniac and inveterate dreamer, Klein was not a political man. His real territory was poetry. His poetry is immaterial, light as a soap bubble, too elusive to be fixed by writing or in time – we grasp it as it floats past us. The Blue Revolution did not make a mark in history, except perhaps as an emblematic event. It would no doubt have been on the curriculum of a rather special school, the Centre of Sensibility, whose program Klein drew up (on 27 March 1959) with the help of Werner Ruhnau.[38] The Centre's mission, the two men wrote, 'is to awaken possibilities of creative imagination as forces of personal responsibility'. The 'immaterialisation of sensibility' was the means to achieve quality rather than quantity. 'The imagination can be realised. It is viable. It must be experienced at the School of Sensibility. This will be the kernel of its influence.'

Naturally, 'immaterial architecture will be the main facet of this school. It will be flooded with light.' Since sensibility has no need of form, '20 instructors and 300 students will work there without a program of teaching or exams.' Klein and Ruhnau referred explicitly to the Bauhaus in order to distinguish their own centre from it. They concluded, 'Materialism – that quantitative spirit – has been recognised as the enemy of freedom . . . The School of Sensibility seeks imagination and immaterialisation. It seeks freedom in the sense of the heart and the head.'

In 1959, Klein set down his Blue Revolution on paper and published a book titled *Le Dépassement de la problématique de l'art* (*Beyond the Problematic of Art*). This compilation, which is often overlooked, has a central place in Klein's œuvre.[39] Its prose is thoroughly creative. The painter has traded his brushes for a pen, yet his words are simple extensions of his painting. They complement the silence of his pictorial work. The almost invisible backbone of the monochrome adventure culminating in the Blue Revolution finds its formal expression in writing.

'I want to take the whole of France as the support for my next painting. This painting will be called the Blue Revolution!'

Fusing art and life:
Dimanche, le journal d'un seul jour

Dimanche, le journal d'un seul jour
(*Sunday, the One-Day Newspaper*)
on display in a Paris newsstand.
27 November 1960.

Dimanche, le journal d'un seul jour.
27 November 1960. Four pages printed
on newsprint, 55 x 38 cm. Private collection.

A year later, Klein proclaimed the Blue Revolution in yet another compilation, *Dimanche, le journal d'un seul jour* (*Sunday, the One-Day Newspaper*, 27 November 1960). Its publication, at the behest of Jacques Poliéri, was one of the events of the Festival d'art d'avant-garde in Paris. A replica of the mass-circulation newspaper, *Le Journal de Dimanche,* its few thousand copies were distributed in newsstands and may even have fooled a number of Parisians. At any event, it was a well-organised practical joke. But the real significance of this tongue-in-cheek publication lies elsewhere. The hoax was in fact only a pretext for expressing a brimming creativity, which encompassed both the artist and his audience. Yves Klein took possession of Sunday 27 November 1960 in the same way that he had appropriated the colour blue and the void. This temporal appropriation limited to twenty-four hours had a remarkably rich literary content.

In keeping with the theme of the festival, Klein outlined his thoughts on the theatre and his personal stage projects. The one-day newspaper overflowed with ideas and proposals for a happening, ballets, musical compositions, plays, films, exhibitions, and so forth. The theatre was given a place in the non-hierarchical system of the Blue Revolution. The ideas outlined in *Dimanche* are plainly connected to the monochrome aesthetic. The familiar leitmotif is there: the priority of the initiatory function of sensation in life (the spectators become actors), presence in absence (blue intrudes on the spectators' dreams; sand retains the traces of a couple's

lovemaking); and above all the total subordination of the spectacle to life (the actor asleep on the stage). Klein's aesthetic rests on a radical rejection of any kind of re-presentation – mimesis is viewed as an artifice, and life, in its immanence, is regarded as being already a work of art. Klein sums up his thought as follows: 'The theatre must be or must at least rapidly attempt to become the pleasure of being, of living, of spending wonderful moments, and with each passing day of better understanding the beautiful present.'[40] 'Thus,' he explained, 'one very soon comes to a theatre without actors, without a setting, with spectators . . . The author lives his creation . . . To live a perpetual manifestation, to experience the permanence of being: to be present everywhere, elsewhere, inside like outside, a kind of sublimation of desire, a material steeped in, impregnated with "everywhere" . . . and everything continues, a monotheatre, beyond the psychological domain at last . . . The future of the theatre is an empty theatre hall, no longer any hall at all!'[41]

| YVES KLEIN PRÉSENTE : LE DIMANCHE 27 NOVEMBRE 1960 | NUMÉRO UNIQUE | FESTIVAL D'ART D'AVANT-GARDE NOVEMBRE – DÉCEMBRE 1960 |

SEANCE DE 0 HEURE A 24 HEURES

| La Révolution bleue continue | # Dimanche | Le journal d'un seul jour |

27 NOVEMBRE

0,35 NF (35 fr.) Algérie : 0,30 NF (30 fr.) - Tunisie : 27 mil.
Maroc : 32 f m. - Italie : 50 lires - Espagne : 3 pes. 3

THEATRE DU VIDE

I. E théâtre se cherche depuis toujours ; il se cherche depuis le début perdu.

Le grand théâtre, c'est l'Eden en fait ; l'important est d'établir une bonne fois nos positions statiques, chacun d'une manière individuelle et non plus personnelle dans l'univers. Depuis longtemps déjà j'annonce partout que je suis le peintre... Je n'en connais pas d'autre aujourd'hui ! Je tiens à dire aussi : « Je suis l'acteur, je suis le compositeur, l'architecte, le sculpteur » Je tiens à dire : « Je suis. » L'on m'objectera sans doute que cela a déjà été hurlé de toutes sortes de manières variées ; c'est certainement juste. Par conséquent, je le répète peut-être cela, mais je suis conscient, bien conscient d'avoir atteint le droit de le dire : et voilà que, pour moi comme pour tous, il n'y a plus rien à faire ; le théâtre officiel, aujourd'hui, c'est « être » et je « suis » bien effectivement tout ce que l'on veut bien que je « sois » et même tout ce que l'on ne veut pas que je « sois » ! J'atteindrai même à ne plus « être » du tout un jour !... Mais, que l'on ne s'y trompe pas : il ne s'agit pas de moi quand je dis je, moi, etc.

C'est parce que l'esprit dans lequel je vis est un esprit d'émerveillement, stabilisé et constant, un esprit classique, que je n'ai aucun caractère d'avant-garde qui, elle, vieillit si vite, de génération en génération.

Mon art n'appartiendra pas à l'époque, pas plus que l'art de tous les grands classiques n'a appartenu aux époques où ils ont vécu, parce que je cherche avant tout, comme eux, à créer dans mes réalisations cette « transparence », ce « vide » incommensurable dans lequel vit l'esprit permanent et absolu délivré de toutes dimensions !

Non, je ne me laisse pas prendre à mon propre jeu en parlant aujourd'hui d'un théâtre du vide avec un tel avant-propos orgueilleux, égocentrique et même vaniteux sans doute en apparence : mon théâtre prendra une valeur universelle dans la mesure même où mes compagnons connaîtront mieux ma pensée que moi-même je ne la connais, car s'ils sont des milliers, ils la refléteront des milliers de fois alors que moi je suis seul.

★

Je me rends très bien compte que je me présente, tout seul, en écrivant ces lignes avec ce qui semblerait une sorte de complexe du plus fort. En signale à ceux qui seraient assez aveugles et maladroits pour me donner l'avantage d'attaquer mon exaspération du moi qu'il est bien facile de m'entraîner à la défaite mais à cette sorte de défaite que sont les veilles des grandes victoires définitives pour ceux qui entrent dans le grand jeu et savent s'exposer.

J'ai lutté contre ma vocation de « peintre », en partant au Japon pour y vivre l'aventure Judo et Arts martiaux anciens ; de même j'ai lutté contre ma vocation « d'homme de théâtre » ; mais précisément, le Judo par la pratique physique et spirituelle des Katas, c'est constitué malgré moi, ma formation dans cette discipline de l'art qu'est le théâtre, d'une manière imprévisible, mais tout aussi profitable et profonde, sinon peut-être plus encore que n'importe quelle autre. En présentant ce qui suit, j'obéis à une nécessité profonde, j'agis en réaliste plein de bon sens. J'aime Molière et Shakespeare parce que, dans leur œuvre, se trouve cette transparence du vide qui me fascine. Pour moi « théâtre » n'est pas

● SUITE EN PAGE 2

L'ESPACE, LUI-MÊME.

ACTUALITÉ

D ANS le cadre des représentations théâtrales du Festival d'Art d'Avant-Garde de novembre-décembre 1960, j'ai décidé de présenter une ultime forme de théâtre collectif qu'est un dimanche pour tout le monde.

Je n'ai pas voulu me limiter à une matinée ou à une soirée.

En présentant le dimanche 27 novembre 1960, de 0 heure à 24 heures, je présente une journée de fête, un véritable spectacle du vide, au point culminant de mes théories. Cependant, n'importe quel autre jour de la semaine aurait pu être aussi utilisé.

Je souhaite qu'en ce jour la joie et le merveilleux règnent, que personne n'ait le trac et que tous, acteurs-spectateurs, conscients comme inconscients aussi de cette gigantesque manifestation, passent une bonne journée.

Que chacun aille dedans comme dehors, circule, bouge, remue ou reste tranquille.

Tout ce que je publie aujourd'hui dans ce journal est antérieur à la présentation de ce jour historique pour le théâtre

Le théâtre doit être ou doit tout au moins tenter de devenir rapidement le plaisir d'être, de vivre, de passer de merveilleux moments, et de comprendre chaque jour mieux le bel aujourd'hui.

Tout ce que je publie dans ce journal ont été mes étapes jusqu'à ce jour glorieux de réalisme et de vérité ; le théâtre des opérations de cette conception du théâtre que je propose n'est pas seulement la ville, Paris, mais aussi la campagne, le désert, la montagne, le ciel même, et tout l'univers même, pourquoi pas ?

Je sais que tout va fonctionner très bien inévitablement pour tous, spectateurs, acteurs, machinistes, directeurs et autres.

Je tiens à remercier ici M. Jacques Polieri, directeur du Festival d'Art d'Avant-Garde, pour son enthousiasme, en me proposant de présenter cette manifestation « le dimanche 27 novembre ».

Yves KLEIN.

du tout synonyme de « Représentation » ou de « Spectacle ».

D'importants chercheurs qui, eux, ont été d'avant-garde, comme Taïroff, par exemple, voulaient théâtraliser le théâtre.

Eivreinoff rêvait du monodrame, de la théâtralité dans la vie quotidienne, pensée — geste — parole.

Stanislavsky, réaliste extrémiste, aurait souhaité la mort effective et définitive de l'acteur qui doit jouer sa mort en scène. Le précurseur Dada Vakhtangof enferma le public dans une salle de théâtre pendant deux heures dans le seul but cynique de les enfermer tout simplement. Cet événement faisait partie, d'ailleurs, de son « théâtre de la révolte » et s'intitulait « La Soirée insolite ».

Le Tchécoslovaque Burian créa un théâtre synthétique ; les personnages de sa pièce, « Roméo et Juliette », étaient des machines fantastiques et infernales qui évoluaient sur la scène pendant que les acteurs en coulisse disaient le texte. Amphithéâtroff montait des piécettes laconiques de dix minutes, coupées de discussions ; les discussions faisaient partie évidemment du programme. Ce qui l'amènera à déclarer souvent à son public, qu'il commandait d'avance ses représentations, qu'il était prêt à supporter les tomates, les œufs pourris, mais en aucune manière, les pavés

Les phonographes, dans « Les Mariés de la Tour Eiffel », de Jean Cocteau, sont aussi de très beaux phénomènes.

Il serait trop long de citer ici toutes les tentatives qui ont été faites pour sortir de la convention, de l'optique apprise, de l'académisme dans le domaine du spectacle de la représentation théâtrale depuis le début du siècle. En fait, presque tout a été fait, jusqu'à Jacques Polieri dans sa mise en scène de la pièce de Tardieu ces temps derniers, qui fait entendre des voix sur la scène où trois panneaux-écrans sont là pour tout décor et toute présence ! (Son idée d'ailleurs est de faire vivre et parler les décors.)

Bravo ! — Quel bonheur que tout cela ait existé, mais attention ; j'avertis bien le lecteur, mon œuvre théâtrale n'a rien, absolument rien à voir avec l'une quelconque de ces directions ou recherches sauf, peut-être, avec celles d'Antonin Artaud, qui sentait venir ce que je propose aujourd'hui ici. Cependant Artaud, comme bien d'autres « Grands » du vrai théâtre, se perdait dans une trop grande conception artificielle et intellectuelle du Verbe qui m'a dérouté tant si longtemps. Pour ma part, je ne sais qu'une chose, c'est qu'au commencement était le Verbe, et le Verbe était Dieu : deux fois « être » pour deux fois « Verbe » plus « Dieu », en tout cinq points qui si on les médite un peu, disent bien ce qu'ils veulent dire : le « Verbe » dans cette aforme n'est pas « Parole » articulée ni même désarticulée.

★

Ce que je désire : Plus de rythme, surtout plus jamais de rythme !

Et puis mon œuvre n'est pas une « recherche », elle est mon sillage. Elle est la matière même de la vitesse statique vertigineuse, à laquelle je me propulse sur place dans l'immatériel ! Attention encore, je tiens à bien préciser que je ne dis pas, en parlant de mon œuvre : c'est plus beau parce que c'est inutile » ! Non, je dis : « C'est ainsi ce sera ainsi, et personne ne pourra jamais rien faire pour que ce ne soit pas ainsi » ! Pourquoi ? Parce que, précisément c'est « classique » » !

★

...Ainsi, très vite, on en arrive au théâtre sans acteur, sans décor, sans scène, sans spectateur... plus rien que le créateur seul qui n'est vu par personne, excepté la présence de personne et le théâtre-spectacle commence !

L'auteur vit sa création : il

● SUITE EN PAGE 2

(Photo Shunk-Kender)

Le peintre de l'espace se jette dans le vide !

Le monochrome qui est aussi champion de judo, ceinture noire 4e dan, s'entraîne régulièrement à la lévitation dynamique ! (avec ou sansfilet, au risque de sa vie).

Il prétend être en mesure d'aller rejoindre bientôt dans l'espace son œuvre préférée : une sculpture aérostatique composée de Mille et un Ballons bleus, qui, en 1957, s'enfuit de son exposition dans le ciel de Saint-Germain-des-Prés pour ne plus jamais revenir !

Libérer la sculpture du socle a été longtemps sa préoccupation. « Aujourd'hui le peintre de l'espace doit aller effectivement dans l'espace pour peindre, mais il doit y aller sans trucs, ni supercheries, ni avion, ni parachute ou en fusée ; il doit y aller par lui-même, avec une force individuelle autonome, en un mot, il doit être capable de léviter. »

Yves :

« Je suis le peintre de l'espace. Je ne suis pas un peintre abstrait, mais au contraire un figuratif, et un réaliste. Soyons honnêtes, pour peindre l'espace, je me dois de me rendre sur place, dans cet espace même »

Sensibilité pure

Une petite salle.

Les spectateurs, après avoir dûment payé chacun leur entrée, assez chère... pénètrent dans la salle et prennent place.

Le rideau est baissé. La salle illuminée.

Dès que la salle est pleine, un homme se présente sur la scène, devant le rideau toujours baissé et déclare :

« Mesdames, Messieurs en raison des circonstances, ce soir nous allons être contraints de vous enchaîner chacun à vos sièges (et, de plus, vous bâillonner) pour la durée de la représentation.

» Cette mesure de sécurité est nécessaire, afin de vous protéger contre vous-même, en présence de ce spectacle particulièrement dangereux, d'un point de vue affectif pur !

» Nous exprimons d'avance nos regrets au personnes qui ne pourraient supporter d'être ainsi enchaînées et bâillonnées avant le lever du rideau ; nous les prions aimablement de bien vouloir quitter la salle pour se faire rembourser à la sortie. Aucune personne non enchaînée solidement à son siège ne sera tolérée dans la salle pendant le spectacle. Merci !

...Aussitôt un groupe d'enchaîneurs-bâilleurs pénétrent dans la salle et, systématiquement, rang après rang, paralysent rapidement tous les spectateurs.

● SUITE EN PAGE 2

Sensibilité pure (suite)

Quand tout est prêt... l'obscurité se fait dans la salle. Le rideau se lève lentement avec l'éclosion d'un pétillement continue, semblable à celui que fait l'eau gazeuse fraîchement débouchée, mais prodigieusement amplifié. C'est une inondation sonore, monotone, s'imprégnant d'une manière volumétrique dans l'espace, perceptible par l'oreille sensible de chaque spectateur.

Sur la scène : une salle vide blanche, très blanche ; tous les angles sont arrondis... Tout est vide, absolument vide avec je ne le tellement ! (dans le cas où les spectateurs ne seraient pas étalonnés il faudrait couper l'acoustique).

Dans la salle de très belles filles nues ou, à la rigueur, en bikini, sorte d'ouvreuses-hôtesses.

Capture du vide

Une ville entière, voire même une capitale, ou, encore mieux, un pays entier doit servir de scène et de décor.

L'État, lui-même, annonce la date de la représentation dans tout le territoire. Le jour dit, à l'heure dite, exactement, tout le monde rentre chez soi, s'enferme à double tour et, l'extérieur est vide de tout être humain pendant deux heures.

Dans les rues plus personne, plus personne du tout dans les bureaux administratifs et autres lieux publics ; plus personne dans les campagnes, tout est fermé, tout le monde est chez soi et ne bouge plus.

Le territoire doit sembler aux yeux de l'Espace, pour deux heures, entièrement vide de sujets vivants !

Les voleurs d'idées

Quand l'urbanisme de l'air et encore, et surtout, après cette étape. Quand l'immatérialisation totale et définitive de l'architecture aura été accomplie, c'est-à-dire lorsque nous vivrons l'Éden perdu, de nouveau dans la nature climatisée, nus, sans obstacle artificiel aucun, il ne certain que notre conception actuelle de l'intimité, aura bien changé. Nous verrons en permanence tout ce qui, aujourd'hui est très secret et caché chez les autres et les autres verront de même en nous, dans tous les moindres événements de notre vie quotidienne. La sensibilité sera alors développée d'une telle manière qu'il deviendra possible d'envisager même la possibilité de voir entre nous nos pensées les plus profondes ; ces pensées ne seront pas lues intellectuellement ni perçues ; elles seront « saisies », et plutôt par imprégnation, qu'autre chose, « sensibilité » plus que par pénétration psychologique ; aura presque ou complètement disparu alors.

Cependant, si tous les hommes arrivent à conquérir cette possibilité de « rêver dans le rêve des

pourtant pensé à cela le premier !

L'acteur de droite : « Quel merveilleux paysage ! »

L'acteur de gauche reçoit ces paroles comme un coup de poing à l'estomac et se tourne, convulsionné, vers le public, en montrant un visage défait. Dans le paysage de son côté, des nuages s'amassent et le vent redouble de violence. La voix, dans le vent, dit : « J'avais vu cela avant lui !... » « C'est lui... » C'est le voleur d'idées ! » Et ainsi, d'idées en idées, et en constatations futiles en constatations futiles et universelles sans plus de valeur et sans propriétaire, l'acteur de gauche passe par tous les tourments d'entendre l'autre, l'acteur de droite, énoncer tout avant lui. La pièce

est presque un monologue puisque l'acteur de droite parle tout le temps, debout face aux écrans, tournant le dos aux spectateurs, ou considérant, le temps à autre, son bon-qui se tord de plus en plus de désespoir à côté de lui, dans une série de mimes, qu'il exécute en faisant tantôt face aux spectateurs, tantôt face au décor-film.

Le film, en étroit rapport avec les idées toujours volées, peut projeter toutes sortes d'événements pensés par l'acteur de gauche, qui découlent de la constatation première du paysage au soleil.

Le fond sonore composé avec le déroulement du tout, évidemment.

Ainsi, de stupidité en stupidité, celui qui est toujours volé de vient une épave, effondrée sur le sol, qui pense toujours le premier, mais que désemparé, à toutes sortes de choses de plus en plus importantes et de plus en plus ainsi volé effec-

(Les dialogues sont en préparation)

tivement. (Sur lui, directement, peuvent être projetées, toutes sortes de couleurs violentes figurant son désarroi émotionnel).

L'acteur de droite reste toujours debout, le soleil brille et le paysage est toujours le même ; il est heureux.

Dans la salle, une jeune fille se lève parmi les spectateurs dans l'orchestre, et se dirige vers la scène.

L'acteur de gauche l'aperçoit le premier.

L'acteur de droite dit, cependant, encore le premier : « Comme elle est belle ! » La jeune fille sourit et le rejoint sur la scène ils se regardent, ils se tournent autour, ils se prennent les mains...

Soudain la jeune fille voit l'épave vivante, à côté, par terre dans le secteur où tout est noir, lamentable et désastreux.

Attirée, naturellement, par ce qui souffre, elle lâche brusquement les mains de l'acteur de droite et va, lentement, se pencher sur l'acteur de gauche en le dévorant des yeux. Elle le relève doucement.

Le barrage mental est dressé l'acteur de gauche a en tête l'image de sa campagne qui est venue à son secours instinctivement. L'amour ne laisse plus voir les pensées à l'autre. Le paysage merveilleux revient de son côté, il enlace la jeune fille.

Au même moment, l'obscurité brusque se fait dans le secteur de l'acteur de droite qui disparaît !

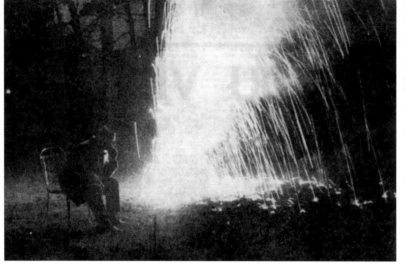
Les fontaines de feu, d'Yves. Pour un crépuscule de dimanche. (Photo Véron)

Du vertige au prestige (1957-1959)

Depuis des années, je m'exerce à léviter et je connais bien les moyens d'y arriver effectivement (chutes judo).

Il y a d'une part le vampirisme légendaire et traditionnel pour subir l'immobilité physique absolue durant le jour. C'est une question de diastole et de systole, et d'autre part la libération effective de la personnalité dans tous ses aspect dans l'individu par l'exaspération du Moi, pratiquement jusqu'à une sorte de sublimation purificatrice absolue.

J'ai récemment déclaré, en janvier 1959, dans une communication en Allemagne, que, libéré du monde psychologique, l'artiste de demain créera et se recréera lui-même, capable de léviter dans une totale liberté physique et

spirituelle. J'ai déjà procédé à des tentatives de réalisation d'œuvres de ce genre, telles les sculptures volantes aéro-statiques de 1957, composées de mille et un ballons bleus ; cette expérience de l'Obélisque et de la place de la Concorde illuminé en bleu de nuit, le socle restant dans l'ombre, et aussi les vapeurs de l'inauguration de l'époque bleue en 1957. C'est ce que j'appelle depuis toujours le passage du vertige au prestige (libération de l'esclavage du socle en sculpture).

C'est ainsi qu'il me serait bien agréable bientôt de me présenter moi-même sur la scène d'un théâtre allongé dans l'espace à quelques mètres du sol, sans aucun tense ni superchérie, pendant quelque cinq à dix minutes au minimum, et le tout sans commentaires.

« Viens avec moi dans le vide »

Je peins d'après modèle le plus souvent et même avec la collaboration effective du modèle depuis quelques années déjà. En effet, d'après nature ne suffisant pas : je sentais qu'il y avait autre chose. Le modèle ne m'apporte la sensualité dans l'atmosphère. Attention ! pas la sexualité !

Le modèle crée le climat sen-

d'après les nus. La raison de chercher une forme vivante humaine à dessiner et à copier depuis longtemps, je me demandais pourquoi les peintres figuratifs ou même abstraits quelquefois tel Fautrier par exemple, ressentent le besoin de peindre

suel à l'intérieur de l'atelier, comme éventuellement à l'extérieur, qui permet de stabiliser la matière picturale. C'est le gros bon sens le plus complet quand l'artiste s'enferme dans les sphères de création d'art avec le centre de gravité des valeurs charnelles dans le sens de la vraie foi chrétienne qui dit : « Je crois à l'incarnation du Verbe, je crois à la résurrection des corps » et il se trouve, là aussi, le Vrai sens du théâtre du Verbe : le Verbe, c'est la chair !

J'ai donc pris des modèles, j'ai essayé ; c'était très beau. La chair, la délicatesse de la peau vivante, sa couleur extraordinaire et si paradoxalement incolore et si peu fascinante.

Mes modèles riaient beaucoup de me voir exécuter d'après elles de splendides monochromes bleus bien unis ! Elles riaient, mais de plus en plus se sentaient attirées par le bleu.

Un jour j'ai compris que mes mains, mes outils de travail pour manier la couleur ne suffisaient plus. C'était le modèle lui-même qu'il me fallait pour peindre la toile monochrome... Non, ce n'était pas de la folie érotique !

C'était encore plus beau. J'ai jeté une grande toile blanche par terre, j'ai vidé au milieu vingt kilos de bleu et le modèle s'est littéralement rué dedans ; elle a peint le tableau en se roulant sur la surface de la toile dans tous les sens, avec son corps.

Je dirigeai l'opération debout, en tournant rapidement tout autour de cette fantastique surface au sol guidant tous les mouvement et déplacements du modèle. La fille, tellement grisée par l'action et par le bleu vu de si près et en contact avec sa chair, finissait par ne plus m'entendre lui hurler : « Encore un peu plus à droite, là, revenez en vous roulant sur ce côté-là, cet espace n'est pas encore couvert dans cet autre coin-là, venez y appliquer votre sein droit, etc. »

Il n'y a jamais rien eu d'érotique, de pornographique ni de quoi que ce soit d'amoral dans ces séances fantastiques ; dès que le tableau était terminé, mon modèle prenait un bain. Je ne les ai jamais touchées d'ailleurs, c'est pour cela qu'elles avaient confiance et qu'elles aimaient à collaborer et aiment encore collaborer ainsi, de tout leur corps, à ma peinture. Et puis c'était la solution apportée au problème de la distance en peinture : mes pinceaux étaient vivants et téléguidés.

Avec moi elles comprenaient, elles f'sssient quelque chose, elles agissaient. Avant, avec les figuratifs qui les dessinaient, elles se reconnaissaient après sur les peintures. Ensuite sont venus les abstraits en art ; c'était inquiétant, psychologique, malsain. Elles ne comprenaient plus et elles se servaient en fait.

Avec moi, au début, elles m'ont cru fou ; après, elles ne pouvaient plus se passer de venir poser pour moi ou plutôt de venir travailler avec moi !

C'est ce que je veux représenter sur scène avec, comme fond musical, la chanson « Viens avec moi dans le vide », musique Hans Martin Majeski.

Quand je pense à toi :

Le même rêve revient toujours
Nous marchons enlacés
Dans le chemin sauvage de nos [vacances
Et puis, peu à peu,
Tout semble disparaître autour [de nous
Les arbres, les fleurs, la mer
Au bord du chemin,
Il n'y a plus rien non plus autour [d'ain
Nous sommes à notre bout du [monde
Alors... Allons nous retourner ?
Non... Tu dis non je sais
Viens avec moi dans le vide !
Si tu reviens un jour
Toi qui rêves aussi
A ce vide merveilleux
A cet amour absolu
Sans aucun mot à nous dire,
Nous nous jetterons
Dans la réalité de ce vide
Qui attend notre amour,
Comme moi je t'attends chaque [jour :
Viens avec moi dans le vide !
1957.

Conclusion

...Si mal, il y a ; «...Je n'ai pas voulu ça ! »
Voir dans *Naturemétrie* de l'Époque bleue le développement pictural de cette proposition.

Ballet du feu

Dans un jardin : un immense écran hémisphérique de papier blanc ignifugé ou dissimulant que le feu d'une lampe à souder le perfore mais fait la faire s'enflammer.

Le public assis face à cette surface blanche unie voit soudain une flamme apparaître après avoir en une fraction de seconde foré un trou. La flamme disparaît, une lampe à souder recule, l'écran se reconstitue et de nouveau une flamme apparaît par derrière, brûle et disparaît dans la toute, cette même toile pour devenir enfin un visiteur du gigantesque musée du temps passé qu'est devenu le monde moderne d'aujourd'hui !

THÉATRE DU VIDE

● *Suite de la première page*

est son public, et son triomphe ou son désastre. Rapidement, l'auteur n'est même plus là lui-même, et pourtant tout continue...

...Vivre une constante manifestation, connaître la permanence d'être : être là, partout, ailleurs, dedans comme dehors, une sorte de sublimé du désir, une matière imblödée, imprégnée dans « partout »... une continue, monothéâtre, hors du monde psychologique enfin... L'avenir du théâtre ; c'est une salle vide : ce n'est plus de salle du tout !

★

Ce manifeste de 1954 m'a, depuis, inspiré des propositions médiatrices telles que celles qui vont suivre :

Créer une sorte de théâtre privé, à fréquenter (affectivement), par abonnement.

Les membres reçoivent chacun, en échange de leur cotisation, un siège à leur nom dans la salle vide du théâtre où se donne la constante manifestation sans acteur, sans spectateur, etc. Cette constante représentation, dans cette salle où ne pénètre plus personne après son installation, doit avoir des moments plus intenses que d'autres ; signalés, au début, aux abonnés, par le programme qu'ils reçoivent par la poste ou... autrement ! Les moments particuliers, le soir de

préférence, ou au petit matin, au lever du soleil, le théâtre doit être illuminé, brillamment, de manière que cela se voit bien de l'extérieur (la situation idéale d'un tel théâtre, pour l'instant, serait à Paris, celle du Marigny, par exemple).

Encore une fois, je le répète, tout est fermé, personne ne peut entrer à l'intérieur, seul le bureau de location à l'entrée est ouvert pour que les retardataires et non abonnés puissent, au dernier moment, louer les quelques défections avant chaque manifestation. Le directeur d'un tel théâtre devra rechercher dans la ville, à la campagne ou au cours de longs voyages effectués à cet effet, les acteurs qui constituent et ainsi constamment renouveler la troupe. Les acteurs seront choisis par lui dans la rue, partout ou ailleurs, et devront s'engager par contrat ferme, avec avance sur leurs honoraires.

Le nouvel acteur ainsi choisi aura à faire à faire qu'à savoir qu'il est un acteur et à passer pour toucher ses cachets après chaque séance « au moment d'hyper intensité » indiqué dans le programme des abonnés.

Après avoir ainsi été engagé, l'acteur s'enfuira chargé de cette nouvelle et grave responsabilité d'être un acteur choisi par la société, pour devenir enfin un visiteur sérieux dans la toute, cette même toile pour devenir enfin un visiteur du gigantesque musée du temps passé qu'est devenu le monde moderne d'aujourd'hui !

Projet pour un institut national théâtral

Les spectateurs sont reçus par un médecin psychiatre qui leur fait subir un examen général d'aptitude aux séances de l'Institut. Puis, ils passent tous dans une piscine où ils sont lavés et nettoyés à fond par de splendides et jeunes spécimens féminins de la race humaine.

Ils passent ensuite dans un sauna pendant vingt minutes, puis, dans une chambre d'oxygénation où ils sont douchés à la lance pendant quatre heures et admirer, par le sens du toucher

seulement (en passant leurs mains et leurs bras dans des manchons aux murs et à tâter sans les voir) les sculptures tactiles hypersensibles qui sont de ravissants modèles vivants, nus, hommes et femmes, exposés à la portée des mains des spectateurs de l'autre côté des murs.

Ensuite après ozonisation, les spectateurs sont plongés dans un sommeil artificiel de vingt-quatre heures, puis réveillés, massés, douchés, rhabillés et expulsés violemment dehors.

Le contrat

1er ACTE

Le rideau se lève, sur la scène l'acteur et le spectateur sont assis face à face aux extrémités opposées du plateau. Au centre un peu en retrait, l'auteur. Discussion entre les trois personnages sur le théâtre d'Yves Klein et toutes les autres possibilités théâtrales...

2e ACTE

Le rideau se lève sur une salle de théâtre avec l'orchestre, les balcons, etc., tous les sièges sont occupés par des acteurs ; c'est comble. La salle reconstruite sur scène est identique en tous points à celle dans laquelle se trouvent les vrais spectateurs au centre, mais des salles plusieurs auteurs se tiennent debout devant de petites tables et président, à tour de rôle, le débat.

Stupéfaction monochrome

Les spectateurs convoqués entrent dans une salle vide dont le sol est recouvert de riches tapis très épais en longue laine blanche et où leur sont distribuées des pilules bleues à consommer sur-le-champ.

Deux ou trois minutes plus tard, les personnages ayant consommé ces pilules tombent sous l'effet du stupéfiant : c'est-à-dire, une agréable torpeur dynamique dans laquelle apparaît un espace immense intérieur et extérieur bleu, bleu uni monochrome.

(Cependant, dans ce bleu, deux autres couleurs semblent bien distinctes et séparées les unes des autres : c'est l'or et le rose, mais tout est bleu uni I.K.B. en fin de compte.)

C'est la béatitude des paradis artificiels en bleu.

Tout le monde s'y prélasse.

Les cinq salles

Le lien entre l'esprit et la matière est l'énergie. Le mécanisme combiné de ces trois états donne notre monde tangible, prétendu réel mais éphémère. C'est ainsi que depuis si longtemps le théâtre est spectacle, et nous ne sortirons de ce désastre que lorsque nous prendrons la décision d'être indifférents vis-à-vis de l'énergie. C'est à ce moment-là que se fera l'illumination extraordinaire et extra-dimensionnelle et l'on sera alors dans l'esprit et la matière, en direct !

La manifestation en cinq salles parcourues par les spectateurs traînant des boulets aux pieds est une proposition dans cet esprit.

1. — Entrée par la salle des neuf tableaux monochromes bleus, tous du même format et du même bleu (I.K.B.) (1).

2. — Passage dans la salle vide entièrement blanche immaculée (sol y compris) (I.K.I.) (2).

3. — Passage dans la salle des neufs Monogolds du même or fin 999,9 (I.K.G.) (3) et toujours sous du même format que les précédents bleus de la première salle.

4. — Passage dans la salle vide obscure entièrement noire presque (I.K.N.) (4).

5. — Passage dans la salle des neuf monopincks toujours du même format que les bleus et ors des salles précédentes (couleur exacte : I.K.P. (5) laque de garance rose...) sortie.

Dans le même ordre d'idée, une manifestation avait été prévue en 1958 en collaboration avec Jacques Duchemin.

Le but essentiel était de rendre hommage à Sa Sainteté le pape Jean XXIII.

Une grande salle carrée : sur l'un des murs, une immense tableau bleu monochrome I.K.B. sur le mur en face un immense tableau blanc monochrome de même format qui tourne au bleu en l'espace de trente minutes exactement.

Sur les deux autres murs, deux tableaux, toujours du même format, l'un rouge et l'autre vert, qui devient se dissoudre dans le même rouge en même temps de trente minutes à peine exposée à l'air ambiant de la salle.

Le thème de la manifestation : « Le Mal et la Guerre disparaissant devant Jean XXIII ».

Le public aurait été invité à entonner un Te Deum durant les trente minutes de la manifestation.

(1) I.K.B. = International Klein Bleu.
(2) I.K.I. = International Klein Immatériel (vide).
(3) I.K.G. = International Klein Gold.
(4) I.K.N. = International Klein Néant.
(5) I.K.P. = International Klein Pinck.

La guerre

Petite mythologie personnelle de la monochromie, datant de 1954, adaptable en film ou en ballet

(Avertissement : J'ai tenu à laisser ce texte intact, tel qu'il a été écrit en 1954. Il est certain qu'aujourd'hui je le trouve un peu naïf et n'emploierais plus sans doute les mêmes termes.)

Deux principaux personnages abstraits ; la ligne et la couleur, qui se combinent, se multiplient et s'interpénètrent pour la suite. Pour tout décor un immense écran hémisphérique (écran destiné à recevoir en transparence la projection d'un film en couleur, lisse, ou de front).

Premier Tableau : Projection d'un blanc intense et immaculé sur l'écran pendant quatre secondes.

Deuxième Tableau : Passage progressif du blanc à l'or (couleur de l'or fin 999,9) quatre secondes fixes avec l'éclosion d'un son continu monoton (longueur d'onde de l'or).

Troisième Tableau : Passage progressif de l'or au rose (laque de garance, rose carminé). Passage progressif du son continu or au son continu rose. Quatre secondes fixes de rose sur l'écran ainsi que quatre secondes de monoton rose.

Quatrième Tableau : Passage progressif du rose au bleu (bleu I.K.B.). Passage progressif du son continu rose au son continu bleu. Quatre secondes bleu fixe sur l'écran accompagnée de quatre secondes de monoton bleu.

Cinquième Tableau : Sur l'image bleu un apparaît soudain, gigantesque, une main (empreinte préhistorique de main, Castello, Espagne, abbé Breuil). Un fort à-coup dramatique dans le son continu.

Commentaire : Profitant d'un besoin qu'éprouve le premier

homme de projeter sa marque hors de lui, la ligne qui ne se trouve nulle part en fait dans l'espace incommensurable depuis l'éternité, mais qui pourtant est et attend, réussit à s'introduire dans le royaume jusqu'ici inviolé de la couleur et de l'espace.

Ici départ de la composition en musique concrète.

Départ éventuel aussi du ballet.

Les danseurs qui, jusqu'à présent, se tenaient couchés sur la

scène invisibles, se relèvent lentement devant l'écran et commencent à danser les contours de la main gigantesque projetée sur l'écran. Lentement, la main s'anime sur l'écran. La main disparaît progressivement, trois doigts, puis deux seulement, dessinent dans la glaise découvrent des traces linéaires... Apparaissent alors successivement les tracés aux doigts préhistoriques relevés par l'abbé Breuil à Ornos de la Pena et Alta Mira, Espagne.

Les danseurs, dans leurs mouvements, suivent les formes digitaux sur l'écran.

Dans le même temps une musique concrète linéaire suit le tracé des doigts.

L'homme dans cette partie du ballet découvre toutes les formes de la nature, les formes du monde de la réalité tangible et sensuelle sur laquelle viennent de s'ouvrir ses yeux. Il découvre les formes de la femme au même titre que celles d'un rocher, d'un lion, d'une plante. Il se peut s'ajouter une danse légèrement suggestive, voire même érotique : la découverte mutuelle de l'émotion affective sensuelle entre l'homme et la femme.

Puis, c'est l'époque du meurtre (Abel et Cain) le passage définitif du rêve à la réalité.

★

A PARTIR DE CE MOMENT C'EST AU CHOREGRAPHE EVENTUEL A DECOUPER CE QUI VA SUIVRE EN TABLEAUX.

★

Rapidement maîtrisée, la pure couleur, âme universelle dans laquelle baignait celle de l'homme en état de paradis terrestre, est emprisonnée, compartimentée, ciselée, réduite à l'esclavage. Sur l'écran, projection des tracés cernés de rouge de Ornos de la Pena ou de Pech-Merle dans le Lot ; tracés australiens de la Tribu Worora, Port George, argementés aussi à pieds.

La musique concrète continue en s'adaptant aux images projetées sur l'écran.

Dans la joie et le délire de sa victoire par ruse, la ligne subjugue l'homme et lui imprime son rythme abstrait à la fois intellectuel, matériel et émotionnel. Le réalisme va apparaître bientôt.

★

Le premier moment de stupéfaction passé, l'homme préhistorique réalise qu'il vient de perdre la vision.

Il se ressaisit en découvrant la forme dite figurative.

Réalisme et abstraction se combinent dans un horrible mélange machiavélique qui devient la vie humaine terrestre et c'est la mort vivable : « L'horrible cage »... Le paradis est perdu, la façonnant, cette âme universelle colore qui est la vie elle-même conquise, envahie, brimée par la ligne, puissance magique du mal

Nuestra Senore del Castillo, Almaden, abbé Breuil. Hordes guerrières de Cueva del Val del Charco del Agua Amarga, Terruel. Musique concrète agrémentée de rythmes nègres.

Cette écriture d'une fausse réalité qui s'élabore, la réalité physique figurative, permet à la ligne de s'organiser presque définitivement déjà, en terrain conquis.

Son but : ouvrir les yeux de l'homme sur le monde extérieur de la matière qui l'entoure et lui permettre la marche vers le réalisme. Au loin, dans l'homme, s'éloigne, sans pouvoir le quitter tout à fait cependant, sa vision intérieure colore perdue, à la place de laquelle se crée une sorte de vide atroce pour les uns, bouleversant ou merveilleusement romantique pour les autres et devient la vie déchirée par l'actualité de la ligne.

La couleur souillée, humiliée, vaincue, va cependant préparer tout au long des siècles une revanche, un soulèvement plus fort que tout. Sur l'écran, projection de figures courantes, de Bassonto, Afrique du Sud. Bisons de Lascaix avec larges taches de couleur rouge et verte. Chevaux de Lascaux, puis taches de couleur indépendantes du dessin. Dessins gravés abstraits sur objets néolithiques, ou gravés, tracés cernés de signes, Andalousie du Sud relevés par l'abbé Breuil.

★

Enchaînement musical sur la « Messe des pauvres » de Eric Satie.

Ainsi l'histoire de la très longue guerre, de la ligne et de la couleur commence avec celle du monde, de l'homme et de la civilisation.

★

La couleur héroïque fait des signes à l'homme toutes les fois qu'il ressent le besoin de peindre (phénomène de tentative faite par le corps affectif pour une libération dans l'espace) qui lui vient de très loin en lui, d'au delà de son âme...

La couleur cligne de l'œil à l'homme, enfermé dans les formes par le dessin. Des millénaires passeront avant que l'homme comprenne ces appels désespérés et se mette tout à coup fébrilement à l'action pour délivrer la couleur comme lui-même. L'enchevêtrement des lignes devient comme les barreaux d'une véritable prison qui s'ailleurs, de plus en plus, la vie psychologique humaine. Le drame de la mort inévitable et des mortels à où ils sont entraînés par la coexistence orageuse de la ligne et de la couleur en guerre, provoque la naissance de l'art.

★

Cette lutte pour la création éternelle, et surtout immortelle, pour arriver à transmuer dans l'objet, dans la forme, dans le son ou dans l'image, en la façonnant, cette âme universelle colore qui est la vie elle-même conquise, envahie, brimée par la ligne, puissance magique du mal

et des ténèbres, terrible, parce qu'elle tue.

De la situation des formes figuratives et de l'enchantement que l'homme ressent à séparer le dessin de la couleur qui lui laisse toujours une impression vague de remords lorsqu'il ne le fait pas, naît l'écriture. Sur l'écran, défile de pièces maîtresses illustrant toujours les premiers symptômes de la naissance de l'écriture ; véritable et unique mission valable de la ligne et du dessin. Hiéroglyphes. La couleur soulagée respire et redevient pure bien que toujours prudemment compartimentée dans l'Egypte ancienne. Chaque caste a ses couleurs (rituel des couleurs). Amérique : Civilisation aztèque, toltèque, maya.

★

En Chine, la couleur semble se libérer par un truchement, une ruse (plutôt encore, ici, le caractère rituel de la couleur au quel tente à se substituer le symbolisme graphique, l'idéographisme).

La couleur envahit dans les images les surfaces avec délicatesse et le dessin semble lui être soumis pour un temps ; mais ce n'est pas par des ruses que quel temple à la couleur veut se libérer, elle le sent bien.

C'est dans la monochromie, en effet, que la peinture chinoise a excellé, notamment à l'époque des « Song ». Parfois l'artiste ajoute aux teintes plates un pointillé à l'encre qui permet d'obtenir des jeux de lumière. Les plus anciennes peintures monochromes dans un style sévère : tel le célèbre rouleau de soie, conservé au British Museum, à Londres (œuvre du peintre Koukaï-tché, IVe siècle). Ce n'est qu'au XIIIe siècle que les tons violents, rouges et pourpres, font leur apparition. Mais cependant la couleur reconnaît elle-même en lui ce clair-obscur, cette peinture délicate d'atmosphère, ces nuages de ton et de demi-ton passant sans heurt de l'un à l'autre, bien que très striés par le dessin, ce n'est pas une vraie victoire ! C'est qu'armistice et tout au plus compromis. La couleur ne veut pas d'une fausse libération. Elle veut une vraie victoire dans tout malaise.

Bientôt grâce à de telles tentatives de coexistence, la ligne arrive à se faire aimer, ou plutôt estimer, par ceux chez qui règne la paix, ce qui fait que pour qu'une histoire de l'art existe, comme une histoire des peuples, il faut simplement qu'il y ait de la guerre ! Il faut de la guerre et puis de la paix, et ensuite de la guerre à nouveau et de la paix encore — Dualité - Duel - Contraste - Opposition - Progression et évolution par comparaison et analogie.

C'est ce qu'on peut reprocher à l'art, sauf quelques exceptions, est, justement, de n'avoir été jusqu'à ce jour qu'une histoire de la couleur et de constant témoignage de l'époque. Bien sûr, bien de des génies ont vécu tout de même en véritables artistes ; c'est-à-dire plus ou moins inconsciemment transportés leur art bien au-delà, en marge de leur époque, parfois de quelques siècles, souvent en arrière d'autant.

Mais c'est ce lien invisible, cette colle qui tient tout l'univers à travers le temps qui est éternelle, qui devrait être perçu et transmis dans la création d'art. Les artistes véritables devraient être comme les prophètes de la paix, profonde et violente d'intensité, plus forte que la guerre destructrice. Aujourd'hui, la ligne s'est poursuivie jusque même dans ses retranchements les plus sûrs par cette nécessité de l'absolu à retrouver. L'évolution très rapide de ces dernières années dans la calligraphie japonaise en est la preuve, la ligne disparaît, se transforme plutôt en des formes dénuées de contours, ou presque, et remplissant toute la surface d'une manière presque uniforme.

La ligne jalouse de la couleur habitante authentique de l'espace tente de se libérer de sa condition de touriste de l'espace : le trait se dissout et envahit la surface picturale. C'est dans la découverte de la dominante toute-puissante à révéler au grand jour, l'évolution permet cette initiation qui ramènera tout dans l'ordre. Tous désirent, partout, la paix véritable : non pas ce mot plein de fausseté et malhonnête : « La Paix des Nations », mais cette paix ineffable dans la nature et dans l'homme d'avant l'intrusion de la ligne dans la couleur.

Aujourd'hui, le calligraphe japonais pourrait presque remplir de sa présence qualitative spatiale, d'une manière égale et

unie, une surface donnée, le résultat serait une dominante partout imprégnée de lui-même par son choix et sa qualité de créateur. Plus de barreau psychologique linéaire. Devant la surface colore, on se trouve directement devant la matière de l'âme.

★

L'Inde, les Etrusques, le Japon, civilisation d'Asie Mineure, Moyen-Orient, Grèce, Rome. La religion qui défend souvent la représentation figurative dans l'art, la couleur chez les Nègres ; bien montrer le « rituel ».

★

Le monde pictural chrétien : oriental et occidental.

★

Les enluminures irlandaises abstraites, le Moyen Age en Europe.

★

Les primitifs italiens, la Renaissance, pour atteindre jusqu'à nos jours, c'est-à-dire d'abord par les précurseurs de l'impressionnisme.

★

Dernier sursaut et tentative de défense de la ligne dans l'opposition Ingres-Delacroix. « La couleur, disait Ingres, alors des ornements à la peinture (il entendait dessin, composition), mais elle n'en est que la dame d'atour... »

Mais Delacroix recopiait dans son journal des observations qui l'avaient frappé : « Les couleurs sont la musique des yeux... Certaines harmonies de couleurs produisent des sensations que la musique, elle-même, ne peut pas atteindre. »

★

Très important, le concept lyrisme retrouvé.

★

Opposition entre le pouvoir rituel essentiellement colore de la couleur et le symbolisme rationalisant du graphisme.

★

L'histoire de l'art c'est l'âme de l'histoire des peuples. Les peuples heureux n'ont pas d'histoire : or, les peuples heureux sont ceux chez qui règne la paix, ce qui fait que pour qu'une histoire de l'art existe, comme une histoire des peuples, il faut simplement qu'il y ait de la guerre ! Il faut de la guerre et puis de la paix, et ensuite de la paix encore — Dualité - Duel - Contraste - Opposition - Progression et évolution par comparaison et analogie.

La connaissance du réel fournie par nos sens est à la base des expériences de l'espace ; analogue sera la notion que s'en construit l'intelligence. Bergson l'a rappelé : « La prise physique de la pensée que celle des mots ou des notions claires, défaille quand on passe de ce qui se ressent par son intensité ou sa qualité seule. Il n'y a d'idée claire ou distincte que par analogie avec les séparations de l'espace. La sensibilité pure est confuse... Elle n'est que durée : donc communicabilité. »

« L'enfant s'est couché. La chambre est obscure. Il ferme les yeux, il appuie deux doigts tendus en fourche sur ses paupières. Et il voit de grandes flammes. Il les voit et cependant elles sont là où sont les yeux, plus profondes même que les yeux. Mais il n'y a plus ni dedans ni dehors, plus d'objets, plus d'yeux. L'enfant voit, tout simplement de la couleur intense. Il ne maintenant ses mains de ses yeux et c'est un merveilleux assemblage de losanges accolés, mobiles comme de l'eau, doux comme du velours qui serait liquide et répandrait la phosphorescente lumière comme des fleurs d'arbuste dans la nuit.

Mais cette étonnante lumière n'est ni du jour ni de la nuit. Elle est immuable et pourtant tremble doucement. Elle est là dans sa tête depuis toujours. Y restera-t-elle toujours ? La couleur est plus belle que toutes couleurs vues toujours, somptueuse comme la couleur chargée des pensées du jardin, mais sans cette apparence d'étoffe ancienne moisie on ne sait où. L'enfant appelle sa mère et lui demande : « Qu'est-ce que c'est que l'on voit quand on ferme les yeux ? » Mais sa mère ne comprend pas d'abord, il explique et sa mère lui répond : « Il ne faut pas faire ça... tu deviendrais aveugle ! »

● SUITE EN PAGE 4

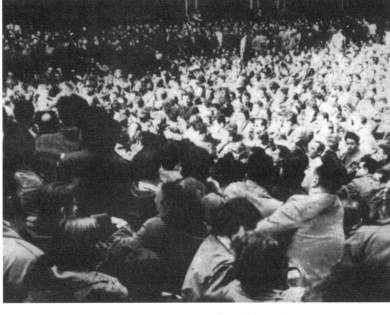

Les spectateurs assis sur la chaussée dans la rue sont contemplés par les acteurs sur les trottoirs !

La guerre (suite)

Delacroix et le réalisme romantique : Le 20 février 1824, bien que décidé à calquer pour ainsi dire la nature, il écrira : « Hé ! réalisme maudit, voudrais-tu, par hasard, me produire une illusion telle que le me figure que j'assiste en réalité au spectacle que tu prétends m'offrir ? C'est la cruelle réalité des objets que je fuis quand je me réfugie dans les sphères des créations d'art. »

« Malheur au tableau qui ne montre rien au-delà du fini. Le mérite du tableau est l'indéfinissable, c'est justement ce qui échappe à la précision. » Qu'est-ce donc ? « C'est ce que l'âme a ajouté aux couleurs et aux lignes pour aller à l'âme. » Delacroix cherchait l'expression totale de lui-même dans la couleur.

Mais là où il se trompe et où il y a confusion du sens du mot âme, c'est quand il ajoute : « L'âme raconte et dessinant une partie de son art essentiel. Il ne s'agit plus de l'âme lorsque l'on parle de dessin et là le XXe siècle fera le point. Il s'agit du subconscient, c'est très différent. Et quand il dit : « C'est en toi qu'il faut regarder et non autour de toi », c'est juste, mais attention : en nous se trouve une partie essentielle, la seule vraie vie et même vitalité que nous possédons, c'est l'âme, le reste n'est que le réalisme, celui que tout le monde entend comme tel et qui n'est que l'éphémère. Le subconscient, l'intellect, la sensualité, etc., etc.

★

C'est tout de suite après l'époque appelée « réalisme » que s'accomplit la révolution picturale qui va amener par la suite enfin au grand déchirement du voile du temple de l'art. Il s'agit de l'impressionnisme.

L'impressionnisme sera une révolution technique. Sans qu'il faille exagérer sa portée, comme on l'a fait, l'importance des théories d'un Hood ou d'un Chevreul sur la vision colorée. Les impressionnistes étaient, pour la plupart, fort incapables de la suivre, l'idée était dans l'air, dirons-nous... Il reste que ces peintres ont été frappés par les ressources que leur offrait la décomposition de la lumière en couleurs élémentaires par le prisme. Ils ont compris que deux couleurs juxtaposées pouvaient se confondre pour l'œil en s'exaltant réciproquement, tandis que leur mélange offre un aspect lourd et terreux. Ils ont précisé, dès lors, l'emploi de leur pure et franchement claire. Quelques-uns même ont prétendu bannir le noir et ses dégradations de gris, qui, d'ailleurs n'existent point dans la nature.

★

C'est ainsi que se trame le vaste plan délibération de la couleur au XIXe siècle. Manet, Renoir, Monet, Degas. La lumière intérieure est toute couleur.

S'il est vrai que le monde physique est le reflet ou même la projection directe du monde spirituel. Alors dans ce cas, nous sommes bien libérés de ces deux aspects ou états. Mais, en tout cas, de tout temps, les époques de décadence dans toutes les grandes civilisations ont été des époques où la sensibilité : domaine émotionnel essentiellement est exclusivement humain s'est porté à son comble de raffinement et de justesse.

★

Quoi de plus délicieux pour le nouveau continent aujourd'hui qui vit de sa puissante, active et dominatrice période décadente, d'observer la vieille Europe, qui meurt immensément riche de sensibilité, débarrassée de toute matérialité et spiritualité.

Quel immense grand corps humain elle représente. L'Europe ça, bien de la « chair » pure, gorgée du sang des civilisations passées et muette de bonheur intérieure. Nous deviendrons rapidement des anthropophages.

« Le peintre de l'avenir sera un coloriste comme il n'y en a jamais encore eu... » Cela vous dans une génération plus loin, Van Gogh prévoyait la monochromie.

Dans l'œuvre de Van Gogh, la couleur a une valeur plastique qui révèle une vision nouvelle de l'espace, on sait que cette même couleur était, pour ce génial Hollandais, le langage et le symbole direct de sa sensibilité.

★

J'ai ressenti, devant n'importe quel tableau qui vit et parle, bien sûr, une sensation d'être emprisonné, de voir, derrière les barreaux constitués par le des- sin du tableau, la vie d'un monde coloré, libre et vrai.

C'est, je crois, dans ce sens que Van Gogh voulait être délivré par l'alchimie de la peinture « de je ne sais quelle cage horrible ». Ce que je peux supporter dans ma condition physique d'homme, c'est d'habiter une maison aux fenêtres sans barreaux, alors ainsi la vie est supportable.

Tout cela fera bien rire ceux trop nombreux qui croient que la solution se trouve dans l'équilibre. L'équilibre du dessin et de la peinture. L'équilibre est un tour de force qui réclame une constante attention pour ne pas tomber à la moindre faute. C'est une fausse solution horrible qui garde les gens aveugles toujours, pendant qu'ils s'attachent, avec d'infinies précautions, à bien peser le pour et le contre de tout, ils ne voient pas et passent à côté de la vraie vie.

★

Et c'est ainsi qu'un nouveau déluge ravagera bientôt l'espèce humaine en quête d'équilibre et qui ne le trouvera jamais parce qu'il n'y a pas à être trouvé : la destinée de l'homme c'est sa chair, sa vie.

★

Il est à remarquer dans l'art que dès que les événements s'assombrissent, il y a toujours renaissement des lignes sur le tableau. Les années difficiles de n'importe quelle vie de civilisation ou même simplement encore à l'échelle de la vie humaine et individuelle, sont striées immédiatement et obscurcies de lignes dans leur art pictural. Pour en revenir à l'équilibre, c'est une position qui ne vaut rien, c'est dans son élément, dans sa race, dans son sol et dans sa dominante qu'il faut rechercher la vie et la paix : la dominante humaine est colore, toute une immense évolution à travers les âges le prouve et tend vers la découverte du mystère de la couleur.

★

Van Gogh 1865 : « La couleur par elle-même, exprime quelque chose, on ne peut s'en passer, il faut en tirer parti : ce qui est beau, vraiment beau, est vrai également. » C'est une tendance organique venant du plus profond de nous-mêmes qui nous pousse aujourd'hui tous à redécouvrir la couleur, notre vie.

★

Le dessin dans la peinture, c'est de l'écriture autour d'un état d'âme ! Cette écriture explique et décrit des absurdités et qui ne le trouvera jamais parce que l'éphémère superficiel et sans âme de l'homme s'exprime dans les absurdités et ce complexe engrenage, le roit au chevalet de la vie.

Van Gogh à Théo (lettre 459) : « Les peintures sont leur vie propre qui vient entièrement de l'âme du peintre. » En somme, un peintre est un homme qui, consciemment ou non, dépose sa propre âme en s'extirpant, avec ou sans douleur, ou avec joie, pour chaque tableau, des lambeaux pour la transformer, par l'alchimie de la peinture (génie créateur) en matière de l'âme éphémère périssable et physique.

Jean - 6 - 53 : « En vérité, je vous le dis, si vous ne mangez la chair du fils de l'homme ou si vous ne buvez son sang, vous n'aurez point la vie en vous-même... »

Tout au long du ballet... apport éventuel de grands coups de vents, chauds, froids ou tempérés — odeurs.

Projet de ballet sur aspect de fugue et choral

(écrit en collaboration avec Jean-Pierre MIROUSE, 1959)

L'idée essentielle de ce ballet en trois mouvements est un aspect de fugue musicale, chorégraphique, chromatique. En effet, de strictes correspondances lient ici ces trois disciplines. Sur l'écriture d'une fugue à quatre parties sera exactement subordonné et synchronisé le mouvement d'un ballet, composé de quatre groupes de danseurs, une autre groupe de couleur différente étant attaché à l'une des voix et à l'autre des voix et l'explosion tantôt principale, tantôt mineure.

De même une représentation picturale, en quatre couleurs, interviendra dans le décor : ainsi à l'entrée de chaque partie se juxtaposent sur la même forme commun l'entrée d'un groupe de danseurs et l'apparition d'une couleur la même que celle des danseurs sont semblables et simultanées, coordonnées d'une façon rigoureuse à la voix correspondante de la fugue.

Exemple : Chaque fois qu'une voix imite son sujet d'entrée au cours de la fugue, les danseurs attachés à la voix imitent les phases de leur mouvement d'entrée dans le décor.

Un son monoton et tendu, se faisant entendre seul au début et à la fin du ballet, se soutient par les discontinuité durant la fugue et le choral. Ce son monotone et tendu se faisant en « contrepoint » ainsi que le rigoureux et inéluctable développement de la fugue tendront à créer un étincelant climat de tension aussi bien dans la libération que dans la pureté vivante d'un choral. Les danseurs, pour avoir le courage conscient de s'engager dans la composition, à partir d'éléments simples et premiers, auront gagné, au sortir de ce complexe engrenage, le rivoir au choral de la vie.

Le décor informel s'organise en paysage de connaissance par lequel s'évaderont quatre danseurs. A ceux qui se sont soumis sans conscience, prostrés pendant le choral, ne s'offrira qu'une solution : celle de suivre à rebours l'irrémédiable processus qui leur a donné un instant la vision de ce qu'ils auraient pu être.

La même fugue alors, comme si l'on inversait le sens de sa marche, entrera dans sa phase de destruction homothétique, suivant une simplification inexorable dans son expression musicale, chorégraphique et chromatique.

DÉTAIL. — Le lever du rideau découvre une scène semi-circulaire, d'une seule paroi scintillante de blanc, presque éblouissante, de telle sorte qu'on ne puisse distinguer aucun angle, ni avoir connaissance de la profondeur du plateau, des dimensions, ni celles de la scène.

Son monocton grave. Entrée de la première voix. Entrée linéaire de quatre danseurs.

Entrée réponse de la seconde voix. Entrée de quatre danseurs bleus : fulgurance bleue dans le décor. Composition bleue — blanche sur scène et dans le décor.

Entrée de la troisième voix — fugue à deux parties — deuxième sujet. La « tête » de ce sujet a la même allure que la tête du premier, et entre consécutivement au rappel du premier sujet.

Entrée linéaire de quatre danseurs or.

Fulgurance or dans le décor. Brève fugue à trois parties, composition blanche-bleue-or.

Entrée réponse de la quatrième voix.

Entrée linéaire de quatre danseurs roses.

Fulgurance rose, composition blanche-bleue-or-rose.

Fugue à quatre parties.

La fugue devient de plus en plus serrée, « stretto » au fur et à mesure qu'elle se démultiplie et se développe.

Crispation chorégraphique, danse à deux, particulière, application, à reprendre la musique en fourmillement.

Le rythme de la composition chromatique double, effet de crépitement visuel.

Deuxième partie

Arrêt de la musique sauf le son monoton grave.

Choral.

Effondrement immobile des danseurs, les quatre danseurs étoiles dansent seuls le choral dans le paysage.

Les couleurs tremblent et s'organisent en un paysage très simple dont l'objet principal sera un feuillage de quatre troncs d'arbres, en carré, dont les rameaux se mêlent en un nœud dans la voûte de la scène quart-sphérique.

Au moment où les danseurs s'engagent dans le carré végétal, l'obscurité totale se fait sur scène, on ne perçoit aucun son. (Durée à déterminer d'après les conditions harmoniques de l'ensemble.)

INDICATIONS

De la musique : Ce ballet ne relient de la fugie d'école dans son écriture, que la composition formelle.

Exposition, sujet au 6e degré, réponse au 3e degré, 2e divertissement, sujet au 4e degré, transition, sujet au 2e degré, divertissement. Mais le sujet est long et atonal, les altérations peuvent chromatiques comme chromatiques. La fissure contrapunctique du sujet est en hauteur dite principale et les rapports de cette figure avec celles des réponses et des autres sujets seront conformes, sauf évidemment du point de vue de la tonalité. D'autre part, les entrées de la troisième et quatrième voix seront imitées en fugue à deux, trois, puis quatre voix.

De la chorégraphie : Trente-six danseurs répartis en quatre groupes de neuf, chacun en un costume classique (tutus et collants), les quatre groupes sont juxtaposés sur la même forme commun ; blanc, bleu, or, rose. Pour chaque danseur d'un même groupe, les figures seront semblables et simultanées, coordonnées d'une façon dynamique que possible.

PROGRAMME DU FESTIVAL D'ART D'AVANT-GARDE

Paris, novembre-décembre 1960

Renseignements et location : Durand, 4, place de la Madeleine ; Salle Gaveau ; Pavillon Américain, Porte de Versailles ; Unesco ; Musée des Arts décoratifs ; Galerie des Quatre Saisons ; Studio Raneiagh ; Alliance française ; agences et S.V.P.

Mercredi 16 novembre : U.N.E.S.C.O., 21 h. - Théâtre (à l'occasion de l'ouverture de l'Assemblée générale de l'U.N.E.S.C.O. : « Chitra », mise en scène : Sylvain Dhomme ; architecture scénique : Claude Parent.

Vendredi 18 novembre : Pavillon américain, porte de Versailles, 18 h. - Arts Plastiques, vernissage-exposition* : Décors pour un spectacle imaginaire : Fautrier, Rotaud, Soulages, Schneider - Bioc, Gilioli, Hajdu, Kémény, Kostec, Martin, Neveloon, Seuphor, Stahly - Aldine, Bellegarde, Bertrand, Guitet, Sato, Stein, Neubauer, Di Teana, Mathieu, Michaux, Bryen. - Nouveaux réalistes : Arnal, Arman, César, Dufrêne, Hains, Raysse, Rotella, Spoerri-Feinstein, Villeglé, Y. Klein - Estivals, Isou, Lemaître - Art et mouvement : Agam, Bury, Kramer, Mack, Malina, Piene, Rot, Soto, Tinguely, Uecker - Architecture : Sermanon, Gillet, Neutra, Van der Roche, Schein.

Lundi 21 novembre : Musée des Arts décoratifs, 21 h. - Cinéma*, films de formes animées : Rétrospective Hy Hirsh.

Mardi 22 novembre : Galerie des Quatre Saisons, 21 h. - Anthologie de la Poésie phonétique - Altagor : Artaud, Ball, Beaudouin, Bryen, Dufrêne, Hausmann, Heidsieck, Dinah, Isou, Khlebnikov, Lemaître, Monfuc, Morgenstern-Pomerand, Schwitters, Seuphor, Wolman.

Mercredi 23 novembre : Ranelagh, 21 h. - Cinéma*, films récents de peintres : Lapoujade, Viseux, Ian Hugo, Alechinsky, Kamler, Reuterward, Brisoot.

Jeudi 24 novembre : Galerie des Quatre Saisons, 21 h. - Poésie d'aujourd'hui : Artaud, Beckett, Michaux, Tardieu, Luca, Bonnefoy, Weingarten, Lambert.

Vendredi 25 novembre : Ranelagh, 21 h. - Théâtre expérimental (I) : Ballet théâtre mécanique de Kramer.

Samedi 26 novembre : Galerie des Quatre Saisons, 21 h. - Au plus récents poètes, dont la poésie est en cours : Borne, Chaulot, Candid, Depierris, Dumontet, Em-

manuel, Follain, Guillevic, Humeau, Looten, Manoll, Ménard, Miatlev, Norge, Piel, Rousselot, Sabatier, de Soler, Tortel.

Dimanche 27 novembre : Paris, 0-24 h. - Théâtre du Vide : Yves Klein, le Monochrome présente le dimanche 27 novembre.

Lundi 28 novembre : Musée des Arts décoratifs, 21 h. - Conférence : Richard-J. Neutra : Architecture et scénographie (A propos du Congrès de Berlin).

Mardi 29 novembre : Salle Gaveau, 21 h. - Concert de musique contemporaine : Cardew, Berio, Webern, Amy, Artig,, Meslam.

Mercredi 30 novembre : Musée des Arts décoratifs, 21 h. - Théâtre, Allemagne : Paul Portner - Variations pour deux acteurs.

Jeudi 1er décembre : Galerie des Quatre Saisons, 21 h. - Théâtre expérimental (II) : Isou, Almuro. Estivals.

Vendredi 2 décembre : Galerie des Quatre Saisons, 21 h. - Colloque confrontation « Art et Science » : Le Lionnais.

Mardi 6 décembre : Musée des Arts décoratifs, 21 h. - Cinéma : films de science-fiction et les plus significatifs présenté par Pierre Kast.

Mercredi 14 décembre : Galerie des Quatre Saisons, 21 h. - Théâtre. Pologne : Miron Bialoszewski Mime et poésie.

Jeudi 15 décembre : Pavillon américain, porte de Versailles, 21 h. - Théâtre, Jacques Polieri : Dispositif scénique mobile : Rythmes et images. Sculptures de Brancusi. Adam, Jacobsen, Colvin, Pevsner.

Les programmes sont donnés sous réserve de modifications.

* L'exposition sera ouverte tous les jours, du 18 novembre au 15 décembre 1960, de 11 à 18 heures.

* Les programmes cinématographiques seront donnés tous les jours, à 20 heures, au « Ranelagh » à partir du 23 novembre 1960.

La marque de l'immédiat

En 1953, je propose à un producteur de cinéma à Tokio de tourner un petit film en couleurs sur un voyage visuel mystico-réaliste et très contemplatif mais aussi dynamique que possible. Il s'agit de montrer à la fois, la surface des différentes matières attachés à la voix imitent les phases de leur mouvement d'entrée dans le décor montrer aussi leur vie profonde plongée dans le sommeil intégrant mais bien réveillée en fait.

Je veux montrer l'homme dans la nature par les traces et les marques qu'il y laisse malgré lui et qui sont toujours d'une grandeur merveilleuse, artificielle, éphémère et pourtant indestructible à jamais.

La caméra remplace les yeux d'un promeneur qui s'assied un moment au bord d'une plage accompagné d'une très belle fille à la chair vibrante, qui se déshabille pour s'allonger dans le sable à ses pieds dans le soleil d'un été torride.

Ce promeneur lève alors les yeux à la verticale et contemple le ciel bleu pur et sans nuages.

Puis, ses yeux descendent lentement jusqu'à l'horizon en parcourant cette sorte de surface volumétrique, transparente et utile bleue, pour finalement s'arrêter un instant sur la ligne d'horizon entre les deux éléments, l'air et l'eau bleue.

Parcourant ensuite la surface de la mer jusqu'au rivage, le regard se pose sur les vagues du bord de la plage. Puis ses yeux parcourent la plage pour rejoindre à ses pieds le corps de la belle fille allongée dans le sable paresseusement.

Là, évidemment, inspection du corps de la fille en détail.

Ensuite, arrêt illuminé du regard sur la peau elle-même. La peau aussi vue de très près comme au microscope avec les petits poils, les pores, éjectant la transpiration et semblables à de mystérieux petits volcans, quels le frémissement général de la peau, son haletement, tout cela observé de très près.

La tension nerveuse monte et devient rapidement une tension sensuelle, il fait très chaud.

Le regard cherche alors à respirer et se promène au faîte des arbres, dans les feuilles. Il voit les feuilles de très près avec leurs nervures, et très bien ; sa sève circuler sous le vert calme.

Les yeux descendent le long du tronc de l'arbre, voient l'écorce de très près, les insectes microscopiques, puis c'est le sol, les pierres, l'herbe.

Le regard vient maintenant tout près des pieds du promeneur. Là, il voit le, les tout petits mégots de sa cigarette qui s'éteint.

Inspection microscopique de ce sol : il est couvert d'une sorte de rosée comme les feuilles et les troncs des arbres d'ailleurs. Tout semble transpirer, pourtant l'air est sec, il fait toujours très chaud.

C'est alors que je réaliserai mon rêve de toujours : devenir journaliste-reporter !

Soudain le vent se lève.

Le regard se porte au ciel d'un seul coup, inquiet, il voit quelques nuages.

Le regard redescend sur le corps de la fille nue allongée.

Le vent alors redouble et soulève un nuage de poussière. La poussière se colle au corps en transpiration de la belle jeune fille et se mélange à la sueur.

Je sors alors un grand mouchoir blanc de sa poche et l'applique avec délicatesse sur la peau de la jeune fille pour essuyer de cette fine boue qui s'est formée en un instant à la fleur de sa peau.

Quand il retire, le grand mouchoir blanc, il y a une empreinte qui s'y trouve : l'empreinte du la chair !

Le vent est nerveux et prend une serviette pour s'essuyer encore. Empreintes en mouvement sur la serviette blanche.

Le promeneur regarde son mouchoir marqué puis le jette par terre.

La fille regarde sa serviette marquée et la jette à terre aussi.

Le promeneur intrigué sort un grand mouchoir et prend prudemment l'empreinte du sol à la même place où la poussière s'est déposée. Puis il regarde cette empreinte et va prendre successivement l'empreinte de l'écorce de l'arbre et d'une feuille. Il regarde chaque fois émerveillé le résultat imprimé sur son mouchoir blanc. Puis il jette le mouchoir qui va s'accrocher aux bout des branches d'un petit buisson.

La fille se sent mal à l'aise ; se lève et court plonger dans le sable.

Le promeneur voit alors l'empreinte du beau corps dans le sable.

La tension sensuelle monte à nouveau.

Les yeux se portent encore une fois au ciel d'un seul coup pour essayer de se distraire. Ils rencontrent le soleil de face et éblouissant.

Le promeneur supporte un instant la terrible lumière, puis il fait retomber son regard sur la plage ; la même, l'arbre, et les linges qui traînent par terre à présent.

Un coup de vent de nouveau. Dans le paysage sauvage où les yeux du promeneur volent un peu en négatif après avoir été éblouis par le soleil ou vu de face ; les mouchoirs et la serviette qui traînent par terre, si artificiels dans cette grande nature, ils roulent sur le sol sont emportés par le vent en tout sens folle et déséquilibrée vers nulle part.

La fille sort de l'eau ruisselante et court se coucher de nouveau le plage ; la même, l'arbre et le linge qui traînent par terre.

Ils s'étreignent et s'allongent dans le sable.

Là c'est un flash de fugue amoureuse et de confusion des deux corps qui luttent.

La fille domine et se retrouve à cheval sur le promeneur couché sur le dos qui voit de nouveau le ciel, cependant cette fois, morceau de soleil aussi dans le côté de l'image qui s'offre à lui. Longtemps il regarde émerveillé le ciel taché du nuage et illuminé par un morceau de soleil.

Puis le regard se porte à l'horizon car le promeneur et la jeune fille sont debout à présent et s'apprêtent à s'en aller. Le promeneur regarde derrière lui dans le sable : l'empreinte de leurs étreintes et de leur combat sensuel est là.

Il lève les yeux au ciel et le ciel est de nouveau bleu pur et sans nuages comme au début du film.

La statue

Lorsque je serai enfin devenu comme une statue par l'exaspération de mon mol qui m'aura amené à cette sclérose ultime. Alors, alors seulement, je pourrai mettre cette statue en place et sur de mol dans la foule pour aller voir le monde, enfin. Personne ne s'apercevra de rien car ils regarderont tous la statue et moi je pourrai me promener, enfin libre...

Le sommeil

Le rideau se lève sur une scène, là se trouve une chambre, un grand lit, dans ce lit un homme dort. L'acteur qui remplira ce rôle chaque soir devra se crever de fatigue toute la journée pour dormir effectivement dans son lit sur scène au lever du rideau. Tout le monde le voit dormir pendant dix minutes environ, puis rideau.

Le tout se sera passé en silence et surtout pas d'applaudissement aucun, de peur de réveiller l'acteur qui est très fatigué et besoin de dormir.

Renversement

Il serait peut-être intéressant de donner une fois une pièce de théâtre quelconque, à l'envers.

Je veux dire que toute la pièce serait jouée par les acteurs la tête en bas, les pieds en haut, au plafond ; cela par quelques trucs, doit être possible aujourd'hui. Tous les meubles seraient aussi au plafond qui serait en somme le plancher, et par terre le plancher, le décor du plafond, c'est-à-dire par exemple : un lustre accroché solidement qui léviterait statique dans l'espace.

COMBAT et PRESSE DE FRANCE réunis, 18, rue du Croissant, PARIS 2e

Travail exécuté par les ouvriers syndiqués.

Directeur-gérant : Yves KLEIN.

Traces of life

'Bas-reliefs dans une forêt d'éponges'

In June 1959, a fortnight after the exhibition of the Gelsenkirchen sketches and models, the Galerie Iris Clert again opened its doors to Yves Klein. Under the heading 'Bas-reliefs dans une forêt d'éponges' ('Bas-Reliefs in a Forest of Sponges'), the painter presented his best sculptural pieces. This new demonstration of his art was based on a sustained use of natural sponges.

For several years, Klein had been endeavouring to render palpable the immaterial in everything – the fundamentally dynamic void. His blue had lost its substantiality. Its materiality had evaporated. Only a trace of it remained, a vital, intangible essence, a breath. In using natural sponges in his work, Klein stood his method on its head. Yet his goal – the plenitude of sensible space – remained unchanged. Unlike the monochrome paintings, the sponges did not signal the disappearance of the visible. On the contrary, they were dense and heavy, filled with substance. The sensation of plenitude no longer stemmed from an ineffable presence but from the 'corporeity' of sheer matter. In this sense, Klein could be compared to Jean Dubuffet, Alberto Burri and Antoni Tàpies.

Klein did not use sponges to absorb liquids, clean or spread paint; he did not use them as paintbrushes. He merely regarded them as a raw material. Once it was positioned on the surface of a painting, a sponge ceased to be a utilitarian object and acquired an aesthetic value that contrasted singularly with its nature. Is anything more banal than a sponge? In 1962, Klein, no stranger to such deliberate reversals of meaning, exhibited industrial paint rollers soaked in blue paint: the instrument was a material.

'When working on my paintings in my studio I sometimes used a sponge. Naturally, it would very soon turn blue! One day, I became conscious of the beauty of the Blue in the sponge, of that extraordinary capacity of the sponge to soak up anything – in this instance Blue!'

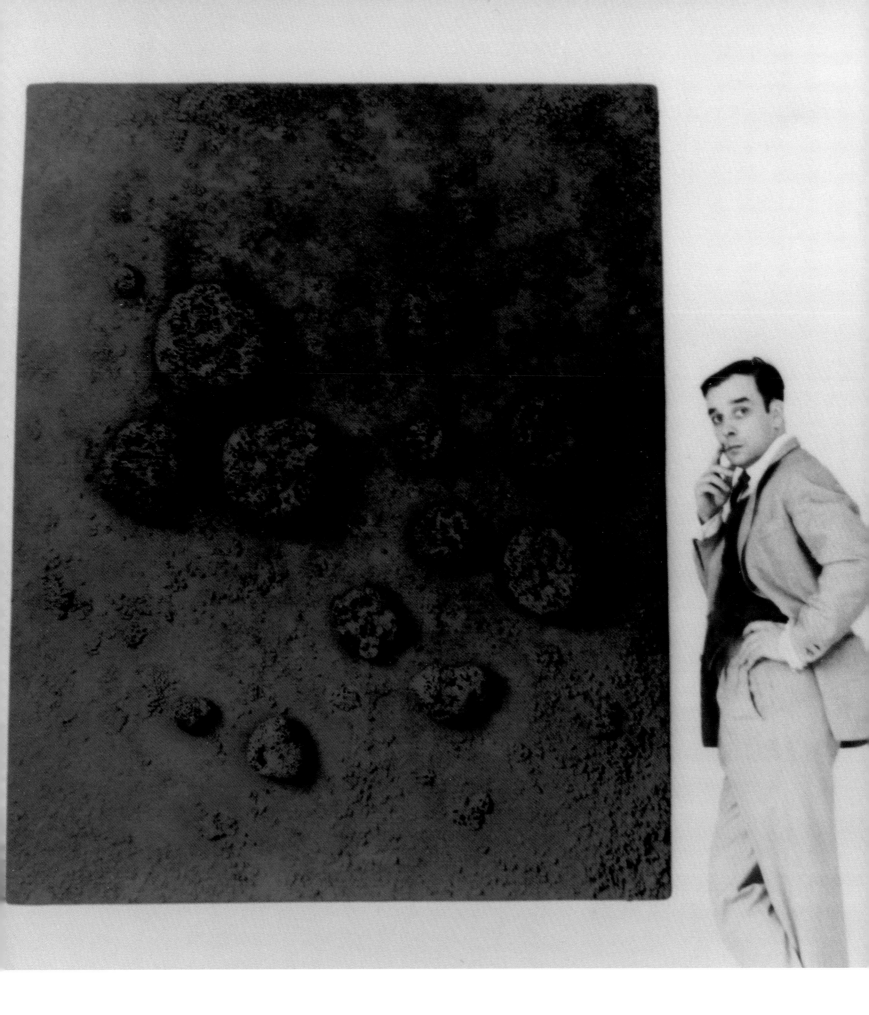

**Yves Klein standing in front
of a sponge relief (RE 10).**
Museum Haus Lange, Krefeld, Germany.
14 January 1961.

The aesthetic of saturation

Were the sponge reliefs – those hybrids of readymades and monochromes – that succeeded the Gelsenkirchen panels something entirely new in Klein's aesthetic? Firstly, the thickness of the pictorial crust in high relief clashed with the concept of a gradually disappearing colour. Secondly, unlike the uniform monochromes, no two Klein reliefs are identical. The unicolour principle still held true, but now shapes could be made out emerging from the original IKB matrix. The shift from a flat treatment to three-dimensionality engendered figures. In short, composition, banned from Klein's earlier work, was now returning to haunt the surface of the painting. Yet there was no break between the spectator's perception of the sponge-reliefs and his perception of the monochromes. In fact, the reliefs gave the impression that they were enlargements of the monochromes' content. The magic of 'colour' had simply gained more power. Are we to conclude that the sponge reliefs were really super-monochromes?

Indeed, the formless materiality of the reliefs was not an end in itself; it was phenomenal as well. Like the human body filled with blood, the sponge gorged with fluid paint is both an object and a process, form and motion. Likewise, blue is 'darkness becoming visible' – an apparition. The monochrome aesthetic is an aesthetic of displacement from colour to sensibility, from blue to the void, from fire to ashes, water to vapour, being to trace, exterior to interior. Like a human being, the sponge is at once an object and a phenomenon of saturation. Matter in its raw state – whether pigment, human body or natural sponge – comes to life in proportion to its capacity for being permeated. Sensibility is the fluid of the human sponge. Once it is inhabited, the body participates in the movement of the universe.

At the iconological level of interpretation, as Panofsky defines it, the thematic of purification combines with the thematic of saturation. The two phenomena are inextricably connected in Klein's work. Just as a sponge soaked in water cleanses, sensible impregnation possesses purifying virtues. Painting and observer wash their gaze in their deep immersion in blue. The pictorial body and the human body in their substantiality are cleansed of original sin and quicken under the spirit of life. Saturation purifies and vitalises.

The conjunction of the phenomena of saturation, purification and vitalisation occurs as the human limits of space and time are dissolved. Colour's permeation of the panel's depth is echoed by the penetration of sensibility into human depth. Invisible, impalpable and immaterial, the latter can be thought of as a fourth dimension. Inner space expands beyond 'the meagre possibilities of perspective in painting, "trompe l'œil", as it is so aptly termed, the sorry privilege of the impotent who feel like failed sculptors'.[1] Similarly, depth seen as a vital spirit is timeless. Its immanent presence is eternal. For the time of presence does not pass.

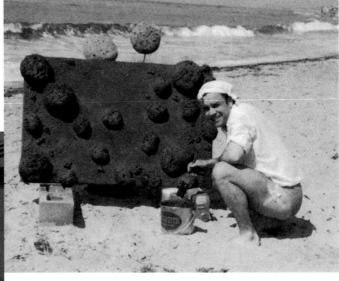

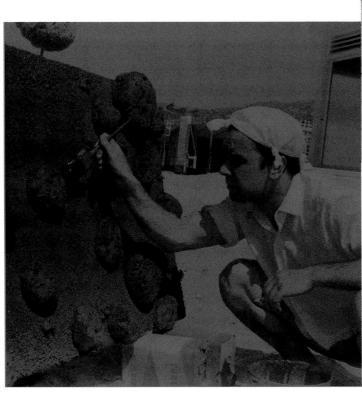

Yves Klein executing a sponge relief on a beach at Malibu. June 1961.

Le Rose du bleu (The Rose of Blue) **(RE 22).** Rose sponge relief. c.1960. Sponges, gravel, dry pigment and synthetic resin on board, 199 x 153 cm.

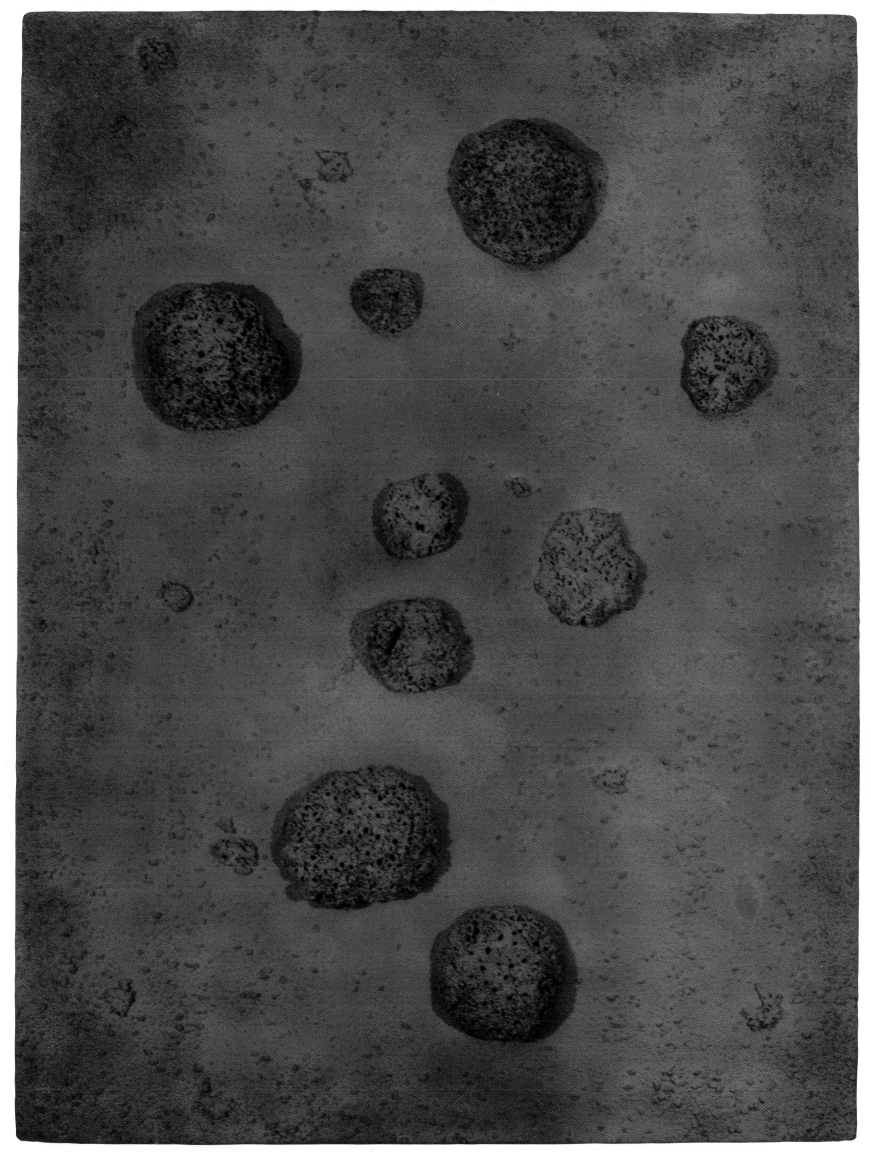

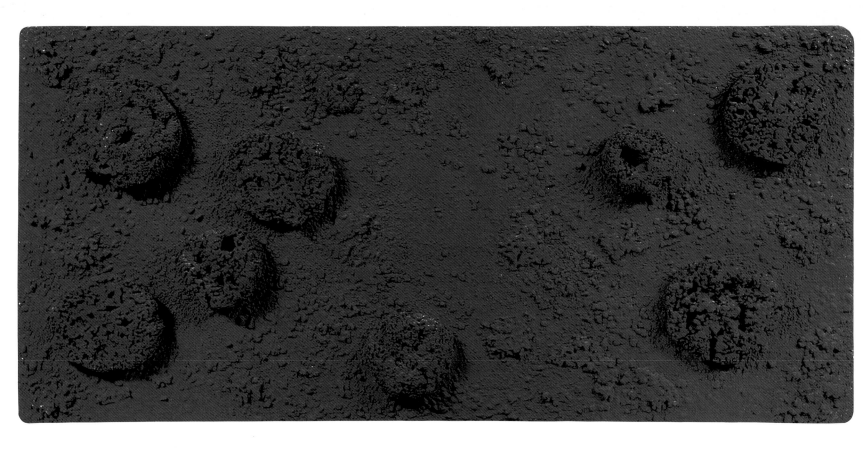

'Blue is in any case something elementary and general,

fresh and pure, pre-existing the word. It suits all that envelops and immerses.'

(Paul Claudel)

Sol (*Ground*) **(RE 48).** Blue sponge relief.
1960. Sponges, gravel, dry pigment
and synthetic resin on wood, 71 x 154 cm.
Mizne-Blumenthal Collection, New York.

Les Boules dorées (*The Gilded Balls*)
(RE 33). Monogold sponge relief (detail).
c. 1961. Gold leaf on sponges and gravel
on board, 74 x 58 cm. Private collection.

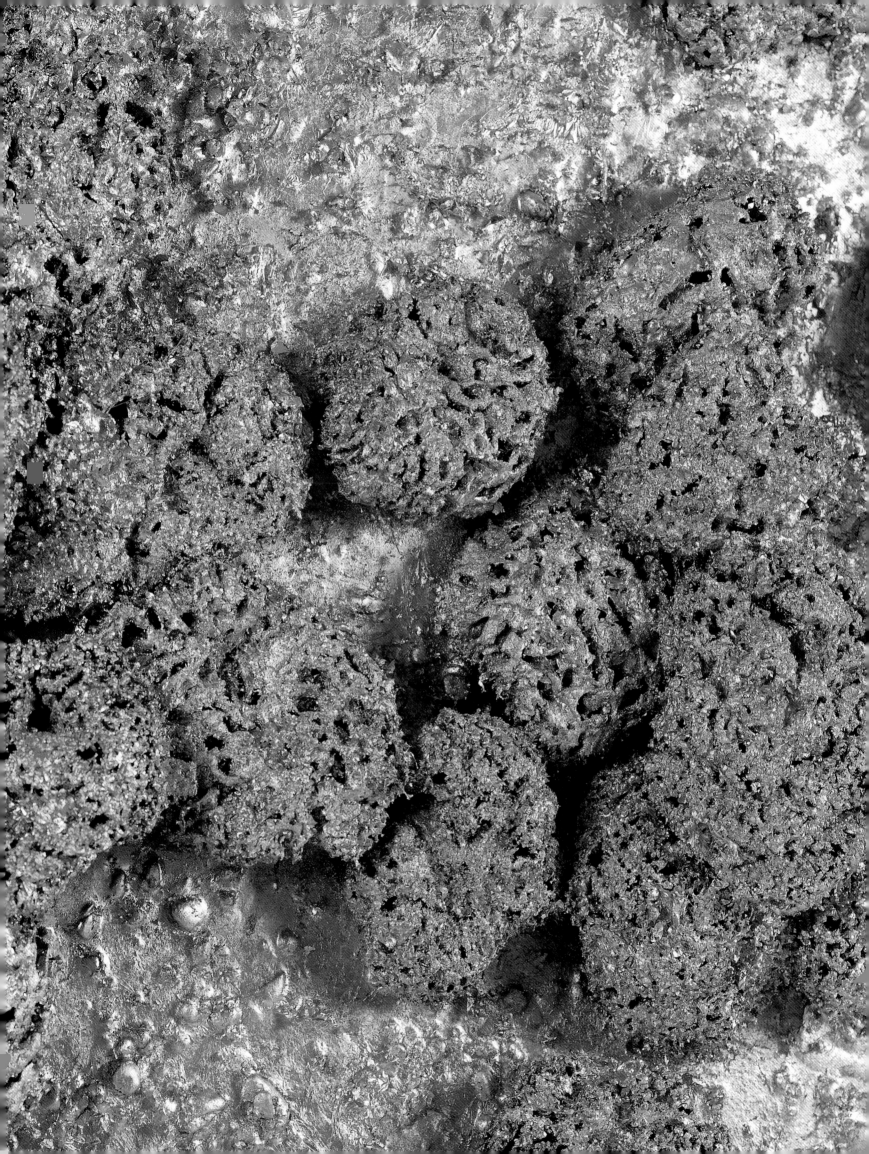

This descent into the substantiality of matter could be described as deep-sea diving. Natural sponges are gathered on the seabed, deep down in the 'Big Blue'. Klein skilfully juggles figurative allusions, yet always avoids reducing his paintings to a single interpretation. Are we observing an ocean bed or stars dancing? The spectator is free to project the images of his or her choice.

Untitled (RE 32). Rose sponge relief. 1961. Sponges, gravel, dry pigment and synthetic resin on board, 90 x 78 cm. Private collection.

Untitled (RE 19). Blue sponge relief. 1958. Sponges, gravel, dry pigment and synthetic resin on chipboard, 199 x 165 x 11.5 cm. Museum Ludwig Collection, Cologne.

Do-Do-Do (RE 16). Blue sponge relief. 1960. Sponges, gravel, dry pigment and synthetic resin on board, 199 x 165 cm. Private collection.

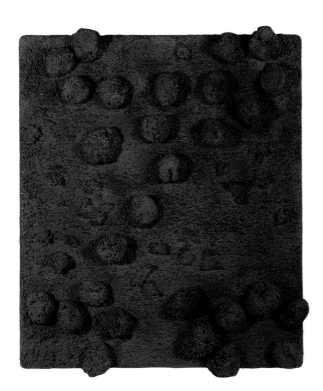

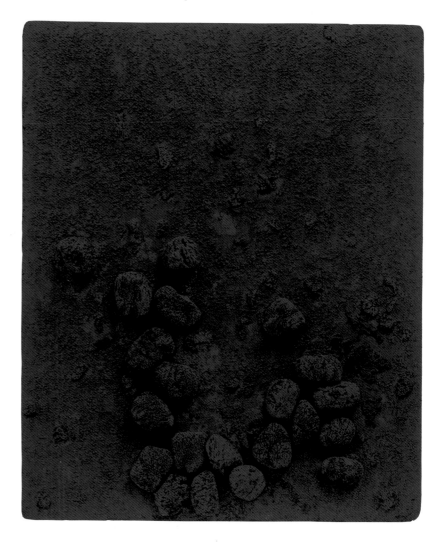

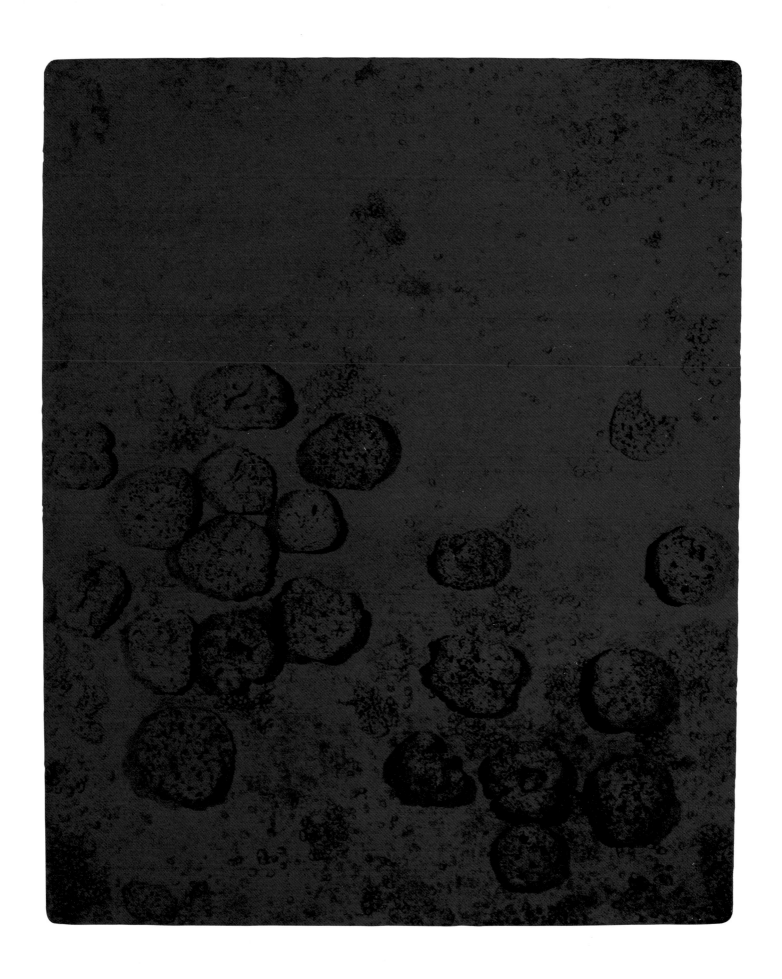

Sponge sculptures: between presence and the immaterial

The figurative displacement in Klein's *œuvre* became even more manifest with the artist's sponge sculptures (whose prototype had been exhibited at Colette Allendy's in 1957). In one of his manuscripts, Klein suggests that they should be viewed as 'portraits of the readers of monochromes, who, after seeing a Blue painting, after travelling inside [it], are totally saturated with Blue like sponges'.[2] Sponges soaked in blue were fastened to metal rods stuck in rough stone bases. They assumed an extremely broad range of shapes. The forest of sponges was like a jungle, unicolour through and through, polymorphous in its details. Klein created all kinds of sponge sculptures – small, large, round, slender, homogeneous, perforated, smooth, lumpy sponges supported by straight, bent, twisted, short, long, single or double rods inserted in white, beige, grey, yellow, ochre or brown stones.

Untitled (SE 33). Sponge sculpture. 1961. Dry pigment and synthetic resin on natural sponge, with plaster base, 42 × 37 × 20 cm. Private collection.

Untitled (SE 90). Sponge sculpture. 1959. Dry pigment and synthetic resin on natural sponge and metal rod, with stone base, 35 × 21 × 12 cm. Private collection.

Though widely differing from each other, all the sponge pieces exemplify the phenomenon of saturation. Moreover, the systematic disproportion of the volumes in each piece – large sponge mass, small base – creates an overall impression of weightlessness.

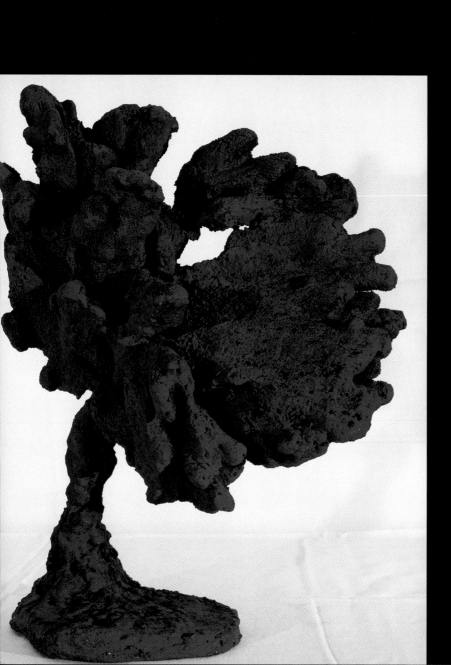

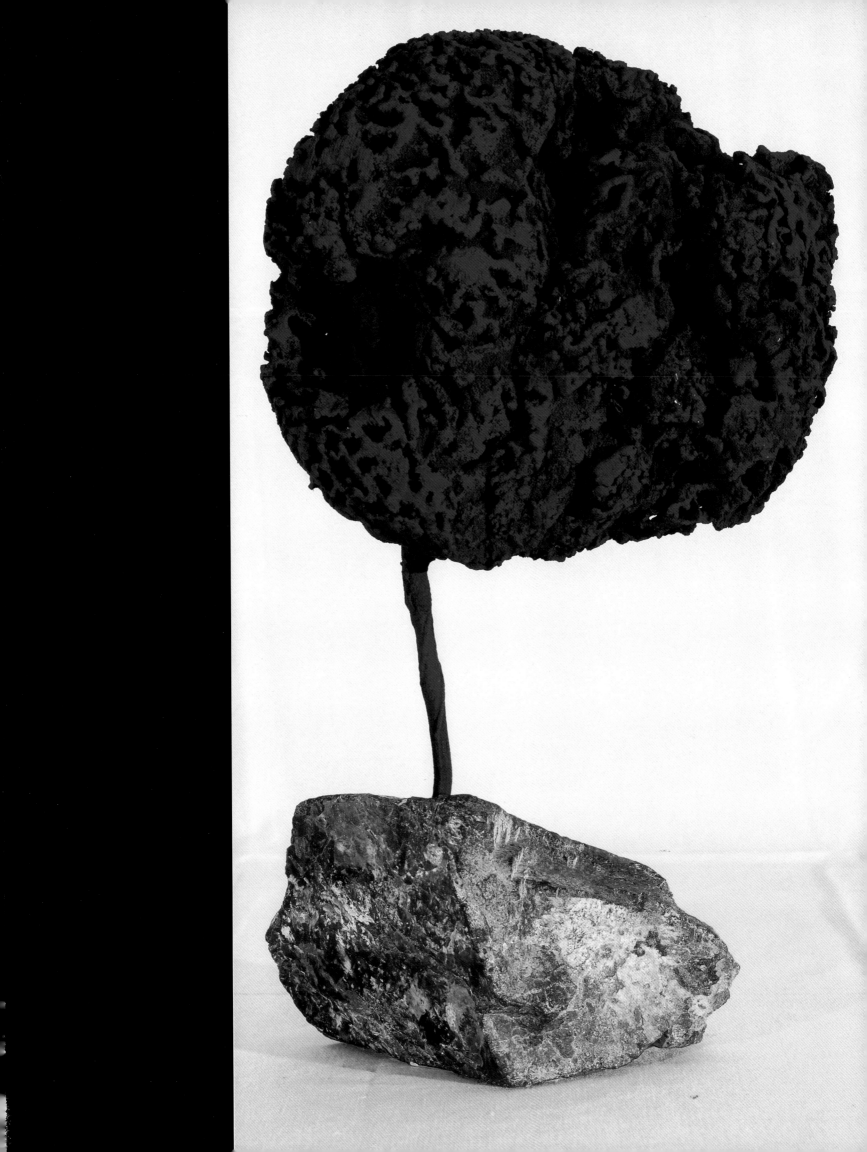

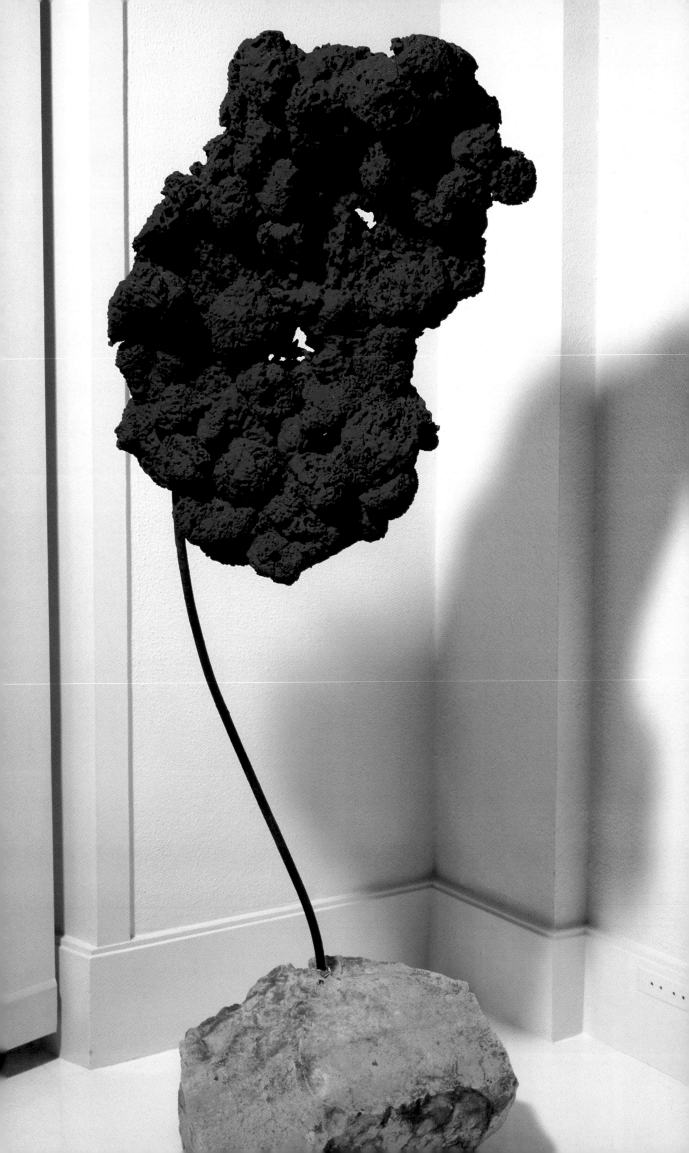

Like the artist's monochromes, these sculptures are mostly untitled, with a few exceptions. Klein played on likenesses. While the formal and nominative diversity of these pieces flouts the principle of uniformity that underlies Klein's work from the Blue Period on, it does not fundamentally alter the monochrome aesthetic. Though widely differing from each other, all the sponge pieces exemplify the phenomenon of saturation. Moreover, the systematic disproportion of the volumes in each piece – large sponge mass, small base – creates an overall impression of weightlessness. The sponges appear to be suspended in thin air.

In keeping with the monochrome aesthetic, the sponge sculptures address the issue of the material and the immaterial. Klein wanted to 'free sculpture from the base', just as he had freed colour from drawing. This meant totally rethinking sculpture. The sponge sculptures put traditional perceptions of bulk, weight and size to a severe test.

***Untitled* (SE 167).** Undated blue sponge sculpture. Dry pigment and synthetic resin on sponges and metal rod, with stone base, 138.5 x 52 x 23 cm. Private collection.

***Untitled* (SE 167).** Blue sponge sculpture (detail).

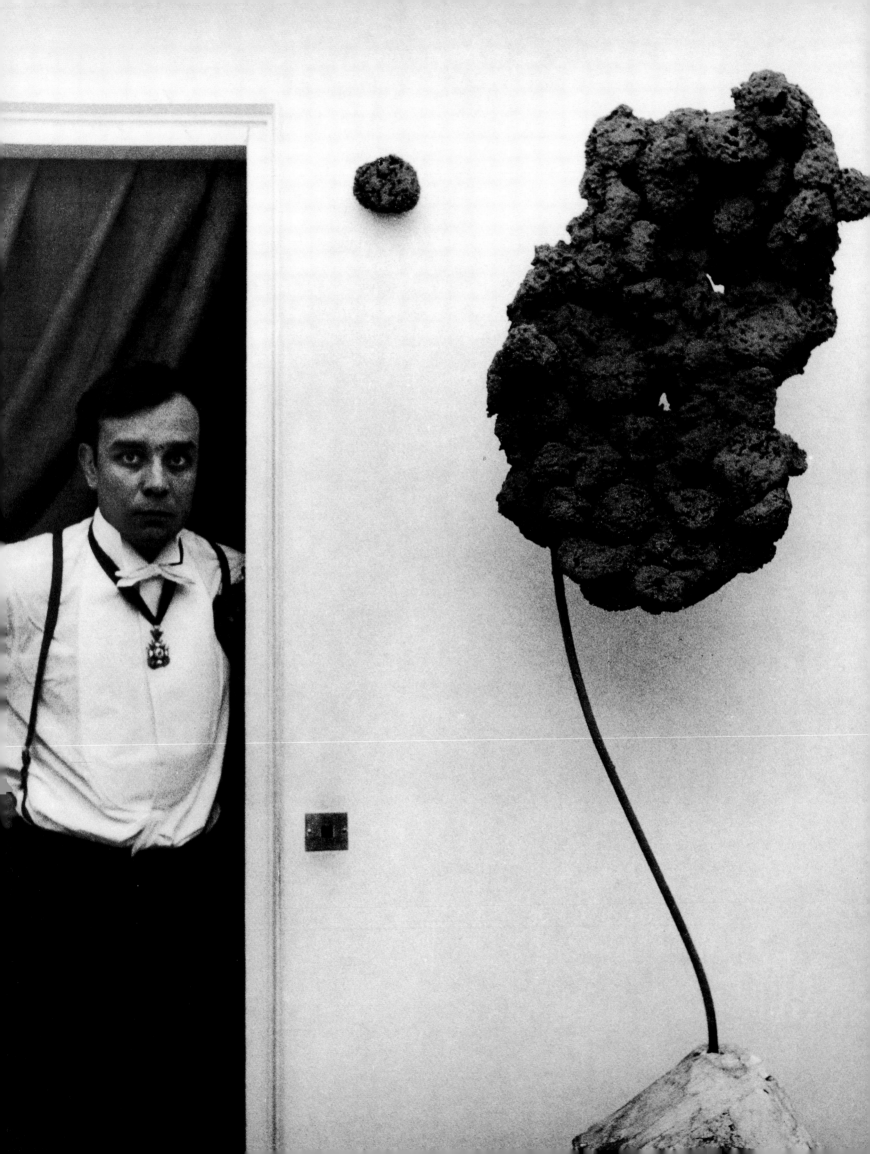

The first experiments with air sculpture were floating objects. In March 1957, *1001 Ballons bleus* (*1001 Blue Balloons*) were released into the sky above Paris. Klein subsequently worked on stabilising forces. His sponge sculptures are poised between soaring and plunging, but they are not really weightless and the metal rod that supports them is a plainly visible artifice. The air sculpture concept culminated with the invention of the 'tube lévitant' (levitating tube) and 'aeromagnetic sculpture' (April–June 1959). The principle of the latter is simple: a balloon filled with helium and a scrap of metal are inserted in a blue sponge, and a magnet is placed in the piece's base. The sponge floats in space at the point where the two opposing forces of buoyancy and magnetic attraction are in equilibrium. 'It will be pure levitation! Magnetico-aerial!' Klein trumpeted in a letter to Iris Clert.[3] Enthusiastic, confident and totally absorbed in his vision, he seems to have been incapable of distinguishing between dreams and reality. The true believer and the mutant, the man of faith and the man of the future – such are the two faces of that poet of the immaterial. Though it remained a pipedream, aeromagnetic sculpture deserves to be regarded as an integral part of Klein's *œuvre*. It was, after all, his vision of a sculpture that loosens its moorings and drifts off into space.

Yves Klein wearing the cross of the Knights of Saint Sebastian next to a sponge sculpture (SE 167) in his apartment on rue Campagne-Première, Paris. 1960.

Untitled (SE 89). Blue sponge sculpture. *c.* 1960. Dry pigment and synthetic resin on natural sponge, with stone base, 42 x 20 cm. Private collection.

Opening night of 'Bas-reliefs dans une forêt d'éponges' ('Bas-Reliefs in a Forest of Sponges') at the Galerie Iris Clert. 15 June 1959.

The forest of sponges was like a jungle, unicolour through and through, polymorphous in its details.

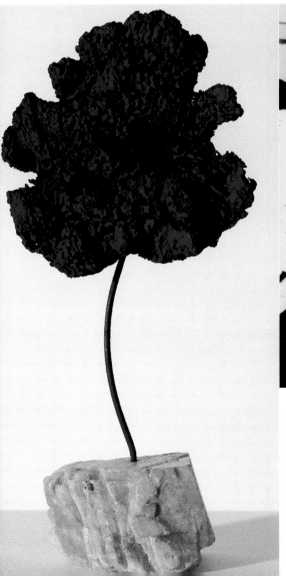

149

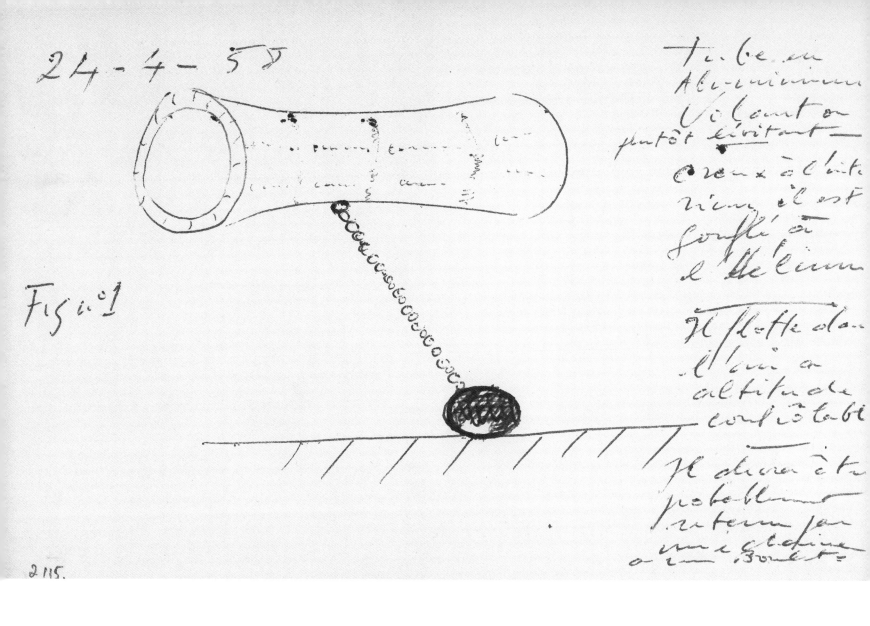

The air sculpture concept culminated
with the invention of the 'levitating tube'
and 'aeromagnetic sculpture'.

**Sketch of an aluminium 'levitating
tube'**, registered on 14 April 1959
and dated 24 April 1958. Ink on paper,
11.5 x 20 cm. Private collection.

Sculpture aéro-magnétique
(*Aeromagnetic Sculpture*). 30 June 1959,
with the annotation 'invention du mois d'avril
1959' ('invention of April 1959').
Pencil on paper, 11.6 x 21.1 cm.
Private collection.

24-4-58

Fig n°3

dans toutes
les directions

Le même
Tube
gonflé à
l'hélium
c'est flotter
librement dans
l'espace
peut-être
obligé par
des Forces
magnétiques
qui lui
impriment
des mouvements
et déplacements
dans l'espace

2115

Body prints

Imprinting session with 'living brush'
in Klein's studio-apartment on rue Campagne-
Première, Paris. 1960.

The 'living brushes' performance

Count Maurice d'Arquian opened his luxurious Galerie
internationale d'art contemporain on Paris's Faubourg
Saint-Honoré to Yves Klein on 9 March 1960. The performance
that took place that evening was meticulously organised. Klein even
thought of providing body lotion and bathrobes for his models.
Sheets of immaculate white paper were spread on the floor
of the gallery, in front of an immense blank canvas on the wall.
A monumental blue sponge relief served as a backdrop behind
a row of empty chairs reserved for a small orchestra. More chairs
were ranged at the back of the gallery for a very exclusive
audience of roughly one hundred guests. D'Arquian, a somewhat
eccentric and secretive figure in Paris high society, ran a small
stable of artists whose star was the painter Georges Mathieu.

The ambience in the gallery was discreet and elegant. Evening
dress and a personal invitation were mandatory. At 10 o'clock,
nine musicians filed in silently and sat down on their chairs,
followed by the painter wearing a dinner jacket and sporting
a white bow tie and the Maltese Cross of the Order of the Knights
of Saint Sebastian. On a signal from Klein, the orchestra intoned
a single, uniform chord that sounded as if it came from beyond
the grave. Its performance of the *Symphonie monoton-silence* was
'very lively – very taut – sustained'. The musicians played on
imperturbably as three superb naked models, their hair pinned
back in a chignon, walked across the room, each carrying a pot of
ultramarine paint, and started daubing blue paint over their faintly

glistening skin. Then, with thighs, belly and breasts coated blue,
they pressed their bodies against the sheets of paper in a solemn,
uninterrupted ballet conducted by the master of ceremonies, Yves
Klein. Without ever touching the paint or his 'living brushes', the
painter orchestrated their movements and gestures with tranquil
authority.

This body-printing ceremony carried on for twenty minutes
accompanied by the solemn low-pitched chord of the *Symphonie
monoton-silence*. Then the sound died and silence filled the gallery
for a further twenty minutes – a magical silence in which the
sustained note of the first half of the symphony continued to
resonate. The body-printing ritual assumed a religious atmosphere.
The public and protagonists were variously baffled and fascinated;
a few of the people present were deeply moved; all found
the experience exhausting. The performance ended and Klein had
a chance to regain his breath while Pierre Restany delivered
a short speech on the mythological significance of the ritual that
had just taken place.

This was followed by a discussion between Klein, Restany and the audience. Georges Mathieu, a figurehead of gestural abstraction, leapt up and demanded aggressively, 'What is art for you?' Without batting an eyelid, Klein replied, 'Art is health!', charming the audience with an impish smile. It was a luminous retort, a merciless jab at Klein's tormented inquisitor as well as a splendid formulation of the aesthetic of the 'anthropometries'[4] and, indeed, the monochrome adventure as a whole.

Guests in evening dress at the performance of 'Anthropométries de l'époque bleue' ('Blue Period Anthropometries') at the Galerie internationale d'art contemporain, Paris. 9 March 1960.

Yves Klein directing the anthropometry performance at the Galerie internationale d'art contemporain. 9 March 1960.

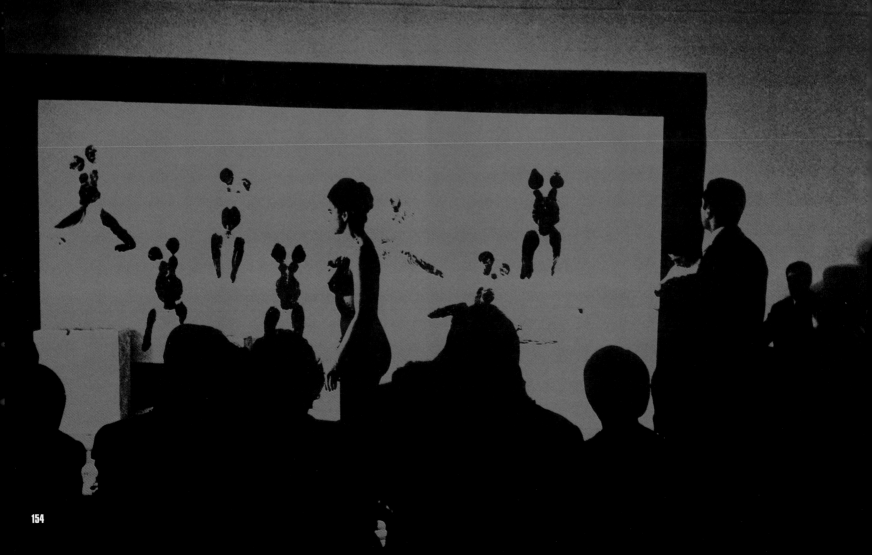

'What is art for you?'

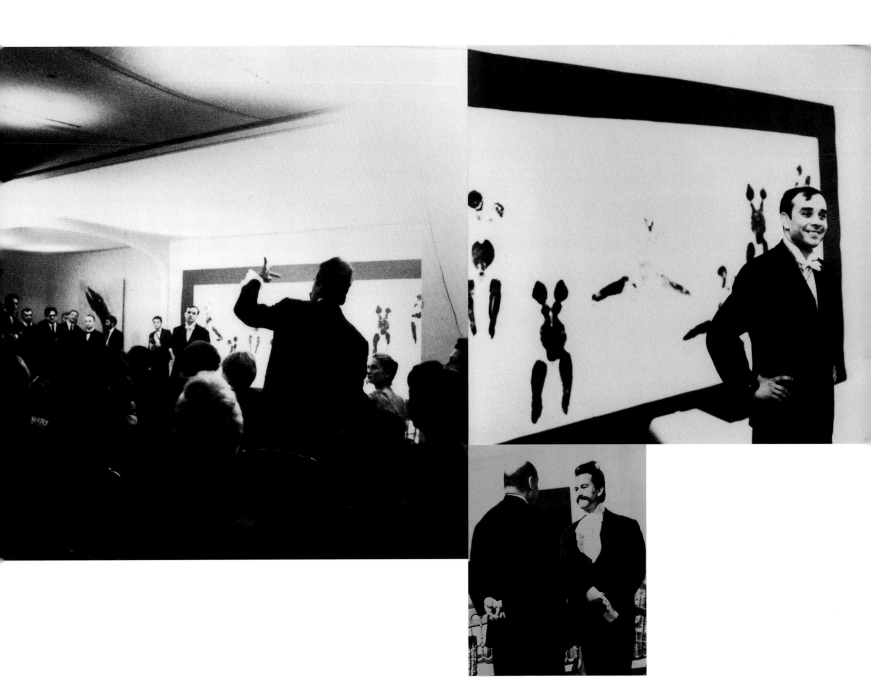

'Art is health!'

Anthropometry performance
at the Galerie internationale d'art
contemporain. Georges Mathieu heckling
a smiling Yves Klein during the public
discussion following the performance.
9 March 1960.

155

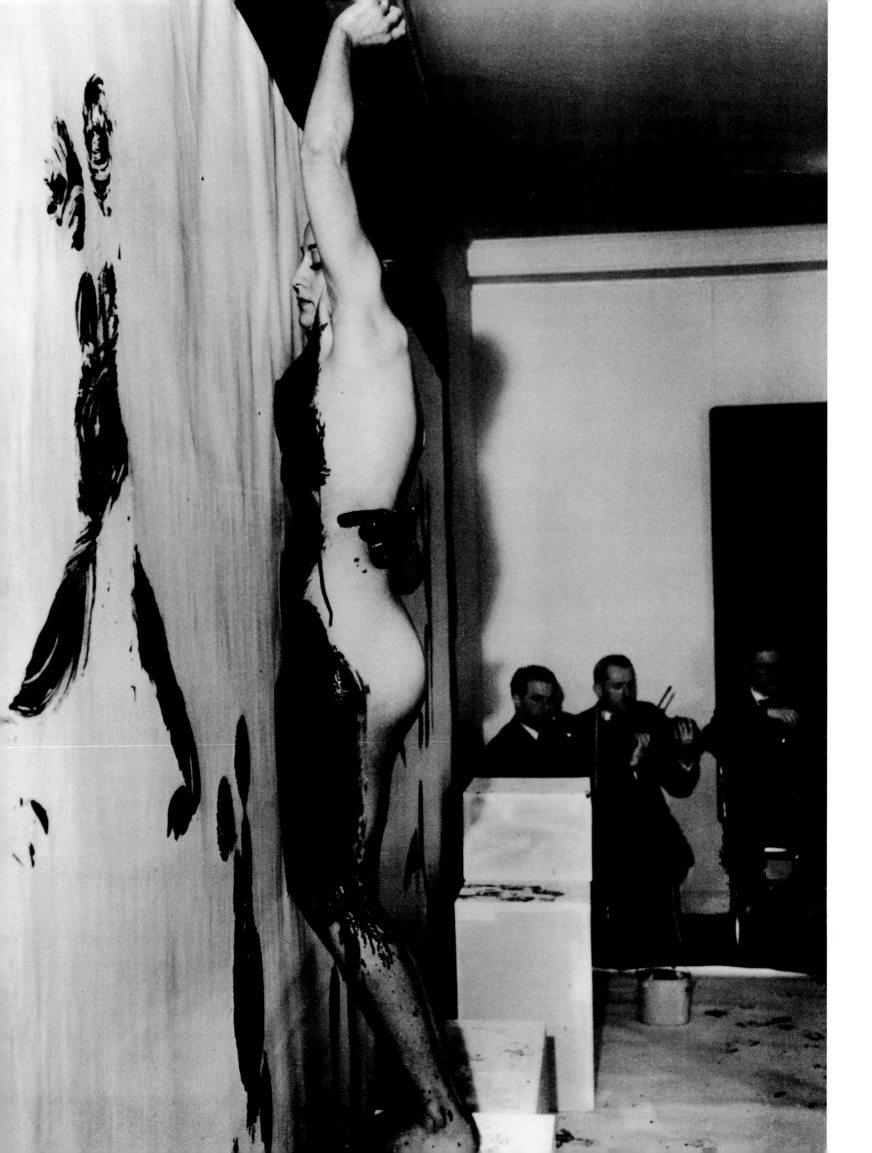

The presence of flesh

The audience would have had to be blind not to see the 'health' of the performance. The naked models embodied the wonderful vitality of life lived naturally – the vitality of the sensitive body. Initially, Klein had merely sought the presence of naked models in his studio: 'their flesh, present in my studio, long stabilised me during the illumination that executing my monochromes produced. It kept me to the spirit of the cult of "health", of that health that keeps us alive, at once carefree and responsible to our essential participation in the universe.'[5] The making of body prints meant that the models' presence could now be made durable: 'Now it is flesh itself that applies colour to the surface at my instructions.'[6]

Anthropometry performance
at the Galerie internationale d'art contemporain. The model is imprinting her anatomy on a sheet of paper while the orchestra plays the *Symphonie monoton-silence*. 9 March 1960.

**Yves Klein directing
an anthropometry session** at his flat on rue Campagne-Première in Paris. 1960.

Following pages: **'Blue Period Anthropometries' performance** at the Galerie internationale d'art contemporain. 9 March 1960.

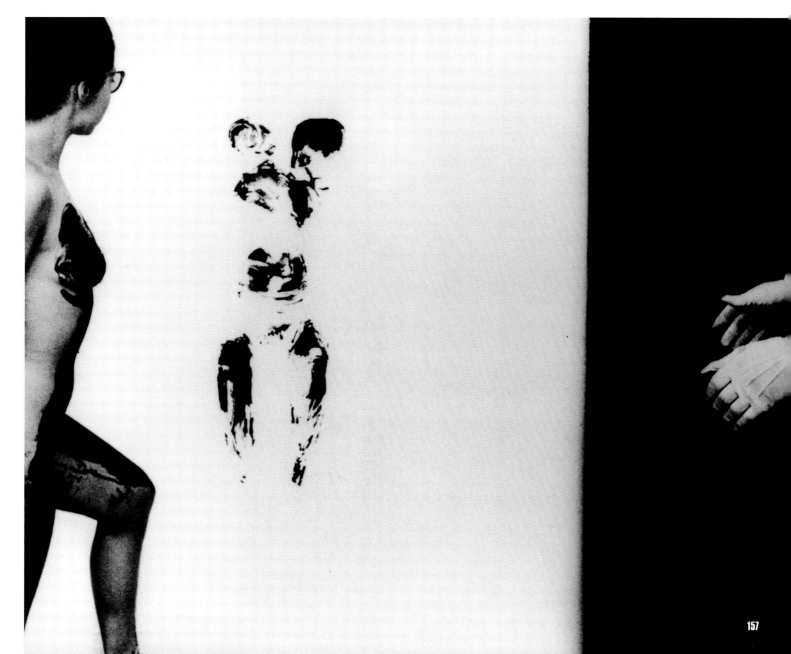

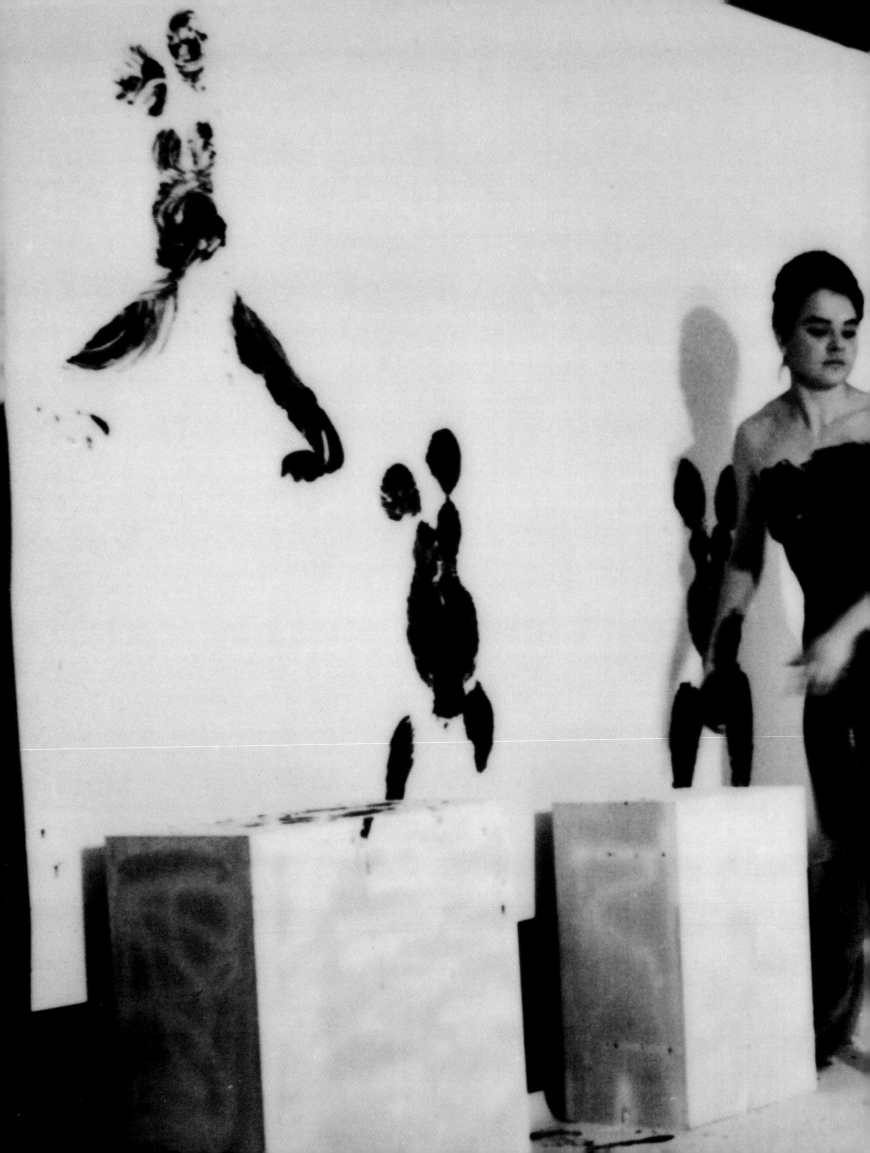

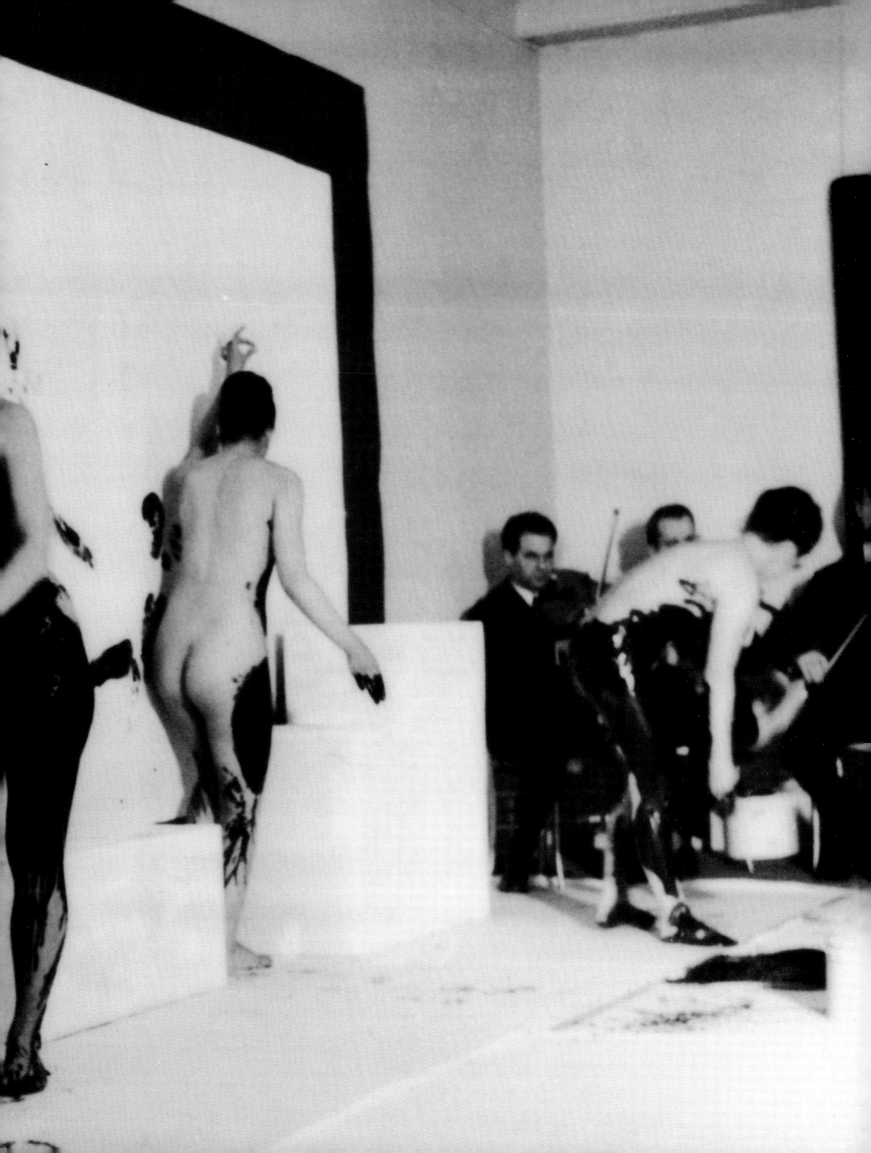

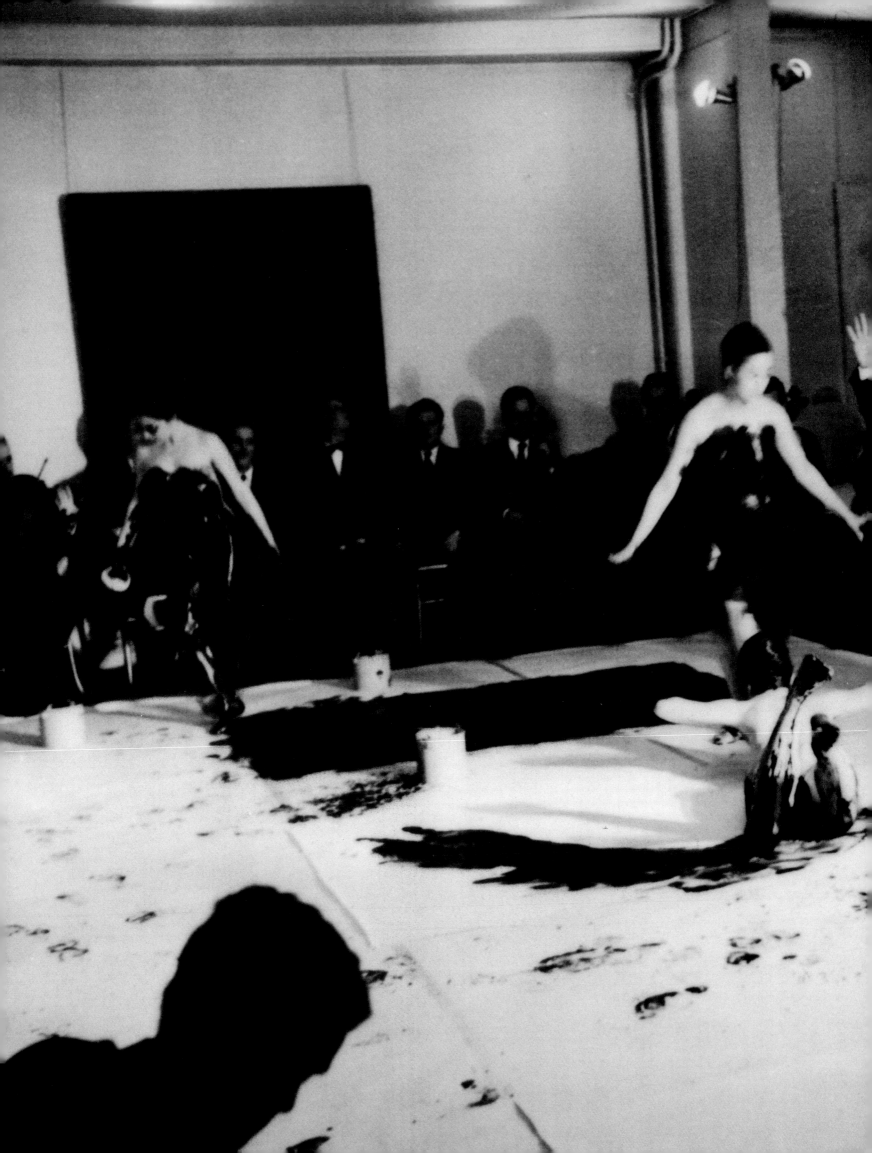

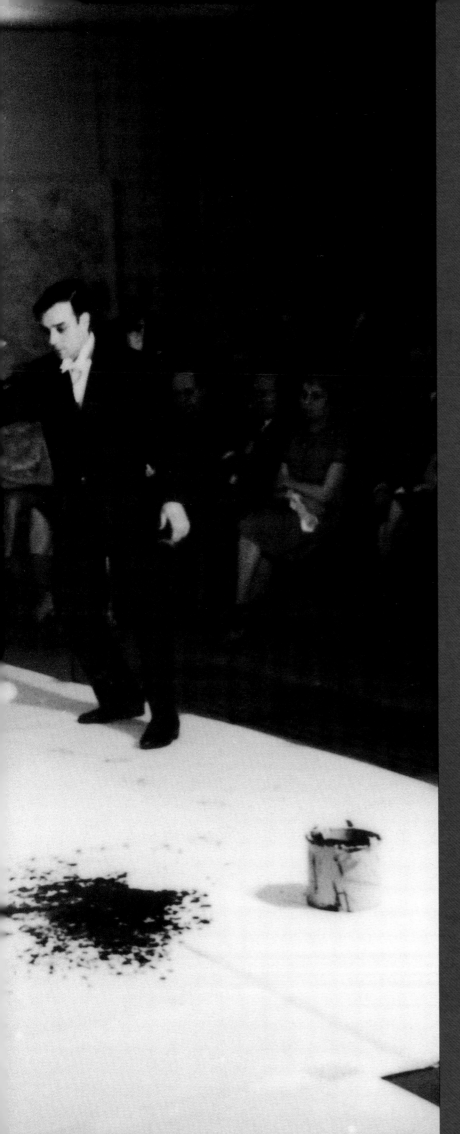

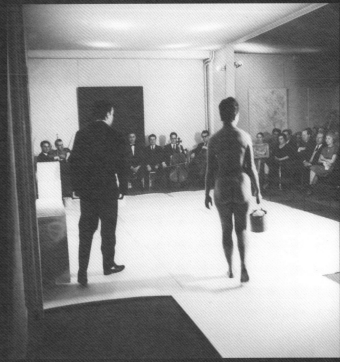

Three superb naked models
walked across the room,
each carrying a pot of
ultramarine paint.

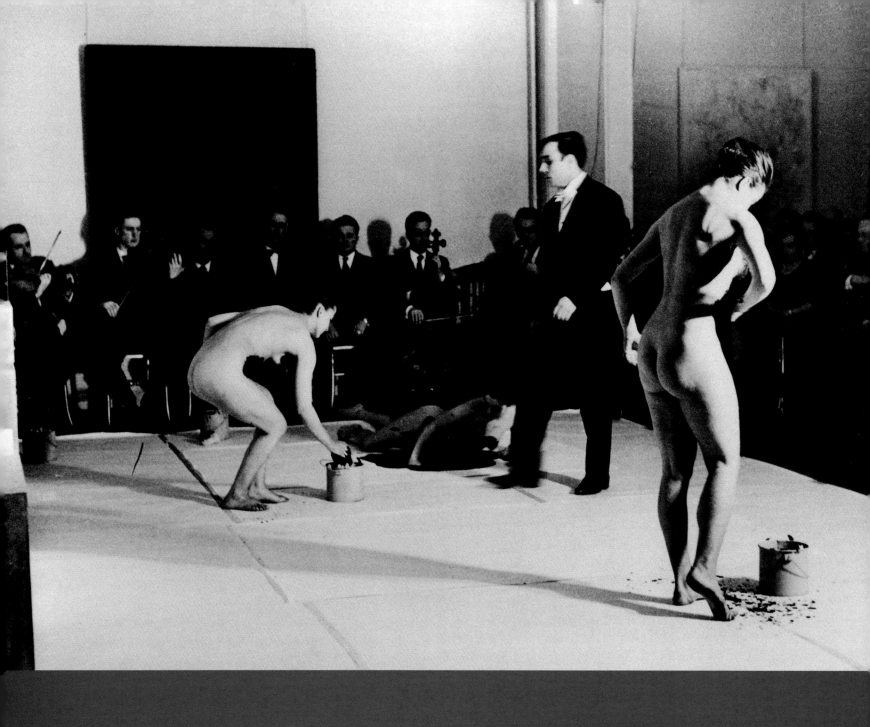

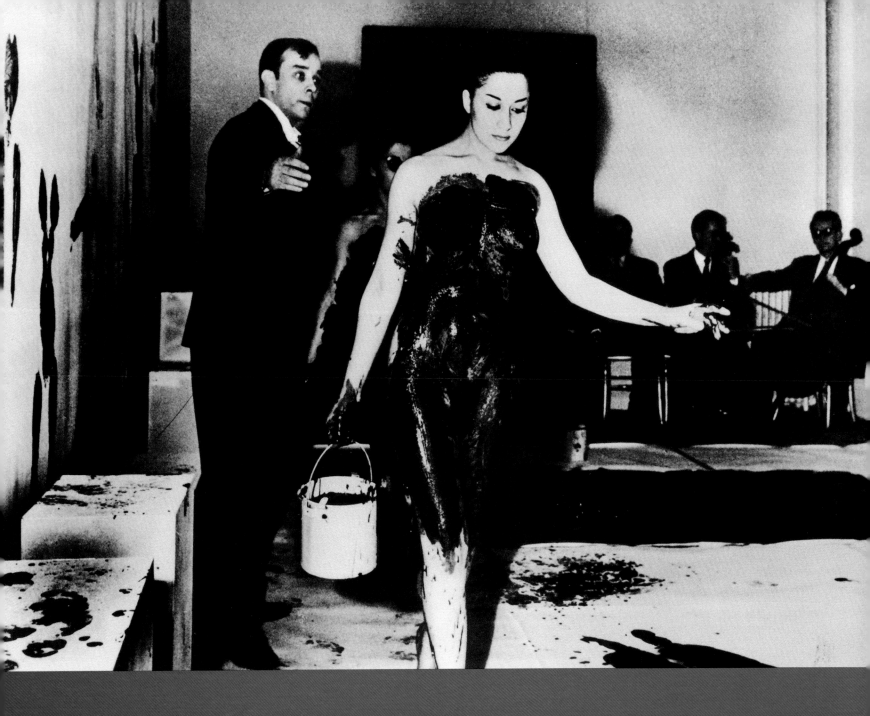

'Now it is flesh itself
that applies colour
to the surface
at my instructions.'

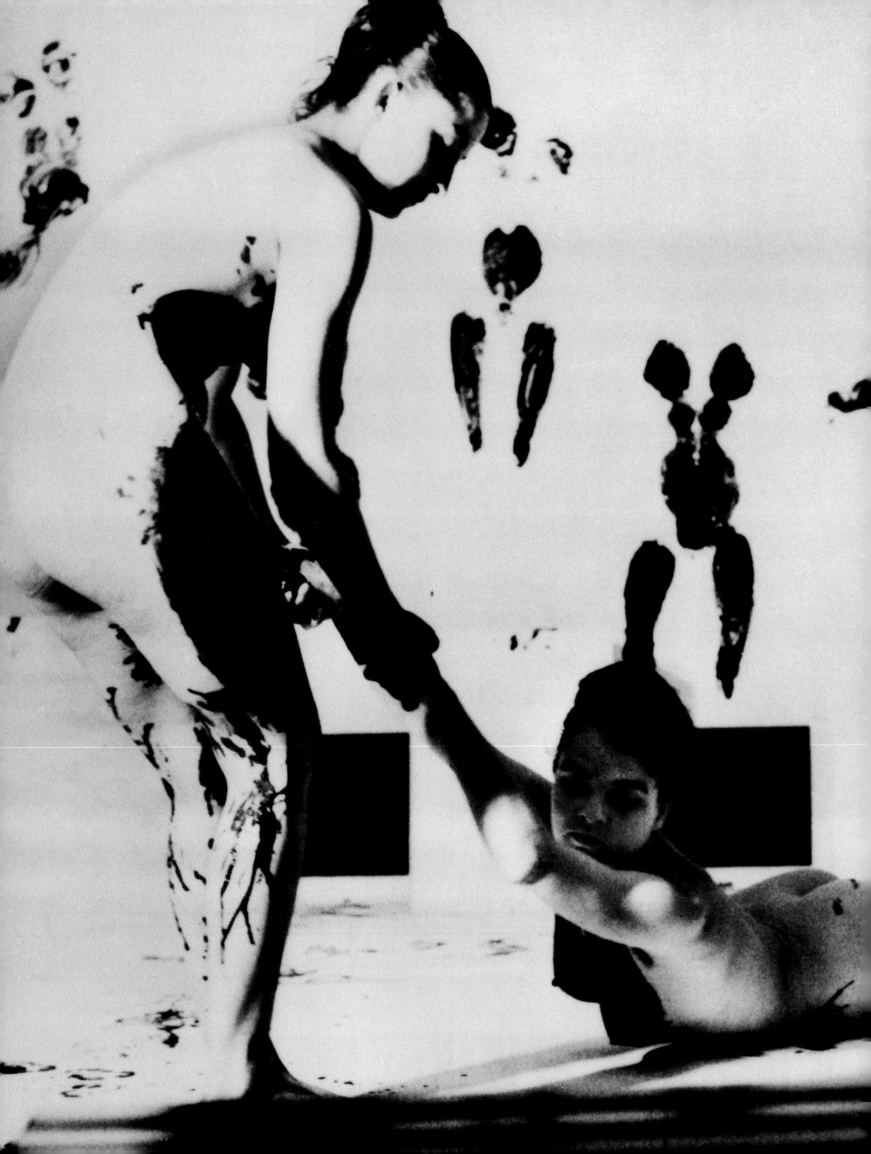

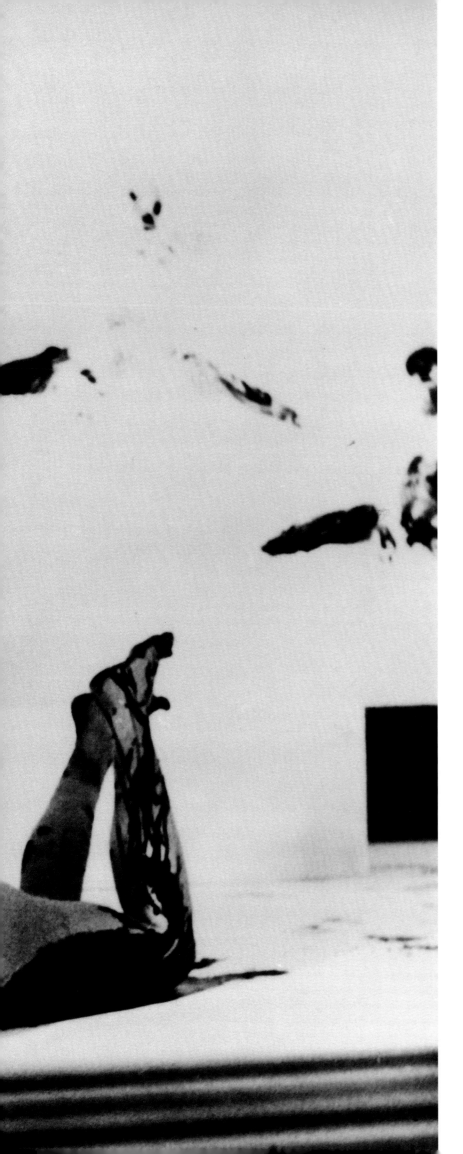

Few things are as fascinating as an imprint.[7] An imprint is the trace of a presence-within-absence, the substratum or deposit of a being who no longer exists, the mark left by a moment beyond recall. Such impressions pose the problem of being and nothingness, fullness and emptiness, presence and absence. Far from seeking to sidestep that problem, Klein's anthropometries address themselves to the heart of the issue. Klein, as we have seen, was radically opposed to any type of re-presentation. He did away with drawing, lines, composition, and all that remained was colour in its immanence – colour saturated with an energetic sensibility. Klein's monochromes and 'void' creations are invisible-yet-visible traces of sensibility, and the painter's endeavours to capture traces of life are made in the same spirit. His body prints are both images and clues – images of reality and traces that point to something that was. The illusionist veil has been lifted. A trace is not a make-believe copy of an object of reference.

Since re-presentation is a (cultural) artifice, presentation alone can sustain an 'authentic (natural) realism'. The imprint preserves the memory of the contact. It is a natural 'inscription' preceding writing. The aesthetic of the trace is opposed to the aesthetic of mimesis. It counters the mimetic with a presence. Body traces, traces of 'health', are records of a pristine state of life.

Anthropometry performance
at the Galerie internationale
d'art contemporain. The models imprint sheets
of paper on the floor. 9 March 1960.

Informal painting, vampires and nature

That the anthropometries reduce the human body to its vital organs and sexual parts (thighs, pubis, belly and breasts) is hardly surprising. Klein's explanation is that 'I very quickly noticed that it was the mass of the body itself, in other words the torso and part of the thighs, that fascinated me. The hands, arms, head, legs were of no importance. Only the body lives, all-powerful and non-thinking. The head, the arms, the hands are intellectual articulations around the mass of flesh that is the body! / The heart beats without our being aware of it; we cannot will it to stop. Digestion takes place without our interference, be it intellectual or emotional. We breathe unconsciously. / True, the whole body consists of flesh, but the essential mass is the trunk and thighs.'[8] The imprints of the essential body obtained by means of a ritual thousands of years old are traces of man's primal fusion with the world.

Klein's body traces are headless. They do not refer to any individual face or body, but to the primal being within each individual. In a sense, they are the genetic memory of humankind. Klein reconciles man and nature in a general attempt to do away with formal boundaries. He blends all cultural fields and obliterates the distinctions between culture and nature, life and art. His faceless imprint becomes 'informal' art. It bears a vague resemblance to a chromosome (from the Greek *krôma* for colour and *sôma* for body). Having smashed the taboo of the disfigured body, he was now confronting the ban on showing the body in its

primitive brutality. The most extreme expression of this undertaking is a series of prints he made with his wife, Rotraut, one evening in June 1961 after he had smeared her with beef blood. Frightened that he had gone too far, he burned these works the next morning. This did not deter him from hailing cannibalism and vampirism as alternatives to our civilisation: 'Vanquishing silence, dismembering it, removing its skin and clothing oneself in it so as never again to be spiritually cold. Face to face with universal space I feel like a vampire! . . .'[9] Universal cannibalism, which is approaching, the anthropophagous era which we are soon going to live through will not be of a fierce or inhuman nature; quite the contrary, it will be the experienced expression or rather the assimilation of . . .' The text ends abruptly, the artist having partially burned the sheet of paper on which he wrote it. A 'shroud' (an imprint on a piece of fabric) incidentally bears the suggestive title *Vampire,* and Klein from time to time organised nocturnal outings to the cemeteries of Vence and Èze.

A vampire sucks the blood of its victims like a sponge absorbing paint or water. There seemed to be no limits to Klein's craving for absorption. Defining blood transgressions as experiences of abjection, Julia Kristeva shows how transgression is combined with religiosity in the revival of ancestral rites associated with pollution. Abjection and religiosity undermine the foundations of culture 'in order to return to the obscure territory of primal indetermination, that of the fusion of the outer and inner worlds, of matter and the creator, of the impersonal'.[10]

'Blue Period Anthropometries'
performance at the Galerie internationale
d'art contemporain. 9 March 1960.

Vampire (ANT SU 20). Anthropometry
shroud. *c.* 1961. Blue, black and pink
pigments and synthetic resin on fabric,
140 x 94 cm. Private collection.

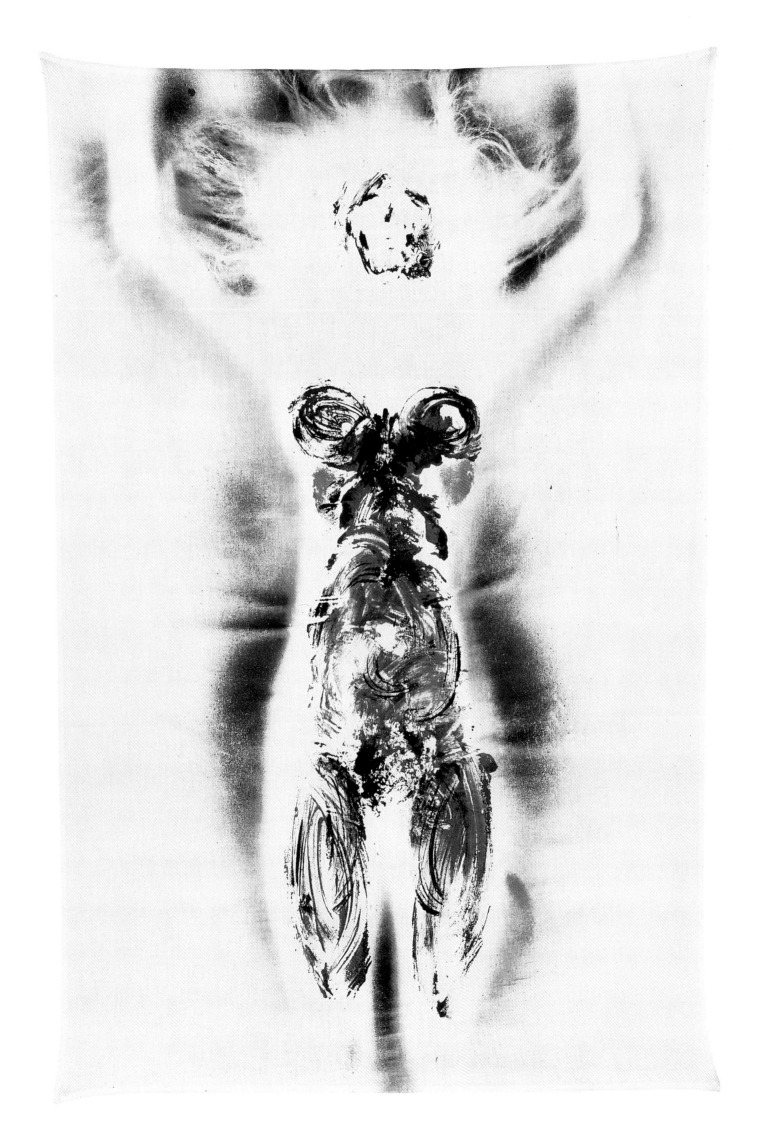

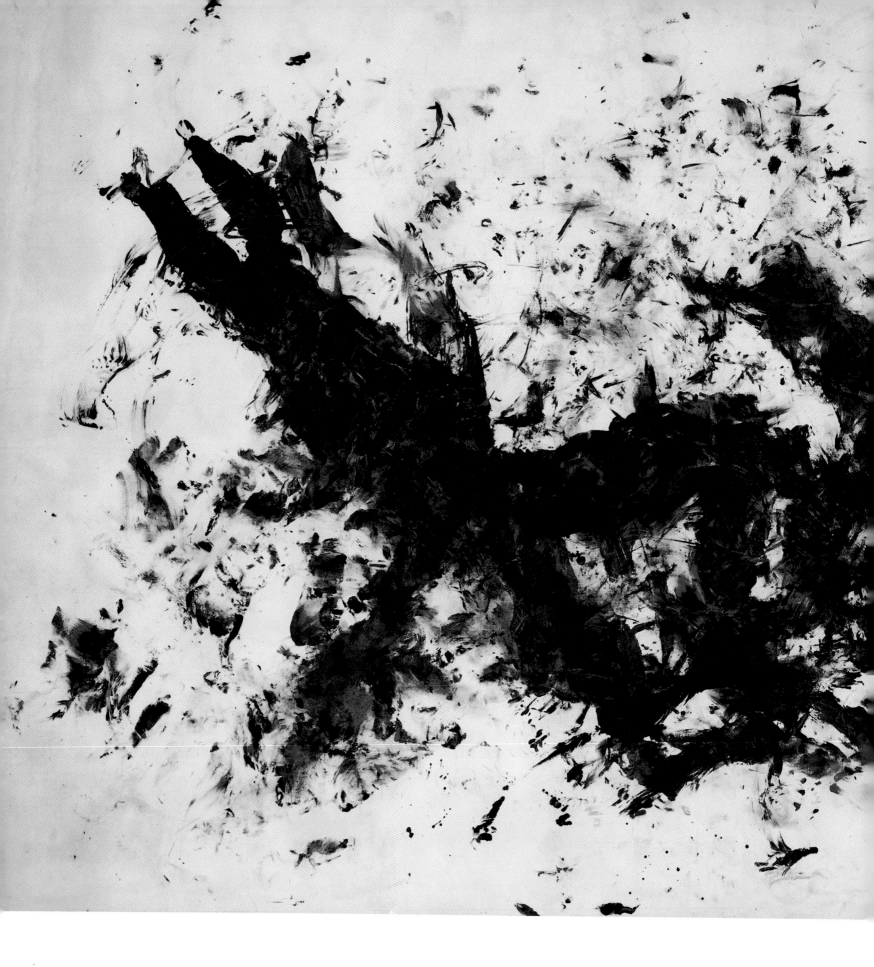

Untitled (ANT 104). Anthropometry.
1960. Dry pigment and synthetic resin
on paper, 278 x 410 cm.

Untitled (ANT SU 12). Anthropometry
shroud. c. 1960. Dry pigment and synthetic
resin on fabric, 228 x 80 cm.
Private collection.

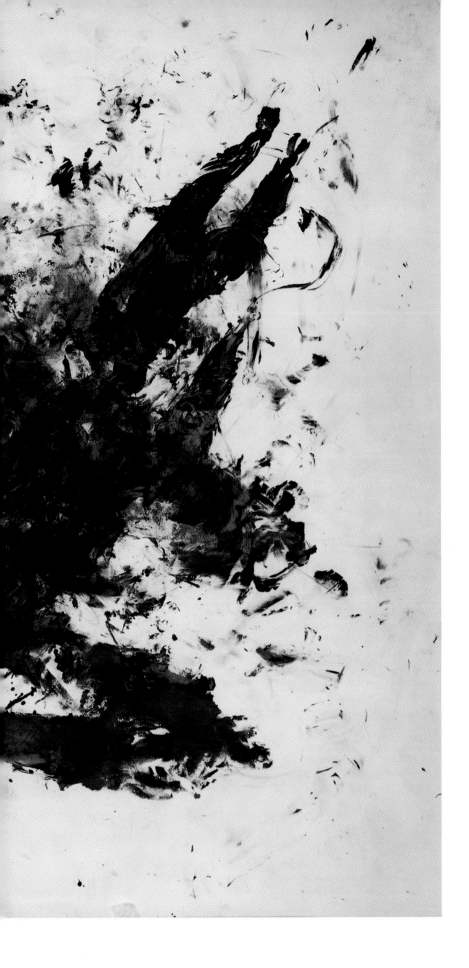

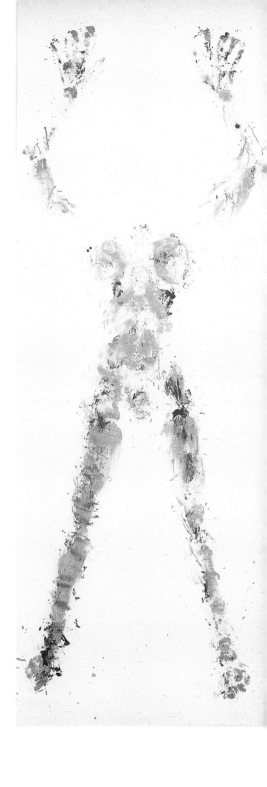

'Vanquishing silence, dismembering it, removing its skin and clothing

oneself in it so as never again to be spiritually cold.

Face to face with universal space I feel like a vampire!'

Being, not doing

The creator distanced himself from his creatures. Klein's body prints were literally the work of his 'living brushes'. The artist did not dirty his own hands: 'Personally, I would never attempt to smear colour on my own body and become a living brush myself; on the contrary, I would rather wear my dinner jacket and slip my white gloves on. The idea of soiling my hands with paint would not even occur to me. Detached and distant, it is before my eyes and at my instructions that the labour of making art is carried out. Then, as soon as the artwork begins to take shape, I stand there, present at the ceremony, immaculate, calm, relaxed, perfectly conscious of what is taking place and ready to deliver the art being born to the tangible world.'[11] The artist (that 'nuclear reactor of sensibility') is a mediator, not a midwife. He says nothing, expresses nothing, is merely present, experiencing his role. 'True "painters and poets" don't paint and don't write poems.' 'To materialise or intellectualise is indecent and obscene. To consciously live poetry or painting or simply art is sufficiently sensual in the abstract!' Only the process of imprinting, of registering traces, enables the creator to step back physically from his creation and the object to be asserted as 'a living and autonomous presence'.[12]

The radical distinction that Klein made between art and egocentric expression was directed primarily against gestural abstraction, which had become widespread in France and America in the 1950s. Klein was outspoken: 'I hate artists who empty themselves into their painting, as is often the case at present. It's morbidism; instead of thinking of the beautiful, the good and the true in their work, they vomit, ejaculate, spew all their horrible, rotten, infectious complexity into their painting as if to relieve themselves and saddle others, "the readers" of their works, with all their failures' burden of remorse.'[13] He was often brutal, almost insulting, towards the Abstract Expressionists (including Georges Mathieu). With the appearance of his anthropometries, the issue of the painter's physical engagement with the artwork took on a new dimension. For the body print was both a trace and a tracing, a shape and a movement. Unlike the image frozen in mimetic replication, the imprint was fraught with energy.

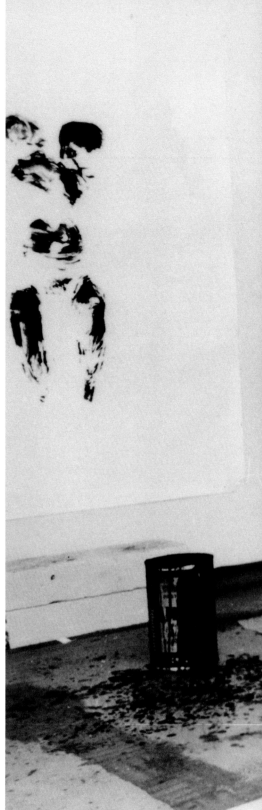

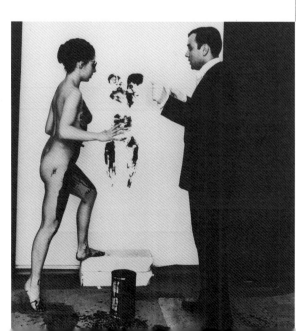

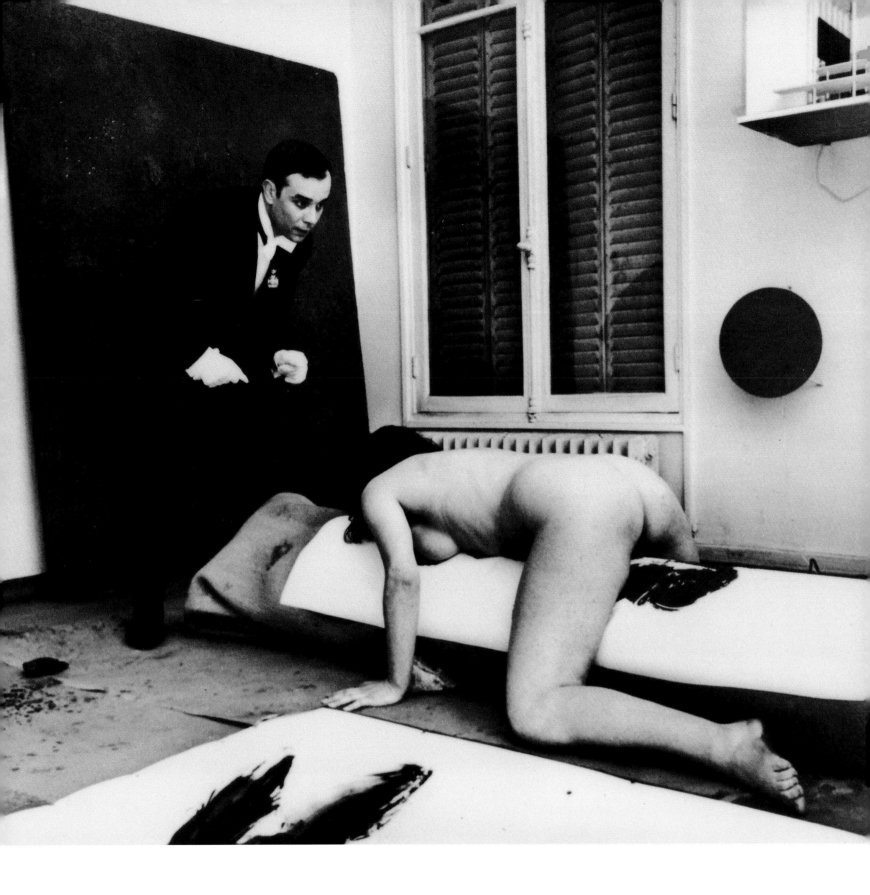

Yves Klein directing an anthropometry session at the artist's home on rue Campagne-Première, Paris. 1960.

Yves Klein and model creating an anthropometry shroud, rue Campagne-Première, Paris. 1960.

171

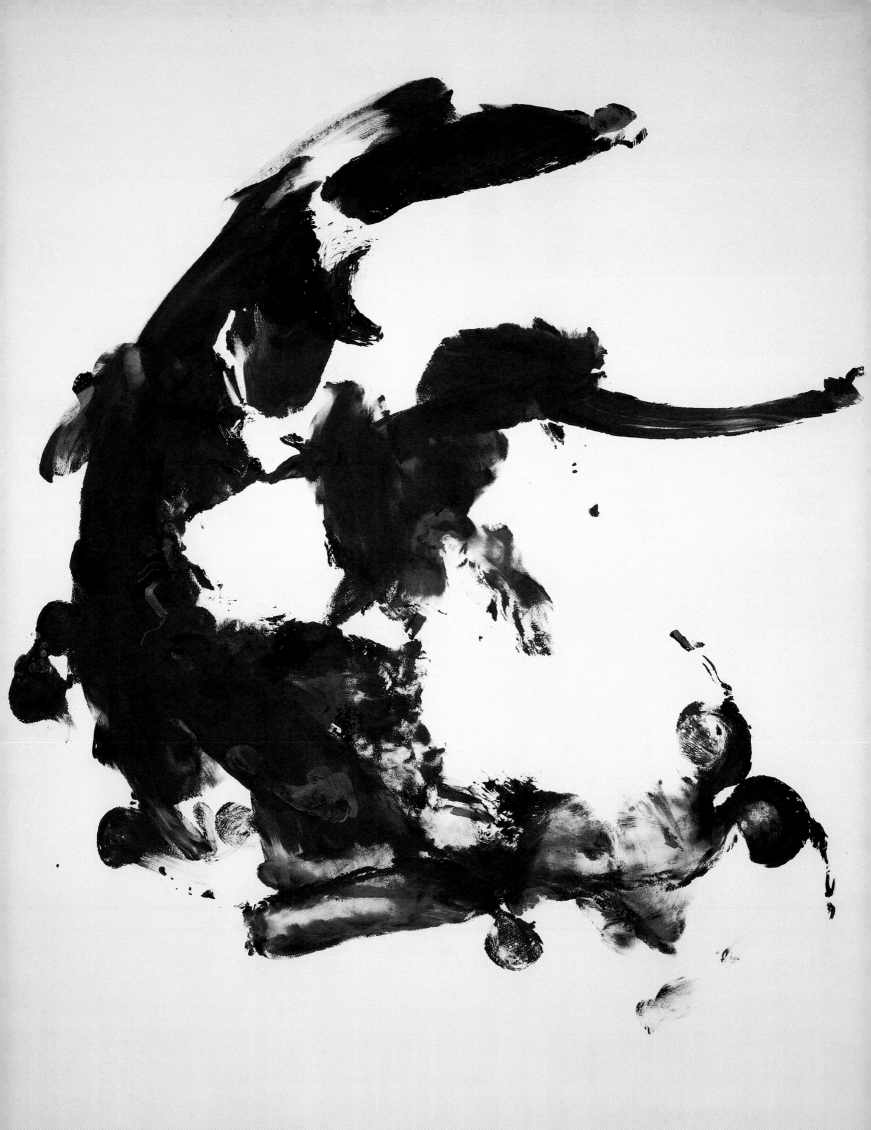

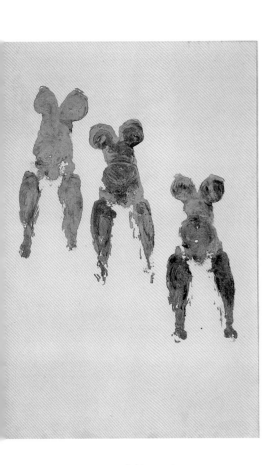

An art of process

The art of imprinting is an art of process: instead of stable images (icons), we have the indetermination of traces. Between appearance and disappearance, form and the informal, positive and negative, mould and moulded object, shadow and light, being and nothingness, the imprint escapes precision. For Klein, the logic of 'matter becoming form'[14] meant shifting from studio art to a Performance Art encompassing the randomness, dynamism and indeterminacy of real life. And still the painter remained detached, declining to throw himself, like Jackson Pollock with his 'drippings', into an existential act that would totally involve his body and mind. Commenting on his anthropometries, Klein took care to explain: 'I want people to realise that my endeavour distinguishes itself from "action painting" inasmuch as I am in fact completely detached from all physical work during the time it takes to complete the creation.'[15] In other words, though the body print was clearly a shape and energy in its own right, Klein opted for the performance as his mode of creation while sticking to the principle of detaching himself from his creation.

The soirée of the 'living brushes' at d'Arquian's gallery inaugurated the now very widespread genre of Performance Art, but above all it was a tremendously powerful renewal of the art of the imprint. I believe that this is one of Yves Klein's chief contributions to art history, although the issue of innovation is secondary. As Denys Riout puts it, 'there are followers but there are no precursors: the existence of precursors is always postulated with hindsight . . . In the living reality of their appearance *here and now,* artworks are not organised along a single axis of universal time. They are organised around a multiplicity of centres . . . History, which is by definition retrospective, cannot resist the temptation to unify by placing things in perspective, elaborating a construct from a unified viewpoint.'[16] The teleological vision of history as an unbroken succession of inventions is a delusion. Time is not geo-central but fragmented into multiple spaces. Klein did not invent Performance Art in France any more than Claes Oldenburg invented it in America. He simply revealed its true significance, just as he had earlier revealed the true significance of monochromy.

Untitled (ANT 80). Anthropometry.
c. 1960. Dry pigment and synthetic resin on paper, 205 x 155 cm. Private collection.

Untitled (ANT 92). Anthropometry.
c. 1960. Dry pigment and synthetic resin on paper on canvas, 220 x 150 cm. Private collection.

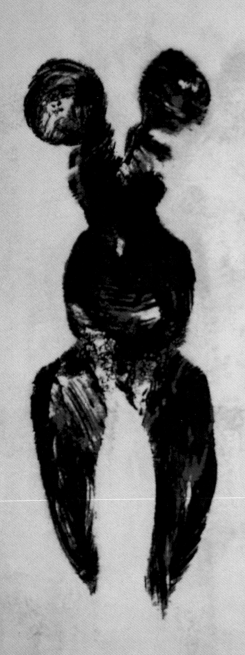
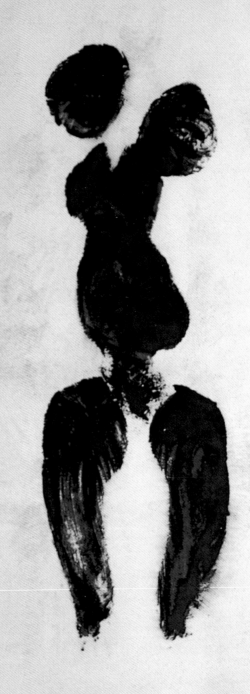
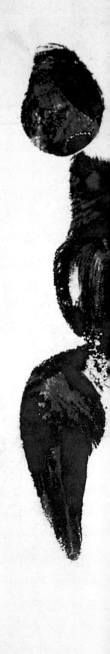

Untitled (ANT 82). Anthropometry. 1960.
Dry pigment and synthetic resin on paper
on canvas, 156.5 x 282.5 cm.
Musée national d'art moderne Collection,
Paris.

Overleaf: *Untitled* (ANT 55).
Anthropometry. 1960. Dry pigment and
synthetic resin on paper, 89.5 x 146.6 cm.
Private collection.

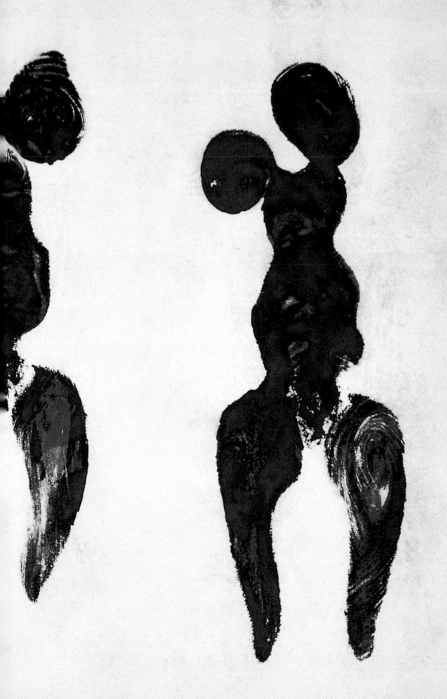
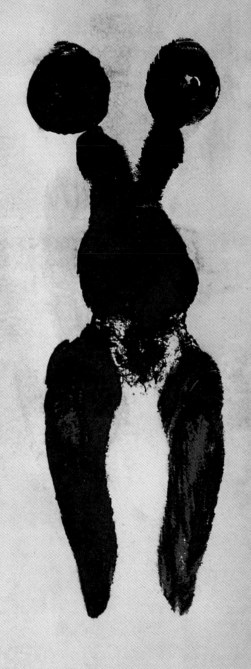

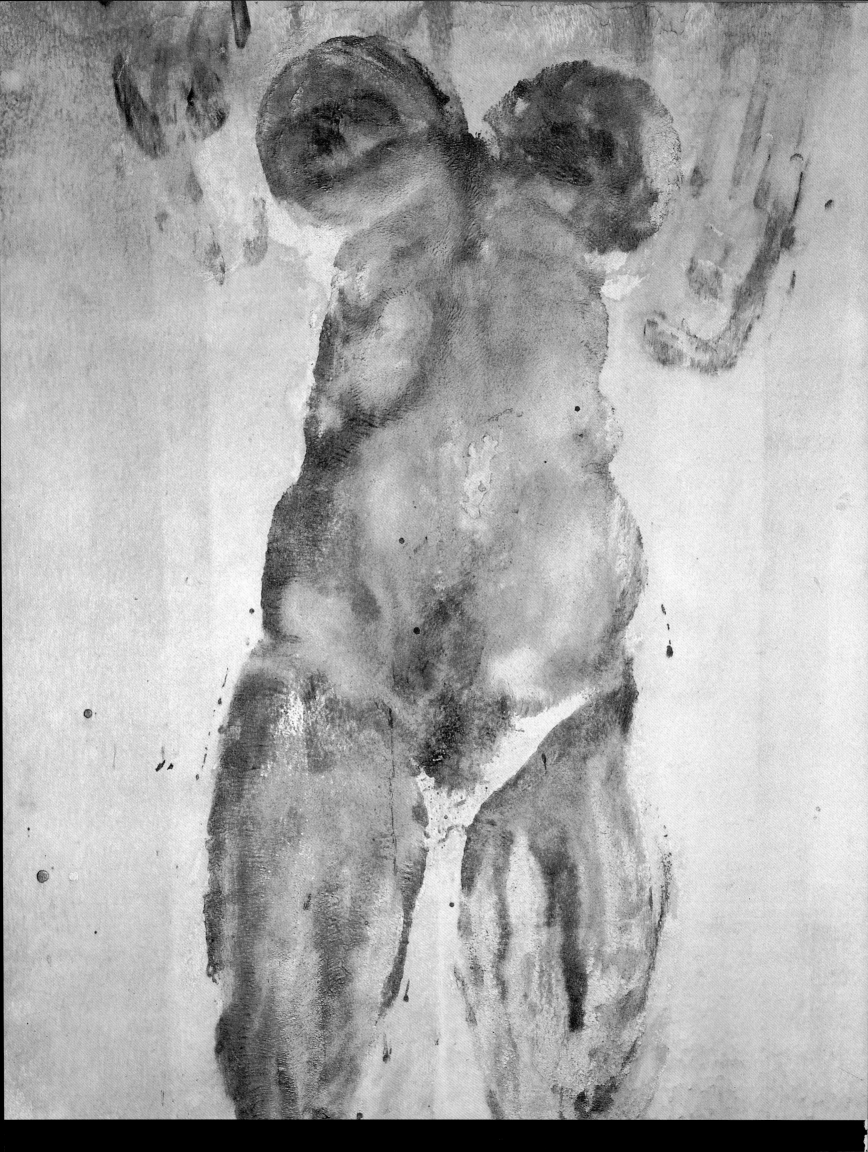

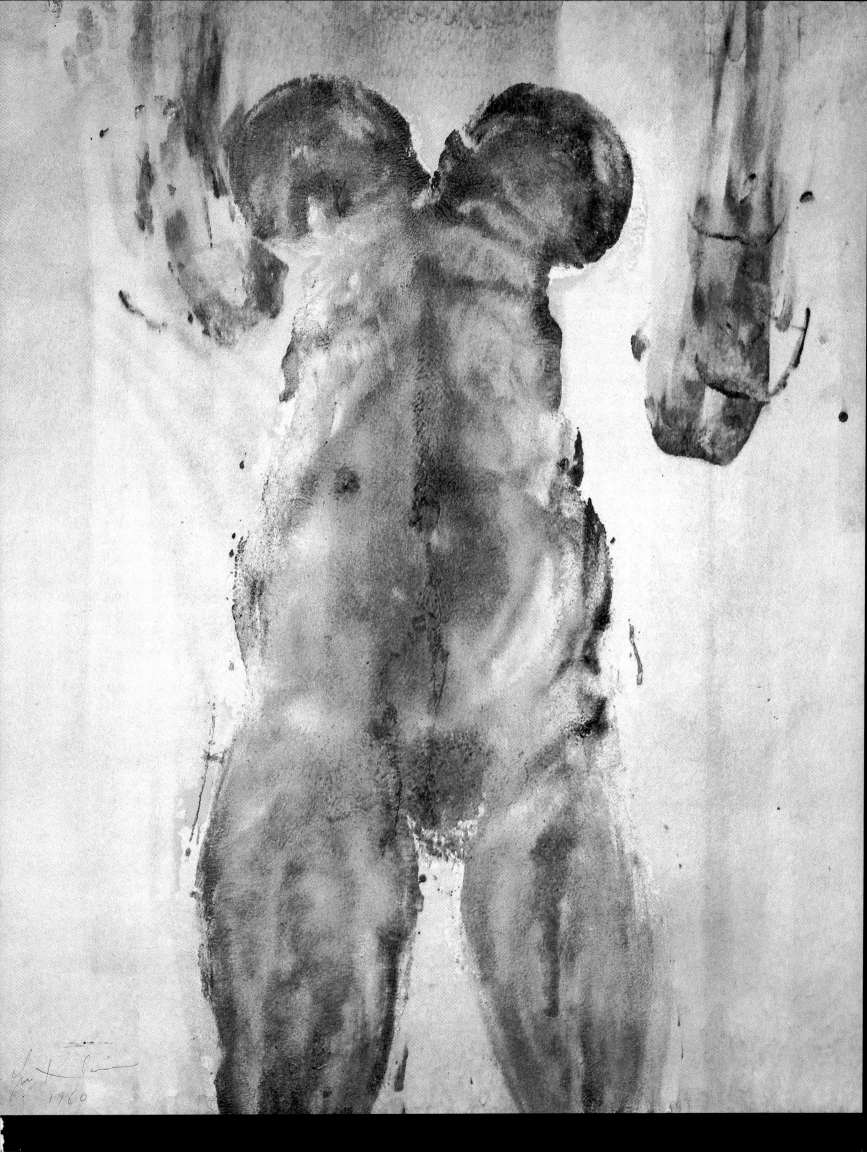

The changing forms of an unchanging message

Klein's anthropometries are impersonal traces of the energetic flow of sensibility, which is the origin of all life. The human fusion with nature takes place on a plane of pure energy. And if 'the blood of sensibility is blue', as Shelley writes, the imprint's medium is in principle blue. For its inventor, IKB paint was an invisible fluid of sensibility. Life ignited at its contact. The revelation of the living realm of IKB imprints transcended the problematic of form. Since each trace pointed to a vital energy, the painter could compile an index of forms. Aesthetics were subordinated to ethics and form to content. Each one of Klein's numerous imprints – no two of which are identical – are traces of life. Whatever their guise, their forms lend visibility to an essential content, that of the inhabited body.

In the wake of the performance of 9 March 1960, Klein executed a large number of imprints, using an extremely wide array of techniques, sizes and compositions. Pierre Restany distinguishes between Klein's anthopometries (imprints on paper or canvas), his shrouds (imprints on cloth), static imprints (fixed marks), dynamic imprints (marks in motion, trails), positive imprints (made by applying paint to a model's body) and negative imprints (spray paint outlining the body).[17] To this list one could further add Klein's 'battle' paintings (informal agglomerations of dynamic imprints), polychrome imprints and imprints exemplifying the architecture of air. In short, though the same plasma of energy pulsed in the veins of each imprint, the forms it took were infinitely varied.

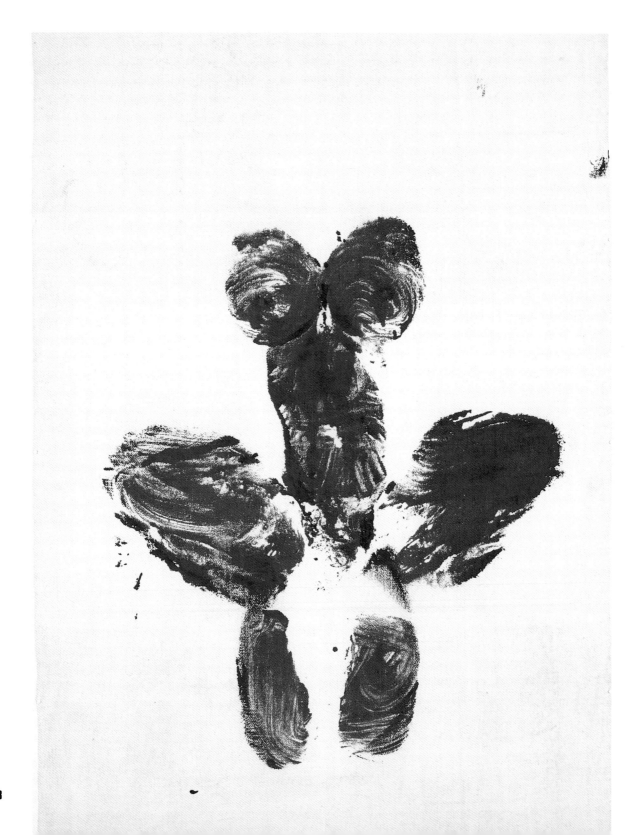

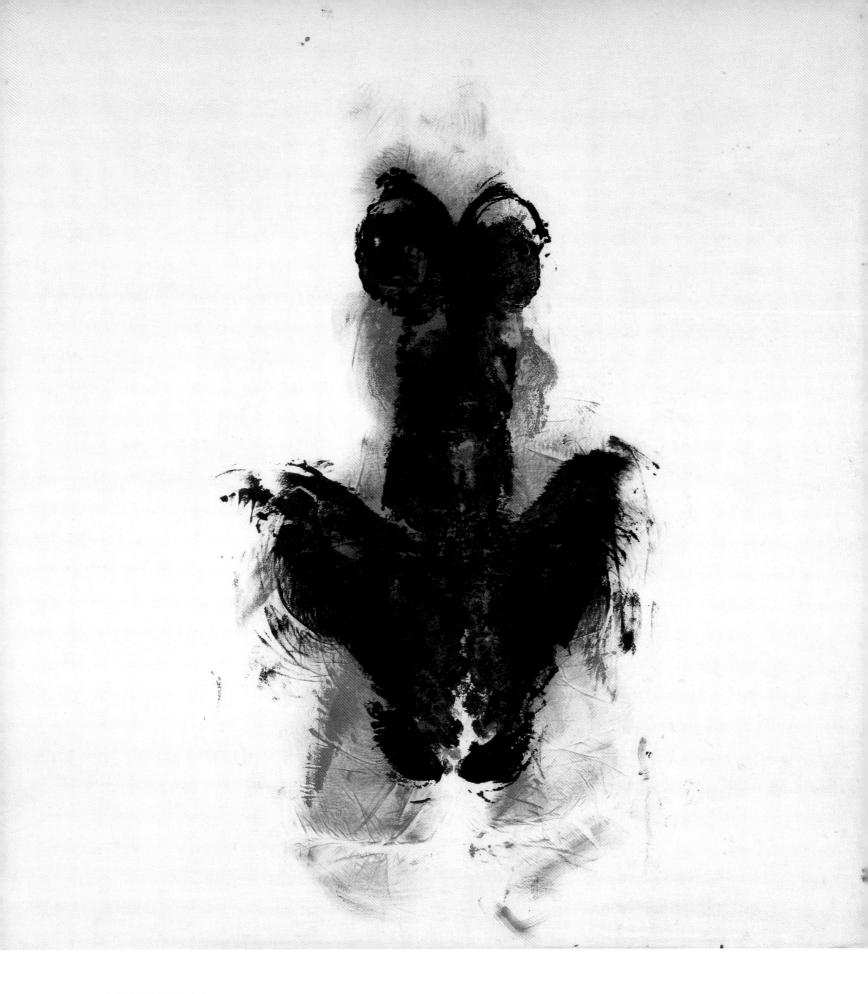

Untitled (ANT SU 13). Anthropometry
shroud. *c.* 1960. Dry pigment and synthetic
resin on fabric, 125 x 85 cm.
Private collection.

Untitled (ANT SU 9). Anthropometry
shroud. *c.* 1960. Blue, black and pink
pigment and synthetic resin on fabric,
141 x 136 cm. Private collection.

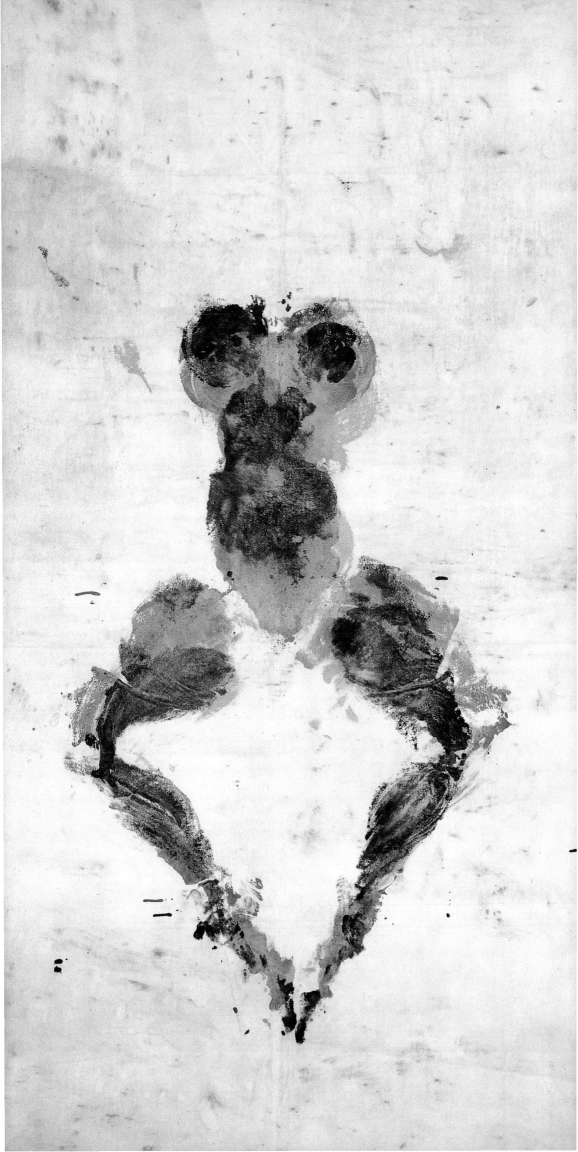

Klein's anthropometries are impersonal traces of the energetic flow of sensibility, which is the origin of all life.

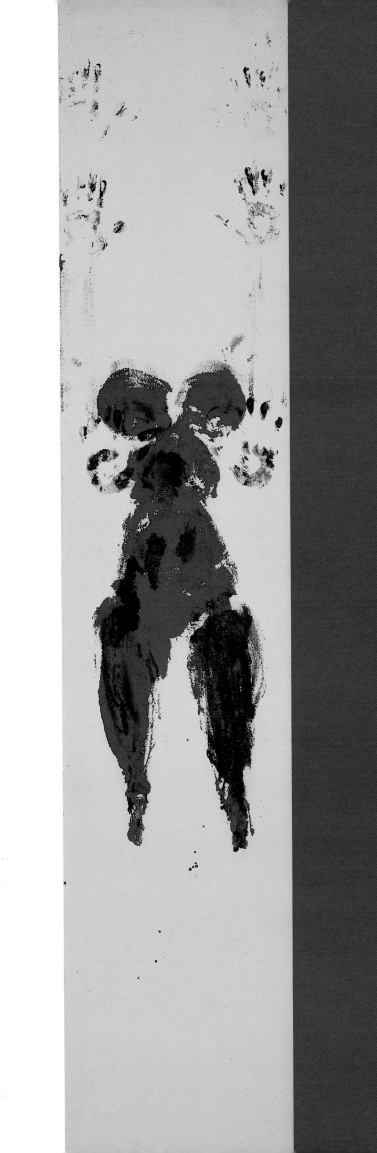

Nature prints

Klein had struck too rich a lode to stop there. 'Every event of nature's "subjects" – humans, animals, plants, minerals and atmospheric circumstances – all this interests me for my naturometries,' he observed.[18] His nature prints are extensions of his work relating to the human anatomy. Klein's monochromes had been traces of 'poetic events' (through his use of pure colour and thanks to the physical presence of nude models in his studio), while his anthropometries had been imprints of flesh 'wrested from [his] models' bodies'.[19] His naturometries, or cosmogonies, are imprints which are made directly from nature: 'I rush outside and in a jiffy I'm on the banks of the river, among the canes and reeds. I spray paint over everything and the wind, bending the slender stems, applies them with precision and delicacy to the canvas that I present to quivering nature: I obtain a plant mark. Then it starts to rain – a drizzling spring rain. I expose my canvas to the rain and, abracadabra, I get rain marks! The marks of an atmospheric event.'[20]

In 1960–1961, Klein collected plant, rain and wind traces. The result was magical. The forms of these imprints are sometimes distinct; more often than not they dissolve into a tormented, dynamic ground. The wind prints especially possess a striking energy. Klein made one of them, *Vent du voyage* (*Journey's Wind*) by fastening a canvas to the hood of his 2-CV Citroën and driving one thousand kilometres, exposing it to wind and rain.

Klein's body and nature prints are the supremely aesthetic phase of his monochrome researches. With them, Klein abandoned the austerity of his Blue Period works. His vocabulary gained the decorative function all images have. What is more, he freely expanded this decorative function, like Matisse towards the end of his life jubilantly cutting shapes directly in colour. Klein's increasingly sensual imprints belong to a certain tradition of empathy in painting; they evince a desire to take part in the world, a craving for harmony between nature and man. Thus the appeal of abjection, at the height of Klein's involvement with the thematic of saturation-absorption, was merely a passing temptation. The transgression of blood frightened the demiurge artist: after signing his 'forbidden objects',[21] Klein burned them in June 1961. Life remained his abiding preoccupation. Hence the aesthetic displacement from minimalism to sensuality took place on a formal level. The poet eclipsed the vampire.

Yves Klein making sand, twig and plant imprints (cosmogonies) on the banks of the River Loup at Cagnes-sur-Mer. 23 June 1960.

Untitled (**COS 25**). Cosmogony. *c.* 1961. Dry pigment in undetermined fixative on paper on canvas, 102.5 x 60 cm. Private collection.

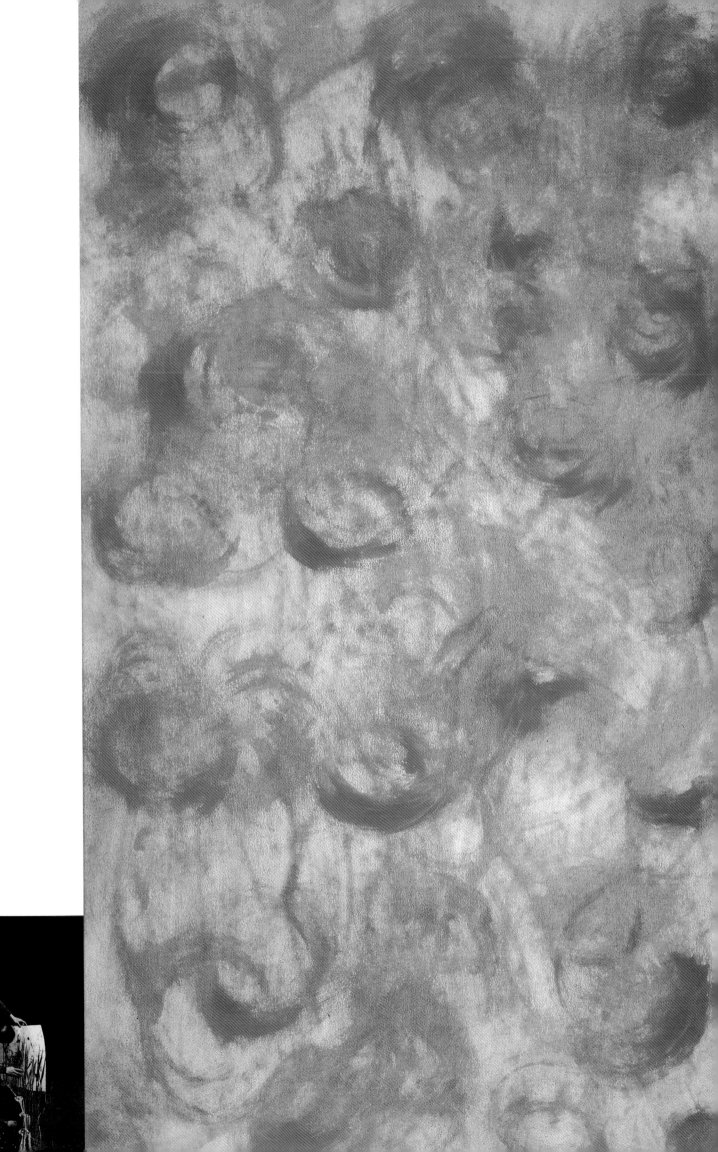

Untitled **(COS 3).** Cosmogony. 1960.
Dry pigment in undetermined fixative
on paper, 49 x 64 cm. Private collection.

Une pluie fine du printemps *(A Spring
Drizzle)* **(COS 30).** Cosmogony. 1960.
Dry pigment and synthetic resin on paper,
41.5 x 58 cm. Private collection.

Overleaf: *Vent Paris-Nice* *(Paris-Nice
Wind)* **(COS 10).** Cosmogony. 1960.
Dry pigment in undetermined fixative
on paper, 93 x 73 cm. Private collection.

Alchemy

The pen and the brush[1]

In 1959, as a first assessment of his trajectory as an artist thus far, Klein published a compilation of his writings under the title *Le Dépassement de la problématique de l'art* (*Going Beyond the Problematic of Art*). This was soon followed by a second, more ambitious literary project: the artist collected his best writings in a manuscript of some one hundred and fifty typewritten pages. The fact that he made a number of dummies of this volume and wrote several successive introductions to it shows that he intended it to be an extensive compilation of his texts and that he placed great existential value in it:

'This book begun practically ten years ago and carried on with difficulty [word crossed out] after much negligence and laziness to the point that today it already seems old to me!

'I have moved beyond all those ideas and to me they are, without any exaggeration, like photographs that have already yellowed with time! / It seems to me that this phenomenal effect stems precisely from the fact that "I have written"! Thus I hope to be strong enough hereafter not to add anything to them. / I really want to Live much more intensely than all of that; I am sure that I will go further if I say nothing more and write nothing more. / To others, who are willing to die in the ephemeral, I leave the task of continuing to write in this vein.'[2]

Somewhat hurriedly entitled *L'Aventure monochrome* (*The Monochrome Adventure*), then, for lack of anything better, *Mon Livre* (*My Book*), this compilation, which was Klein's conception from beginning to end, was truly 'his' book, the book of his life as an artist. Unfortunately, he died before he could finish it. The manuscript remains as he left it and, except for a few excerpts, is still waiting to be published. It slumbers under a thin film of dust, a sleeping beauty in her golden bed.[3]

That same year, 1959, Klein gave yet another summation of his career in a lecture delivered at the Sorbonne (on 3 June). Published after his death as a two-record set and, later, a booklet, this text presents his work as a whole in terms of its linear development, and in a teleological mode, as a self-revelation in several stages. The ensuing years – 1960, 1961 and the first half of 1962 – witnessed a transfiguration of Klein's pictorial work and a tremendous surge in his Promethean creativity. The pace of the monochrome adventure was picking up.

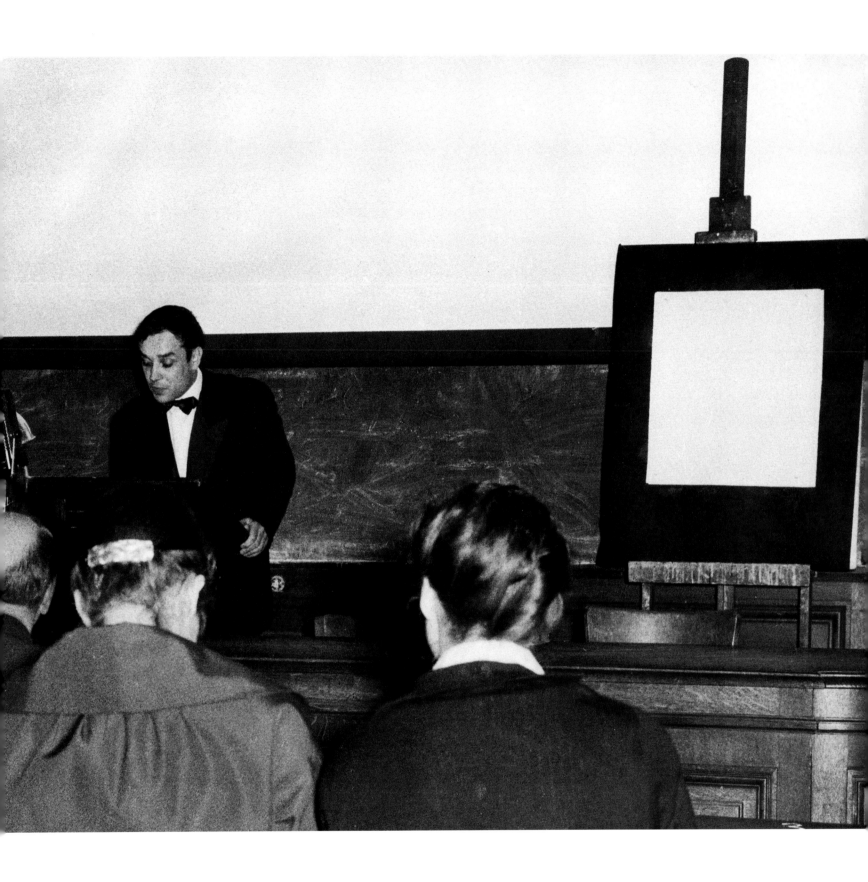

Yves Klein delivering his Sorbonne
lecture, Paris. 3 June 1959.

Quivering gold and light

Water, fire and gold

By 1960, following his Blue Period, 'Le Vide' and the Blue Revolution, Klein was recording imprints of models, plant life and atmospheric conditions. Germinally present in his monochromes and conceptualisations of emptiness, the imprints gave his work a cosmogonic dimension sufficient to raise it to the level of myth. Universality ghosted the monochromes, so to speak. It was about this time, too, that Klein ritualised his transfers of immaterial space. He restored the gold he received from these transactions to nature, specifically to the bed of the River Seine, where it slumbered in the depths of life-sustaining water. And the receipts for the sales went up in smoke between the fingers of the purchasers of invisible sensibility. Water, fire and gold – purification, illumination and regeneration – the conjunction of these three elements makes the ritual's symbolism quite plain.

From 1960, Klein began painting with gold. Moving steadily from polychromy to blue, from blue to the void, and from empty space to gold, his engagement with matter was also clearly an engagement with infinity. His blue was permeated with the poetry of the fleeting moment experienced as feeling. His empty spaces breathed the pure sensibility of blue. Gold rendered blue and its vital energy immortal. Like a beam of divine light, a halo of sacredness or the solar chariot of Apollo (the sun god who is also the god of poetry), gold defies the passing of time. It is the attribute of God in His omnipotence. The gold backgrounds of medieval illuminations guarantee that the scenes depicted against them are timeless and immaterial. The 'monogolds', the panels that Klein created entirely in gold leaf – and with a complete absence of drawing and representation – are the apogee of this tradition.

Following his earlier offering of small gold ingots to nature for a breath of immaterial sensibility, in February 1960 Klein exhibited at the Musée des arts décoratifs in Paris a panel of quivering gold leaf. Deposited with a jeweller's delicacy and loosely affixed to the support, the individual leaves stirred at the slightest breath of air. This monochrome was like a luminous pool of water being ruffled into gold by a twilight breeze. Gold, the most immaterial of minerals, scintillates and escapes the eye's attempts to take possession of it. The gossamer thinness of the mineral worked into a semi-transparent leaf evokes the purity and immateriality of blue, that 'darkness made visible'.[4] In effect, this quivering monogold concretises two separate zones of immaterial pictorial sensibility.[5]

Untitled (**M 59**). Gold monochrome. 1959. Gold leaf on glass, 46 x 31 x 0.6 cm. Private collection.

Untitled (**MG 23**). Monogold. 1961. Gold leaf on board, 58 x 41 cm. Museo Reina Sofia Collection, Madrid.

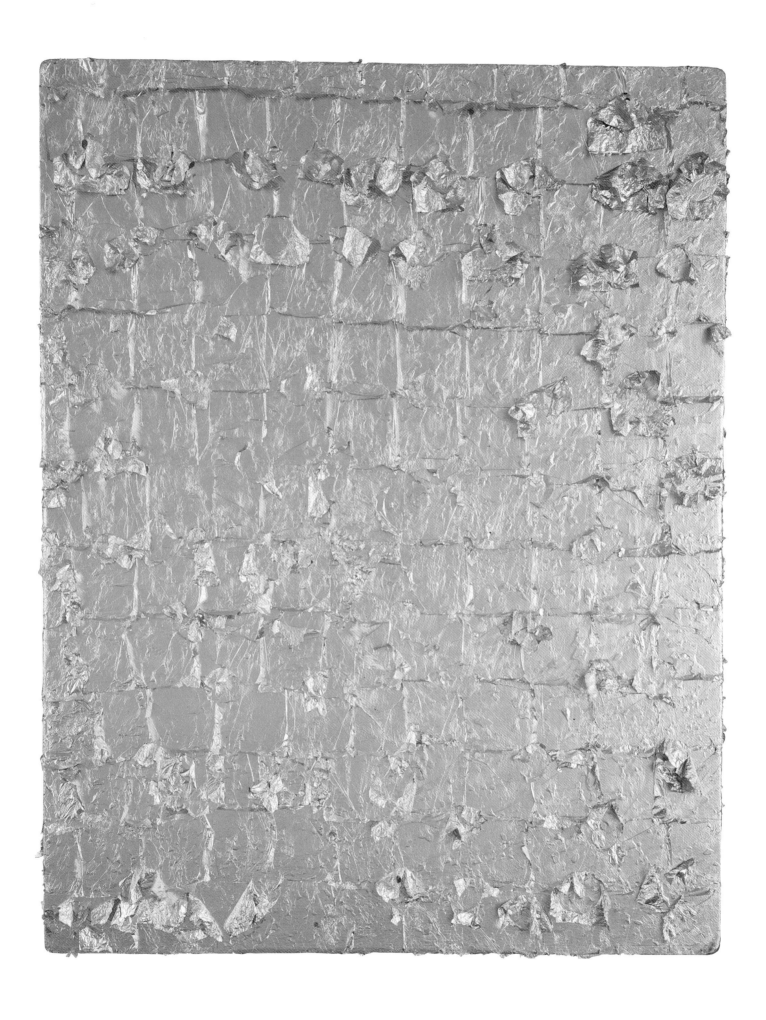

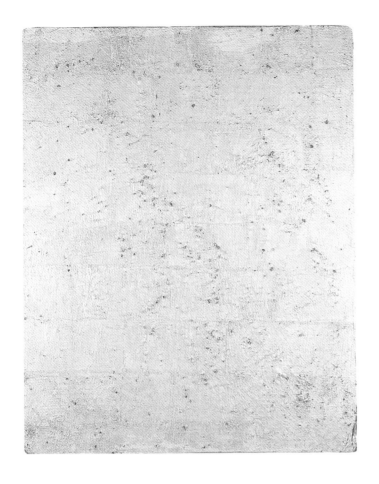

To have gold in one's fingers, as they say, is to possess the secret genius of an alchemist transmuting base matter into gold. The idea of painting with gold delighted Klein, 'the painter who sold hot air'.[6] It was his way of creating a synthesis between his Christian upbringing and his dreams of alchemy. As he had done earlier with the anthopometries and sponge sculptures, he varied the size, texture and technique of his monogolds with the virtuosity of a true initiate. The result was an orgy of light: 'to make colour solar . . . what would it be like? Pure colour, everything has to be sacrificed to it,' wrote Gauguin.[7] Klein's few shimmering monogolds were complemented by other gold works: panels of static gold leaves, their grids distinctly visible, and burnished gold surfaces as smooth and uniformly bright as gold ingots. Here and there, a slight concentric high or low relief, a 'welt or crater',[8] accentuated the throbbing of the gold. Two panels, *Résonance* (*Resonance*) and *Le silence est d'or* (*Silence is Golden*), vibrate in this manner, enriched with a bubbling lava-like matter. Klein called his first series of monogolds *L'Âge d'or !* (*The Golden Age!*) and dedicated it to his friend and fellow artist, the master of Spatialism Lucio Fontana. He also sprayed a sponge relief and several sponge sculptures with gold pigment.

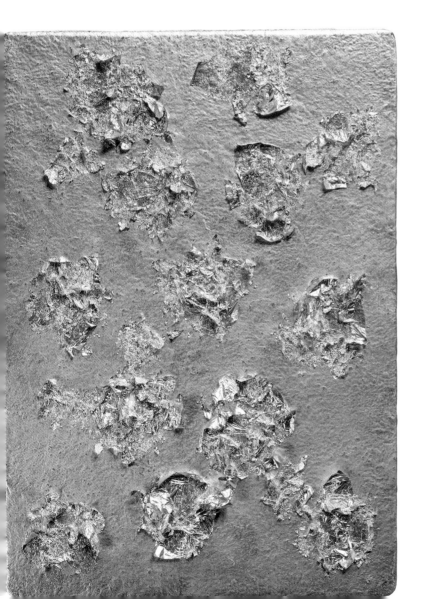

Facing page: ***Untitled*** (**MG 8**). Monogold. 1962. Gold leaf on wood, 81.5 x 73 cm. Private collection.

Untitled (**MG 6**). Monogold. 1961. Gold leaf on wood, 60 x 48 cm. Private collection.

L'Âge d'or ! (*The Golden Age!*) (**MG 46**). 1959. Gold leaf on wood, 33 x 23.5 cm. Private collection.

A triad of colours: blue, pink and gold

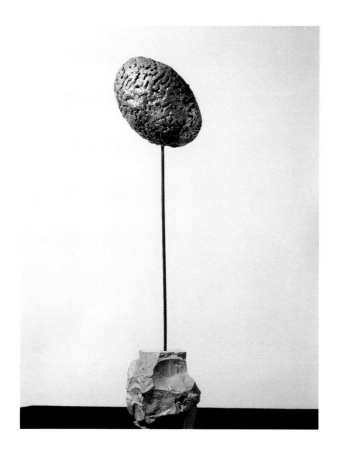

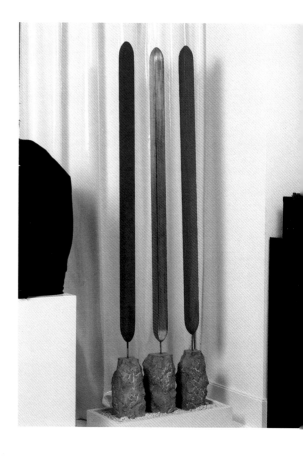

Obélisque, Concorde bleue (*Obelisk, Blue Concorde*) **(S 33)**. 1960. Dry pigment and synthetic resin on plaster, with stone base, ht.: 197 cm. Private collection.

Obélisque, Concorde or (*Obelisk, Gold Concorde*) **(S 34)**. 1960. Gold leaf on plaster, with stone base, ht.: 195 cm. Private collection.

Obélisque, Concorde rose (*Obelisk, Pink Concorde*) **(S 35)**. 1960. Dry pigment and synthetic resin on plaster, with stone base, ht.: 195 cm. Private collection.

Untitled (**SE 202**). Sponge sculpture. Sponge and gold on metal rod, with stone base, ht.: 63 cm. Private collection.

Obélisque, Concorde bleue, or et rose (*Obelisk, Blue, Gold and Pink Concorde*) **(S 33, 34, 35)**, detail.

In that same year, 1960, Klein added one more colour – rose or pink – to his chromatic pantheon. The sky's blue, 'the path to infinity down which reality is transformed into imagination',[9] was mirrored in gold, which manifests the infinite where the imaginary becomes real. But between the domain of sensibility and that of timelessness, there was room for the spirit. Breath, the spiritual principle that engenders life, insinuated itself into the duality of blue and gold. Only the glow of red could symbolise the spirit. In the Bible, the spirit is manifested as breath or flames. If one breaks down the hues of fire, one obtains a continuum from yellow through blue to pink. Flamboyant pink does not have the brilliance of royal purple or the purity of blood-like crimson, but it nonetheless possesses an incomparable sensuality. Like a flame, crimson rose is a caress. It is the colour of love, of the heart and spirit joined together.

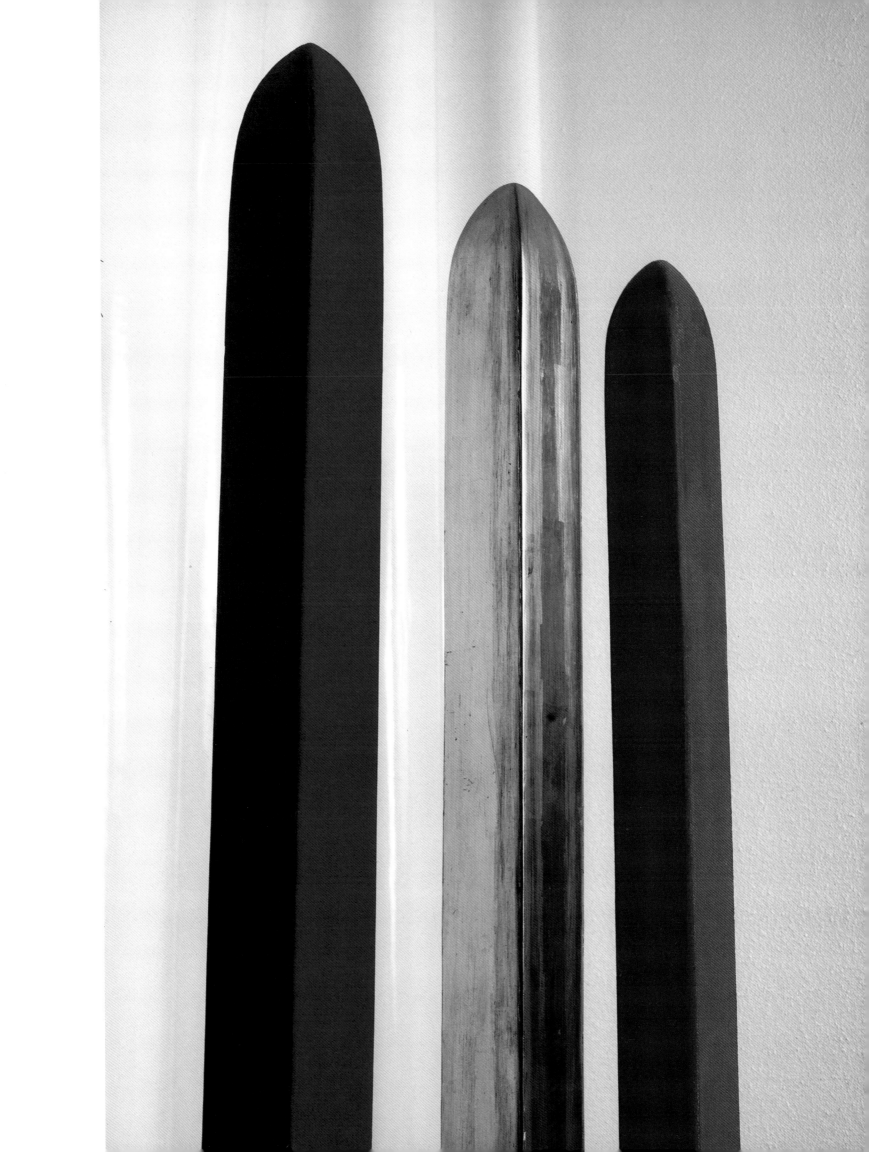

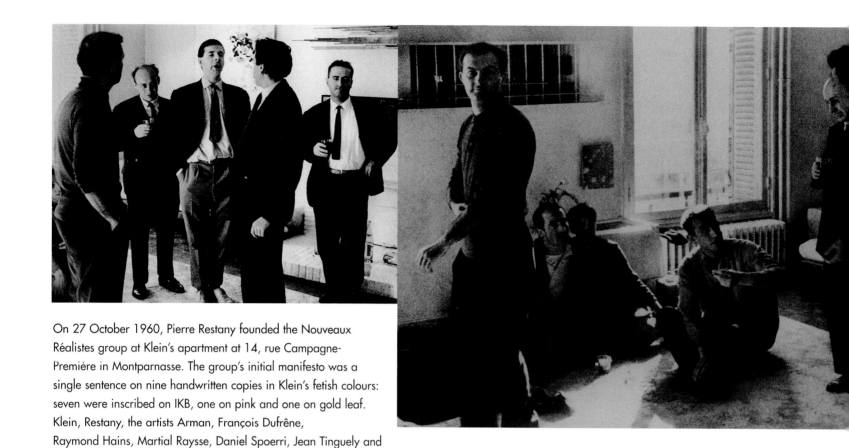

On 27 October 1960, Pierre Restany founded the Nouveaux Réalistes group at Klein's apartment at 14, rue Campagne-Première in Montparnasse. The group's initial manifesto was a single sentence on nine handwritten copies in Klein's fetish colours: seven were inscribed on IKB, one on pink and one on gold leaf. Klein, Restany, the artists Arman, François Dufrêne, Raymond Hains, Martial Raysse, Daniel Spoerri, Jean Tinguely and Jacques de La Villeglé[10] drew lots for their personal copies and, as chance would have it, Restany got the pink version (which was appropriate, pink being the colour of the spirit and the intellect).

Signing of the *Déclaration des Nouveaux Réalistes* at Klein's rue Campagne-Première flat. Left-hand photo, from left to right: Arman, Villeglé, Dufrêne, Restany, and Hains. Right-hand photo, from left to right: Arman, Tinguely, Rotraut, Spoerri, Villeglé and Restany. 27 October 1960.

Untitled (MP 19). Monopink. c. 1962. Dry pigment and synthetic resin on canvas on wood, 92 x 72 cm. Private collection.

Déclaration des Nouveaux Réalistes. 27 October 1960. Paper on canvas, 100 x 66 cm.

Le Jeudi 27 octobre 1960,

Les nouveaux réalistes ont pris conscience de leur singularité collective.

Nouveau Réalisme = nouvelles approches perceptives du réel.

Yves le monochrome
MARTIAL RAYSSE

RESTANY

ARMAN

Tinguely

Hains

Spoerri
Hundertwasser

Dufrêne

Villeglé

In October and November 1960, Klein exhibited an ensemble
of blue, pink and gold monochromes at the Galerie Rive-Droite
in Paris. As Restany puts it, pink symbolises the Holy Spirit,
gold God the Father, and blue Christ, in other words
human sensibility.[11]

Plunged in a typically Kleinian bath of pure feeling, blue, yellow
and red metamorphosed into IKB, gold and pink. Along with blue
and gold works, Klein showed two splendid sponge reliefs
saturated with pink pigment: *Le Rose du bleu* (*The Rose of Blue*)
and *Ho! Ho!* (a reference to its two natural 0-shaped sponges
wrested from the seabed and offered to the spectator's startled
gaze). Several pink sponge sculptures were included in a forest
of blue sponges, together with a few gold sponges. This synthesis
of colour into blue, gold and rose tones was the brilliant overture
to Klein's Flamboyant Period.

Untitled (MP 9). Red monochrome.
c. 1961. Dry pigment and synthetic resin
on gauze on wood, 54 x 48 cm.
Private collection.

Yves Klein in his studio. c. 1956.

Assiette bleue (*Blue Plate*). c. 1959.
Dry pigment and synthetic resin on ceramic,
28 cm. Private collection.

Assiette rouge (*Red Plate*). c. 1959.
Dry pigment and synthetic resin on ceramic,
28 cm. Private collection.

Assiette or (*Gold Plate*). c. 1959.
Dry pigment and synthetic resin on ceramic,
28 cm. Private collection.

Le Saut dans le vide

Shortly before his final burst of creativity, 'the painter of space' threw himself into the void.[12] A famous photograph published in *Dimanche, le journal d'un seul jour* on 27 November 1960, shows Klein soaring into myth. 'He claims that he will soon be able to rejoin his favourite work in space: an aerostatic sculpture made up of one thousand and one balloons, which, in 1957, fled from his exhibition into the sky of Saint-Germain-des-Prés never to return again!'[13] This emblematic gesture of the birdman is a perfect recapitulation of the painter's poetics of the void.

A suspended impulse

The image is powerful. Klein is poised in midair, a few centimetres from the facade of a suburban house, from the roof of which he has just hurled himself, and some four or five metres above the ground. It looks as if he is about to crash onto the pavement. Further up the street life continues; a cyclist goes his way, oblivious of the drama taking place behind him. The soaring human body is captured in the tragic instant when its flight becomes a fall. For a fraction of a second, the artist is suspended in space. Time stops. Such is the magic of photography.

The photograph is now enshrined in art history. Widely reproduced, it has become an emblematic image of contemporary art, not to mention of Yves Klein himself. *Le Saut dans le vide* (*The Leap into the Void*) has been written about extensively and scholars still ponder its true meaning. Some of them comment on the existential nature of the act (Klein made the jump at the risk of his life and the photograph is thus a signature of his existence); others insist that the picture is a hoax – a montage – and argue that the artist deliberately inserted clues in it to make it clear that it is an artefact. And, of course, the image is a montage. Still, Klein really did jump from the roof – onto a tarpaulin held taut by ten judo champions. After a number of trials, reports Rotraut, Klein, whose judo training made him an exceptional athlete, decided he wanted to jump without a safety net. Panicked at this idea, Rotraut pleaded with him not to do it.[14] So much for the anecdotal history of this famous happening.

Inhabited space

There is no disputing the poetic force of the artist's gesture. Even a quick glance at the photograph produces a powerful emotion. Where does it spring from? The image of the 'man in space' is the antithesis of conceptual art; it rocks you from the instant you set eyes on it. It actualises the poetics of the void underlying the unicolour aesthetic. To cite Bachelard, 'The instinct of weightlessness is one of life's deepest instincts . . . Oneiric flight is, in its extreme simplicity, a dream of instinctive life.'[15]

Not only is the void in the image literally inhabited, but we also see the human figure launching himself into space 'without a rocket or sputnik'. Spatial conquest is subordinated to the artist's spiritual quest for the emptiness that shapes the potter's vessel. The photograph's space is not intergalactic but 'inter-animate', to coin a term: 'It's through the terrible yet peaceful power of sensibility that man will venture forth and inhabit space. It's through an impregnation of the sensibility of man in space that the real conquest of that deeply desired territory will take place.'[16] The figure's flight is not so much an image as an impulsion.

Yves Klein, **Un homme dans l'espace ! Le peintre de l'espace se jette dans le vide** (*A Man in Space! The Painter of Space Leaps into the Void*). Also known as *Le Saut dans le vide* (*The Leap into the Void*). Photomontage by Harry Shunk and Paul Kender from a photograph taken in front of number 3, rue Gentil-Bernard at Fontenay-aux-Roses on 19 October 1960. Published on the front page of *Dimanche, le journal d'un seul jour*. 27 November 1960.

Overleaf: **photographs of *The Leap into the Void*** not published in *Dimanche*.

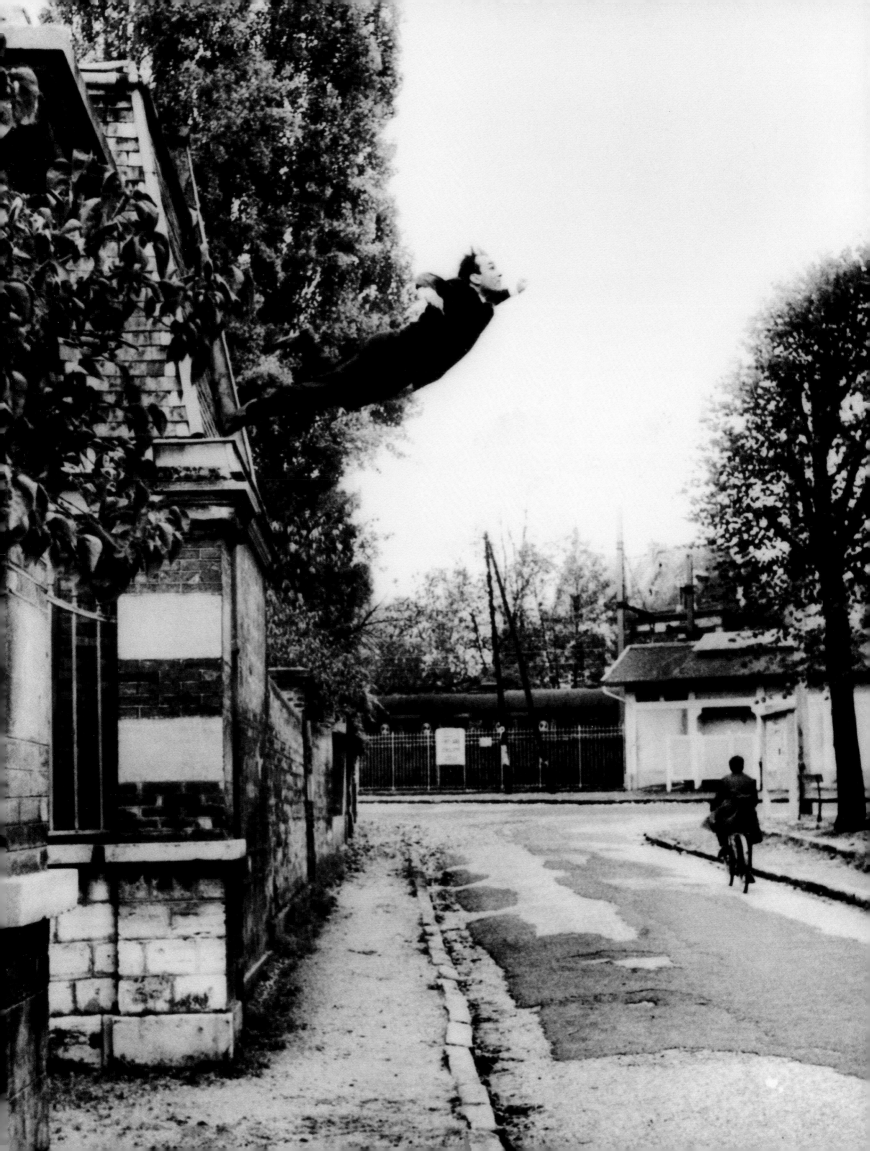

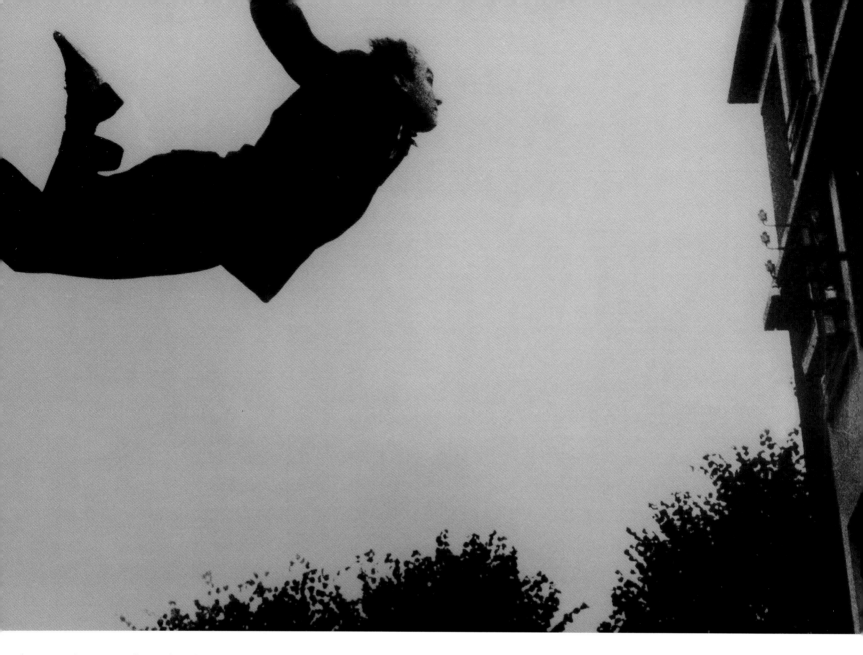

The existential act (Klein does not cheat with his work) is thus also an ontological poetics of the void (the dream of flight vivifies). The 'suspended impulse',[17] the dizzying appeal of the void, is a vital urge, a reaching out to the absolute prestige of freedom. In Klein's conception, 'authentic realism' springs from a 'waking dream';[18] it is the 'will to live one's imagination'. The dream's depth opens new spaces and the imagination soars into the sky beyond the seas, proclaims the painter, echoing Bachelard: 'It seems that an azure, at times a wonderful blue, a golden colour, appears on the peaks to which our dreams elevate us.' At the highest point of a waking dream, 'at the summit of his life,' 'the dreamer, awash in a light that sustains him, has the feeling that he is achieving a synthesis of weightlessness and clarity. He is conscious of being liberated from both the weight and the obscurity of flesh . . . the world then really becomes the other side of a two-way mirror; there is a beyond the imagination, a pure beyond with nothing this side of it.'[19] *Le Saut dans le vide* may be a mythical image, but it is above all an invitation:

'Come with me into the void!
If you return one day
You who, like me, dream
Of that wonderful void
That absolute love
I know that together,
Without needing to say a single word to each other,
We will leap
Into the reality of that void
That awaits our love,
The way I wait for you every day:
Come with me into the void!
1957.'[20]

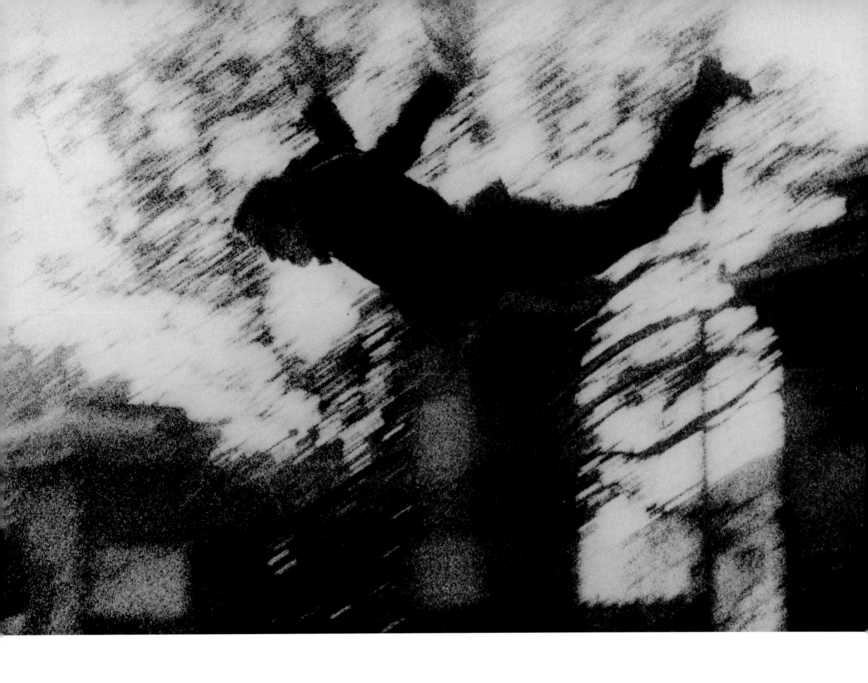

'The earth is now beneath me and the sky above;

I survey my rose garden, the white sand shore,

the blue sea and the seven kingdoms.'

(August Strindberg)

Fire in the heart of the void

'Monochrome and Fire' at Krefeld

In January 1961, Paul Wember, the director of the Museum Haus Lange at Krefeld, in Germany, organised Klein's first retrospective, 'Yves Klein: Monochrome und Feuer' ('Monochrome and Fire'). The exhibition covered the full range of the painter's material and immaterial creations – his entire cosmogony. Monochromes, sponge reliefs, sponge sculptures, trays of pure pigment, rains and obelisks came in a triad of colours (IKB, pink and gold) distributed around three rooms, each devoted to a single hue. Klein's concept of a colour trinity, which he had broached three months earlier at the Galerie Larcade in Paris, had matured. Of the eleven anthropometries in the show, the *Grande Anthropométrie bleue* (*Large Blue Anthropometry*), measuring over 2.7 x 4 m., was by far the most striking. The monumental museum, a transparent structure designed by Mies van der Rohe, obviously called for a presentation adapted to its scale. Klein accepted no half-measures. In close collaboration with Paul Wember, he designed the show down to its smallest details as a grandiose demonstration of colour and fire's potential for absorbing sensibility.

As a supplement to the display of monochrome panels from his early and Blue periods, the artist executed a series of large-scale monochromes and sponge reliefs (199 x 153 cm.), pigment trays (50 x 120 x 100 cm.) and obelisks (195 cm. high). These monumental enlargements conceived to harmonise the artworks and the setting gave more scope to the unicolour concept. True to his method, Klein viewed the exhibition as a platform for new research rather than a mere summing up or retrospective presentation of his œuvre. Injecting the present into the past, he revisited his entire range of work. Embracing fifty-four colour-saturated works and the artist's finest water and fire fountain designs, the Krefeld show was like a coruscation searing the eyes of its visitors. As a counterpoint to his physically incandescent work, Klein included a sample of immaterial sensibility in the form of a totally empty room. It was the artist's tribute to the museum, to which he generously donated this work. Thus the void continues to blaze at Krefeld without ever consuming itself.

Klein's obsession with sensibility impregnation culminated in a blaze of gold and fire. At its most intense, the Klein extravaganza at Krefeld had the mystical aura and mystery of an alchemist's ritual. An extraordinary profusion of gold objects transformed the show's gold room into an incandescent vault. Several of the artist's gold works were impressively large. *Résonance* and *Frémissement* (both 199 x 153 cm.) and *Le silence est d'or* (148 x 114 cm.) were masterful statements executed only one year after Klein's first monogolds. Standing opposite *Valeur or*, a triad of obelisks (all three entitled *Concorde*) affirmed pure verticality. The gold obelisk was placed in the middle, slightly behind the other two, like God in depictions of the Holy Trinity. Lying horizontally in the centre of the room, a strange golden assemblage caught the viewer's eye: *Ci-gît l'espace* (*Here Lies Space*). A very large monogold (125 x 100 cm.) resting on an invisible base a few centimetres above the floor, it seemed to float in space. A thin slab of gold, its smooth surface was pitted with shallow indentations and its upper left corner was adorned with a wreath made of sponges soaked in IKB, diagonally across from a bouquet of pale pink artificial roses. Some twenty crinkled, shimmering squares of gold leaf were affixed to the right side of the slab.

Yves Klein behind one of his *Pluie*
(*Rain*) pieces, Museum Haus Lange, Krefeld.
14 January 1961.

**'Yves Klein: Monochrome und Feuer'
retrospective,** Museum Haus Lange,
Krefeld. 14 January–26 February 1961.

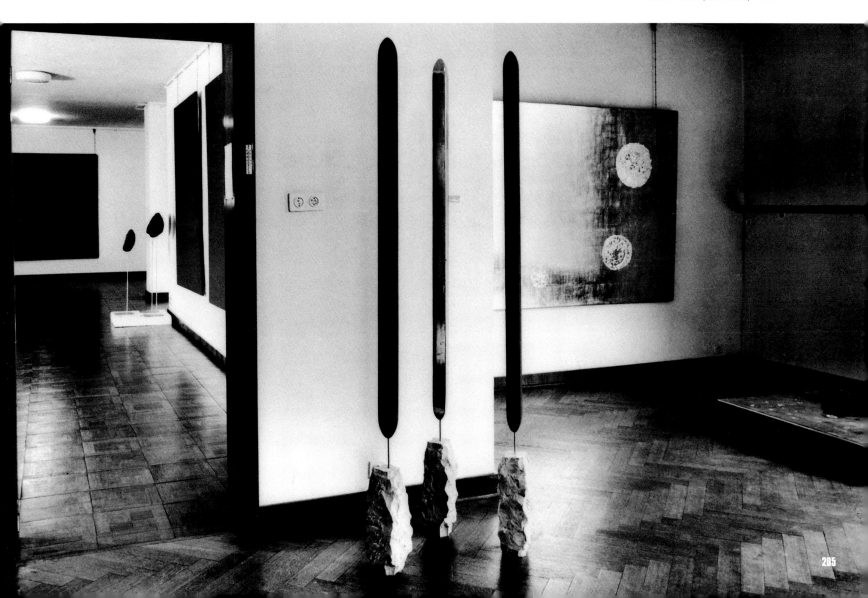

Yves Klein staging his own death
under the 'tomb of space' (*Ci-gît l'espace*
[*Here Lies Space*], RP 3), 14, rue Campagne-
Première, Paris. 30 March 1962.

Yves Klein between the *Suaire
des Nouveaux Réalistes* (*Shroud
of the Nouveaux Réalistes*) and *Ci-gît
l'espace* at the second Festival d'art
d'avant-garde, Palais des expositions,
Porte de Versailles, Paris.
18 November–15 December 1960.

Ci-gît l'espace (*Here Lies Space*) (RP 3).
1960. Gold leaf, sponge and artificial flowers
on board, 125 x 100 x 2.5 cm. Musée
national d'art moderne Collection, Paris.

following pages: *Sculpture de feu* (*Fire
Sculpture*) and *Mur de feu* (*Wall of Fire*),
Museum Haus Lange, Krefeld.
14 January–26 February 1961.

Paul Wember, Rotraut and Yves Klein
in front of the *Sculpture de feu*,
Museum Haus Lange, Krefeld.
14 January 1961.

This one-of-a-kind montage combines the Kleinian triad of colours. According to Pierre Restany, 'The gold panel represents the absolute immortality of God the Father; the sponge wreathe is the attribute of the saturating sensibility of Christ the Son, who assumed a human form; the bouquet of roses testifies to the presence of the Holy Spirit in the love that unites Father and Son.'[21] The critic proposed interpreting *Ci-gît l'espace* as an 'act of physically and tangibly disowning the Heindelian concept of ethereal space'.[22] The tomb of indeterminate ether-space could be regarded as a concrete expression of the sublimation of the void into fire's three elemental colours – gold, blue and rose – and thus an affirmation of the incandescence in the heart of the void. There is also a biographical dimension to *Ci-gît l'espace*. After completing it, Klein had himself photographed lying supine underneath its golden slab. The work may well have been a premonition of his impending death: the artist had a mere eighteen months left to live.

The two complementary poles of Klein's sensibility – irradiating absorption and the presence of the void – reached their expressive peak at Krefeld. Gold and fire, the latest ingredients of the monochrome experiments, acted as amplifiers. Light and darkness, life and death, presence and absence, being and nothingness were united in both elements.

Fires that forbid and regenerate

Two major Klein fire pieces were ignited on the inaugural evening of the Krefeld retrospective (14 January 1961). In the museum's garden blanketed with snow a crowd of guests gathered in front of a flaming wall and a pillar of fire. Flames geysered up from the immaculate whiteness of a snowy pool. The *Sculpture de feu* (*Fire Sculpture*), an immense column of flame standing 3 m. high, surging straight up from the ground like a volcanic eruption, symbolised the earth's power of regeneration, the outpouring of primal life. Between earth, sky, water and fire, life ignites. 'Fire is the ultra-living', wrote Gaston Bachelard.

From Europe to Japan, the symbolism of fire is connected to its regenerative powers. Life-giving fire is often associated with its opposite principle, water: 'Love is a flame from Yahweh and the great waters cannot extinguish it.'[23] In this instance, fire triumphs over water. Huehueteotl, the Aztec god of fire, lived in water. For the Aztecs, fire was the primordial principle, since it changes water into clouds and ultimately into rain. In Chinese alchemy, 'Water belongs to the sky.' The ancient Chinese used both water and fire as purifying elements. Perfectly aware of this symbolism, Klein had Rotraut wear her hair, that Saturday evening in January 1961, in the style of Isis, the Egyptian goddess of water. 'We are witnessing the union of Isis and Osiris!' commented Restany.[24]

Standing a few yards from the great jet of flame that burned day and night for the duration of the show, a wall of fire suspended in space greeted museumgoers. Consisting of a grid of fifty low-combustion Bunsen-burners, each one combining eight separate jets, this rectangular 'wall' rested on two props 75 cm. above the ground. It was semi-transparent and had none of the weight, solidity and materiality usually associated with walls. Ordinarily, a wall delimits, protects, and denies access. This was certainly true of Jean-Pierre Raynaud's monumental white tile wall displayed on the Champs-Elysées in Paris in 1999.[25] Klein's wall, on the other hand, was immaterial, weightless, an open grid. Yet it seemed to set an even more impassable boundary. Fire enforces an absolute interdiction. Paraphrasing Bachelard, Klein notes that fire 'punishes every disobedience among those who seek to play too closely with its flames. . . The first thing one learns about fire is that one must not touch it.' Still citing Bachelard, the artist adds, 'Fire is thus initially the object of a general prohibition; hence this conclusion: social interdiction is our first general experience of fire.'[26] Echoing the existential philosopher, Klein dwells in his own writings mainly on the social aspect of fire. It is clear from his writings that the rectangular *Mur de feu* at Krefeld was clearly intended as a manifestation of social fire, human fire. Perfectly mastered and associated with prohibition, social fire is the counterpart of natural fire. Klein's column of fire was an emblem of regeneration; the wall, on the other hand, affirmed a prohibition.

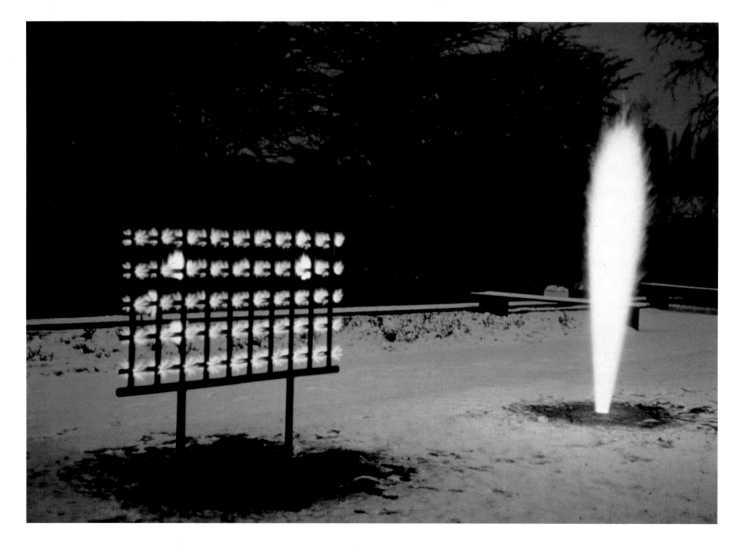

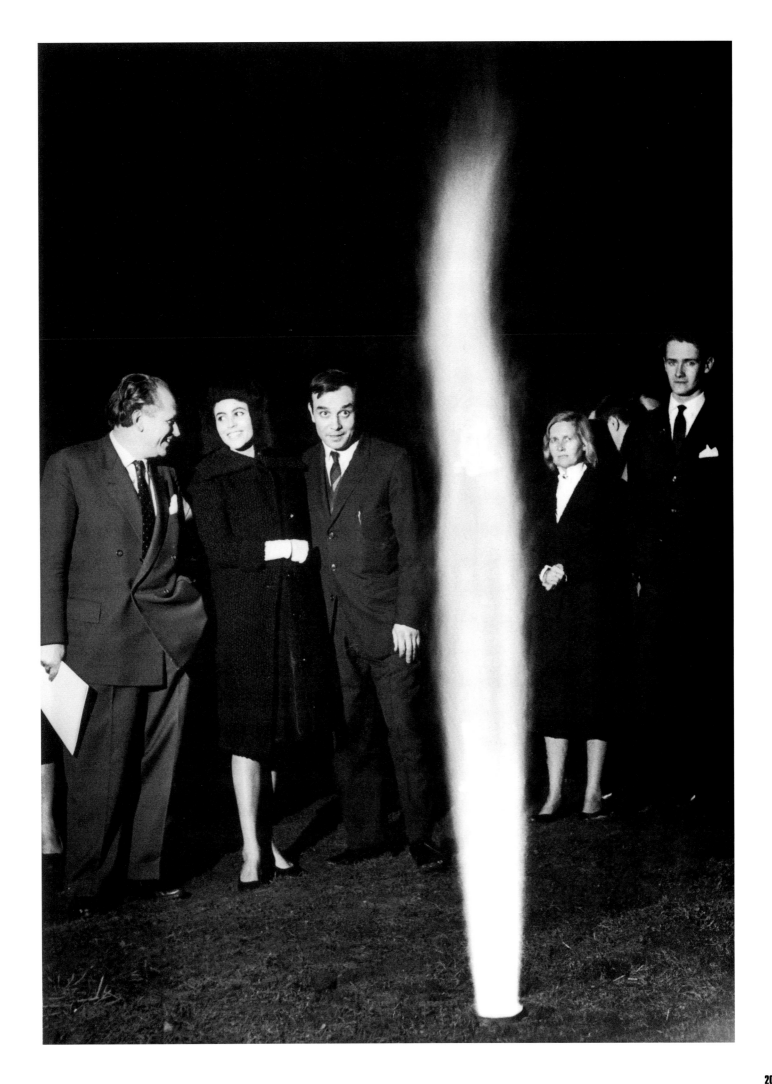

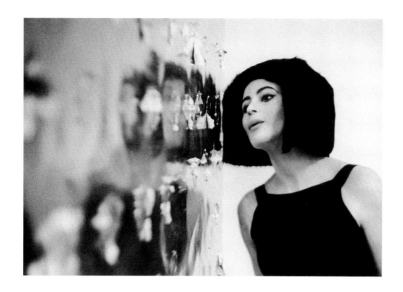

Rotraut blowing on a quivering monogold at the opening night of the 'Yves Klein: Monochrome und Feuer' show, Museum Haus Lange, Krefeld. 14 January 1961.

Untitled (F 34). Fire painting. 1961. Charred pasteboard, 79.5 x 119 cm. Private collection.

Untitled (MG 3). Monogold. 1960. Gold leaf on cardboard, 14 x 12 cm. Private collection.

Preceding pages: **Raum der Leer** (*Room of the Void*), 440 x 160 x 290 cm. Museum Haus Lange, Krefeld. 14 January 1961.

The distinction between natural and cultural values of fire reveals that element's fundamental ambiguity: 'Among all phenomena, it is really the only one to which the two opposing values of good and evil can be so distinctly assigned. It shines in Paradise. It burns in Hell. It is gentleness and torture.'[27] Klein did not choose between the sun's fire and the dragon flames, between the fire that shines and the fire that burns; he embraced both. When the Krefeld retrospective closed on 26 January 1961, he made flames dance on sheets of paper and cardboard. True to the spirit of both his anthropometries and cosmogonies, he recorded traces of the *Mur de feu* and *Sculpture de feu*. These imprints, several of which are exceptional, were the point of departure for Klein's fire paintings.[28]

The permanence and essentialness of fire

The fire paintings have a substantial place in Klein's *œuvre*. They were not, however, the artist's first experiments with fire. In the privacy of his studio, fire had already left its purifying mark on some of the emblematic paintings of his earlier periods. Before becoming fascinated with (natural) regeneration and (cultural) prohibition, Klein had given much thought to fire as an agent of (divine) purification. Shortly after the opening of 'Le Vide' show in May 1957, he had exposed a blue monochrome, IKB 22, to flames. The scorched painting into which two holes were burnt is a concrete expression of the artist's transition from blue unicolour to the void. Similarly, immediately before his first monogold show, in February 1960, Klein blasted the monogold MG 3 with flames, irremediably scarring its gold leaf with intense heat. Finally, his second atmospheric cosmogony entitled *Vent du voyage*, which Arman's wife Éliane Radigue had pressed him to give her, was reduced to ashes before being presented to her.[29] Remember, too, that the buyers of immaterial space were supposed to burn the receipt the artist handed them for their gold purchase. The ritual of purification by fire reached its climax with a large series of body imprints that were subjected to fire.

Significantly, Klein handled fire in its purest form. Playing with matches was not his style. He used jets of flame, which had the destructive power of a concentrated inferno. The element of fire is swift, excessive, violent. Like the ocean whipped to a fury, fire devastates everything in its tracks. Klein clearly preferred the volcanic upheavals of the Romantic tradition to its melancholy moonlight. He executed his fire paintings at the Gaz de France testing centre in March and on 19 July 1961. Wielding a giant blowtorch burning coke gas – a kind of super-powerful flame-thrower – the painter, assisted by a fireman, recorded traces of fire on sheets of compressed cardboard (which were particularly resistant to combustion). Wearing his uniform and shiny helmet, the fireman directed powerful jets of water at the cardboard whenever it caught fire. Yet again, water and fire converged in clouds of vapour. 'My paintings are the ashes of my art.'[30]

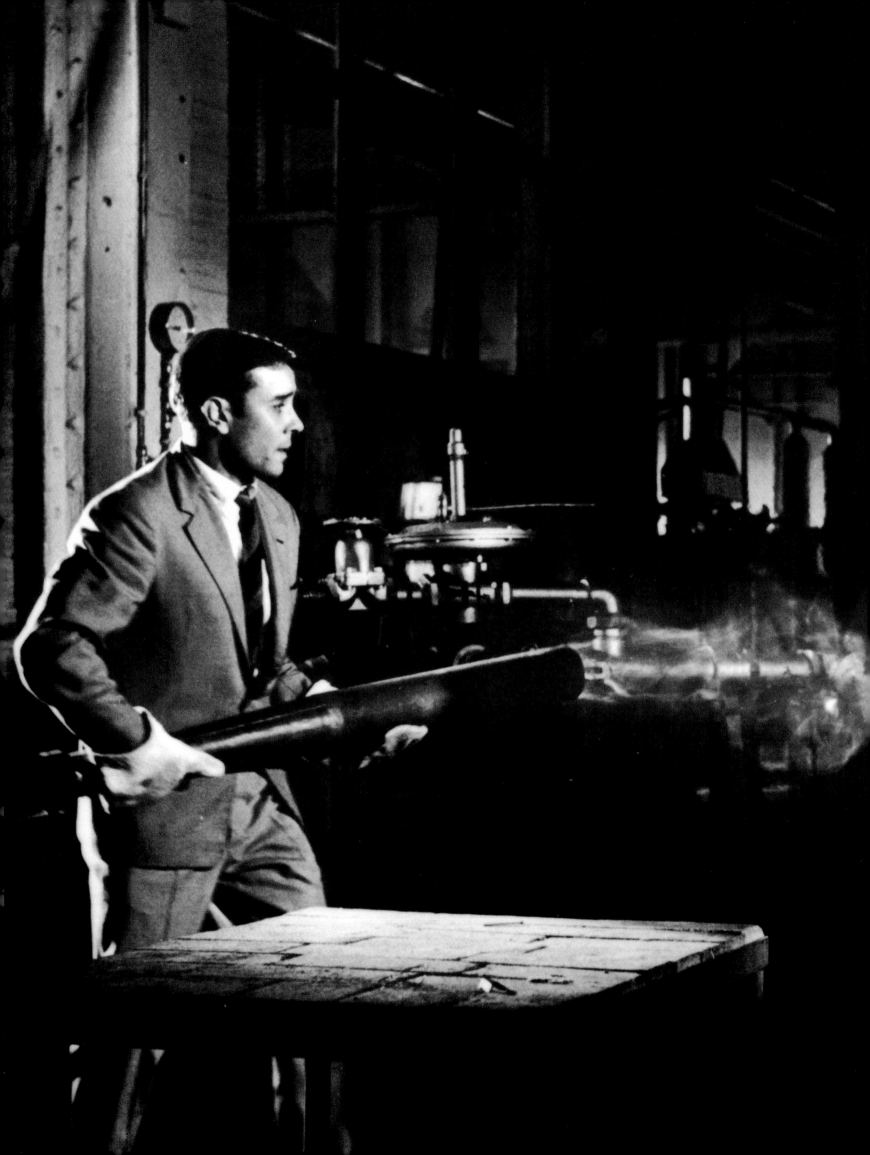

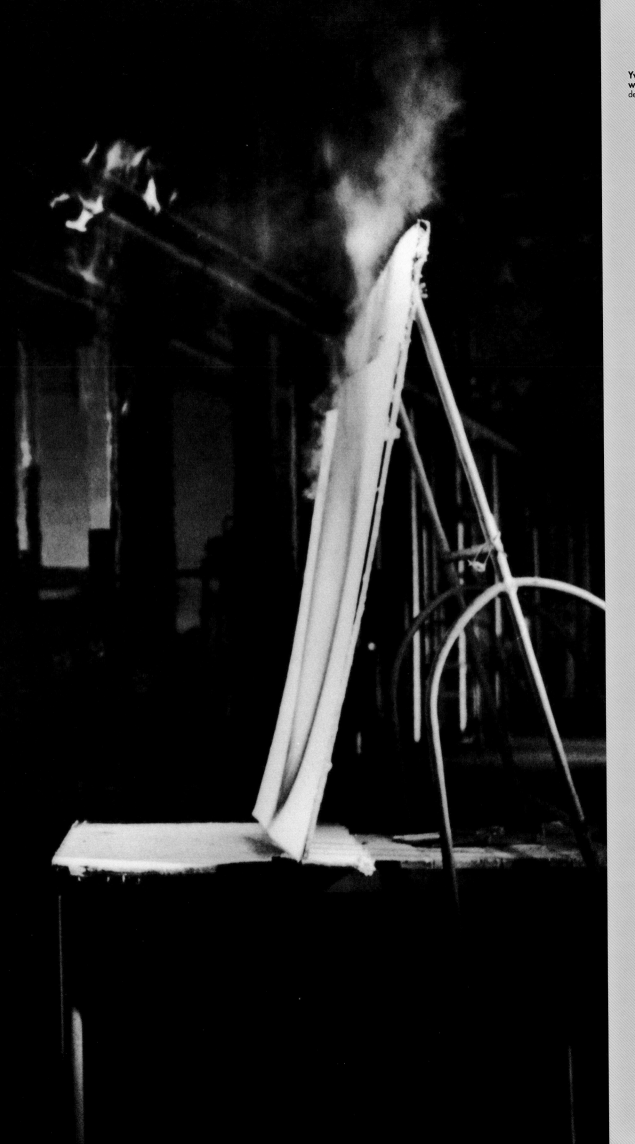

Yves Klein executing a fire painting
with a flame-thrower at the Gaz
de France testing centre. March 1961.

The fire that shines and the fire that burns[31]

Occasionally, the fire that burns took the form of a fire that shines, a fire that leaves the purest of traces – a simple luminous halo or the gossamer imprint of a glancing flame (an 'image of the void sublimated by fire').[32] The sensuality of these fiery imprints extends that of the anthropometries. Fire's flesh and the body's flesh display their nakedness as caresses on the painting's surface. It is pure fire breathing silence. The flames' presence is elusive, almost impalpable. It is merely the sign of a passage. Fire's trace, the memory of a flame-thrower's caress, is so tenuous at times that it becomes a ghostly apparition.

Among the constellation of Klein's fire paintings, Restany distinguishes splashed, cloudy and flowing spatial fires.[33] More expressionistic than Klein's other work, they chronicle the wars of fire and water. From a formal viewpoint, the spurts, drippings and other violent deformations recall the informal compositions of one current of Lyrical Abstraction. With matter in fusion between pollution and the primal *poïen,* Klein was moving towards a painting of the elementary – with one small difference: he removed any personal touch from the process of imprinting fire and water. His fire paintings are, to be sure, lyrical imprints, but they are unmarked by the artist's ego.

Yves Klein executing fire paintings at the Gaz de France testing centre. 19 July 1961.

At a signal from the painter, a fireman uses a fire hose to extinguish the flames on a burning fire painting.

Held by the painter, a fire painting catches fire at the Gaz de France testing centre. March 1961.

Untitled (IKB 22). Blue monochrome, front and back. *c.* 1957. Dry pigment and synthetic resin on charred paper, 18 x 23.5 cm. Private collection.

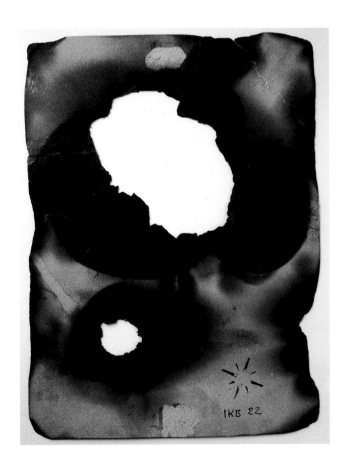

'My paintings are the ashes of my art.'

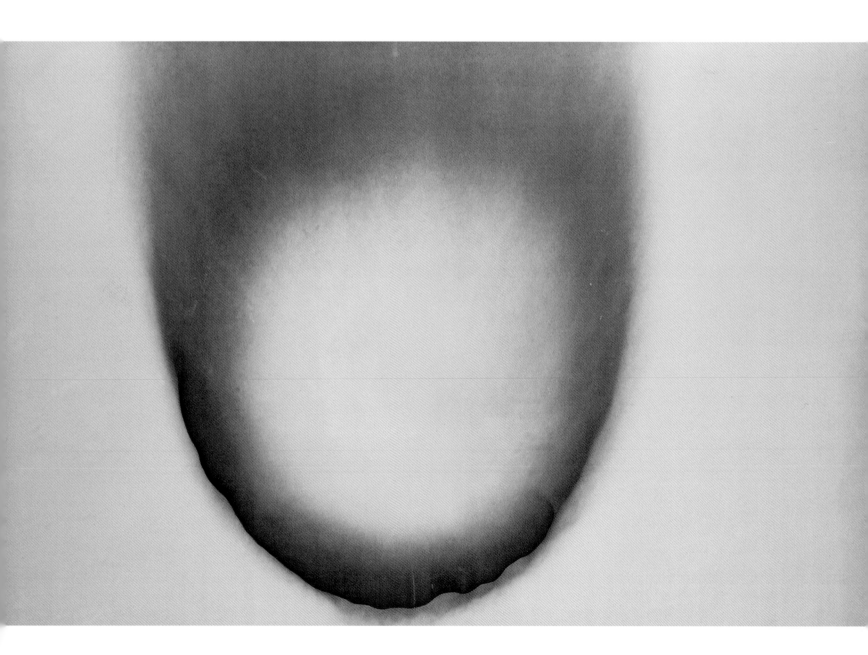

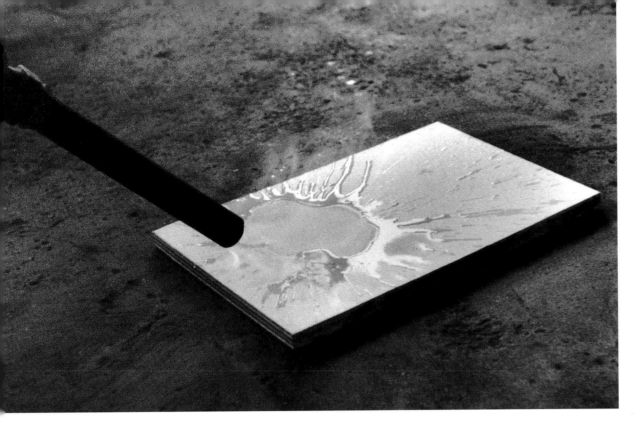

Untitled (F 39). Fire painting. 1961.
Charred pasteboard, 79.5 x 119 cm.
Private collection.

Water and fire at the Gaz de France
testing centre. 19 July 1961.

Untitled (F 43). Fire painting. 1961.
Charred pasteboard, 70 x 100 cm.
Private collection.

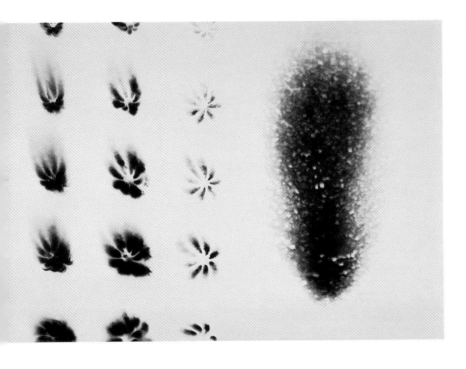

The painter (and the fireman) allowed primal elements to become form. Caresses turned into violent blasts and the void changed into energy. The flame paintings take us right back to the origins of life, to the seething of raw matter and metamorphic travails. Beyond any cultural input, water and fire were being reinstated in their elementary nature.

The phenomenology of imprints attained a peak of expressiveness with the combined fire and body imprints. The naked model yielded the humid, invisible trace of her previously moistened anatomy to the intensity of flames and its trace emerged like a shadow in a furnace. The phantoms of fire are never consumed. Always on the verge of disappearing, their shapes haunt the flames, where half-angelic, half-demonic women dance. The trace sometimes vanishes, melts in the heat like the bodies blasted by the atom bomb at Hiroshima. An almost imperceptible shadow haunts space. Dead or alive, it levitates. Who knows whether its fire is the fire of hell or the fire of paradise? The imprints veiled by flames, those poignant apparitions in fire's blaze, cannot leave anyone indifferent. The phenomenology of traces was never more expressive. No figuration has the authenticity of a human trace in fire.

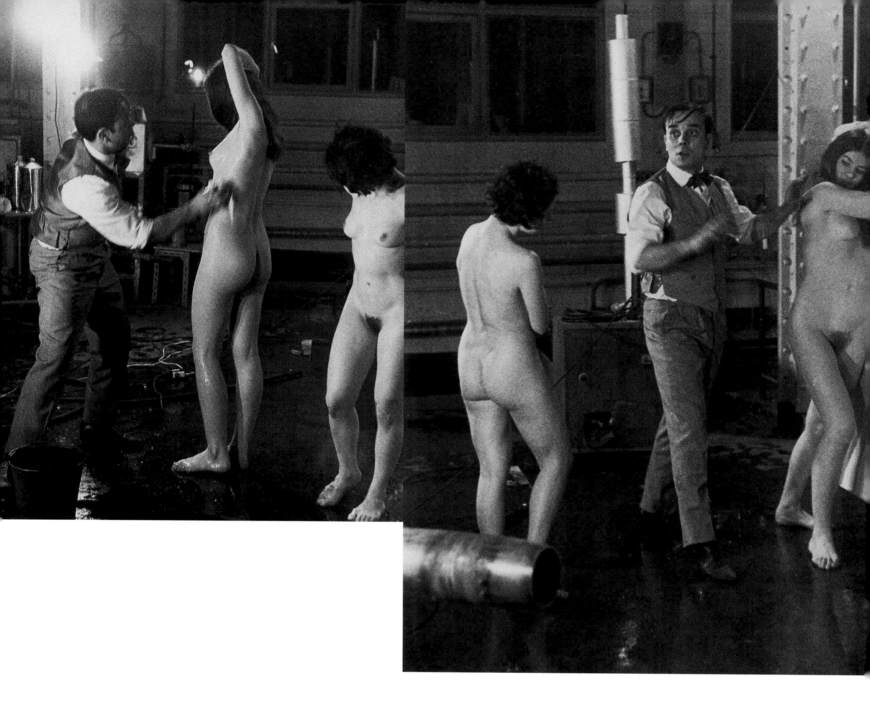

'The mark of fire on the imprint of flesh.'
(Pierre Restany)

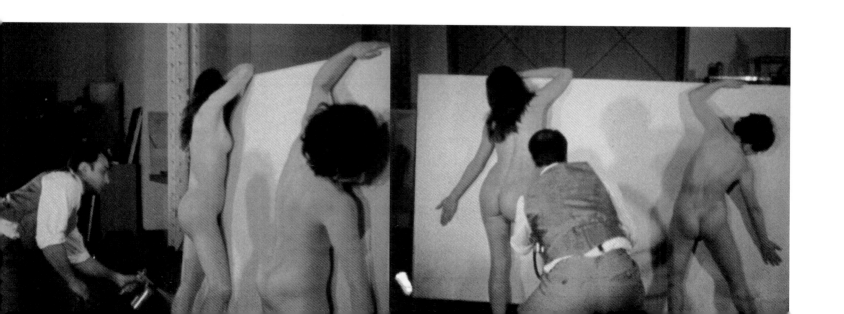

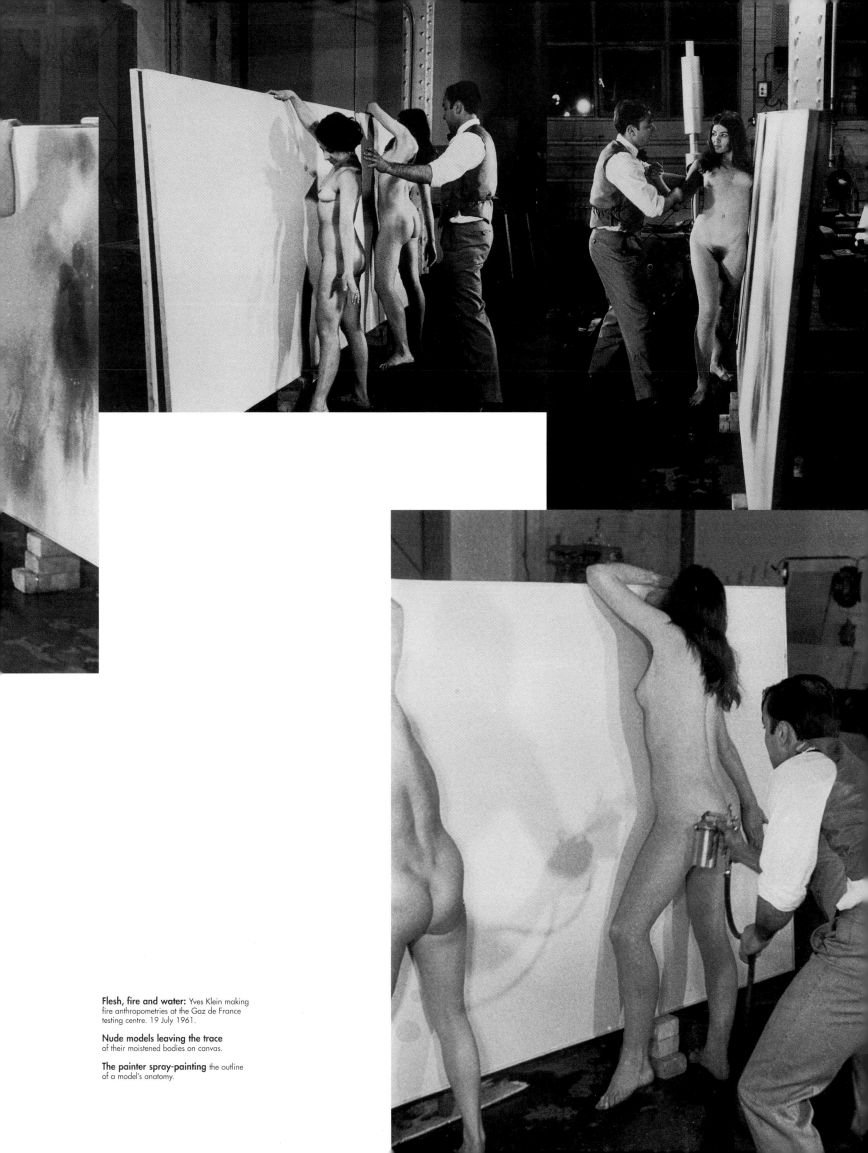

Flesh, fire and water: Yves Klein making fire anthropometries at the Gaz de France testing centre. 19 July 1961.

Nude models leaving the trace of their moistened bodies on canvas.

The painter spray-painting the outline of a model's anatomy.

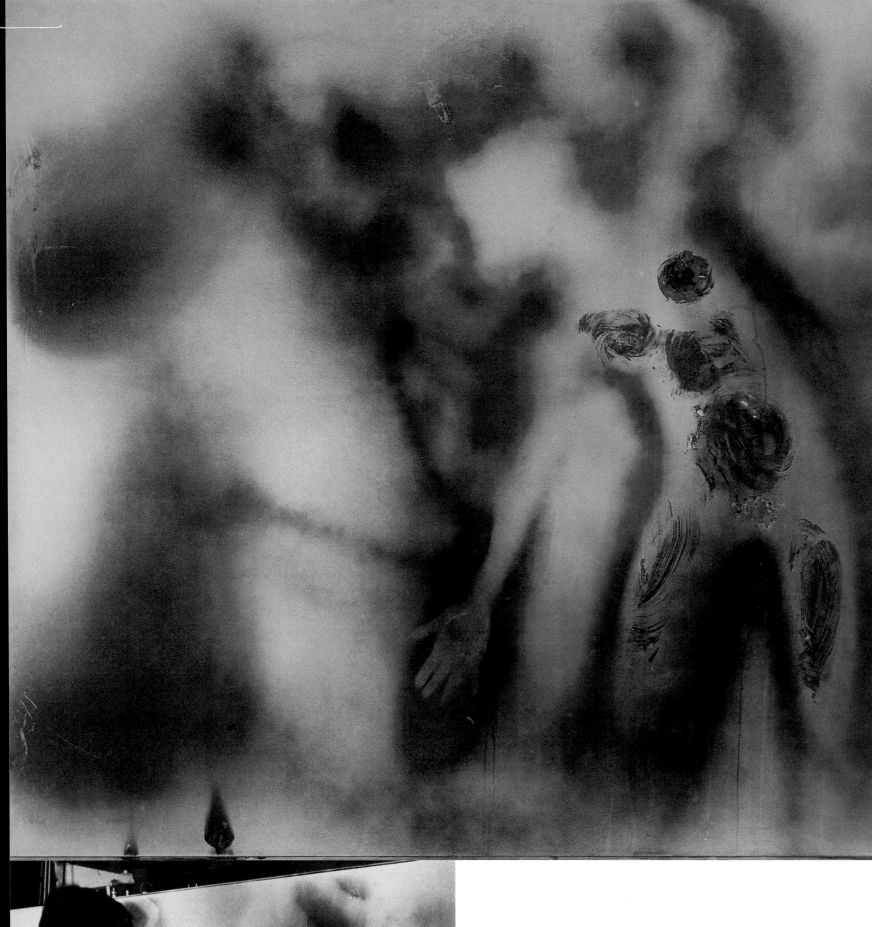

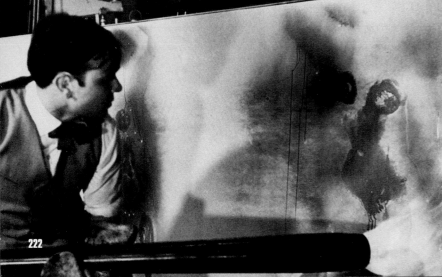

Untitled (FC 1). Colour and fire painting.
1961. Blue and pink pigment and synthetic
resin on paper, 141 x 299.5 cm.
Private collection.

Yves Klein working on a fire painting
at the Gaz de France testing centre. 1961.

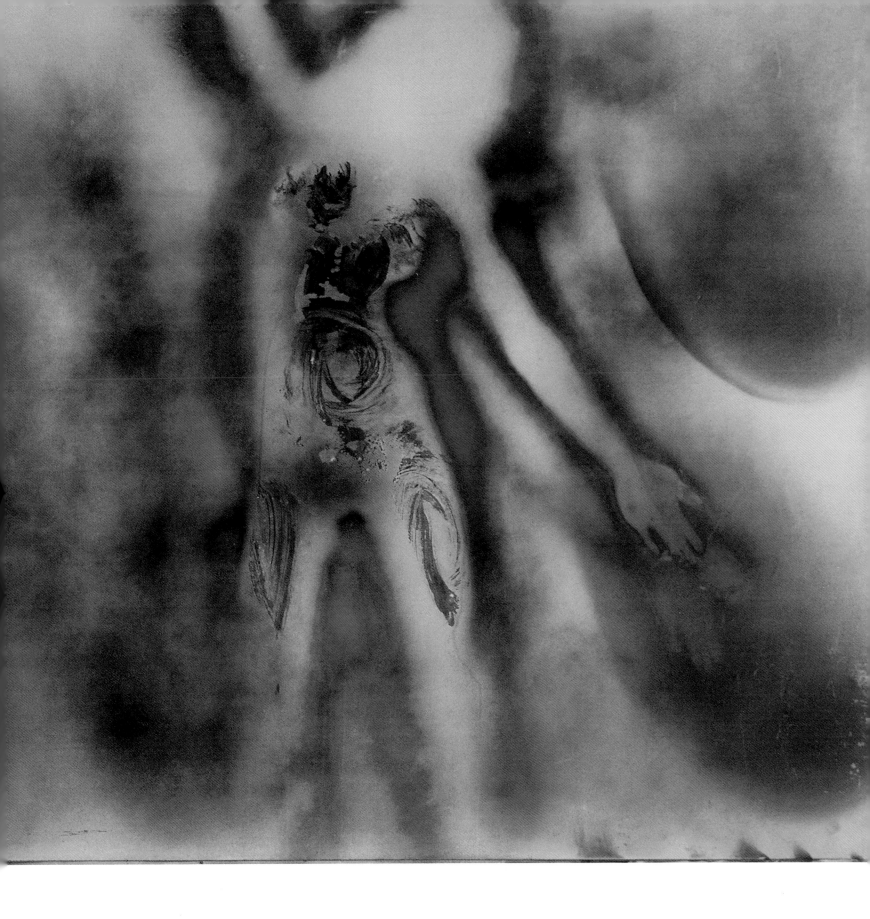

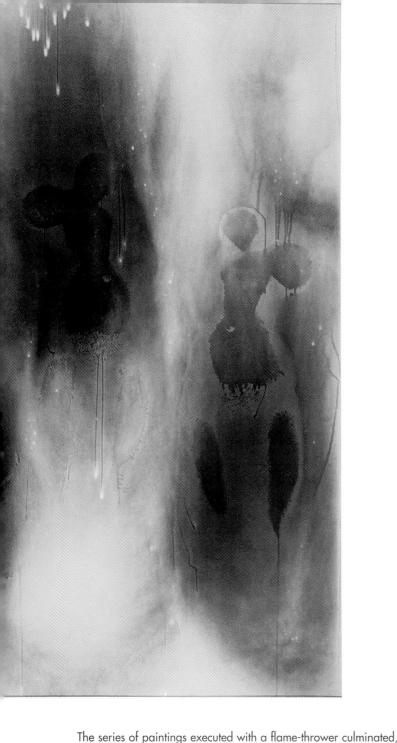

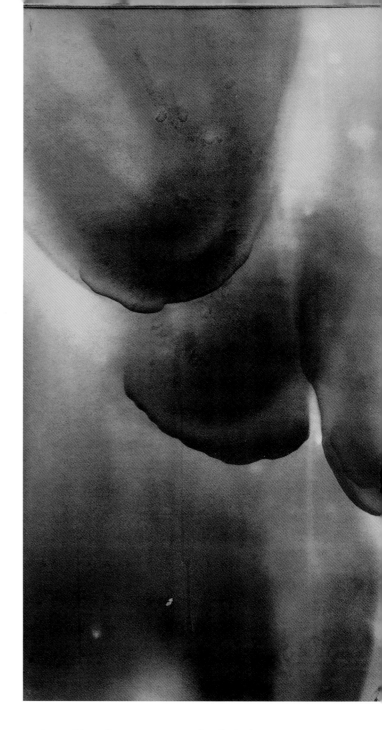

The series of paintings executed with a flame-thrower culminated, in 1962, in a teeming, mysterious outpouring mingling colour and fire. Like the ultimate phase of Gothic art, the works of Klein's Flamboyant Period express a paroxysm. Unbridled freedom and pure poetry transform the artist's colour-fires into the crowning statements of his monochrome researches. Exuberance now replaced rigour, Expressionism elbowed Minimalism to one side, and perhaps fear overwhelmed hope. Death circles the blue imprints of flesh gnawed by fire. Often, where gold once gleamed, the blackness of soot absorbs the light. The sun is obscured. 'To revere the black sun like the other side of the golden sun is to submit oneself to the arcane rites of fiery sublimation,' comments Pierre Restany.[34] Did not the alchemists proclaim that 'the sun is a cold star and its beams are dark'?[35] The more baroque fire and colour paintings 'distinguish themselves from Yves Klein's work as a whole by their gestural freedom, the shrillness of their tones, their vital exuberance'.[36] Flinging blue, red, orange or pink pigment onto cardboard, the artist raked its surface in every direction with a jet of fire.

In the flames' tumultuous blast, the pigment spurted, splashed over the picture surface, then fossilised for an instant before catching fire. From that infernal fire terrifying ghosts seem to surge forth. Restany identifies 'extravagant molluscs, mysterious jellyfish floating in search of their prey, huge, heavy octopuses with powerful, nervous, hairy tentacles'.[37] The amalgamation of shifting forms and volcanic colours ultimately turns Klein's infernos into sumptuous bonfires. Halfway between the golden sun and the black sun, the last stage of the monochrome adventure blazes with all the richness of a sunset.

Untitled (F 80). Fire painting. 1961.
Charred cardboard on board, 175 x 90 cm.
Private collection.

Untitled (F 77). Fire painting. 1961.
Charred cardboard, 107 x 61 cm.
Private collection.

La Coulée bleue (*The Blue Spill*) (D 50).
1960. Dry pigment and synthetic resin
on paper on canvas, 65 x 50 cm.
Private collection.

Untitled (FC 3). Colour and fire painting.
c. 1962. Dry pigment and synthetic resin
on paper, 137 x 74 cm. Private collection.

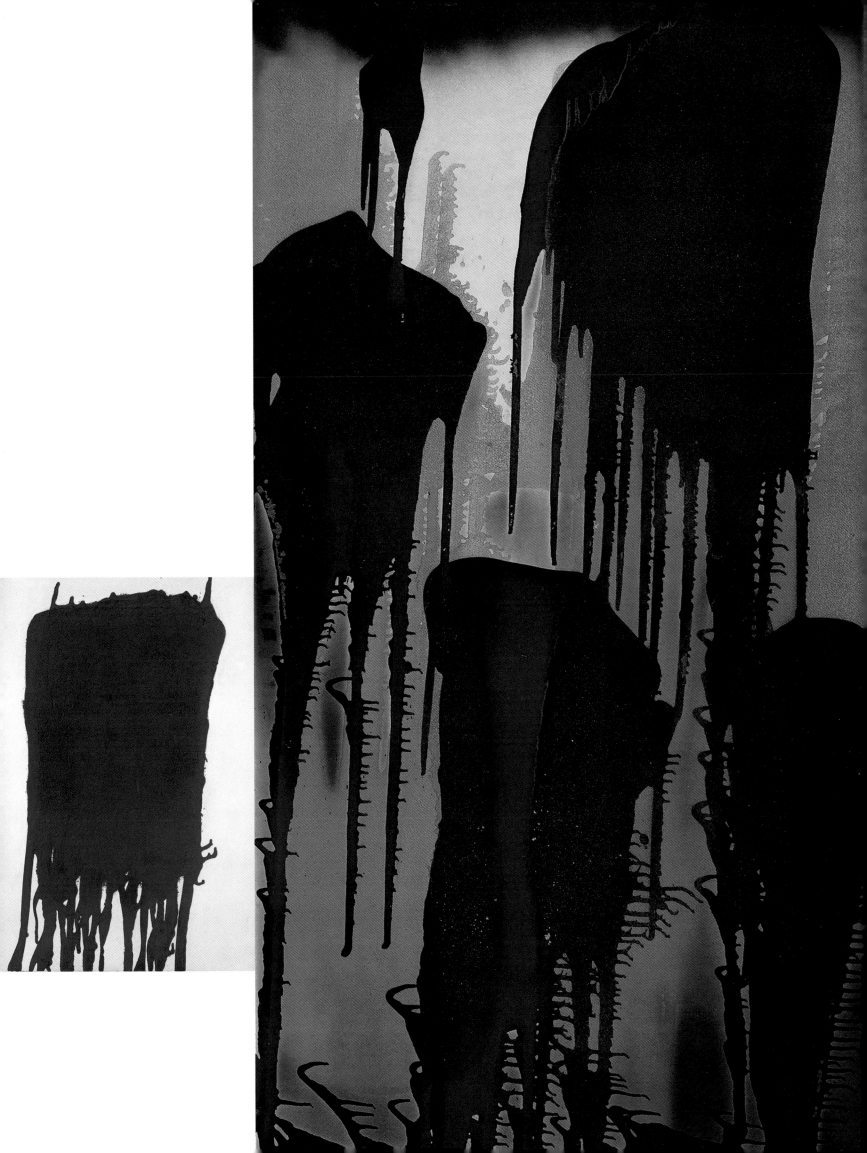

Love's last traces

Yves Klein making plaster mould of Claude Pascal. February 1962.

Yves Klein making plaster mould of Arman. February 1962.

Portrait-relief d'Arman (*Relief Portrait of Arman*) (**PR 1**). 1962. Dry pigment and synthetic resin on bronze, gold leaf on wood, 176 x 94 x 26 cm. Private collection.

The creative ferment of the last four months of Klein's life is awesome. The painter now surrendered wholly to the appeal of sculpture, which underlies all his work. Hardened into three dimensions, the artist's sensitivity to blue makes his initial project of an 'audible silence-presence' altogether palpable. Far from being stylistic exercises, Klein's last sculptures condense his permanent quest for being into emptiness. In addition to the artist's predilection for sculpture, three major vectors of radical appropriation can be identified in the work of his last period: his spiritual family expanded to nature, works of past genius and the cosmos.

Friends

On three separate occasions, Klein created trace images of his spiritual family – his friends. Eternity was not just an idea for him; he wanted to experience it daily. This is what he called the 'authentic realism of today'.

From 8 to 10 November 1960, one week before the official birth of the Nouveaux Réalistes group, Klein made a first plastic record of his closest companions: Arman, Raymond Hains, Pierre Restany and Jean Tinguely. What the *Suaire des Nouveaux Réalistes* (*Shroud of the New Realists*) registers is nothing less than the life of the group. The artists' bodies, faceless and lacking the fullness of their figures, are united for all time. A sheet imbibed with flesh, which was itself imbibed with blue pigment, the shroud is a telling imprint. *Da-sein* (being-there) cannot possibly be presented with greater veracity.

On the first of March 1962, on another, equally gigantic strip of shroud, Klein again gathered the essence of those lives dedicated to creation. The resulting *Store-poème* (*Awning Poem*) unfolds like an unending friendship, a synthesis of past, present and future, a kind of reconciliation between painting and writing as well as culture and nature. In a final tribute, Klein combined texts and works by Arman, Claude Pascal and Pierre Restany. Interspersed with body imprints, poetry, painting and art criticism coalesce in a creative effusion that abolishes the hierarchies between genres. The *Store-poème* concretises the great wave of sensibility that the monochrome adventure proclaimed throughout and its message that 'artists' no longer have the monopoly of feeling and, conversely, that any man capable of being moved is an artist.

One last time, Klein sought to register the sensibilities of his circle of authentically free creators. The two shrouds were not sufficient to capture all their creative energy. A few days before he died, the painter and sculptor used the medium of the plaster mould, which weds sculpture with trace-making. He made head-to-foot moulds of Arman, Claude Pascal and Martial Raysse. Restany, who was detained in Rome, narrowly escaped sharing their uncomfortable fate. Klein wanted to cast the resulting three-dimensional imprints in bronze, paint them blue and install them in front of a gold background. He also planned to include a cast of himself among the group, in gold against a blue background.

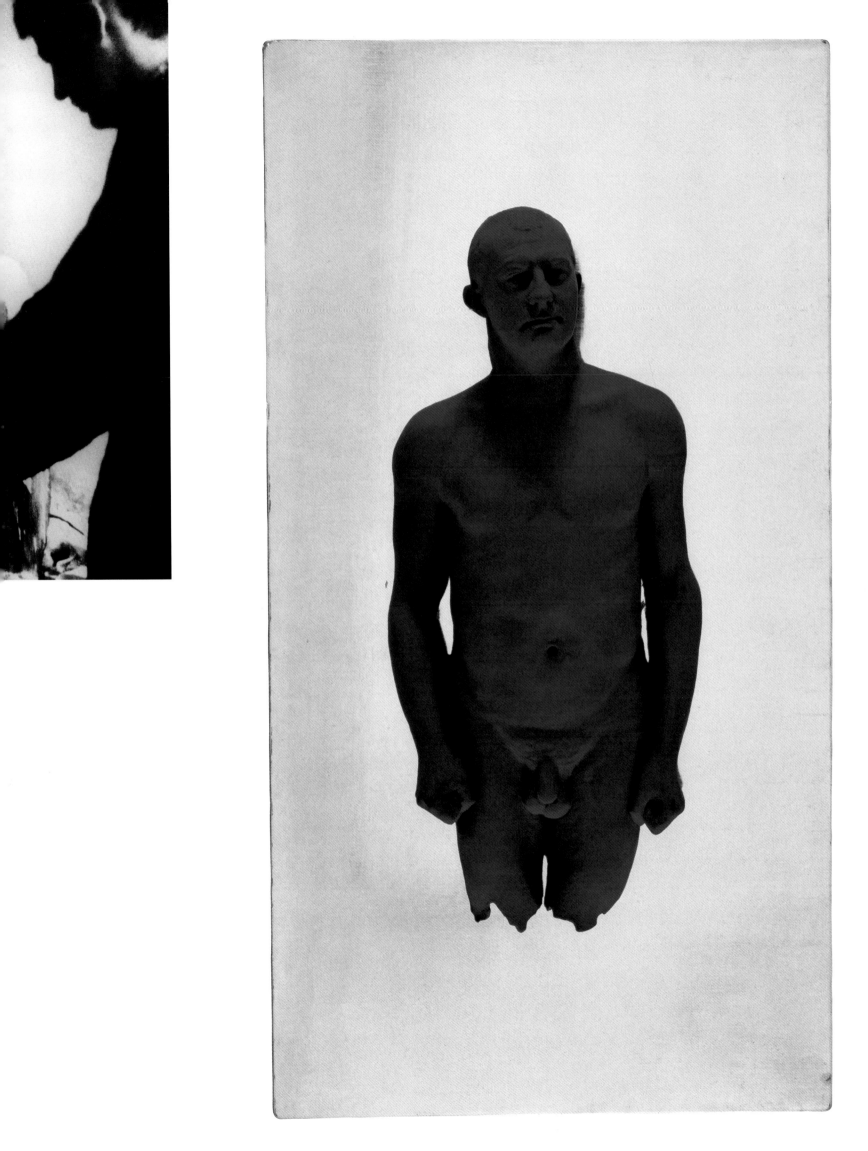

The *Portrait-relief d'Arman* was the only one of these projected sculptures to be completed. With its fossilised face and taut body, its arresting blue presence against gold is profoundly immaterial. Its inspiration lies in the great Byzantine tradition of mosaics. Golden backgrounds, intense blues and hieratic attitudes in the spirit of Ravenna's splendour characterise the ultimate phase of the monochrome experience – the return to serenity. Succeeding the fury of elements, silence has returned to its golden throne. Stripped bare, the body does not breathe a single word; its flesh and blood have crystallised at the passage of sensibility. Between the imprint of a life full of health and the death mask of an inanimate body, its presence-in-absence simultaneously captivates and arouses fear. Laid bare thus, Arman is no longer an individual, or hardly; he is a human fossil. A statue cast in a steely sky, he is a man reborn to eternity.

Opening night of the 'Yves Klein le Monochrome, il Nuovo Realismo del colore' show, Galleria Apollinaire, Milan. Top photo, from left to right: Rotraut, Jean Larcade, Guido Le Noci, Yves Klein, Pierre Restany, Maria Le Noci. Bottom photo: Pierre Restany, Guido Le Noci, Yves Klein. 21 November 1961.

Store-poème (*Awning Poem*) **(ANT SU 15),** detail. 1 March 1962. Dry pigment and synthetic resin on unstretched fabric, 1480 x 78 cm. Private collection.

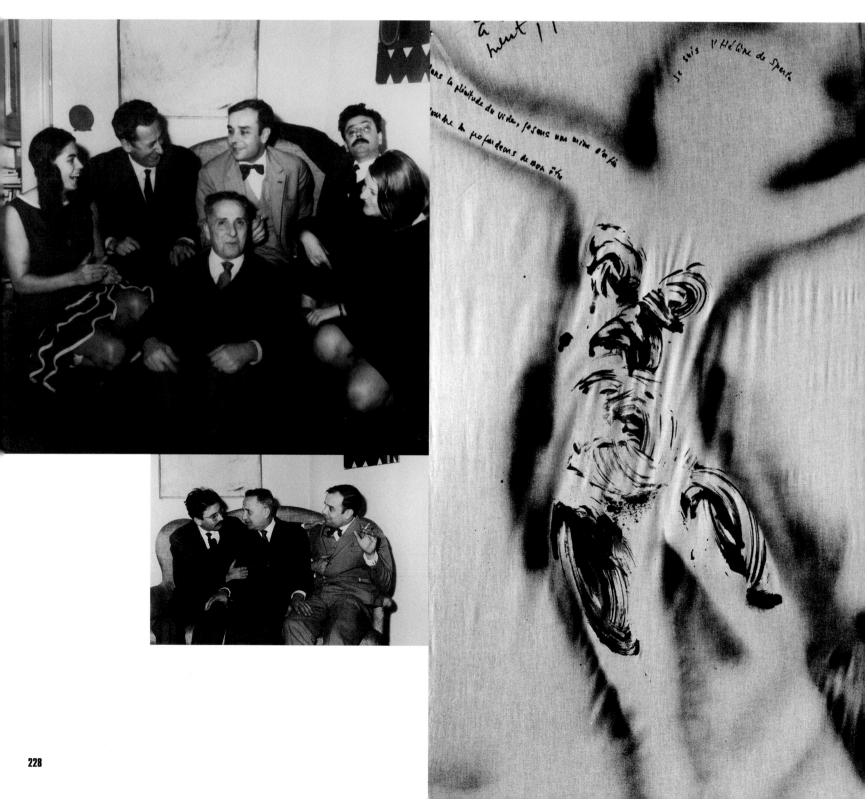

Celebrating the living

Klein carried on the processes of sublimating immaterialisation, using bits of nature rather than bodies. Alongside his work on the cosmogonies, he appropriated natural items and plunged them in IKB. Randomly collecting twigs and rusty metal rods, he restored them to the vitality of their natural origin. Derelict plant and mineral scraps came back to life in a kind of blue ballet. Pieces of wood were bound together and seemed to blossom; bits of wire wrapped around each other and danced to the cadences of spring. Klein made trees grow from relics: pieces of dead wood, corroded iron or deep-sea sponges. The tree as a symbol of life perfectly sums up Klein's involvement with life-celebrating colour.

Untitled **(S 11).** Sculpture. 1961.
Dry pigment and synthetic resin on wood,
99 x 36 cm. Private collection.

Untitled **(S 18).** Sculpture. 1961.
Dry pigment and synthetic resin on metal,
73.5 x 35 cm. Private collection.

Testing great art in blue

In a sense, Klein used sculpture to revisit the phenomenon of impregnation inherent in his method. Thus his anthropometries led naturally to mouldings and his cosmogonies to pure and simple appropriations. His work was haunted by an obsession with human beings and their terrestrial environment.

As a pendant to his interest in the greatness of nature, Klein now sought to incorporate great art into his work. He began to wash masterpieces of art history in blue – a demiurge's gesture. He purchased plaster casts of *The Aphrodite of Cnidus, The Winged Victory of Samothrace* and Michelangelo's *Dying Slave* and, coating them with blue pigment, revealed their bodies' electric sensibility. Veritable paradigms of timeless artworks, these sculptures are logical extensions of Klein's earlier researches. They are his way of making immateriality rime with eternity. The *Blue Venus* in particular has the look of an icon from another world, a universe of timeless incarnations. Its ultramarine velvety texture at once absorbs the viewer's gaze and irradiates space. It is a miracle of presence.

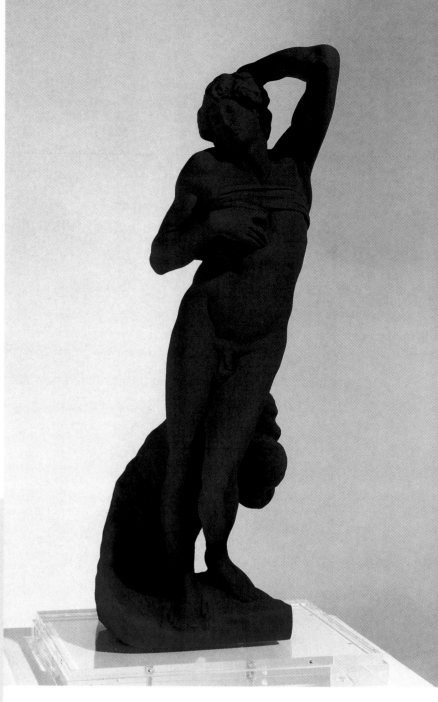

Globe terrestre bleu *(Blue Terrestrial Globe)* **(RP 7).** Sculpture. 1957. Dry pigment and synthetic resin on plaster, 40.5 x 29.5 x 29 cm. Private collection.

Esclave *(Dying Slave by Michelangelo)* **(S 20).** Sculpture. 1962. Dry pigment and synthetic resin on plaster, ht.: 46.5 cm. Private collection.

Victoire de Samothrace *(Winged Victory of Samothrace)* **(S 9).** Sculpture. 1962. Dry pigment and synthetic resin on plaster, with stone base, 49.5 x 25.5 x 36 cm. Private collection.

Vénus *(Blue Venus)* **(S 41).** Sculpture. 1962. Dry pigment and synthetic resin on plaster, ht.: 69.5 cm. Private collection.

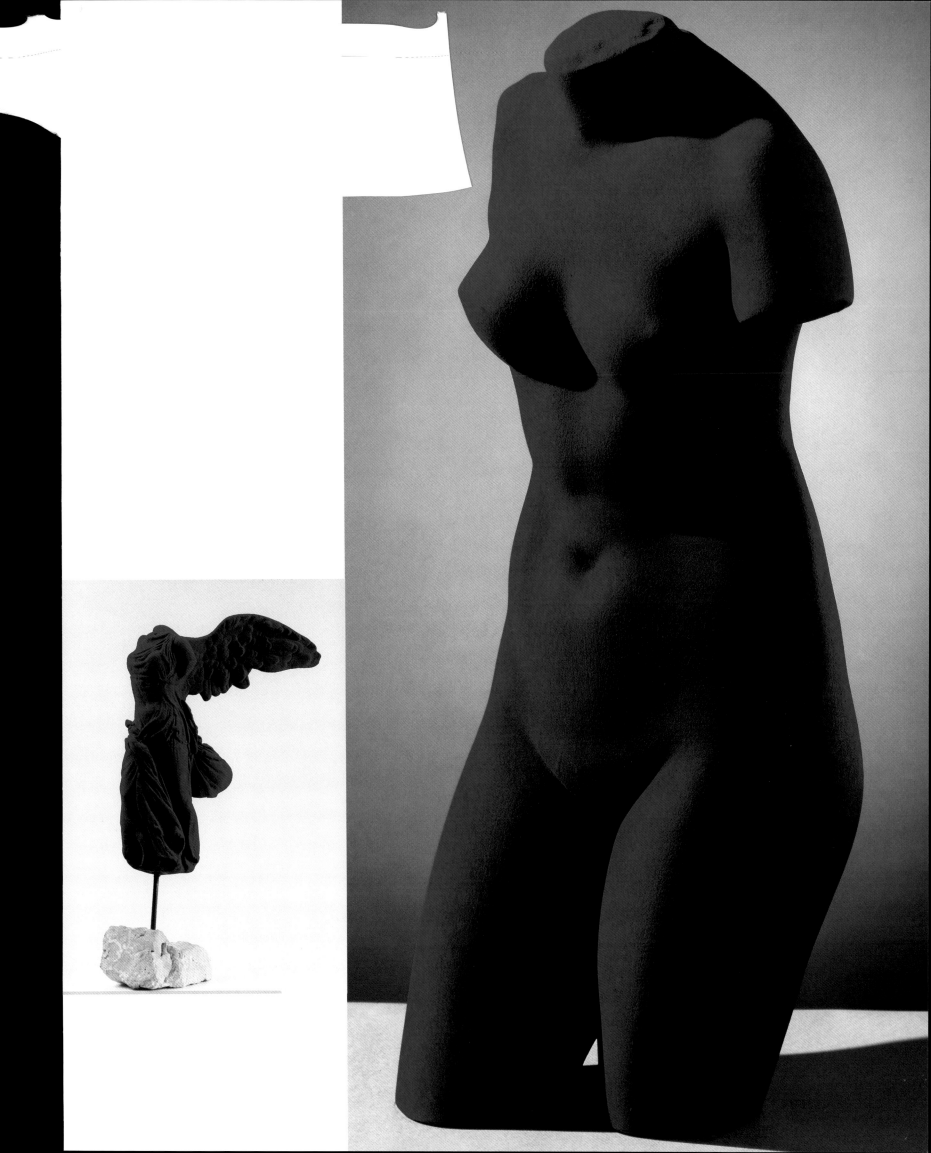

Earth, cosmos

A few months before dying, following a three-month trip
to the United States with Rotraut, Klein brought his experiments
with impregnation to a close. In November 1961, Guido Le Noci
and Pierre Restany organised a retrospective exhibition of his work
at the Galleria Apollinaire in Milan, the gallery where the
monochrome enterprise had been launched almost five years
earlier. It was an opportunity for Klein to show his latest creations,
a series of planetary relief paintings comprising imprints
of the Earth, the Moon and Mars. The sculptor of space
thus concluded his artistic adventure with a mad proposition
for 'expanding' impregnating sensibility to a cosmic scale.

Initially, the artist simply spray-painted relief maps. He then
improved his technique by making plaster casts (imprints) from
moulds of relief maps. The result was stunning: France appeared
in a new, all-blue skin; the earth seen from outer space was indeed
a blue planet; the Moon and Mars were revealed as splendid
volcanic landscapes in fusion. Craters, lava flows and bubbling
magma animated a pink surface, giving them a troubling intensity.

Carte de France (Map of France) **(RP 18).**
Blue planetary relief. 1961. Dry pigment
and synthetic resin, 58 x 58 x 1.5 cm.
Private collection.

Lune (Moon) **(RP 21).** Pink planetary relief.
1961. Plaster and dry pigment on plywood,
95 x 65 cm. Private collection.

Région de Grenoble (Grenoble Region)
(RP 10). Blue planetary relief. 1961.
Dry pigment and synthetic resin on bronze,
86 x 65 x 5 cm. Private collection.

Rotraut

Yves and Rotraut were married at the church of Saint-Nicolas-des-Champs in Paris on 21 January 1962. After the religious ceremony, the painter and his bride exited under an arcade of raised swords, as the knights of the Order of Saint Sebastian honoured one of their fellow members. Klein, who had been knighted into the order in the same church eight years earlier, on 11 March 1956, wore its regalia and looked very dignified. Rotraut, his wife and muse, wore the blue crown of a princess of sensibility. A reference to *Ci-gît l'espace,* her crown interwove an echo of death with love, as if to say, like Christ who at birth bore the signs of his early death, that while it is human fate to return to dust, love is eternal.

On 6 June 1962, Klein had a fatal heart attack. He died a few feet from his wife, in his rue Campagne-Première flat. He was thirty-four. Two months later, on 6 August, Rotraut gave birth to their son, Yves. Klein had had several warnings in the weeks before his death. The wretched parody of his work in Gualtiero Jacopetti's film *Mondo Cane* had upset him deeply. After the film's showing at the Cannes Film Festival, Klein had had a first heat attack on 11 May, followed by a second one four days later. A few minutes before dying, he is said to have declared, 'From now on, I'm only going to make immaterial works.' A year earlier, he had written, 'And all of this because the void has always been my essential preoccupation. And I am quite certain that in the heart of the void as well as in man's heart, fires are blazing.'[38]

Rotraut and Yves Klein in their rue Campagne-Première flat in Paris. 1961.

Marriage of Yves Klein and Rotraut Uecker wearing an IKB crown, surrounded by Knights of the Order of Saint Sebastian. Sunday 21 January 1962.

Epilogue

In 1979, an earthquake followed by violent storms damaged the basilica of Santa Rita at Cascia in Italy. The presbytery was partially destroyed by lightning. During the restoration work, the painter Marocco, who was repairing the stained-glass windows of the shrine, asked the nuns of the convent for some gold leaf. He was handed a votive offering containing gold. 'I realised,' said the Italian artist, 'that we had before us a sensational discovery – a work by Klein dedicated to Saint Rita of Cascia.'[39]

The votive offering had been placed in the shrine in great secrecy in November 1961, when Klein and Rotraut had briefly escaped to Italy, on the artist's third and last pilgrimage to Cascia. He had previously visited the shrine of Saint Rita, the patron of desperate causes, in September 1958, several weeks before beginning his work at Gelsenkirchen, and on that occasion he had made an offering of an IKB monochrome. He had returned to Cascia a second time on or around 21 May 1959.

The 1961 votive offering is a very unusual object. A small transparent plastic box (approximately 14 x 21 x 3.2 cm.), it is divided into three horizontal sections. The lower section contains three small gold ingots, which appear to float on a bed of blue pigment. The middle section houses a written text carefully folded lengthways. The upper section is divided into three compartments, respectively filled with pink pigment, ultramarine pigment and gold leaf. The craftsmanship is impeccable. The box is put together solidly and was plainly made to last forever.

Votive offering to Saint Rita of Cascia.
1961. Dry pigment, gold leaf, gold bars and manuscript in a clear plastic box, 21 x 14 x 3.2 cm. Convent of Santa Rita Collection, Cascia, Italy.

Votive offering to Saint Rita of Cascia.
1961. Catalogue of the 'Monochrome und Feuer' retrospective at Krefeld, Germany.

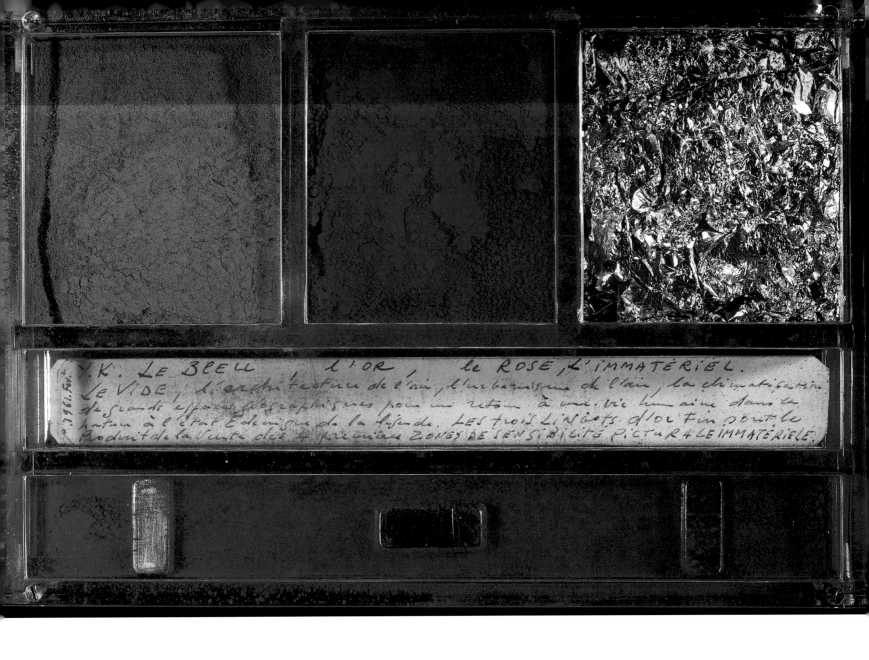

Y.K. LE BLEU, L'OR, le ROSE, L'IMMATÉRIEL.
LE VIDE, l'architecture de l'air, l'urbanisme de l'air, la climatisation
de grands espaces géographiques pour un retour à une vie humaine dans la
nature à l'état Édenique de la légende. LES TROIS LINGOTS D'OR fin sont le
produit de la vente des 4 premières ZONES DE SENSIBILITÉ PICTURALE IMMATÉRIELLE.

The offering contains the treasures of the monochrome adventure.
That it is small in size is of little importance. Its quality and aura
of sensibility are exceptional. Like *Ci-gît l'espace,* it offers
to the viewer's gaze a rare combination of Klein's triad of colours.
The spirit of immateriality suffuses it, from the transparent structure
of its central cavity to the gold bars obtained from the sale
of the first three zones of pictorial sensibility (some of the
purchasers having preferred not to burn their receipts, the artist
remained the temporary custodian of the gold). Lastly, Klein's blue
universe, the realm of visible and invisible sensible matter, of
energy and fire in the core of the void, is manifested as an
oscillation between painting and writing.

The offering's written text, a prayer to Saint Rita, sums up eight
years of creative activity. The artist places his entire *œuvre* under
the saint's protection. Surveying what he has accomplished thus far,
Klein enumerates 'Pictorial sensibility, the monochromes, the IKBs,
the sponge sculptures, the immaterial, the static, positive, negative
and dynamic anthropometric imprints, the shrouds, the Fire
and water-and-fire Fountains – architecture of air, town planning
of air, air conditioning of geographic spaces thereby transformed
into Edens regained on the surface of our globe – the Void /
the theatre of the Void – all the particular variations on the
periphery of my work – the Cosmogonies – my Blue sky –
all my theories in general – .'

Possessed by creativity but conscious of his limitations, Klein asks
Saint Rita to intercede with all-powerful God the Father, so that,
he writes, 'He will always grant me . . . the grace of dwelling
in my works and making them ever more beautiful . . .
May everything that comes from me be Beautiful.' With
a disconcerting innocence, the poet-painter beseeches Heaven
to transform him into an absolute fire. For though death forever
reasserts its hold on life, the fire in the heart of the void is never
extinguished.

A nun at the convent of Santa Rita,
Cascia, in 1999, with Yves Klein's votive
offering found in 1979.

Overleaf: **Gold leaf** on *Ci-gît l'espace.*

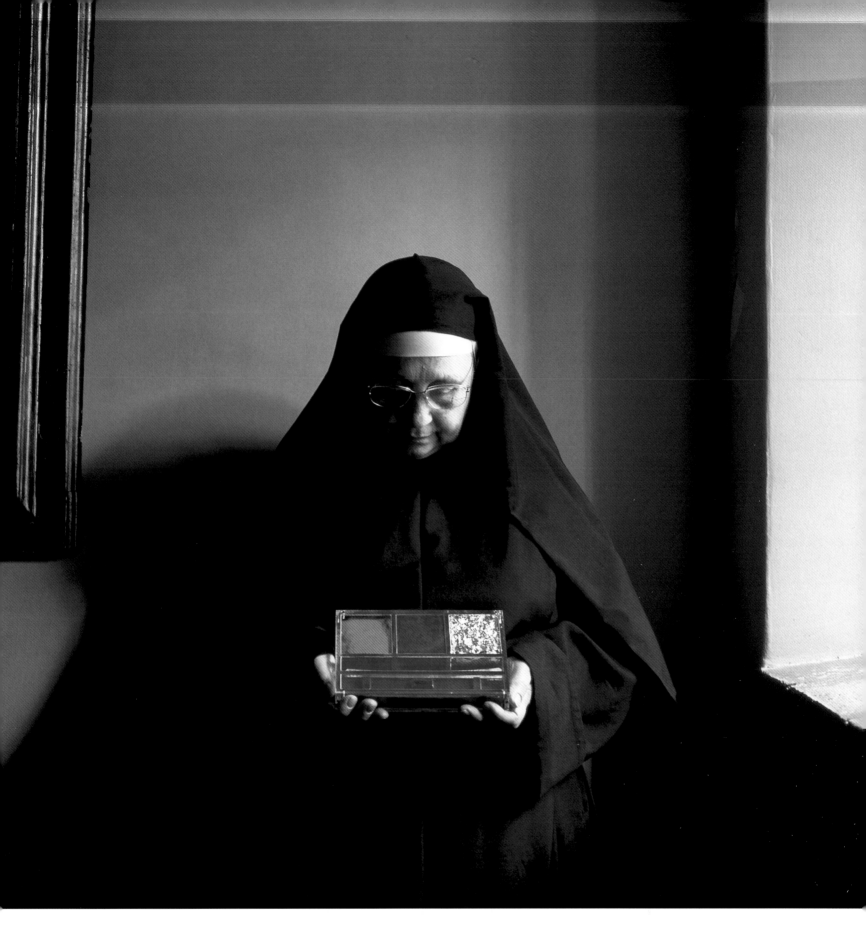

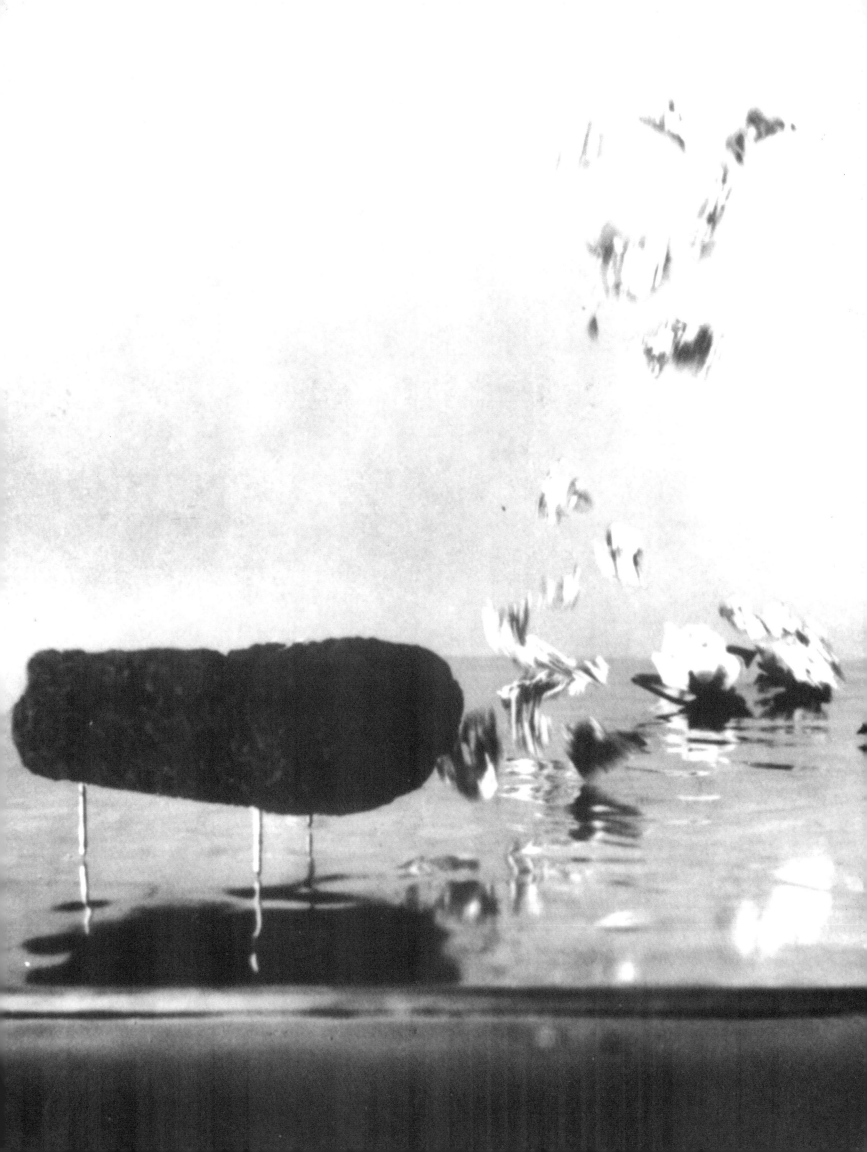

Chronology

1928

Yves Klein born on 28 April at the home of his maternal grandparents in Nice. His mother and father, Fred Klein and Marie Raymond, are both painters. They have been living since 1926 on the rue du Départ in Paris, in the same building as Piet Mondrian. (The building was later torn down to make way for the construction of the Tour Montparnasse.)

1929

The Kleins make friends with Nicolas de Staël and his wife Jeannine Guillou. Young Yves spends the first months of his life (until 1930) on the Côte d'Azur, between Cagnes-sur-Mer, where his father has purchased an old house (La Goulette), and the homes of his grandparents and his mother's sister, Rose Raymond, in Nice.

1930

The Kleins settle in Paris with Yves, aged two. 'We lived in Paris, in the only residence that Le Corbusier built there, on the boulevard Magenta, next door to [the painter Auguste] Herbin,' writes Marie Raymond. The Kleins regularly visit Jacques Villon and Frantisek Kupka in Puteaux.
Yves nearly dies while having his adenoids removed.

1931

The Kleins move to the Paris suburb of Fontenay-aux-Roses, where they settle in 'an old villa constructed from millstones previously occupied by the Swedish sculptor Erik, and a happy year went by', notes Marie Raymond.
Towards the end of 1931, the Kleins, in financial difficulty, move to the South of France.

1932

The Kleins spend the year at the home of Marie Raymond's parents in Nice.

1933–1936

Helped by Marie's parents, the Kleins divide their time between Nice and Cagnes. Marie Raymond recalls: 'After Fontenay-aux-Roses, we returned to my parents' place in Nice. We spent the year living off my parents, but I was there and took care of Yves.' Yves probably spent the weekdays in Nice and the weekends with his parents at Cagnes. His mother remembers that Yves attended a number of schools, 'First at Cagnes, then Nice, then Saint-Jean-Cap-Ferrat.'

1936

The Kleins move back north, to a flat on Place Jules-Ferry in the Paris suburb of Montrouge. Less than a year later, their financial situation worsens and they return to Cagnes.

1937

In Cagnes, Fred and Marie are leading figures in a tightknit artistic community. Many visiting artists stay with them.
For the Universal Exposition, which opens towards the end of the year, Fred and Marie collaborate on a fresco illustrating the theme of water, air and fire for the pavilion of the Grasse perfume manufacturers. Yves and his friends set up a 'theatre of gnomes'.

1938

The Kleins move to a flat at 116, rue d'Assas, in Paris.

1939

'The war caught up with us in 1939 at Cagnes, where we were to spend the next few years,' writes Marie Raymond. The Kleins sell La Goulette and rent a 'large, beautiful house' above Cagnes.

1940–1943

Yves takes piano lesson. He plays in Nicolas de Staël's studio with Anteck (Antoine Tudal), the son of the painter's wife Jeannine Guillou.

1943

The Klein family returns to Paris in June. 'We sold our furniture and went back to the rue d'Assas, which had been empty since the beginning of the war,' writes Marie Raymond. The family lives in poverty. Yves, by now fifteen, makes regular trips to the home of family friends in the country, to bring back food.

1944–1946

Yves takes courses to prepare for the École de la marine marchande (Merchant Marine School), but fails to pass the *baccalauréat* examinations and, in June 1946, is told he cannot be a candidate.
Marie Raymond is asked to exhibit her work at the Galerie Denise René in a group show with Dewasne, Deyrolle, Hartung and Gérard Schneider ('Peintures abstraites', Galerie Denise René, 26 February–20 March, 1946).
In July, Yves accompanies his parents on a trip to London and spends two months in the English countryside.
September: Marie Raymond's regular 'Lundis' ('Mondays') begin.
Lying on his back on the beach at Nice, Yves signs his 'name to the other side of the sky'.

1947

Yves starts taking judo courses and meets Armand Fernandez and Claude Pascal.
He conceives the project of making imprints of his fellow *judokas'* hands on wrestling mats. At Klein's suggestion, he, Claude and Armand paint the Fernandez' basement blue and make hand prints on the walls.

1948

In Nice, Louis Cadeaux initiates Yves into the mysteries of the Rosicrucian order.
In June, Yves starts taking correspondence courses with the Rosicrucian Society.
In September, he hitchhikes through Italy.
In November, he starts his military service at a French military camp near Lake Constance, Germany.

1949

Yves conceives the *Symphonie monoton-silence*.
He completes his military service and returns to France on 27 October.
In November, he leaves for London with Claude Pascal, where he goes to work for a friend of his father's, the frame-maker Robert Savage. He contacts several London art dealers on his parents' behalf.
He executes his first monochromes, on paper and on cardboard, often using pastels, and shows them to friends.

1950

4 April: Yves and Claude Pascal leave London for Ireland, where they take horse-riding lessons.

Yves Klein. 1928.

Page 245 : **Yves Klein** standing behind *Ci-gît l'espace*. 1961.

They live on a shoestring.
21 May: in his diary, Yves mentions his pictorial activity and an overwhelming attraction for painting.
25 August: he returns to Robert Savage's in London.
December: he returns to Nice, where he meets François Dufrêne.
31 December: he visits the Vence Chapel and views Matisse's recently completed decorations.

1951

January: Yves studies Spanish in Nice.
4 February: travels to Spain where he seeks work in Madrid. Executes several monochromes and mentions in his diary that, on seeing these paintings, one of his friends is stunned. Klein visits Spain's leading museums and travels to Toledo.
April: gets work as a judo instructor at two Madrid clubs.
Reflects on the paradox of static speed.
May: organises shows of his parents' work.
June: spends ten days travelling in Spain with his parents, his grandmother and his Aunt Rose, before returning to Nice for the summer holidays.
September: travels to northern Italy with his Aunt Rose.
October: moves to his parents' rue d'Assas flat before getting a studio of his own at 108 bis, rue de Rennes in Paris. Occasionally attends Marie Raymond's weekly meetings of artists and critics.

1952

January: moves to 97 bis, rue Notre-Dame-des-Champs in Paris.
25 January: sees Isidore Isou's Lettriste film Traité de bave et d'éternité (Venom and Eternity).
February: Klein is depressed, filled with uncertainty about his future. Follows Japanese language courses at the École des langues orientales (until March). All winter, he trains intensively at two Paris judo clubs.
1 April: returns to his parents' rue d'Assas flat.
June: his article 'Des Bases (fausses), principes . . . et condamnation de l'évolution' published in the Lettriste review Soulèvement de la jeunesse.
23 September: embarks on La Marseillaise bound for Japan. The voyage, in steerage, is an ordeal for him.

1953

Spends fourteen months in Tokyo. Strenuous judo training with leading Japanese champions.
In January he is promoted to first dan black belt; in February, to second dan, and in December, to fourth dan.
With the aid of an American judoka, Harold Sharp, Klein films and takes still pictures of basic judo movements.
20–22 February: organises a 'Marie Raymond / Fred Klein' show at Tokyo's Franco-Japanese Institute.
July–August: two further 'Marie Raymond / Fred Klein' shows, at the Kamakura Museum of Modern Art and at the Bridgestone Gallery in Tokyo (3–15 November). Exhibits his monochromes in a private home.
Plans on making a film, La Marque de l'immédiat, of virtually invisible human imprints in nature.
Late December: returns to France.

1954

Meets Raymond Hains in Paris.
Reads Delacroix's Journal.
19 February: The French Federation of Judo refuses to recognise his Japanese diploma.
Signs contract with Bernard Grasset for a book on judo. Writes Les Fondements du judo in March and April.
Mid-May: at the invitation of his friend Fernando Franco de Sarabia, Klein leaves for Spain where he hopes to organise a 'judo kingdom'.
Aged 26, he is named technical consultant to the Spanish Federation of Judo. Earns a good salary and gives numerous judo demonstrations to make himself known.`
Shows monochromes in judo centres.
Following a major disagreement with the president of the Spanish Federation of Judo, Klein resigns.
Autumn: Yves, peintures and Haguenault, peintures printed on a press owned by Fernando Franco de Sarabia.
November: returns to France in low spirits.
The judo films he shot in Japan go on sale.
Publication of Les Fondements du judo.
December: notwithstanding his high level of training, Yves is not authorised to participate in the European judo championships in Brussels. He attends the championships as a spectator.
Projects his judo films at one of Marie Raymond's Monday gatherings. Raymond Hains shows two of his abstract films on the same day.
27 December: in a deep depression, he notes in his diary that his life so far has been a failure and blames himself. Develops his first theory of monochromy.
End of December: conceives a film scenario, La Guerre de la ligne et de la couleur, ou vers la proposition monochrome, with his own texts and drawings. (The film was never made.)

1955 Plural monochromy

1 January: writes in his diary, 'I think I'm a genius, yet I'm producing nothing sensational.'
13 January: shows Yves, peintures to Hans Hartung, Pierre Soulages, Gérard Schneider, and other abstract painters in his mother's circle.
23 February: gets a job as judo instructor at the American Students and Artists Centre.
Spring-summer: Decides to become a painter.
1 July: the administrative committee of the Salon des réalités nouvelles rejects his submission, the monochrome Expression du monde de la couleur mine orange.
Meets his future companion Bernadette Allain and makes friends with Jean Tinguely.
5 August: writes a letter to Jacques Tournier about monochrome painting. By this date, the general outline of his theory of monochromy has been worked out.
Late September: opens his own judo school with the financial support of his mother and his aunt, and shows several monochromes there.
15 October: his first public show, 'Yves, peintures', at the Club des solitaires, Éditions Lacoste, Paris.
December 1: makes the acquaintance of Pierre Restany and, later, Iris Clert and Heinz Mack.

1956

21 February–7 March: 'Yves, propositions monochromes' show at the Galerie Colette Allendy in Paris, for which Pierre Restany writes a presentation, La Minute de vérité.
11 March: knighted into the Order of the Knights of Saint Sebastian at the church of Saint-Nicolas-des-Champs in Paris, by Monseigneur Douillard. Adopts the motto, 'For colour, against line and drawing!'
Summer: in spite of his efforts to recruit students, Klein is forced to close his judo school.
In Nice for the summer holidays, he decides to limit his palette to a single colour.
4–21 August: participates in his first group show at Marseilles' first Festival d'art d'avant-garde organised by Jacques Poliéri and Michel Ragon.
Sometime during the course of this year, Klein works out the formula of IKB (International Klein Blue).

1957 Blue Period

2–12 January: 'Yves Klein, proposte monocrome, epoca blu' show of identical blue panels at the Galleria Apollinaire in Milan. Meets Piero Manzoni and Lucio Fontana. Dino Buzatti reviews the Galleria Apollinaire show ('Blu, blu, blu', Milan, 9 January 1957).
March: Klein makes the acquaintance of the architect Werner Ruhnau, who is deeply impressed with his monochromes.
12 April: participates in the 'Micro-salon d'avril' group show at the Galerie Iris Clert in Paris.
10–25 May: 'Yves le Monochrome' one-man show at the Galerie Iris Clert. The invitation card is mailed with a Klein blue stamp.
Aerostatic sculpture of 1001 blue balloons. First public showing of a Klein sponge sculpture.
14–23 May: 'Pigments purs' show at the Galerie Colette Allendy in Paris.
31 May: a competition is launched for decorating the Gelsenkirchen Musiktheater. Ruhnau wants Klein and Norbert Kricke to enter it.
31 May-23 June: 'Yves, propositions monochromes' show at the Galerie Schmela in Düsseldorf. Contacted by Norbert Kricke, Klein applies for the Gelsenkirchen Musiktheater project.
24 June–13 July: 'Monochrome Propositions of Yves Klein' exhibition at Gallery One in London. Along with his monochromes paintings, Klein displays a sponge sculpture in the show. His work creates a furore.
26 June: public discussion, with Klein and Pierre Restany, at the Institute of Contemporary Art in London.
Summer: first designs for the foyer of the Gelsenkirchen Musiktheater. Klein meets his future wife, Rotraut Uecker, in Nice.
Nel blu dipinto di blu, the Italian song inspired by Klein's monochromes, climbs to the top of the charts.
Restany organises the group show 'Ouverture sur le futur' show at the Galerie Kramer, Paris.
August: 'Internationaler Bericht der Gesellschaft der Freunde Junger Kunst' group show at the Düsseldorf Kunsthalle.
23 August: Klein writes in his diary, 'My monochrome propositions are landscapes of freedom; I am an Impressionist and a disciple of DELACROIX.'
September: Klein signs the 'Manifesto contro lo stile' (Milan) with Restany and Arman.
12–30 October: 'Arte Nucleare 1957' group show at the Galleria San Fedele in Milan.
November: travels to Gelsenkirchen to settle final details of his Gelsenkirchen decorations with Werner Ruhnau. The two men envisage creating reliefs and sponge reliefs.
15 December: returns to Gelsenkirchen

in the hope of obtaining a contract and fee. Klein now thinks of executing his decorations in ultramarine and undertakes to persuade Ruhnau, the members of the theatre commission and the mayor of Gelsenkirchen to agree to this idea.

1958 The Blue Revolution

21 January: the Gelsenkirchen commission officially approves Klein's candidacy. His contract sets his fee at 65,000 DM. Winter and spring: Klein works intensively on his project for the Gelsenkirchen Musiktheater. He develops a method for using sponges to animate a monumental surface.
Early April: travels to Assisi and views Giotto's frescoes.
His article 'Ma position dans le combat de la ligne et de la couleur' is published in *Zero*.
24 April: conceives the 'levitating tube' project.
26 April: 'aerostatic sculpture': trials for illuminating the obelisk on Place de la Concorde with blue light.
28 April: Klein turns thirty. Inauguration of his show 'La spécialisation de la sensibilité à l'état matière-première en sensibilité picturale stabilisée', better known as 'Le Vide', at the Galerie Iris Clert in Paris. Three thousand guests attend the event, and the police and firemen are called in to disperse the crowd.
May: Klein drafts his Blue Revolution manifestos and other texts later included in the draft of *Mon Livre*.
19 May: letter to President Eisenhower proclaiming the Blue Revolution.
June: returns to Gelsenkirchen to present drawings and models of sponge reliefs.
5 June: first experiment with the technique of 'living brushes' in the evening at the home of Robert Godet on the Ile Saint-Louis in Paris.
Summer: moves to 14, rue Campagne-Première in Montparnasse, which is to be his home for the rest of his life.
September: Klein's fist pilgrimage to Cascia with his Aunt Rose. Makes a votive offering of an IKB monochrome.
October: returns to Gelsenkirchen to begin work on his reliefs. Klein makes numerous sojourns at Gelsenkirchen over the next six months.
17 November: 'Yves Klein, Jean Tinguely, Vitesse pure et stabilité monochrome' show at the Galerie Iris Clert.
End of November: thanks to a vibrant speech before the Gelsenkirchen theatre commission, which had been specially convened to hear him, Klein gets approval for coating all his reliefs with blue paint.
Late 1958: Rotraut joins Klein at Gelsenkirchen as his assistant and interpreter. Klein and Norbert Kricke jointly design fire and water fountains. Klein's other projects include an air tower for a ruined church in Germany; beaming blue light on artworks exhibited at the Salon des réalités nouvelles in Paris (with Jean Tinguely); and a blue Stations of the Cross for the chapel of the collège Saint-Martin-de-France at Pontoise, near Paris.

1959 Traces of life

January–May: Klein spends most of his time at Gelsenkirchen working on his decorations. Klein and Ruhnau conceive 'architecture of air' and talk about setting up a School for Sensibility.
17 March: opening of the 'Vision in Motion' group show at the Hessenhuis in Antwerp.

Klein stands in the space assigned to him and declaims, 'First there is nothing, then there is a deep nothingness and then there is a blue depth.' He offers to sell a zone of immaterial pictorial sensibility for one kilo of gold.
27 March: Klein and Ruhnau draw up plans for their School of Sensibility.
14 April: Klein applies for patents for the air roof and the levitating tube.
May: returns to France following his six-month stay in Germany.
21 May: makes his second pilgrimage to Cascia.
29 May: 'La collaboration internationale entre artistes et architectes dans la réalisation du nouvel opéra de Gelsenkirchen' group show at the Galerie Iris Clert.
3 June: Klein's Sorbonne lecture, introduced by Iris Clert.
Mid-June: Klein and the architect Claude Parent collaborate on designing water-and-fire fountains.
15–30 June: 'Bas-reliefs dans une forêt d'éponges' one-man show at the Galerie Iris Clert.
30 June: Klein files a patent for aeromagnetic sculpture and specifies 'invention of April 1959'.
3 July: 'Junge Maler der Gegenwart' group show at the Vienna Künstlerhaus.
2–25 October: an IKB monochrome is displayed at the Paris Biennial along with works by the Nouveaux Réalistes François Dufrêne, Raymond Hains, Jacques de La Villeglé and Jean Tinguely.
16 October–22 November: 'Kunstsammler an Rhein und Ruhr: Malerei 1900-1959' group show at the Städtlisches Museum in Leverkusen, Germany.
20 October–7 November: 'Works in Three Dimensions' group show at the Leo Castelli Gallery in New York (with John Chamberlain, Follet, Giles, Jasper Johns, Kohn, Marisol, Louise Nevelson, Artman, Rauschenberg and Scarpitta).
November: 'Dynamo 1' group show at the Renate Boukes Gallery in Wiesbaden, Germany.
18 November: first sale of a zone of immaterial pictorial sensibility (to Peppino Palazzoli).
December: Iris Clert has receipts printed for the transfers of zones of immaterial pictorial sensibility.
Publication of Klein's book *Le Dépassement de la problématique de l'art,* La Louvière: Éditions de Montbliard, Belgium.
Klein puts together a dummy of a second book, an anthology of his writings *(Mon Livre).*
Several minutes devoted to Yves Klein in Jean-Pierre Mirouze's film on the School of Nice.
15 December: Klein attends the inauguration of the Gelsenkirchen Musiktheater. He is told that his fixative agent may have seriously damaged his health. The American Centre in Paris cancels his contract for teaching judo.

1960

4 January–1 February: 'La nouvelle conception artistique' group show with Kilian Breier, Enrico Castellani, Oskar Holweck, Heinz Mack, Piero Manzoni and Almir Mavignier at the Azimuth Gallery in Milan.
February: 'Antagonisme' group show at the Musée des arts décoratifs in Paris. First public showing of a quivering monogold. Klein also exhibits two zones of immaterial pictorial sensibility.

Klein creates his first monogolds.
2 March: patents the 'living brushes' technique.
9 March: 'Anthropométries de l'époque bleue', Galerie internationale d'art contemporain, Paris. The *Symphonie monoton-silence* performed on the opening night. The 'living brushes' performance is followed by a public discussion, in which Georges Mathieu participates.
23 March: executes his first cosmogonies at Cagnes-sur-Mer.
April: 'Les Nouveaux Réalistes' group show at the Galleria Apollinaire in Milan. Pierre Restany prefaces the catalogue. Klein is not happy with the group's name and would prefer it to be called 'Le réalisme d'aujourd'hui'.
18 May–18 June: 'Hommage à Colette Allendy' group show at the Galerie Colette Allendy in Paris, with a text by Yves Klein.
May: drawings for the *Projet pour la fin d'une civilisation* and *Propositions pour un monde nouveau*.
19 May: IKB (International Klein Blue) patented.
11 October–13 November: 'Yves Klein le Monochrome' exhibition at the Galerie Rive-Droite in Paris. First showing of Klein's trinity of colours (blue, gold and pink).
19 October: Klein's 'leap into space' is photographed at number 3, rue Gentil-Bernard at Fontenay-aux-Roses. The photomontage by Harry Shunk and John Kender is published in *Dimanche, le journal d'un seul jour,* on 27 November 1960.
27 October: signature of the founding manifesto of Nouveau Réalisme at Klein's Paris flat.
8–10 November: Klein creates the *Suaire des Nouveaux Réalistes (Shroud of the Nouveaux Réalistes)* with Arman, Hains, Restany and Tinguely.
18 November–15 December: group show of the second Festival d'art d'avant-garde at the Palais de expositions de la Porte de Versailles in Paris. Klein shows the *Suaire des Nouveaux Réalistes* and *Ci-gît l'espace*. A vandal damages both works.
27 November: *Dimanche, le journal d'un seul jour* is issued in conjunction with the Festival d'art d'avant-garde and distributed in a large number of Paris newsstands.
A press conference is held at the Galerie Rive-Droite.

1961 Alchemy

5 January: patents a transparent plastic table filled with pure pigment.
14 January–26 February: 'Yves Klein: Monochrome und Feuer' show, Museum Haus Lange, Krefeld, Germany. Klein collaborates closely with the museum's director, Paul Wember, in organising the retrospective and in setting up the *Mur de feu* and *Sculpture de feu* in the museum's garden. He impregnates a room in the museum with his presence.
20 February: a body imprinting session is filmed for the BBC's *Heartbeat of France* programme in the studio of the photographer Charles Wilp at Düsseldorf.
26 February: Klein executes his first fire paintings at the Krefeld museum (imprints of the *Mur de feu* and the *Sculpture de feu*).
March: first fire painting sessions at the Gaz de France testing centre.
26 March: Yves and Rotraut arrive in New York and take a room at the Chelsea Hotel.

11–29 April: 'Yves Klein le Monochrome' show, Leo Castelli Gallery, New York.
Klein writes the *Manifeste de l'hôtel Chelsea*.
26 April: Klein appears in the television show *En français dans le texte*.
17 May–10 June: 'À quarante degrés au-dessus de Dada' group show, introduced by Pierre Restany. Klein fires off a message to the critic from the United States to object to his associating Dada with Nouveau Réalisme. Klein subsequently writes *Le nouveau réalisme est mort, vive le réalisme d'aujourd'hui* and urges his fellow Nouveaux Réalistes to mutiny.
29 May–24 June: 'Yves Klein le Monochrome' show, Dwan Gallery, Los Angeles. First public showing of a monogold sponge relief.
Late June: Yves and Rotraut return to France.
June: group show at the Galleria La Salita in Rome. 'Nouveaux Réalistes' group show at the Samlaren Gallery in Stockholm, organised by Daniel Spoerri.
July: 'Le Nouveau Réalisme à Paris et à New York' group show at the Galerie Rive-Droite in Paris (with Arman, Lee Bontecou, César, John Chamberlain, Chryssa, Raymond Hains, Jasper Johns, Robert Rauschenberg, Niki de Saint-Phalle, Richard Stankiewicz and Jean Tinguely).
Klein's article 'Le vrai devient réalité' [1960] published in *Zero 3*, Düsseldorf.
12 July: the contracts for Gualtiero Jacopetti's film *Mondo Cane* are signed.
13 July–13 September: notwithstanding the organised mutiny against Restany, Klein participates in the first Festival du Nouveau Réalisme, at the Galerie Muratore and the Abbaye Roseland in Nice.
17–18 July: the anthropometry sequences for *Mondo Cane* are shot. The film's editing pokes fun at Klein.
19 July: last fire painting session at the Gaz de France testing centre. On learning to his horror that Klein is using naked models in his laboratory, the centre's director puts an end to the experiments.
Summer holidays in Nice with Rotraut.
8 October: 'Le jour des observateurs neutres' ('The day of the neutral observers') meeting of the Nouveaux Réalistes. Klein, Raysse and Hains declare the group dissolved.
November: accompanied by Rotraut, Klein makes a third and last pilgrimage to Cascia and leaves a votive offering in a clear plastic box containing blue and pink pigment, gold leaf, small gold ingots and a hand-written prayer to Saint Rita (discovered in 1979 by the painter Marocco and authenticated in 1981 by Pierre Restany).
1 November: signs an exclusive contract with Jean Larcade, which goes into effect on this date. The artist and the dealer soon have a falling out.
21 November: opening of the 'Yves Klein le Monochrome: il Nuovo Realismo del Colore' retrospective at the Galleria Apollinaire in Milan. First showing of Klein's planetary reliefs, including *Mars* and the *Moon*.
In collaboration with Claude Parent, Klein designs water-and-fire fountains for the Palais de Chaillot in Paris.

1962
Sunday 21 January: Klein organises the ceremony of his and Rotraut's wedding at the church of Saint-Nicolas-des-Champs in Paris, with the Knights of the Order of Saint Sebastian in full regalia. A rehearsal takes place several days before the wedding. The church ceremony is followed by a reception at La Coupole and a party at Larry Rivers' Paris studio.
26 January: transfer of a zone of immaterial pictorial sensibility to Dino Buzzati.
February: makes plaster moulds of Arman, Martial Raysse and Claude Pascal as a first step to executing relief portraits of his friends.
4 February: sale of a zone of immaterial pictorial sensibility to Michael Blankfort.
March-April: Yves Klein presents a zone of immaterial pictorial sensibility at the 'Comparaisons' Salon at the Musée d'art moderne in Paris.
1 March: executes the *Store-poème* at his home with Arman, Claude Pascal and Pierre Restany.
7 March: 'Antagonismes 2' group show at the Musée des arts décoratifs in Paris. Showing of the *Store-poème*, a *Rocket pneumatique* and two panels recapitulating the architecture of air. Restany writes the explanatory statements.
30 March: Klein has himself photographed lying under *Ci-gît l'espace*.
12 May: Klein attends the premiere of *Mondo Cane* at the Cannes Film Festival. Notwithstanding his repeated requests, the guarantees in his contract and the filmmaker's promises, he was unable to see the film before its showing at Cannes. He is appalled to discover that he has been included in a sort of freak show of human monstrosity. He has a first heart attack that evening.
14 May: he cancels his contract with Jean Larcade.
15 May: opening of the 'Donner à voir' group show at the Galerie Greuse in Paris. His doctor advises him to get some rest without delay.
6 June: at home, late in the afternoon, Klein says that henceforth he will only create immaterial works. At 6 p.m. he dies of a heart attack. He is thirty-four years old. His son Yves is born exactly two months later, on 6 August.

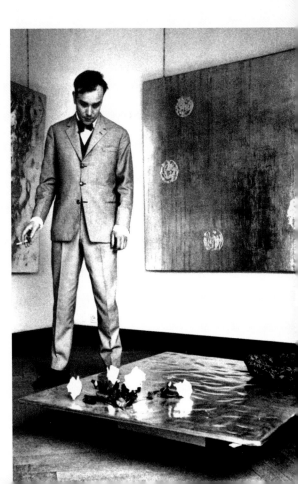

Cette petite histoire m'est revenue à propos de "Pourquoi pas deux couleurs à la fois?"

Eh bien parce que je refuse de donner un spectacle. Je refuse de comparer et de ~~les mettre~~ mettre en présence pour faire ressortir tel ou tel élément plus fort par rapport à d'autres plus faibles.

La représentation ~~même~~ la plus civilisée est basée sur une idée de combat entre différentes forces et le lecteur assiste dans un tableau à une mise à mort à un drame, morbide par définition qu'il s'agisse d'amour ~~ou~~ de haine ~~ce que je~~ Le tableau pour moi est comme un individu — je désire le considérer ~~comme~~ tel qu'il est et ne pas le juger — surtout ne pas juger —

Dès qu'il y a deux couleurs dans un tableau, c'est un combat ~~il n'ont~~ deux ~~combat~~ spectacle permanent

Yves Klein's published writings

• 'Des bases (fausses), principes, et condamnation de l'évolution', *Soulèvement de la jeunesse,* Paris, June 1952, no. 1.

• *Yves, peintures,* preface by Pascal Claude, Madrid: Fernando Franco de Sarabia, 1954.

• *Haguenault, peintures,* preface by Pascal Claude, Madrid: Fernando Franco de Sarabia, 1954.

• *Les Fondements du judo,* preface by Ichiro Abé, Paris: Bernard Grasset, 1954.

• 'Propositions monochromes du peintre Yves', interview with Bernadette Allain, *Couleurs,* Paris, 1956, no. 15.

• 'Meine Stellung im Kampf zwischen Linie und Farbe', *Zero,* Düsseldorf, April 1958, no. 1; reprinted in Otto Piene and Heinz Mack, *Zero,* Cambridge, Mass.: M.I.T. Press, 1973.

• *Le Dépassement de la problématique de l'art* (*Beyond the Problematic of Art*), La Louvière, Belgium: Éditions de Montbliard, 1959 (includes 'Le dépassement de la problématique de l'art', 'Préparation et présentation de l'exposition du 28 avril 1958'; 'Discours prononcé après le vernissage de l'époque pneumatique'; 'Esquisse du manifeste technique de la révolution bleue'; 'Esquisse et grandes lignes du système économique de la révolution bleue'; 'Discours prononcé à l'occasion de l'exposition Tinguely à Düsseldorf' [January 1959]; 'Exemple de collaboration réalisée, évolution générale de l'art actuel vers l'immatérialisation' [Yves Klein and Werner Ruhnau]; 'Ma systématique d'évolution'; 'Yves Klein [dit le Monochrome]'; 'Histoire personnelle'; 'N. B.'; 'Création d'un centre de la sensibilité').

• 'Yves Klein, l'homme qui a vendu du vide', interview with Pierre Descargues, *Tribune de Lausanne,* Lausanne, 30 October 1960.

• 'Mes idées sur la peinture', *Geijutsu-Shincho,* Tokyo, July 1960.

• *Dimanche, le journal d'un seul jour* (*Sunday, the One-Day Newspaper*), Festival d'art d'avant-garde, Paris: Presse de Combat and Presse de France, 29 November 1960, single issue (page 1: 'Le théâtre du vide'; 'Actualité'; 'Un homme dans l'espace'; 'Le peintre de l'espace se jette dans le vide'; 'Sensibilité pure'. Page 2: 'Capture du vide'; 'Les voleurs d'idées'; 'Du vertige au prestige [1957–1959]'; 'Viens avec moi dans le vide'; 'Projet pour un institut national théâtral'; 'Le contrat'; 'Ballet de feu'. Page 3: 'Stupéfaction monochrome'; 'Les cinq salles'; 'La guerre [petite mythologie personnelle de la monochromie datant de 1954, adaptable en film ou en ballet]'. Page 4: 'Projet de ballet aspect de fugue et chorale'; 'La statue'; 'La marque de l'immédiat'; 'Le sommeil'; 'Renversement'; 'Programme du Festival d'art d'avant-garde').

• 'My Monochrome Attempt Has Conducted Me . . .', catalogue of the 'Yves Klein le Monochrome' exhibition, Leo Castelli Gallery, New York, 1961.

• 'Le vrai devient réalité', *Zero,* Düsseldorf, July 1961, no. 3; reprinted in Otto Piene and Heinz Mack, *Zero,* Cambridge, Mass.: MIT Press, 1973. (Also includes 'Nice 1947, l'époque de la rencontre . . .' and 'Projekt einer Luft-Architektur', with Werner Ruhnau).

• 'Climatisation de l'espace' (with Pierre Restany), catalogue of the 'Antagonismes 2' exhibition, Musée des arts décoratifs, Paris, 1962. Also 'La climatisation de l'atmosphère . . .' (with Pierre Restany) and 'Store-poème' (with Claude Pascal, Pierre Restany and Armand Fenandez).

• 'Due to the fact that . . .' (with Neil Levine and John Archambault), catalogue of the 'Yves Klein' exhibition at the Alexandre Iolas Gallery, New York, 1962; French version, 'Manifeste de l'hôtel Chelsea', catalogue of the 'Yves Klein' show, Galerie Alexandre Iolas, Paris, 1965.

• 'Le Réalisme authentique d'aujourd'hui', *KWY,* published by Lourdes Castro, Christo Javacheff, Jan Voss and René Bertholo, Paris, spring 1963, no. 11.

• 'Pour satisfaire la sensualité . . .', catalogue of the 'Arman' show, Stedelijk Museum, Amsterdam, 1964. Also: 'Après mon vide, le plein d'Arman'.

• 'Rien n'est bleu, Tout est bleu . . .', catalogue of the 'Yves Klein' show, Palais des Beaux-Arts, Brussels, 1966. Also: 'Moi je suis jaloux . . .' (excerpt of a conversation with Pierre Restany).

• 'Reçu pour une zone de sensibilité picturale immatérielle, le 8 décembre 1959', catalogue of the 'Yves Klein' show, The Jewish Museum, New York,1967. Also: 'Faire-part du mariage d'Yves Klein avec Rotraut Uecker, le 21 janvier 1962'; 'Symphonie monoton-silence'; and excerpts from 'The Monochrome Adventure' (reissued in French, 'L'Aventure monochrome', *Art et Création,* Paris, January–February 1968, no. 1).

• 'Quelques extraits de mon journal en 1957', *Art et Création,* Paris, January–February 1968, no. 1.

• 'Reçu pour une Zone de Sensibilité Picturale Immatérielle, le 18 novembre 1959', catalogue of the 'Le Monochrome' show, Galleria Blu, Milan, 1969.

• 'Lorsque je serai enfin devenu comme une statue . . .', catalogue of the 'Yves Klein' show, Galleria d'Arte Martano, Turin, 1969.

• 'Humilité . . .', in Giuliano Martano, *Yves Klein, il Mistero Ostentato,* Turin: Martano Editore, 1970. Also 'Malevitch ou l'espace vu de loin' (drawing); 'Ma chère maman . . . il n y a que le grand art qui compte' (postcard); 'I Pennelli umani . . .'; 'Yves il monocromo naturometria'; 'Le Spugne'; 'Ma devise: Pour la couleur! Contre la ligne et le dessin!'; 'Solution de 58 au problème de socle . . .'; 'Il Fuoco, ou l'avenir sans oublier le passé'.

• 'On est en train de créer quelque chose . . .', translated into German by Manfred de La Motte, catalogue of the 'Yves Klein' show, Kunstverein, Hanover, 1971.

• 'Pourquoi j'en suis venu à cette époque bleue? . . .', extract from Klein's Sorbonne lecture, 3 June 1959, *Yves Klein* (cat.), Paris, Galerie Karl Flinker, 1973; reprinted in *Yves Klein* (cat.), Ludwigshafen am Rhein, Städtliche Kunstsamlungen, 1974.

• *Yves Klein, 1928–1962: Selected Writings,* London, The Tate Gallery, 1974 (brief excerpts from Klein's writings with photographs and other documents, and texts by Jacques Caumont, Michael Compton, Jennifer Gough-Cooper and Norman Reid).

• 'Le BLEU, l'OR, le ROSE, l'IMMATÉRIEL, le VIDE', manuscript by Yves Klein in the votive offering to Saint Rita of Cascia, in Pierre Restany, *Yves Klein e la mistica di Santa Rita da Cascia,* Milan: Editoriale Domus, 1981.

• 'The Blue Revolution', letter to President Eisenhower, 20 May 1958, in Pierre Restany, *Yves Klein,* Paris: Le Chêne/Hachette, 1982; *Yves Klein,* New York: Abrams, 1982.

• 'Des Nouveaux Réalistes', with Martial Raysse and Arman, text of a public discussion hosted by Sacha Sosnovsky, *Yves Klein* (cat.), Paris, Musée national d'art moderne, 1983. Also: 'Dialogue avec lui-même'; 'La Terre est plate et carrée'; 'Sur la monochromie'.

• 'Conférence à la Sorbonne, 3 juin 1959', two 33 r.p.m. records, Paris: RPM, no date; published as a booklet, *Conférence à la Sorbonne, 3 juin 1959,* Paris: Galerie Montaigne, 1992.

• 'Klein-Ruhnau Correspondence' (extracts) in Werner Ruhnau, *Baukunst,* Düsseldorf: Rainer Meyer, 1992. This volume also contains Klein's speech to the Gelsenkirchen Musiktheater committee.

• 'Je crois que dans le futur . . .', in Hannah Weitemeier, *Yves Klein 1928–1962, International Klein Blue,* Cologne: Taschen, 1995. Also: 'BLEU BLEU BLEU' (manuscript), poster for the double 'Yves Klein' show at the Iris Clert and Colette Allendy galleries, Paris, 1957; and the envelope registering the invention of IKB.

Overleaf:
Yves Klein. c. 1956.

Notes

Introduction

1 Yves Klein, 'Yves KLEIN le Monochrome: Je suis le peintre de l'espace . . .' Yves Klein Archives, T16.6.

2 Jean Tinguely, 'Un superbon camarade,' in the 'Yves Klein' exhibition catalogue, Paris, Musée national d'art moderne, Centre Georges-Pompidou, 3 March–23 May 1983.

3 Yves Klein, 'Quelques extraits de mon journal en 1957,' *Mon Livre*, Yves Klein Achives. Klein's writings preserved in the Yves Klein Archives are mostly unpublished. As early as 1958, the painter had started working on an anthology of his major writings. This dummy was never published and is difficult to reconstruct. I refer to it hereafter as *Mon Livre*, the title the author gave to it. Extracts from this project, notably the anthology's first section, which was designed as a 'livre d'artiste', were published under the title *L'Aventure monochrome* (see the 'Yves Klein' exhibition catalogue, The Jewish Museum, New York, 1967; *Art et création*, no. 1, Paris, January-February, 1968; MNAM catalogue, *op. cit.*). All of the quotations from *Mon Livre* cited in the present volume are from Yves Klein's typescripts paginated and annotated by Yves Klein (documents T8.10, T10.2, T6.6). For more concerning this subject, see Nicolas Charlet, 'Les quatre livres d'Yves Klein, fondement existentiel d'une écriture silencieuse', *Histoire de l'art*, 'Sur le XXᵉ siècle', no. 44, Paris, June 1999, pp. 109–121.

4 The founding members of the Nouveaux Réalistes group were the artists Arman, César, François Dufrêne, Raymond Hains, Yves Klein, Martial Raysse, Pierre Restany, Jean Tinguely, Daniel Spoerri, Jacques de La Villeglé. Christo, Gérard Deschamps, Mimmo Rotella and Niki de Saint-Phalle subsequently became members of the group.

5 Heinz Mack, Otto Piene, Günther Uecker.

6 Yves Klein, 'Qu'on ne vienne pas me raconter des Histoires . . .', manuscript, Yves Klein Archives, M12.11.

The atomic gestation of a painter

1 Yves Klein, 'La vie des arts: la révolution par le vide', *Arts*, Paris, May 14, 1958.

2 Michael Gaudet, 'Yves . . .', 'Yves Klein-Marie Raymond' exhibition catalogue, Château-musée de Cagnes-sur-Mer, 16 December 1972–17 February 1973.

3 Raymond Cogniat, *Le Figaro*, February 1969.

4 Georges Huisman, July 1946, cited in Sadi de Gorter, *Fred Klein*, Libourne: Arts Graphiques d'Aquitaine, 1972, p. 116.

5 Marie Raymond exhibited at the Galerie Denise René in 1946, twice in 1947, twice in 1948, and once respectively in 1949, 1950, 1951, 1953, 1954 and 1955.

6 Marie Raymond exhibited at the Galerie Colette Allendy in 1949, 1950 and 1960.

7 Marie Raymond exhibited at the Galerie de Beaune in 1949, 1950 and 1951.

8 Marie Raymond, 'Causerie de Madame Klein, 18 March 1937', Marie Raymond Archives.

9 Marie Raymond, 'Je revois ce dîner . . .', typescript, Marie Raymond Archives.

10 Cited by Roger van Gindertaël, *Arts d'aujourd'hui*, March 1951, p. 20.

11 Marie Raymond, 'Une exposition à Paris sur l'art abstraite Marie Raymond (sic)', manuscript, Marie Raymond Archives.

12 Marie Raymond, 'Les expositions à Paris', typescript, Marie Raymond Archives.

13 Marie Raymond, 'L'art abstrait tient sans doute . . .', manuscript, Yves Klein Archives.

14 Charles Estienne, *L'Art abstrait est-il un académisme?* Paris: Éditions de Beaune, 1950.

15 Georges Mathieu, *Au-delà du tachisme*, Paris: Julliard, 1963.

16 See the MNAM catalogue, *op. cit.*

17 Daniel Abadie, *Bryen abhomme*, Brussels: La Connaissance, 1973.

18 Yves Klein, 'Préparation de l'exposition du 28 avril 1958 chez Iris Clert . . .', *Le Dépassement de la problématique de l'art*, La Louvière: Éditions de Montbliard, 1959; *Mon Livre*, Yves Klein Archives.

19 See Roland Sabatier, *Le Lettrisme*, Nice: Z'Editions, undated.

20 Raymond Hains and Jacques de La Villeglé, *Hépérile éclaté*, Paris: Librairie Lutétia, 1953.

21 Yves Klein, 'Par la couleur . . .', *Mon Livre*, Yves Klein Archives.

22 Arman, 'De la spiritualité à la conquête affective des espaces', typescript signed and dated 'arman, 25 August 1960', Yves Klein Archives.

23 Arman, 'L'esprit de la couleur', MNAM catalogue, *op. cit.*, p. 260.

24 Yves le Monochrome 1960, 'Le vrai devient réalité', *Zero*, Düsseldorf, July 1961, no. 3; reprinted in Otto Piene and Heinz Mack, *Zero*, Cambridge (Mass.): MIT Press, 1973, p. 85.

25 Max Heindel, *Cosmogonie des Rose-Croix*, Paris, n.d.: reprinted Paris: Leymarie, 1947.

26 *Ibid*, Paris: Maison rosicrucienne, 1981, p. 412.

27 Thomas McEvilley, 'Yves Klein conquistador du vide', 'Yves Klein et les Rose-Croix', MNAM catalogue, *op. cit.*

28 Yves Klein, 'Par la couleur . . .', *op. cit.*

29 See Yves Klein, *Journal d'Espagne, Journal d'Irlande, Journal du Japon*, Yves Klein Archives.

30 See Yves Klein's correspondance with his parents, 1950–1954, Yves Klein Archives and Marie Raymond Archives.

31 See Pierre Darcourt, *Aventure judo en Extrême-Orient*, Paris: Peyronnet & Cie., 1957, pp. 222–284.

32 Yves Klein, *Les Fondements du judo*, preface by Ichiro Abé, Paris: Bernard Grasset, 1954.

33 *Ibid*.

34 Author's interview with Pierre Restany, Paris, 26 October 1999.

35 Yves Klein, 'Réflexions sur le judo, le Kiaï, la victoire constante', manuscript, Yves Klein Archives, M21.14.

36 *Ibid*.

37 *Yves, peintures*, Madrid: Fernando Franco de Sarabia, November 1954; *Haguenault, peintures*, Madrid: Fernando Franco de Sarabia, November 1954. These two booklets are at present practically impossible to find in France. Neither the Bibliothèque nationale nor the Musée national d'art moderne library owns a copy. The copies the author examined are in the Yves Klein and Marie Raymond Archives.

38 Yves Klein, *Journal*, 1954–1955, Yves Klein Archives, T11.11.

The life of pure colour

1 Yves Klein, 'Par la couleur . . .', *Mon Livre*, Yves Klein Archives.

2 Yves Klein, *Le Dépassement de la problématique de l'art*, *op. cit.*

3 *Ibid*.

4 *Ibid*.

5 Yves Klein, 'Les voleurs d'idée', *Dimanche, le journal d'un seul jour*, Paris, 27 November 1960, Festival d'art d'avant-garde, published as a special issue of the daily newspaper *Combat*.

6 Yves Klein, 'Le vrai devient réalité', *Zero*, *op. cit.*

7 Hannah Weitemeier, *Yves Klein*, Cologne: Taschen, 1995, pp. 11–12.

8 Yves Klein, 'Les Vrais Créateurs sont des penseurs . . .', Yves Klein Archives, T25.8.

9 For an extremely detailed account of Yves Klein's life and work, see Sidra Stich, *Yves Klein*, Stuttgart: Cantz, 1994.

10 Yves Klein, 'Par la couleur . . .', *op. cit.*

11 Yves Klein, *Journal*, 1954–1955, Yves Klein Archives, T11.11. Published in the MNAM catalogue, *op. cit.*, p. 312.

12 Yves Klein, 'Par la couleur . . .', *op. cit.*

13 Yves Klein, *Journal de 1954*, Yves Klein Archives.

14 Yves Klein, 'Aujourd'hui 1955' *Journal*, 1954–1955, manuscript, Yves Klein Archives, M8.11.

15 See Nicolas Bourriaud, *Formes de vie. L'art moderne et l'invention de soi*, Paris: Denoël, 1999, pp. 45–62.

16 Yves Klein, 'Mon avis sur Mathieu . . .', manuscript, Yves Klein Archives, M1.4.

17 Yves Klein, 'Texte de présentation de l'exposition aux Éditions Lacoste, sept.-oct 1955' , Yves Klein Archives, T12.21.

18 *Ibid*.

19 Yves Klein, *Le Dépassement de la problématique de l'art*, *op. cit.*

20 I borrow this phrase from Denys Riout landmark study, *La Peinture monochrome. Histoire et archéologie d'un genre*, Nîmes: Jacqueline Chambon, 1996. Chapter 1 (pp. 15–37) deals with Yves Klein and is without a doubt one of the best pieces of writing to date on the artist's work.

21 Yves Klein, *Conférence de la Sorbonne, 3 juin 1959,* two long play records, Paris: R.P.M., n.d. The text of this lecture was published by the Galerie Montaigne in Paris, 1992.

22 See Pierre Restany and Yves Klein's abundant writings. See also *Pierre Restany, une vie dans l'art* (conversations with Jean-François Bory), Neuchâtel: Ides et Calendes, 1983.

23 Pierre Restany, *Yves Klein*, Paris: Hachette, 1974, reissued by Le Chêne/Hachette, 1982, p. 22; *Yves Klein*, New York: Abrams, 1982.

24 Pierre Restany, 'Qui est Yves Klein?' MNAM catalogue, *op. cit.*, p. 13.

25 Yves Klein, 'Quel a été le rôle de Pierre Restany?', manuscript, Yves Klein Archives, M19.10.

26 'The monochrome propositions [were] termed thus by Pierre RESTANY because their material presentation makes them authentic supports for colour', writes Klein in *Mon Livre*.

27 Yves Klein, 'Par la couleur . . .', *op. cit.*

28 Yves Klein, 'Ma position dans le combat entre la ligne et la couleur', *Zero*, Paris, April 1958, no. 1.

29 Yves Klein, '1953, c'est avec la monochromie que je me grise le plus . . .', manuscript, Yves Klein Archives, M5.19.

30 Yves Klein, 'Par la couleur . . .', *op. cit.*

31 *Ibid.*

32 Quotations taken from Yves Klein, 'Par la couleur . . .', *op. cit.*

33 *Ibid.*

34 *Ibid.*

35 Yves Klein, *Le Dépassement de la problématique de l'art*, *op. cit.*

36 Yves Klein, 'Par la couleur . . .', *op. cit.*

37 *Ibid.*

38 Yves Klein, 'La peinture n'est pas de la couleur . . .', manuscript, Yves Klein Archives, M5.25.

39 Yves Klein, 'Ma position dans le combat . . .', *Zero*, *op. cit.*

40 Jean Chevalier (ed.), *Dictionnaire des symboles*, Paris: Robert Laffont, 1969.

41 Yves Klein, *Le Dépassement de la problématique de l'art*, *op. cit.*

42 Eugène Delacroix, *Journal*, quoted by Klein in 'Par la couleur . . .', *op. cit.*

43 Though not patented, Yves Klein's IKB blue is protected by a sealed statement in the Yves Klein Archives. Klein wrote a detailed account of his invention and sealed it in an envolope which he mailed to the French National Institute for Industrial Protection, where it was dated and stamped

before being returned to the artist.

44 See *Mon Livre*, Yves Klein Archives. Incidentally, the Nice sky deserves a place in the artist's catalogue raisonné.

45 Quotes taken from Klein's *Conférence de la Sorbonne*, *op. cit.*

46 Yves Klein, 'Par la couleur . . .', *op. cit.*

47 *Ibid.*

48 For a complete list of reviews concerning Yves Klein, see the MNAM catalogue, *op. cit.* and Florence Jaillet, *La Réception d'Yves Klein de son vivant*, master's dissertation under the directorship of François Fossier, University of Lyon-II.

49 Nan Rosenthal, 'La lévitation assistée', MNAM catalogue, *op. cit.*, p. 215.

50 Gaston Bachelard, *L'Air et les songes*, Paris: José Corti, 1943; 1994 edition, p. 194.

51 Eugène Delacroix, *Journal*, cited by Yves Klein in 'Par la couleur . . .', *op. cit.*

52 Yves Klein, 'Du vertige au prestige (1957–1959)', *Dimanche, le journal d'un seul jour*, *op. cit.*

53 Yves Klein, 'Remarques sur quelques œuvres exposées chez Colette Allendy', manuscript, Yves Klein Archives, M12.22. Except where otherwise indicated, all of the quotations concerning works exhibited at Colette Allendy's are taken from the above 'Remarques'. This unpublished text is invaluable, for it sheds light on Klein's radical method of associating painting and writing in his work.

54 Yves Klein, *Le Dépassement de la problématique de l'art*, *op. cit.*

55 Yves Klein, 'La guerre', *op. cit.*

56 Yves Klein, 'Remarques sur quelques œuvres . . .', *op. cit.*

57 Nicolas de Staël, letter to Jacques Dubourg, June 1952, in *Nicolas de Staël. Rétrospective de l'œuvre peint*, Paris: Fondation Maeght, 1991, p. 186.

58 Yves Klein, 'Réflexions sur le Bleu', Yves Klein Archives, T6.1.

59 Yves Klein, *Mon Livre*, *op. cit.*

60 Yves Klein, 'Préparation de l'exposition . . .', *op. cit.*, reproduced in *Mon Livre*, *op. cit.*

61 *Ibid.*

62 *Ibid.*

63 *Tao Tê Ching*, chapter XI, lines 3–4, in Arthur Waley, *The Way and its Power*, London: Allen & Unwin, 1934, p. 155.

64 Yves Klein, 'Réflexions sur le Bleu', *Mon Livre*, *op. cit.*

65 François Cheng, *Vide et plein. Le langage pictural chinois*, Paris: Le Seuil 'Points', 1991, p. 45.

66 Chuang Tzu, cited in François Cheng, *op. cit.*

67 Huainan Tzu, cited in François Cheng, *op. cit.*

68 Yves Klein, 'Préparation de l'exposition . . .', *op. cit.*

69 Pu Yen-t'u, cited in François Cheng, *op. cit.*

70 Yves Klein, 'Préparation de l'exposition . . .', *op. cit.*

71 *Ibid.*

72 I take the term from Yves Klein, *Mon Livre*, *op. cit.* 'I hate artists who empty themselves into their paintings . . . they vomit, they ejaculate, they spew out all their complexity.'

73 In the lecture he gave at the Sorbonne on 3 June 1959, Klein declared, 'I feel like shouting to those artists, Action Painters, etc, etc., : but stop making all those gesticulations, just because one moves around like a lunatic doesn't mean one is active!'

74 Yves Klein, *Conférence de la Sorbonne*, *op. cit.*

75 *Ibid.*

76 See Thierry de Duve, *Cousus de fil d'or. Beuys, Warhol, Klein, Duchamp*, Villeurbanne: Art Éditions, 1990, p. 62. 'A mystified mystifier, Yves Klein was unknowingly, like these [modern] economists, a theologian of artistic merchandise. The "real value" of the painting is invisible and can only be the social relationship hidden within it and brutally revealed by its price.' Thierry de Duve concludes somewhat hastily that Klein had

a grasping nature. His Marxist approach does not account for Klein's aesthetic in all its complexity.

77 Yves Klein, 'Règles rituelles . . .', Yves Klein Archives, T16.7.

78 *Ibid.*

79 *Ibid.*

80 *Ibid.*

81 See the last chapter of the present book ('Alchemy').

Igniting sensibility: the Blue Revolution

1 Oral presentation to the Gelsenkirchen commission, Yves Klein Archives. Published in Werner Ruhnau, *Baukunst*, Düsseldorf: Rainer Meyer, 1992.

2 Yves Klein, 'Compte-rendu de l'exposition en collaboration avec Jean Tinguely chez Iris Clert, Vitesse pure et stabilité monochrome', manuscript, Yves Klein Archives, M12.1.

3 Yves Klein, *Conférence de la Sorbonne*, *op. cit.*

4 Yves Klein, 'Quelques extraits de mon journal en 57', *Mon Livre*, *op. cit.*

5 Georges Mathieu, *Au-delà du tachisme*, *op. cit.*, pp. 157–160.

6 Yves Klein, 'La Terre est plate et carrée', *Mon Livre*, *op. cit.*, T10.2.

7 *Ibid.*

8 Yves Klein, *Conférence de la Sorbonne*, *op. cit.*

9 Michel Conil Lacoste, *Tinguely, l'énergétique de l'insolence*, Paris: La Différence, 1989.

10 Yves Klein, 'Compte-rendu de l'exposition en collaboration avec Jean Tinguely chez Iris Clert . . .', *op. cit.*

11 *Ibid.*

12 *Ibid.*

13 Yves Klein, 'Discours prononcé à l'occasion de l'Exposition TINGUELY à DUSSELDORF (janvier 1959)', *Le Dépassement de la problématique de l'art*, *op. cit.*

14 Yves Klein, L'EAU ET LE FEU, *Mon Livre*, *op. cit.*, T6.6. The original manuscript is in the Yves Klein Archives (M5.28).

15 *Ibid.*

16 Yves Klein, *Conférence de la Sorbonne*, *op. cit.*

17 Yves Klein patent no. 58972, 14 April 1959.

18 I am indebted to Pierre Restany for this idea. See Pierre Restany, *Yves Klein, le feu au cœur du vide*, Paris: La Différence, 1990, p. 113, note 47.

19 Yves Klein, L'EAU ET LE FEU, *op. cit.*

20 See Yves Klein, *Conférence de la Sorbonne*, *op. cit.*

21 *Ibid.*

22 Yves Klein, 'Exemple de la collaboration réalisée . . .', *Le Dépassement de la problématique de l'art*, *op. cit.*

23 *Ibid.*

24 Yves Klein, *Le Dépassement de la problématique de l'art*, *op. cit.*

25 *Ibid.*

26 *Ibid.*

27 Yves Klein, 'L'habitation immatérielle', *Mon Livre*, *op. cit.*

28 Quotations taken from table ANT 102, *Architecture de l'air*, 1961.

29 Yves Klein, 'La grande force de ce mouvement que j'ai créé, c'est l'espace . . .', *Mon Livre*, T6.6. All the citations in the following paragraphs relating to the Blue Revolution are taken from this unpublished text.

30 'La grande force . . .', *op. cit.*, T6.10 (second version of the above text).

31 *Ibid.*

32 Yves Klein, 'Manifeste technique de la révolution bleue', *Le Dépassement de la problématique de l'art*, *op. cit.*

33 *Ibid.*

34 Yves Klein, 'La France rayonne sur le monde . . .', manuscript, Yves Klein Archives, M12.23.

35 'THE BLUE REVOLUTION', letter to Dwight D. Eisenhower, President of the United States, 20 May 1958, Yves Klein Archives, T13.35.

36 Yves Klein, draft of a letter to the 'Secretary General of the International Geophysical Army [?]', Yves Klein Archives, M1.15.

37 Yves Klein, 'Explosions Bleues, letter to the President of the International Conference for the Detection of Nuclear Explosions', Yves Klein Archives, T16.8.

38 Yves Klein and Werner Ruhnau, 'Création d'un centre de la sensibilité', translated from the German, Gelsenkirchen, 15 December 1958, in Yves Klein, *Le Dépassement de la problématique de l'art, op. cit.* All quotations relative to the School of Sensibility are taken from this text.
39 Nicolas Charlet, 'Les quatre livres d'Yves Klein, fondement existentiel d'une écriture silencieuse', *Histoire de l'art*, 'Sur le XXᵉ siècle', *op. cit.*, pp. 109–121.
40 Yves Klein, 'Actualité', *Dimanche, le journal d'un seul jour, op. cit.*
41 Yves Klein, 'Théâtre du vide', *Dimanche, le journal d'un seul jour, op. cit.*

Traces of life

1 Yves Klein, 'Réflexions sur le Bleu', *Mon Livre, op cit.*
2 Yves Klein, 'Remarques sur quelques œuvres exposées chez Colette Allendy . . .', *op. cit.*, M12.22.
3 Yves Klein, letter to Iris Clert, Cascia, 21 June 1959 (dated 21 May 1959), Yves Klein Archives, M1.21.
4 Coined by Pierre Restany and adopted by Yves Klein, 'anthropometries' is the generic title of Klein's body prints.
5 Yves Klein, 'Le vrai devient réalité', *Zero, op. cit.*
6 *Ibid.*
7 See Marie-Christine Poirée, *L'Empreinte au XXᵉ siècle. De la Véronique au 'Verre ironique'*, Paris: L'Harmattan, 1997.
8 Yves Klein, 'Le vrai devient réalité', *Zero, op. cit.*
9 *Ibid.*
10 Marie-Christine Poirée, *L'Empreinte au XXᵉ siècle, op. cit.*, p. 63.
11 Yves Klein, 'Le but de ce procédé', Yves Klein Archives, T16.28.
12 Quotations taken from 'Par la couleur . . .', 'Quelques extraits de mon journal en 57', *Mon Livre, op. cit.*
13 Yves Klein, 'Par

la couleur . . .', *Mon Livre, op. cit.*
14 Georges Raillard's term, cited in Marie-Christine Poirée, *L'Empreinte au XXᵉ siècle, op. cit.*, p. 156.
15 Yves Klein, 'Le but de ce procédé', *op. cit.*
16 Denys Riout, *La Peinture monochrome. Histoire et archéologie d'un genre, op. cit.*, p. 35.
17 The terms of the inventory of the works in Klein's studio, after the artist's death. The inventory was drawn up under Pierre Restany's supervision.
18 Yves Klein, 'Le vrai devient réalité', *Zero, op. cit.*
19 *Ibid.*
20 *Ibid.*
21 Pierre Restany, *Yves Klein, le feu au cœur du vide, op. cit.*, p. 61.

Alchemy

1 I borrow this expression from Dario Gamboni, *La Plume et le pinceau. Odilon Redon et la littérature*, Paris: Minuit, 1989.
2 Yves Klein, 'Ce livre commencé . . .', manuscript, Yves Klein Archives, M8.2.
3 See Nicolas Charlet, 'Les quatre livres d'Yves Klein . . .', *op. cit.*
4 Under Bachelard's influence, Klein significantly altered Paul Claudel's dictum, *'le bleu est l'obscurité devenue visible'* (blue is darkness made visible) into *'le bleu est l'obscurité devenant visible'* (blue is darkness becoming visible).
5 See Pierre Restany, *Yves Klein, le feu au cœur du vide, op. cit.*, p. 45.
6 In French: 'Le peintre qui vend du vent'. Anonymous, 'Klein vend du vent', *Arts*, 21–27 February 1962. Klein cut out, annotated and pasted this article into a scrapbook of press clippings, Yves Klein Archives.
7 Cited in Jacqueline Régnier, *Les Couleurs, notes et choix de textes d'artistes et d'écrivains*, Paris: Volets verts, 1994.
8 Pierre Restany, *Yves Klein le Monochrome, op. cit.*, p. 205.

9 Jean Chevalier (ed.), *Dictionnaire des symboles, op. cit.*
10 César had not been able to come to the group's founding meeting, but was regarded from the outset as a full-fledged member.
11 Pierre Restany, *Yves Klein, le feu au cœur du vide, op. cit.*, p. 59.
12 'Le peintre de l'espace se jette dans le vide' is the caption of the photo published in *Dimanche . . ., op. cit.*
13 Boxed item under the photograph published in *Dimanche . . ., op. cit.*
14 Rotraut Klein-Moquay to Thomas McEvilley, cited in the MNAM catalogue, *op. cit.*, p. 53.
15 Gaston Bachelard, *L'Air et les songes, op. cit.*, p. 39.
16 Yves Klein, 'Le vrai devient réalité', *Zero, op. cit.*
17 The expression is by Shelley.
18 See Yves Klein, *Conférence de la Sorbonne, op.cit.*
19 Klein cites Bachelard without giving the source (Gaston Bachelard, *L'Air et les songes, op. cit.*, p. 94).
20 Yves Klein, 'Viens avec moi dans le vide', *Dimanche . . ., op. cit.*
21 Pierre Restany, *Yves Klein, le feu au cœur du vide, op. cit.*, p. 100.
22 *Ibid.*
23 The Bible.
24 Pierre Restany, *Yves Klein, le feu au cœur du vide, op. cit.*, p. 102.
25 'Les champs de la sculpture 2000', group show; Jean-Pierre Raynaud, *Mur (Wall)*, 1999, white ceramic tiles and building materials, 373 x 2107 x 46 cm.
26 Yves Klein, 'Le Feu ou l'avenir sans oublier le passé', Yves Klein Archives, T9.7 (incomplete manuscript: M10.31). The citations are from Gaston Bachelard, *La Psychanalyse du feu*, Paris: Gallimard, NRF, 1949, pp. 21–29.
27 *Ibid.*
28 According to Restany, F 31 is 'the prototype of the pure fires' and F 49 is 'an exemplary document'. See Pierre Restany, *Yves Klein, le feu au cœur*

du vide, op. cit., pp. 122–123.
29 *Ibid.*, p. 40.
30 Handwritten annotation in 'Par la couleur . . .', *Mon Livre, op. cit.*
31 Pierre Restany, *Yves Klein, le feu au cœur du vide, op. cit.*
32 *Ibid.*, p. 142.
33 *Ibid.*, pp. 138–139.
34 *Ibid.*, p. 147.
35 *Ibid.*, p. 146, note 67.
36 *Ibid.*, p. 151.
37 *Ibid.*
38 Yves Klein, with Neil Levine, John Archambault, 'Due to the fact . . .', *Yves Klein* catalogue, Alexandre Iolas Gallery, New York, 1962; in French in *Manifeste de l'hôtel Chelsea*, Galerie Alexandre Iolas, Paris, 1965.
39 All citations from Pierre Restany, *Yves Klein e la mistica di Santa Rita da Cascia*, Milan: Domus, 1981.

Sources of the citations in the epigraphs

Page 85 : Wassily Kandinsky, *Concerning the Spiritual in Art*, New York: Dover, 1977; London: Constabe, 1977.

Page 99 : Victor Hugo, cited in Jacqueline Régnier, *Les Couleurs, notes et choix de textes d'artistes et d'écrivains*, Paris: Volets verts, 1994.

Page 119 : Fernand Léger, *ibid.*

Page 140 : Paul Claudel, *Conversations dans le Loir-et-Cher*, in *Œuvres en prose*, 1935, reissued Paris: Gallimard, 1965.

Page 203 : August Strindberg, *Swanevit*, cited in Gaston Bachelard, *L'Air et les songes*, Paris: José Corti, 1943, reissued 1994; *Air and Dreams*, Dallas: Dallas Institute Publications, 1988.

Page 220 : Pierre Restany, *Yves Klein*, Paris: Hachette, 1974, reissued Le Chêne/Hachette, 1982; *Yves Klein*, New York: Abrams, 1982.

Fire jets on water at the Guggenheim
Museum, Bilbao, Spain. 1998.

Page 254 : **Yves Klein.** *c.* 1960.

Picture credits

Editor:

Marlyne Kherlakian

Design, layout and cover:

Bulnes & Robaglia

Copy-editor:

Bernard Wooding

Index:

Mathilde Rivalin

Photoengraving:

Industrie Grafiche Editoriali Musumeci S.p.A.

Printed by:

**Industrie Grafiche Editoriali Musumeci S.p.A.,
Quart, Val d'Aosta, Italy**